WOMEN'S
CULTURE

WOMEN'S
CULTURE

American Philanthropy
and Art, 1830–1930

KATHLEEN D. MCCARTHY

THE UNIVERSITY OF CHICAGO PRESS
Chicago and London

Kathleen D. McCarthy is associate professor of history and director of the Center for the Study of Philanthropy at the Graduate School and University Center, CUNY.

The University of Chicago Press, Chicago 60637
The University of Chicago Press, Ltd., London

© 1991 by The University of Chicago
All rights reserved. Published 1991
Printed in the United States of America
00 99 98 97 96 95 94 93 92 91 5 4 3 2 1

ISBN 0-226-55583-6 (cloth)

Library of Congress Cataloging-in-Publication Data

McCarthy, Kathleen D.
 Women's culture : American philanthropy and art, 1830–1930 /
Kathleen D. McCarthy.
 p. cm.
 Includes bibliographical references and index.
 1. Feminism and art—East (U.S.)—History. 2. Feminism and art—
Middle West—History. I. Title.
N72.F45M34 1991
701'.03—dc20 91-16632
 CIP

∞ The paper used in this publication meets the minimum requirements of the American National Standard for Information Sciences—Permanence of Paper for Printed Library Materials, ANSI Z39.48-1984.

For my parents,
Joan O. and Daniel D. McCarthy,
and to the memory of my grandmother
Estelle E. Kuemmel

Contents

List of Illustrations *ix*

Preface *xi*

Acknowledgments *xvii*

Part One S E P A R A T I S T S T R A T E G I E S

1. Culture and Gender in Antebellum America *3*

2. Candace Wheeler and the Decorative Arts Movement *37*

3. Separatism and Entrepreneurship *59*

Part Two A S S I M I L A T I O N I S T S

4. Artists and Mentors *83*

5. Museums and Marginalization *111*

Part Three I N D I V I D U A L I S T S

6. Isabella Stewart Gardner and Fenway Court *149*

7. Women and the Avant-Garde *179*

8. Gertrude Vanderbilt Whitney: From Studio to Museum *215*

Notes *245*

Bibliography *281*

Index *309*

Illustrations

Mrs. Sarah Worthington King Peter *2*

Lilly Martin Spencer, *War Spirit at Home* *19*

William Sidney Mount, *The Painter's Triumph* *21*

Candace Wheeler *36*

Victorian household decoration: A "Moorish Pavilion" *42*

Dora Wheeler, Aphrodite tapestry *58*

Candace Wheeler, Miraculous Draught of Fishes tapestry *68*

Mary Cassatt, *Portrait of the Artist* *82*

William Merritt Chase, *In the Studio* *96*

Louisine Havemeyer *110*

Anders Zorn, *Isabella Stewart Gardner* *148*

Fenway Court *164*

Abby Aldrich Rockefeller *178*

Gertrude Stein *181*

Katherine Drier *188*

Abby Aldrich Rockefeller's private gallery *203*

Gertrude Vanderbilt Whitney *214*

Gertrude Vanderbilt Whitney at "Oriental feast" *225*

Preface

One of the most enduring American notions is that women are the nation's cultural custodians, and always have been. According to popular mythology, while men historically immersed themselves in "practical," money-getting pursuits and the task of settling the continent, women lavished their time, their attention, and their husbands' earnings on the arts. Historians such as Ann Douglas trace the "feminization of American culture" to the mid–nineteenth century; others looked to the twentieth and declared it a fait accompli. As the anthropologist Margaret Mead explained, "In some societies like the United States the arts belong to women, while in other societies the arts are completely the prerogative of men." The philosopher George Santayana portrayed this dichotomy as a split between will and intellect: "The one is the sphere of the American man; the other, at least predominantly, of the American woman. The one is all aggressive enterprise; the other is all genteel tradition." While men looked to the future, women conserved the past.[1]

Woven into the warp and woof of American ideology, these perceptions became an accepted verity. Yet the image of female cultural custodianship often obscures as much as it reveals. If the institutional record is carefully examined in a specific area of cultural endeavor, such as the visual arts, a far different pattern emerges. Rather than dominating America's first museums, art unions, and galleries, women were initially accorded a surprisingly limited role. Nevertheless, after the turn of the century a few female patrons did manage to establish major institutions that ultimately contributed to America's emergence as an international art capital. Ironically, within the realm of art women, not men, took the greatest gambles on the art of the future, the untested, the untried.

This in turn raises a host of intriguing questions. Why did antebellum women accept such a meager place in the development of cultural institutions in an era when they figured prominently in a wide variety of charities and social reform movements, and dominated the literary scene? Why did women leave such a limited imprint on the country's major Gilded Age repositories, such as the Metropolitan Museum in New York or the Art In-

stitute in Chicago? When and why did they begin to assume an increased measure of cultural responsibility? Perhaps most important, what can the record of their artistic initiatives reveal about women's philanthropic strategies more generally, both in terms of the opportunities created and the possibilities denied?

The issue of philanthropy is important for several reasons. Before women won the vote in 1920, philanthropic endeavors—giving, voluntarism, and social reform—provided the primary means through which the majority of middle- and upper-class women fashioned their public roles. From the suffrage movement to the creation of social settlements, these women used their philanthropic ventures to wield political power, to create new institutions, and to effect social change. Their activities had important professional implications as well, providing indispensable mechanisms for leveraging new career opportunities. Nursing, medical education, settlements, missionary work, social work—all were opened to women through philanthropic initiatives. Yet these activities have rarely been studied as philanthropy per se, and women's roles as donors have been virtually ignored.

Artistic ventures provide an especially useful laboratory for tracing the dimensions of philanthropic initiatives. Since cultural endeavors (aside from literary efforts) remain a relatively unstudied area, they promise to provide fresh perspectives on women's public roles. They can also help to illuminate the ways in which women used their financial gifts and volunteer time to build institutions and feminize new occupations. Moreover, although many of the women who gravitated toward cultural activities were committed suffragists and social reformers, this was not a prerequisite for their participation. Nonpoliticized women volunteered as well, and the history of their efforts adds a new dimension to our understanding of women's public roles. Unlike abolitionism or the quest to gain the vote, cultural initiatives were less susceptible to the disruptive influences of cyclical reform enthusiasms or to having their programs terminated because their goals had been enacted into law. These efforts can therefore illustrate with special clarity the efficacy, as well as the limitations, of differing philanthropic strategies over extended periods of time.

Within this context, three issues are of particular interest: women's impact on institutional development, the extent to which they used their activities to implement feminist gains, and the ways in which their initiatives differed from those of their male peers. The first can be traced through the history of a variety of institutions for the promotion of the visual and decorative arts. In 1830 women were virtually excluded from pub-

lic artistic ventures. A century later they finally assumed a leading role. The records of galleries, art unions, museums, and artistically oriented voluntary associations reveal the scope and nature of that change.[2]

Since the study of institutions such as these is, by its very nature, limited primarily to the efforts of white, Anglo-Saxon, Protestant middle- and upper-class women and men, the contributions of minorities and immigrants are not examined in these pages. Nor are the efforts of southern women, or those in western states. Instead, this study concentrates on eastern and midwestern cities such as New York, Boston, Philadelphia, Cincinnati, and Chicago, where many of the country's major arts organizations first appeared. My hope is that these findings will encourage others to examine the philanthropic strategies of different religious, ethnic, and racial groups, as well as those of patrons in other regions.

Feminist concerns—the ways in which women used their gifts of time and money to help other women achieve professional gains—constitute another significant theme. The importance of this issue was highlighted by the art historian Linda Nochlin when she provocatively asked, "Why have there been no great women artists?" Nochlin underscored the need to examine the factors that made it *institutionally* impossible for women to achieve excellence or success on the same footing as men, *no matter what* their talent, or genius. Indeed, the record of women's roles in the development of cultural institutions can reveal a great deal, not only about the paucity of prominent female painters but also about the constraints that have historically limited women's professional achievements as a whole.[3]

The third issue is that of gender. Although feminist scholars such as Gerda Lerner and Joan Scott have stressed the need for more comparative studies of the activities of both sexes, to date most histories of women's efforts have focused on women alone. As a result, questions about the ways in which men and women used their voluntary efforts, and particularly their funds, to create institutions have remained relatively unexplored. Did they develop different types of institutions, and if so, how did these decisions shape their public and professional lives? Analysis of these differences can help to illuminate the parameters of "women's culture," as well as the history of women's cultural roles.[4]

It also provides a useful context for testing a series of interrelated hypotheses about the underlying structure of American philanthropy. At the most general level, I will argue that differences between men's and women's institutional strategies became increasingly marked in the decades following the Civil War. Multipurpose museums were one of a number of bureaucratically oriented, hierarchical "nonprofit corporations"

created by wealthy male donors and trustees in the late nineteenth and early twentieth century. Modelled on the modern business corporation, these institutions ultimately helped to engineer the managerial reorganization of American society. Contrary to popular perceptions that the arts were becoming feminized, cultural institutions served as important building blocks in the emergence of a national, male policy-making elite.[5]

Women, on the other hand, continued to sponsor voluntary associations and specialized nonprofit institutions that locally, at least, were more attuned to the preindustrial scale of the family and the church—strategies reinforced by the limited amount of cash at their command. The "parallel power structures" that they created sometimes challenged, sometimes complemented, but rarely precisely replicated the "nonprofit corporations" built by men, stylistic differences that had important implications for their cultural endeavors. Rather than setting the nation's artistic canon through museum development, female art patrons tended to work from the sidelines, continually promoting the cause of neglected genres and groups. Far from assuming a custodial role, they were inveterate pioneers.[6]

They pursued these ends through a variety of philanthropic strategies. Part 1 of the book examines collective initiatives such as the decorative arts movement spearheaded by Candace Wheeler, which promoted women's bid for widened cultural responsibilities in the name of sisterhood and separatist gains. Like women's clubs and the Women's Christian Temperance Union, decorative art societies were largely created, managed, and maintained under female control, and dedicated to helping other women. Feminist scholars have underscored the importance of separatist initiatives within the broad canvas of women's charitable, political, and social reforms, amply documenting their role in fostering new institutions, legitimizing new areas of female endeavor, and leveraging constitutional change. By shifting the focus from social reform to culture, part 1 examines these activities from a somewhat different perspective, exploring not only their strengths but also their weaknesses in achieving parity within male-dominated fields.[7]

Much of this discussion is rooted in nineteenth-century assumptions about the relative merits of the "fine" and "decorative" arts. Rather than commenting on the intrinsic aesthetic value of the paintings, embroideries, ceramics, and statuary that are described in the pages that follow, I have relied instead on the evaluations that were forwarded—and accepted—by the men and women who fostered the development of Gilded Age arts organizations. When women like Candace Wheeler declared that they were promoting a "subordinate" field of art, they did so in order to feminize new areas of artistic endeavor in nonthreatening ways. Whatever the inherent

aesthetic value of the embroideries and ceramics they created, the fact that they themselves accepted these activities as "minor" fields is essential to understanding the nature of the gains they sought to achieve. Although subsequent generations have challenged their assessments, Wheeler and her contemporaries still deserve to be measured in their own terms. To do otherwise would be ahistorical.[8]

Part 2 focuses on assimilationist strategies: the efforts of patrons and painters such as Louisine Havemeyer and Mary Cassatt, who worked within the context of male-dominated professions and institutions. My argument here is that, although the female patrons who supported organizations such as the Metropolitan Museum greatly enriched the country's artistic holdings, they also helped to strengthen a set of institutions and ideas that ultimately trivialized women's contributions as artists, managers, and potential trustees. In the process, they unwittingly condoned not only their own isolation, but that of other women as well.[9]

The final part narrows the focus from collective efforts to more individualistic pursuits. As the segregated "women's culture" of Candace Wheeler's generation was gradually undermined by the growing acceptance of female individualism in the twentieth century, women's cultural authority increased. Beginning at the turn of the century, ambitious patrons such as Isabella Stewart Gardner, Katherine Dreier, and Gertrude Vanderbilt Whitney began to create major arts institutions of their own, exemplifying these trends.

To date, scholars have paid scant attention to the achievements of women such as these. The few historians who have discussed individualistic efforts have tended to cast them in negative terms, describing the women who sidestepped separatist initiatives as "unique—and isolated. They could speak meaningfully only to other women so uniquely situated. . . . Men refused to share power with them . . . [and] divested of their primary alliance with older feminists, they had few resources with which to challenge . . . male power." In effect, they "failed because they lacked the real economic and institutional power with which to wrest hegemony from men and so enforce their vision of a gender-free world."[10]

But this is precisely what women like Whitney and Gardner did have, as did such champions of the avant-garde as Peggy Guggenheim and Gertrude Stein, and therefore the history of their efforts merits closer attention. In addition to establishing a female presence at the forefront of museum development, a few sought to place the works of women artists on an equal footing with those of men, providing a degree of professional parity that earlier, separatist designs had been unable to achieve. Only a few individualists actively pursued these aims, and their innovations often

proved difficult to sustain over the long term. Yet, despite the increasingly erratic nature of these initiatives, when they did occur they served to reiterate the feminist quest for artistic recognition in new and often compelling ways.

The history that follows, then, is neither a celebration of women's achievements nor a jeremiad for lost campaigns. Instead, it represents an attempt to understand how women gradually achieved a position of leadership in what many deemed their divinely appointed sphere; why they were unable to promote the careers of female artists more effectively; and how the history of their efforts illuminates their larger role within American society. This, then, is a book about power, art, and the ways in which women have historically structured their public lives.

Acknowledgments

I have accrued many debts during the course of writing this volume. Some concern professional kindnesses, as when Aaron Warner, Robert Payton, and Thomas Bender helped me to secure library privileges, enabling me to continue my scholarly research at a crucial point in my career, or when Peter Swords and Peter Johnson provided access to invaluable manuscript materials. The many archivists who assisted me along the way included the staffs at the Archives of American Art, the Beinecke Library, Yale, MOMA, the Art Institute of Chicago, the Cincinnati Historical Society, the Museum of Fine Arts, Boston, the Metropolitan Museum of Art, the Isabella Stew-Gardner Museum, and the Rockefeller Archive Center. Other colleagues and friends were conscripted to read the manuscript at various stages, including Paul DiMaggio, John Higham, Alan Brinkley, James A. Smith, Joel J. Orosz, Rosalind Rosenberg, Catharine Stimpson, and John P. Diggins. I particularly wish to thank Nancy A. Hewitt and Susan Chambre for their moral support and incisive editorial comments, all of which helped this manuscript—and me—more than they can possibly know. My staff at the Center for the Study of Philanthropy performed yeoman's service in myriad ways, from checking footnotes to tracking down archival collections. I am especially indebted to Shuang Shen, Jennifer Ohman, Angela Bonnette, Glenn Speer, Andrew Wax, and Janis Ruden for their assistance at key stages in the manuscript's preparation. Others associated with the center helped tremendously as well, particularly Nathan Huggins, Elizabeth Boris, Steven M. Cahn, Virginia Hodgkinson, Stanley N. Katz, and Diana Newell Rockefeller. A number of friends also helped in numerous ways. I especially want to thank Francis X. Sutton, David Garrow, Barry Karl, Kenneth Arnold, Malcolm Call, Mauro and Pauline Calamandrei, Richard and Deborah Kotz, Malcolm and Katherine Richardson, Magda Ratajski, and my sister, Mary Ann Kearns. Finally, I want to thank my parents for their kindness, generosity, encouragement, and unflagging support. In ways too numerous to recount, this book is a tribute to them.

Part One

SEPARATIST

STRATEGIES

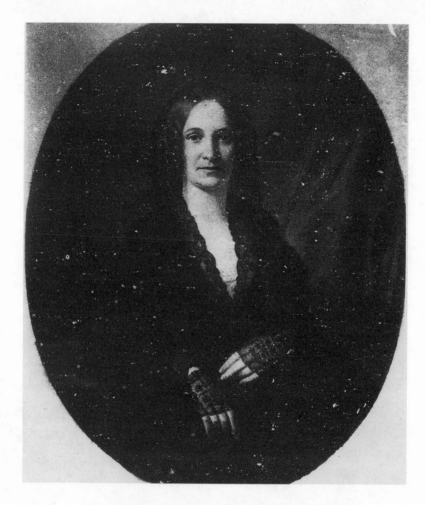

MRS. SARAH WORTHINGTON KING PETER

Culture and Gender
in Antebellum America

A ntebellum America was a nation of joiners. As Alexis de
Tocqueville explained, "Americans of all ages [and] all
conditions" were engaged in voluntary activities in the
decades before the Civil War. Their efforts filled a variety of
social and political functions that often extended well beyond
their organizations' chartered missions. In a democracy, noted
Tocqueville, "citizens are independent and feeble," they are
"powerless if they do not learn to voluntarily help one an-
other." Historians are just beginning to probe the ways in
which these activities helped to recast the social geography of
American cities and the parameters of gender and class.
Within this milieu, voluntary associations provided bases of
power that enabled men and women to shape the contours of
American benevolence, American reform, and American cul-
ture.[1]

At first glance, cultural activities would seem a logical ex-

tension of feminine beneficence and social activism. Voluntarism provided one of the primary mechanisms through which middle- and upper-class women played out their public lives, as they participated in everything from asylum work to more politically volatile abolitionist campaigns. Yet when the nation's first art unions, galleries, and academies were created, women were strikingly absent from their rosters. While middle-class men fashioned arts associations around closely intertwined webs of male friendships, avocations, and business pursuits, women were cautioned to confine their aesthetic ministrations to the home. Whether as patrons or professional artists, they were relegated to the edges of the cultural arena, prescriptions that few effectively challenged.

Culture and the Cult of Domesticity

In part, women's absence reflected the business and professional considerations that served to lend these activities their strikingly masculine cast. It also reflected the intellectual proscriptions that bordered women's lives, and the social and legal prejudices that relegated them to a separate and decidedly unequal sphere. The early decades of the nineteenth century witnessed the increasing isolation of middle-class women within the home. Most professions were closed to them, as were the chances for a thorough education. Moreover, the common law doctrine of *femme couverte* dictated that wives could neither own nor alienate property in their own right. As a result, married women (and this was an era in which most women married) had no legal control over their dowries, their possessions, or their wages. They were, in effect, the legal chattels of their spouses and sires.[2]

While a handful of intrepid feminists and abolitionists campaigned to change the laws that fostered these restrictions, others, perhaps more pragmatically, sought to turn these disabilities to advantage. Domestic publicists such as Catharine Beecher and the editor of *Godey's Lady's Book,* Sarah Josepha Hale, argued that female self-sacrifice and maternal duties held the key to an enlarged role. Under the guise of the cult of domesticity, middle-class women were encouraged to claim an ever-widening share of responsibility within the voluntary sector as educators, missionaries, charity workers, and agents for reform. Always, however, these injunctions were tinged with the underlying warning to eschew the ways of men. Rather than competing for recognition, women would cater to constituencies and institutions of their own. Self-sacrifice, rather than self-assertion, was the rationale that undergirded their public roles.[3]

In particular, they were encouraged to serve the needs of other women, children, and the very old. Within this milieu, women's talents

could safely be extended to the larger society, for the benefit of all, notions strongly seconded by the ministerial profession. As historian Nancy F. Cott explains, "No other avenue of self-expression besides religion at once offered women social approbation, the encouragement of male leaders (ministers), and, most important, the community of their peers." Yet the sanctions easily accorded in the charitable sphere proved far more elusive when shifted to art.[4]

The ministerial profession was slow to endorse the benefits of the visual arts, particularly since so much of the history of artistic patronage was wedded to the Catholic church. Sensuality was a related theme. The lush nudes and baroque excesses that many Americans associated with European painting seemed better suited to kindling the passions than to marshalling moral behavior. How, then, were women to speak for the entire community on a subject steeped in the very sensuality that the cult of the lady sought to deny? As a result, the logic that paved the way for women's entrance into the public charitable sphere impeded their participation in the public promotion of the fine arts. Unlike Bible societies and asylums, work on behalf of galleries and academies lacked the clerical sanctions and public rationale that women would have needed to assume a leading role.

Deprived of a suitable rationale for public involvement, the nation's wives and mothers were urged to exercise their cultural prerogatives within the home. Isolated from the cacophony of business and political pursuits, the domestic circle was to serve as a haven where individual members were nurtured, educated, and refined. Art was an essential element in these designs, a means of tempering the rebelliousness of the young and instilling a lifelong dedication to the pursuit of beauty and culture.

While men's cultural opportunities were continually widened through their friendships, institutions, and clubs, women's roles were correspondingly whittled to fit the context of the domestic sphere. "From Painting," reported Hale, housewives could claim "drawing, Penmanship, [and] Letter-writing" as their own, "from Poetry, the art of reading and taste of selection in literature; from Music, besides household song, we have dancing, gracefulness, and propriety of manner and attire, and many of those innocent home amusements which are beneficial to the heart and soul, mind and body." Drawing, needlework, and the acquisition of suitable household decorations were also deemed particularly appropriate accoutrements to the feminine sphere.[5]

Flowers, shells, minerals, skeletonized leaves, and prints were randomly categorized as exemplary cultural embellishments for the home. Engravings were particularly favored for their ability to "cast a classic influence over the household." Catharine Beecher encouraged her readers

to set aside 20 percent of their household budgets for prints and engravings to grace their parlor walls. Steel engravings were an integral part of the format of popular journals such as *Godey's,* accounting for approximately one-fourth of the journal's production costs by 1865. Because of the time required to make them, these prints were often commissioned first and the literary pieces written to accompany them, a fact that further underscored their importance. Hale offered backlists of *Godey's* prints for readers who wished to frame them to decorate their homes. Like the stories they illustrated, steel engravings were designed to be consumed by women within the privacy of their homes, at modest cost.[6]

The taste for more opulent domestic decorations was roundly discouraged. Tapestried salons and luxurious furnishings were depicted as symbols of female selfishness and excess. While male materialism threatened to undermine society, female indulgence could corrupt the child. Even the stolid art critic James Jackson Jarves was moved to comment on the "degenerating influences" of such refinements. "History tells us," Jarves cautioned, "there is a danger in [such] upholstery, dainty furniture, [and] . . . those things that tend to glitter or mislead." Rather than sumptuous galleries and elegant appointments, therefore, women were expected to cleave to more modest embellishments. Prints for the parlor, rather than masterpieces for public edification and display, stood at the center of female patronage and taste.[7]

Women were also accorded a distinctive intellectual role. Those who advocated improved female education, like Sarah Josepha Hale, did so in pursuit of maternal and domestic goals. The literate wife and mother, so they reasoned, would be a better helpmeet, a better household manager, and a better guardian for the young. But there were limits to these attainments, and they were carefully etched. Properly educated, the young girl would soon surmise that "her intellectual pursuits, her accomplishments and household duties were compatible." Women's intellectual accomplishments practiced within the home were both an embellishment and a necessity. Beyond the domestic sphere, however, they became a liability.[8]

"Woman should not take her intellectual standard from the other sex," *Godey's* sternly noted. "The intellectual pursuits of the sexes may run like parallel lines, but, like those lines, can never meet." Given a choice between head and heart, women were advised to follow their instincts. "A great deal has been said . . . of the INTELLECTUAL powers of woman," snarled one male polemicist, and "the education of the head has been determined to be of more importance than the education of the heart." This, in his opinion, was "all wrong. The head is educated for [a] time, the heart for eternity. . . . The most truly sensible women do not contend for a men-

tal equality." Prudent women were constantly cautioned to "avoid even the appearance of pedantry," for undue "pretensions of learning" invariably proved "more intolerable than absolute ignorance."[9]

Feminists and bluestockings who ignored these injunctions risked ridicule and public censure for their "masculine" ways. "There is nothing more dangerous for a young woman than to rely chiefly upon her intellectual powers, her wit, her imagination, her fancy," cautioned one observer. Doctors, clergymen, and journalists joined the domestic publicists in their campaign to limit the bounds of women's intellectual pursuits and the "passion for self-aggrandizement." As the popular writer T. S. Arthur explained, physiological differences determined that "understanding" would be the province of men, and "will" or the affections women's forte. Those who challenged biological predestination by claiming "INTELLECTUAL equality" were therefore doomed to failure and merited the public disapproval their views received. "Here the greatest error is committed," Arthur commented, "and it is committed by 'intellectual' or 'masculine' women who hold the same false relationship to their sex that 'effeminate' men hold to theirs."[10]

Masculinized by her pedantry and pretensions, the fictional bluestocking was doomed to a lonely fate. In Harriet Beecher Stowe's story "Art and Nature," for example, a mother unwisely educates her two eldest daughters "with such zeal and effect that every trace of an original character" is lost. "All of their opinions, feelings, words and actions, instead of gushing naturally from their hearts, were according to the most approved authority." One, in particular, was "so anxiously and laboriously well and circumstantially informed, that it was enough to make one's head ache to hear her talk." By the time they returned from their tour of the storehouses of European art and culture, the elder girls were "as full of foreign tastes and notions as people of an artificial make generally do return." The moral of the story comes with the appearance of a suitor. Repulsed by the erudition of the overrefined sisters, he chooses the youngest and most unsophisticated girl as his mate. Few could have missed Stowe's underlying message: those who prized their intellectual attainments too highly or too vocally reduced their value on the marriage market. They ran the risk of becoming old maids or spoiled wives. Thus, concluded *Godey's,* the woman "made vain by her polite accomplishments, and unaccustomed to household pursuits . . . disdains the petty cares of her family as beneath the notice of her refined and sentimental feelings."[11]

At minimum, such women be restless and discontented, denied a suitable outlet for their skills. "The great misfortune, then, that lies in the path of highly cultivated women," noted another source, "is the absence of ac-

tive occupation for their mental energy, which, when combined with ambition as it too generally is, lays waste and consumes them." The backlash against the female intellectual, therefore, was aimed at those who sought to enter the public realm, be it in the form of women's rights or invading the artistic prerogatives of men. In the process, women's cultural responsibilities were trivialized and reduced to a domestic scale.[12]

Symbiotic Alliances: Male Artists and Patrons

Within this environment, women who sought more public roles, either as professional painters or as patrons, faced a formidable array of obstacles. Women artists often labored in professional isolation, shielded and encouraged by their fathers, brothers, and husbands (who were most often professional painters themselves), but denied many of the collegial connections these men enjoyed.

Moreover, they were excluded from the networks that bound antebellum male painters and patrons during these years. The antebellum art world was held together by layers of personal and institutional bonds. Many male artists and patrons developed enduring friendships, nurtured through years of study, travel, and mutual aid, which ultimately gave rise to the country's first art academies, galleries, art unions, and clubs. Some hosted informal salons, regularly convening gatherings of male artists, writers, and connoisseurs. Others made the rounds of the local studios during their travels, trading random hints on new varnishes and painting techniques with colleagues in other towns. Artists purchased each other's paintings and maintained contact through constant correspondence, creating a male subculture bound by mutual aspirations and mutual aid.[13]

Groups of male artists regularly travelled together on their European pilgrimages. The painter and inventor Samuel F. B. Morse roomed with the genre painter Charles Leslie during Morse's studies in London, enlivening their evenings with ample rounds of coffee, Madeira, music, and song. Boston painter Benjamin Champney stayed with John Kensett in Paris, where they socialized with members of the Out of Money Club, a group of expatriate artists that included William Morris Hunt. Moreover, contrary to popular stereotypes that limned professional artists as delicate, swooning aesthetes, antebellum painters fashioned an almost gleefully masculine culture centering on drinking, painting, spicy conversation, and the rugged outdoor life. Rather than languishing in their studios, landscapists regularly took hiking trips up the Hudson River valley in search of fresh subjects. Far from effeminate, these were "outdoor men who kept

themselves physically strong" and who were as comfortable with a "hammer, compass and rifle" as with the brushes that marked their trade.[14]

Although their families occasionally accompanied the artists, most of these journeys were taken without the comforts (and constraints) of female companionship. Asher Durand's son recalled trips filled with "discomforts and privations. . . . The obligations and proprieties of society . . . were always, when it was possible, avoided," giving rise to treks filled with the unfettered pleasures of conversation, singing, smoking, drinking, and cards.[15]

The bonds of male camaraderie extended to patrons as well. In addition to accompanying artists on their junkets to Europe and into the American wilderness, many patrons developed enduring friendships with artists in their studios, salons, and galleries, alliances that offered a variety of benefits to both painters and patrons that extended well beyond the bounds of mere conviviality. These relationships were reinforced by the economy of scarcity that surrounded the antebellum art scene. Two factors helped to kindle the taste for American art: the limited availability of suitable (and verifiably authentic) European masterworks, and the paucity of reputable dealers to broker acquisitions. For patrons with neither the time for regular European sojourns nor the patience to retain European agents, American art exerted an increasingly powerful appeal.

Artists' studios played a central role in these developments, providing a convenient meeting ground for painters, literary figures, merchants, professional men, and potential patrons. In New York, much of this activity centered on the University Building at New York University, which also housed the New-York Historical Society and the city's medical academy. Samuel F. B. Morse moved his studio there in 1835, to be followed in turn by Daniel Huntington, John Kensett, and the art critic Henry Tuckerman. Regular visitors included some of the city's leading patrons: Luman Reed, Samuel Ward, Philip Hone, Jonathan Sturges, Gulian Verplanck, and Charles M. Leupp.

In some instances, studios served as the crucible for new institutions. The Brooklyn Art Union was born in Henry Kirke Brown's atelier, which served as the lively focal point for meetings of local artists and writers, including Walt Whitman. According to Whitman's biographer, the sculptor's studio was more like a carpentry shop than a literary salon, providing a particularly inviting setting for men like Whitman. "There I would meet all sorts" the poet recalled, "—young fellows from abroad stopped here in their swoopings; they would tell us of students, studios, [and] the teachers they had just left in Paris, Rome [and] Florence." Pleased with what he

beheld, Whitman not only helped to organize the Brooklyn Art Union, but also publicized its activities in print.[16]

His observations underscored another important aspect of studio life. In addition to cultural exchange, artist's studios served as receiving and dissemination points for other kinds of information as well, gleaned from prominent sitters, local businessmen, and travellers just arrived from exotic ports. The sharp-eyed social observer Harriet Martineau noted that people were constantly dropping by George Caleb Bingham's studio while she was having her portrait painted, "and the news of the hour circulated."[17]

This in turn provided business advantages that transcended the pleasures of cultural exchange. Communications theorists such as Alan Pred have helped to illuminate the importance of information flows in fostering urban growth and business success. Prior to the introduction of the first telegraph lines in 1844, the circulation of long-distance information depended primarily on human interaction. Timely access to fresh information, particularly privately circulated information, was often a key to commercial success. Thus, the grocers, real estate developers, and dry goods merchants who crowded into artists' studios may well have been seeking useful gossip as well as cultural enlightenment.[18]

Patrons such as Robert Gilmor of Baltimore exemplified some of the more subtle ties that wedded artists and patrons during these years. Born in 1774, Gilmor inherited his father's business in the East India trade. Well-travelled and extremely knowledgeable, his voracious appetite for American and European art accorded him a central place in a variety of institutions, including honorary memberships at both the Artist's Fund Society in Philadelphia and the National Academy of Design.

The reason for his popularity stemmed less from his personality, which on occasion could be quite acrid, than from his willingness to help struggling artists in the early stages of their careers, and from the quality of his private holdings. Gilmor amassed his collection at a time when most Americans lived in "almost absolute ignorance of the artistic masterpieces of the world, the statues, the paintings, the palaces, the cathedrals that have been held scared by successive generations of men." Holdings such as his were particularly valuable to aspiring artists who wished to study new techniques. As a result, his gallery became a "school" for artists passing through Baltimore, serving as a primitive museum at a time when few public alternatives existed.[19]

Gilmor was well aware of the educational value of his collection. Setting modesty aside, he candidly avowed having "seen much worse collections abroad, and if mine only stimulates my countrymen to cultivate a taste

for the Fine Arts I shall be well compensated for my experience in making it even such as it is." Unfortunately, Gilmor's plans to turn his gallery into a public institution ran around of financial reverses suffered late in his career, and the collection was liquidated shortly after his death.[20]

Luman Reed was another influential collector. Although Reed's tenure as an American patron was tragically short, he managed to leave a lasting imprint on the careers of many of the artists he befriended. Born in 1785 in Columbia County, New York, Reed began his career as a clerk in a small country store, eventually amassing a sizable fortune in the wholesale grocery trade. As his fortunes grew, he turned to art collecting, beginning with European canvases. His tastes abruptly changed when he learned that some of the "Old Masters" that he had acquired from local dealers were in fact undistinguished copies. Undeterred, Reed turned his attention to the American paintings at the National Academy of Design, where he met the artists as well. He made his first foray into American patronage in the early 1830s, commissioning works by Asher Durand and Thomas Cole to decorate the gallery of his new house.

Other commissions soon followed, providing substantial windfalls for Durand, Cole, William Sidney Mount, and George W. Flagg. At Reed's suggestion, Durand was persuaded to abandon his career as an engraver to pursue painting full time. An extraordinarily generous and genial man, Reed was as lavish with his encouragement and praise as he was with his commissions. Thus, he reassured Durand, "I hope we may often be identified together if my being so will promote your interest and success. . . . Let us make something of ourselves out of our own materials and we shall be independent of others."[21]

Reed was equally enthusiastic about other artists, commissioning their works to fill his private gallery, which he opened to the public once a week, a practice copied by other collectors as well. Some artists were given loans, some were sent to Europe to study, while others received unprecedented sums for their works. Reed even hired Durand's son as a clerk in his store when he learned that the boy needed a job. In one particularly notable instance he voluntarily increased his payment for Cole's *Course of Empire* series from $2,500 to $4,500 upon seeing the finished works. He also tirelessly touted the virtues of American art among his business associates, garnering additional commissions for struggling artists. Even literary figures fell prey to Reed's gentle proselytizing; Washington Irving was given a private showing of Mount's painting *The Bargain*. Irving liked it, asked to meet the artist, and afterward "Mount was never without a commission."[22]

Reed also helped to broker new opportunities for young artists. Thomas Carey later recalled being persuaded to allow one of Reed's pro-

tégés to copy a Gilbert Stuart painting in the Boston Athenaeum. In return, he gained access to some of the country's leading statesmen, whom he might not have met under more business-oriented circumstances. For example, Reed negotiated sittings for Durand with several former presidents, including John Quincy Adams, James Madison, and Andrew Jackson, accompanying the artist on his journey to Madison's estate. Durand's affection for Reed and their mutual respect are echoed in his letters. In one instance, he confessed that he "would say much were I to obey the dictates of my heart" but confined himself instead to conventional "assurances of the highest respect and esteem." Another missive promised that "you shall soon hear from me again. I feel extremely lonesome since your departure at times, almost to melancholy, but do not allow myself time for the indulgence of such feelings."[23]

Reed's premature death in 1836 sent waves of sorrow and shock through the art community. Durand caught the spirit of their dismay when he confided to Cole that "I still find myself so deeply attached to him that the very thought of his loss fills me with a gloom and sadness which almost unfits me for the common duties of the day." Others were equally affected. George Flagg memorialized Reed as "the best friend I ever had. . . . He was *indeed* a Father to me, ever ready to cheer me on."[24]

These friendships were nurtured and strengthened in private salons. Luman Reed was one of several New York hosts who regularly convened parties of artists and writers such as Irving, Cole, Cooper, Durand, and Bryant in the welcoming surroundings of private galleries and homes. David Hosack was one of the earliest and most renowned of these hosts, drawing together a motley array of college professors, literary men, army officers, and foreign visitors at his Saturday soirees. While the writer Catharine Sedgwick graced her brothers' soirees, most of these salons were decidedly male affairs. George and Evert Duyckinck used their ample private library as a lure to writers such as Herman Melville, Richard Henry Dana, Henry Wadsworth Longfellow, and James Fenimore Cooper. "Strictly male" in deference to George's "avowed bachelorhood," these evenings featured "Rabelaisian conversation" among a lively mix of actors, writers, painters, and musicians. The art collector and social diarist Philip Hone was another noted host, as was his fellow connoisseur Samuel Ward.[25]

Nurtured by New York's abundant social life, alliances between male artists and writers were quite common, including celebrated friendships between Washington Irving and Washington Allston; James Fenimore Cooper and Horatio Greenough; William Cullen Bryant, Thomas Cole,

and Asher Durand; Cooper and Samuel F. B. Morse; and Herman Melville and William Sidney Mount. As in the case of artists and connoisseurs, many of these relationships were rooted in symbiotic returns. Thus, Cooper patronized the works of Greenough and Morse and commissioned an illustration of his Leatherstocking tales from Cole. Writers lent money to struggling painters, found buyers for their works, and participated in a growing array of cultural institutions, including the National Academy of Design. In at least one instance, local artists and writers pooled their funds to promote a fellow artist's career, forming a joint stock venture to back the completion of a history painting by Samuel F. B. Morse.[26]

They also pooled their talents in private clubs such as the Bread and Cheese and the Sketch. Cooper presided over the Bread and Cheese, a supper club of writers, editors, artists, and performers that met every Thursday at the Washington Hotel to discuss the latest social and cultural trends. Later rechristened the Lunch, it included Bryant, Hone, John Vanderlyn, Durand, and Morse among its members.

The Sketch Club was more focused, centering on a desire for mutual improvement and the production of literary annuals. Founded in 1829, it brought together a distinguished array of artists, patrons, and writers, including Bryant and Reed, who met at each other's houses each Friday evening. Each session featured a theme, which was illustrated by the artists and rhetorically embellished by the literary men. The meetings were further enlivened by ample refreshments, to the point that the secretary, John Inman, once gleefully reported, "No drawing done but corks." Stories, songs, and philosophical meanderings rounded out the standard format, providing rollicking entertainment for those fortunate enough to be invited to attend.[27]

The Century Association was a descendant of the Sketch Club. It began in 1847 with a nucleus of painters, writers, and patrons, including Philip Hone, Charles M. Leupp, Daniel Huntington, Gulian Verplanck, Asher Durand, Jonathan Sturges, and Henry Tuckerman. More formal than the Sketch Club or the Lunch, the Century provided permanent meeting rooms where artists, writers, and men of affairs could meet to discuss cultural issues with distinguished visitors from out of town. By the time the club was reincorporated a decade later, a library, a reading room, and an art gallery had been added as well, providing better opportunities to display members' creations. Women were admitted only grudgingly, to attend special dinners or the club's semiannual fairs. Like painters' studios and men's salons, clubs represented a form of male cultural terrain from which women were generally excluded.

Women and Art

The absence of middle- and upper-class women from these circles was rein-forced by their relegation to the home and by the amateurishness associ-ated with women's art. For most women, artistic pursuits connoted household pastimes rather than full-time careers. While drawing was deemed a suitable antidote to domestic ennui, the production of "serious" art seemed more suited to male skills. Rather than seeking "to ascend those airy heights of renown upon which man now stands supreme," women were encouraged to copy, not create. In the words of Mrs. Ellis's treatise, *The Family Monitor and Domestic Guide,* "To be able to do a great many things tolerably well, is of infinitely more value to a woman than to be able to excel in any one." In the process, female artistry came to be equated with "frivolous self-indulgence, busy work [and] occupational therapy."[28]

One area in which women were encouraged to give their imaginations free reign was in their needlework. A century later, these works would come to be prized as masterpieces of folk art and harbingers of the interna-tional penchant for abstract design. For nineteenth-century commentators, quilts and samplers were an acceptable female craft because, like literature, they could be created and consumed within the home. Art historians have just begun to descry the layers of symbolic meaning that surrounded many of these works. Antebellum quilts frequently charted stages in the life cycle. Bridal quilts were begun shortly after a girl's engagement was an-nounced. Made of the finest materials and laced with biblical symbols of constancy and love, they served to highlight a young woman's aspirations and skills. Freedom quilts celebrated a young man's coming of age. Crafted by his mother, sisters, and eligible female friends, they marked his passage into the responsibilities of adulthood.

Friendship quilts were frequently made from bits and pieces of clothing from cherished acquaintances, stitched as a memento for women embarking on the journey to new settlements. While family album quilts recorded the contours of domestic life with homely images of relatives, pets, and household artifacts, mourning quilts were steeped in the imagery of mortality. Sized for a single bed and stitched from remnants of the dead person's clothes, they featured such patterns as the "darts of death."

These were quintessentially women's arts, taught, produced, and con-sumed by women within the domestic sphere. While many prominent male painters began their careers in artisanal apprenticeships, young girls under-went informal apprenticeships in needlework skills under the tutelage of female kin, and their efforts were evaluated by female consumers, critics, and peers. Just as the canvases produced by men were shown in galleries

and academy exhibits, women displayed their wares at mechanic's institutes, local fairs, and church gatherings. Quilts and embroidery were also among the goods women commonly produced and marketed at their fund-raising events for social causes, lending a charitable cast to female artistry that further distinguished women's efforts from those of men. Many of these works were signed, dated, and bequeathed to future generations like other works of art. In many respects, the quilting bees that produced these artifacts served as women's counterparts to studio life and clubs, providing an informal meeting ground for relaxation, creative efforts, and information sharing in the company of like-minded peers. Barred from public cultural activities by popular prejudices and the dictates of the domestic sphere, antebellum women devised parallel structures that were uniquely their own, sharpening the boundaries between men's and women's culture in the process.[29]

Those who sought to move into more overtly professional pursuits often met strong resistance. Professional training proved particularly difficult to obtain. "Although some creators accepted pupils—Morse did for a while—the ubiquitous teaching of art as a polite accomplishment to young ladies gave the practice so bad a name that . . . most serious painters" sidestepped the issue entirely. At a time when they were struggling for their own professional recognition, few established artists cared to risk their hard-won reputations by consorting with women students.[30]

Contemporary observers were quick to underscore the relationship between gender and genius, drawing a sharp distinction between male creativity and female talent. "Genius is power; talent is applicability," noted the New England sage Ralph Waldo Emerson. While men were viewed as rational beings ruled by intellect, influential Enlightenment writers such as Jean-Jacques Rousseau held that women were closer to nature, more governed by their emotions and biological imperatives, and therefore more given to imitation than originality. Because creativity was deemed an intellectual endeavor rather than an intuitive gift, women seemed destined to be excluded from true achievement.[31]

In one popular tale of the time, a male artist catechizes his female pupil about the limitations of her sex: "It was impossible for a woman to become an artist—I mean a GREAT artist. Have you ever thought what that term implies? Not only a painter but a poet; a man of learning, of reading, of observation. A gentleman . . . "[32]

The art critic James Jackson Jarves was still more acrid and to the point. "Art looks to America with open arms," he noted. "How is it to be carried out here? Not be misses who run over Europe and bring back a cabin-load of new bonnets, with dresses and trinkets to match; neither by women

whose aim is display and ruling principle vanity; nor by young gentlemen whose attainments are limited to the run of cafes and gambling saloons. . . . We need Art-students, men of sincerity and labor, who will not hesitate to go on their backs and knees, if need be, in the dust, to read the soul language of the mightiest minds in Europe."[33]

Jarves was adamant on this point. "Art is no pretty pastime for the artist," he snapped, "no trifling occupation to grace idle hours. Far from this. It is [the artist's] serious duty, the life-work of which his soul-energies should be bent for his own good and that of his fellow-men." Although Jarves was notorious for his ill-tempered statements, he harbored a particularly venomous disdain for women dilettantes and clearly felt their presence to be an intrusion on the studio scene. "I shall never forget the indignation which burst from the lips of the truest-hearted artist I ever met, as a lady-trifler, in praising a work which had cost him years of the deepest study and incessant application remarked, 'what an agreeable pastime it must be for him,'" the critic recalled. "She could see only in his picture the facility of execution, and not the intensity of thought."[34]

What rankled Jarves the most was the notion that a woman, with an appreciation for neither art history nor techniques, should equate the work of the professional artist with her own. Popular prejudices such as this were encouraged and reinforced by strictures against female intellectuality, providing fuel for those who felt that women's place was in the home, not the professional domain.

While a nuisance for dilettantes, these prejudices were particularly damning for women who aspired to professional careers. As a result, female painters had a harder time securing commissions, suitable subjects, and professional recognition. Few had the fortitude to take to the road in search of commissions, or the resources to pursue their training overseas. Instead, they tended to be educated at home, under the guidance of spouses, brothers, and sires. Thomas Cole's sister became an accomplished artist, as did Gilbert Stuart's daughter Jane, Emily Sartain, Ann Leslie, and a number of Sullys and Peales. Often, they accepted the crumbs from family commissions, painting copies of the works of their more celebrated kin. Ann Leslie, for example, specialized in reproductions of her father's works, while Anna Claypoole Peale completed her father's paintings for him when his eyesight began to fail.[35]

Unlike the rugged individualists who hiked the Catskills in search of themes, women painters tended to seek their subjects closer to home, painting still lifes and miniatures drawn from the domestic scene. The problems of respectability and recognition that troubled male painters were doubly problematic for women in an era when the very choice of a

nontraditional career threatened to place them beyond the pale of middle-class society. In 1832, for example, Harriet Martineau recorded a scant seven occupations in which women played a leading role: millinery, dress-making, tailoring, sewing, domestic and factory work, and teaching. Artists undoubtedly failed to figure in her inventory because their ranks were limited and their presence overshadowed by their more famous male kin.

In an era when most women married and those who failed to do so were regarded with pity and scorn, many female painters remained single in order to maintain their careers. Often their choices were shaped by family needs. Jane Stuart, for example, supported her mother and sisters by painting copies of her father's works, and Maria Louisa Wagner became a painter in order to care for her crippled brother. Conversely, Mary Jane Peale relinquished a promising career to care for her aging parents, while her cousin abandoned her career to pursue the more conventional responsibilities of a doctor's wife.

Those who sought to balance family and career faced an exceedingly difficult task, even with the most supportive of spouses. Lilly Martin Spencer's career is a case in point. Although relatively untutored, Spencer managed to become one of the leading genre painters of her time, drawing heavily on the domestic scenes she found at home. Born in England and reared near Cincinnati, she was the daughter of French intellectuals who emigrated to pursue their utopian dreams in the American Midwest. Her father, who was an active advocate of women's rights, recognized her gifts and encouraged her to study for a professional career. Surprisingly, Spencer declined an offer from Nicholas Longworth, one of the city's leading patrons, to subsidize her studies overseas, opting to work with local painters instead.

She married Benjamin Rush Spencer in 1844. It proved to be a remarkably good match, since her gentle and self-effacing spouse assumed most of the responsibility for managing their growing brood (seven of their thirteen children lived to maturity), allowing Lilly to concentrate on her career. When her painting *Life's Happy Hour* was engraved by the Western Art Union in 1849, Spencer's prospects seemed assured. By the late 1850s, her works had appeared in the galleries of the American Art-Union, the Cosmopolitan Art-Union, the Boston Athenaeum, the Washington Art Association, and the National Academy of Design, and several had been reproduced as highly popular prints.

Despite these seeming triumphs, the family was constantly in debt, forced to live a precarious existence by the fortuitous nature of Spencer's commissions. Her letters to her family during these years reveal almost an obsession with financial worries and household details. After selling two

canvases to the Cosmopolitan Art Association on credit, she confided, "I am very much afraid I shall never get anything for them. I have been told it is a very uncertain affair—but I had to accept this sale as I had no other prospect whatever." Six months later, payment was finally received. Other ventures were more risky, particularly when the deals involved reproductions. Although highly remunerative for the print companies, artists often received few profits in these transactions beyond the initial sale. In 1868 Spencer tried to counter this problem by copyrighting her painting *Dandelion Times* to ensure a 10 percent commission on the resulting chromolithograph sales. Copyright notwithstanding, Binke and Company cheated her out of the profits.[36]

Commenting on conditions in New York, she reported that "there is a perfect swarm of painters here and very, very good ones, too, that can hardly get along." As a result, commissions were hard to come by. "Painting as a profession seems to be gone to the dogs," she complained. "I had expected that after having so many of my pictures engraved that I should have had plenty to do, but it is not so. . . . Purchases are not to be had for fancy pieces—when once publishers have got what they want, there is no one to buy, and portraits, that used to be the mainstay of artists photographing has almost entirely destroyed."[37]

In autumn of 1856 Spencer reported that she had "not for seven or eight months sold a single picture or had a single portrait to paint, notwithstanding my continuing painting picture after picture with the same ambition, to excel in each one." Four years later she was reduced to coloring photographs to keep the family fortunes afloat. Lilly described her decision as something "I thought I never would stoop to do. . . . I have to stick to it so close and to do so many in order to make any profit by it, for they give me a mere pittance for doing them." But since "we had heavy payment to make, and no fancy pieces selling, no portraits coming, I was very glad to get this work." Toward the end of her life, Spencer would be reduced to trading her canvases for food.[38]

The difference between her career and that of her fellow genre painter William Sidney Mount is instructive. Both were popular; both had works that were widely exhibited and reproduced. But Spencer's letters reveal little of the professional camaraderie enjoyed by Mount, being filled instead with the weight of domestic responsibilities. While Mount vowed not to waste his time with people who would not forward his career, Spencer felt compelled to encourage anyone who might take an interest in her work. While Mount admonished, "Never copy," Spencer was reduced to the most menial occupations, including painting photographs. And while Mount roamed the countryside, coming to the city to sell his works and

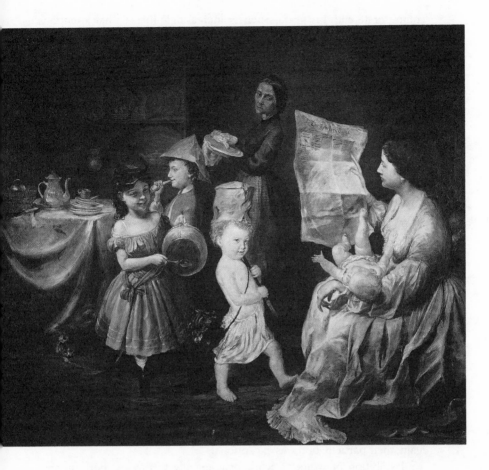

LILLY MARTIN SPENCER, *WAR SPIRIT AT HOME*

Courtesy of the Newark Museum, Newark

commiserate with his peers, Spencer increasingly focused her attentions inward, working and painting at home, using her family as subject matter, and handling her contacts with the public world of dealers and gallery managers through correspondence. She was professionally isolated in a way that men like Mount would neither support nor endure.[39]

Although several of Spencer's customers were women, including wealthy matrons such as Mrs. Phelps Stokes, Mrs. August Belmont, and the wife of Senator Winfield, none used their holdings to promote her works in the manner of Gilmor or Reed. Nor did they develop comparable networks among female artists. Instead, they occasionally visited her studio, wrote a flattering note, and commissioned a portrait, but their support ended there. Ironically, although antebellum women developed a rich assortment of institutional networks, the asylum, temperance, Bible, charitable, and moral reform societies they fostered provided little in the way of cultural backing. Relegated to the periphery of men's professional networks by popular prejudices and the invisibility of their working lives, women artists were equally estranged from female support networks by virtue of their secular, unconventional careers.

Their participation in exhibitions, academies, and artists' societies was equally limited. Only one woman, Ann Hall, was elected to full membership in the National Academy of Design in the 1820s, and only once was she invited to attend the members' meetings, in order to complete a quorum on an urgent vote. Similarly, although two of the charter subscribers to Philadelphia's Artist's Fund Society were women, none were listed among its regular members. Jane Sully and Sarah Peale were elected to membership in the Pennsylvania Academy of the Fine Arts, but once again, their participation was exceptional.

Exhibition of women's works was equally fortuitous. Early in the Pennsylvania Academy's career, trustee Joseph Hopkinson expressed the surprising hope that the academy's walls would "soon be decorated with the productions of female genius; and that no means will be omitted to invite and encourage them." The contributions from women that appeared in these early exhibitions were something of a hodgepodge, ranging from regular canvases to flowers painted on velvet and even a "landscape in embroidery" by a Miss Matthews. By the 1840s, exhibitors at the Artist's Fund Society, the National Academy, and other showings could usually count on contributions from three to six female artists, including Jane Sully, Lilly Martin Spencer, and Anna Claypoole Peale. Female patrons were less common. With the exception of the Baltimore Historical Society shows, which drew as many as nine women donors in a single year, only two to four

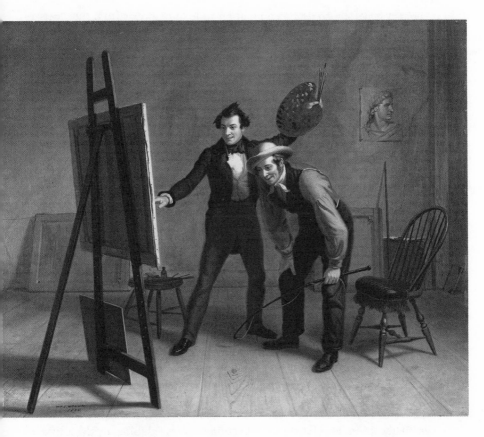

WILLIAM SIDNEY MOUNT, *THE PAINTER'S TRIUMPH*

women generally could be counted on to lend paintings from their personal holdings.[40]

The types of paintings they exhibited revealed an interesting shift in the three decades before the war. In the 1830s, portraits overwhelmingly predominated, with few women's contributions of any other sort. In the 1840s, genre and landscapes became more popular, although portraiture remained the leading staple. By the 1850s, however, genre had become the overwhelming favorite among both female and male patrons, followed at a distant remove by portraits and landscapes. Photography undoubtedly played a role in shifting popular tastes from portraiture to "fancy works." Prior to the advent of photography, paintings were the only means of preserving the likeness of a loved one. In an era of jarringly high mortality rates among children and young adults, this must have exercised a particularly strong appeal. Relocation, too, often meant that departing friends and kin would not be seen again. Portraits helped to fill the gap, providing treasured mementos for the middle class, as well as the well-to-do.

By the 1850s, the first married women's property acts had been enacted, giving matrons in selected states increased power over the dispersion of their dowries and goods. In many instances, women initially inherited rather than bought the paintings they exhibited. Bostonians, in particular, bequeathed paintings by Gilbert Stuart and Washington Allston from generation to generation, spouse to widow, to be patriotically displayed. However, many of the artists whose works these women exhibited were not well known. Only Daniel Huntington seems to have developed a consistent female following during these years. Works by women artists were surprisingly absent from women's collections, unless exhibited by the artists themselves. If women did collect the works of female artists, therefore, they kept them to themselves. Nor did they open their collections to the public, like Luman Reed or Robert Gilmor, since to do so would have compromised the privacy of the domestic sphere and gone against the grain of their expected role.[41]

Although some male portrait and genre painters attracted women customers, the landscapists of the Hudson River school were far less attuned to female buyers. What little evidence remains suggests that women may also have paid on the low end of the scale, making them less attractive as patrons. Although John Kensett commanded prices in the $600-to-$700 range by the mid-1850s, for example, the few canvases he sold to women tended to be priced at almost half that rate.[42]

For portrait painters like Thomas Sully this seems to have posed less of a problem. One of the leading portraitists of his time, Sully was famed for his idealized likenesses of women, as was Washington Allston. Unlike many

artists of the time, he also seems to have been more amenable to female companionship, dining, taking tea, and attending concerts in the company of women. Many, of course, would have been prospective customers. The gentle, cultured Allston departed from the practices of his peers by teaching women students. In the words of one of his admirers, Anna Cabot Lowell, Allston's manners were "polished, his mind improved and elevated, and his morals pure." G. P. A. Healy was another talented portrait painter who had a way with women. In one instance, Healy reportedly persuaded the aristocratic Mrs. Harrison Gray Otis to have her portrait done by telling her, "I want to paint a beautiful woman. Will you sit for me?" She did, and later financed his trip to France as well. Yet these alliances were far less common among the artists who did not base their livelihood on women's cooperation and good will.[43]

Male Culture and Institutional Development

Beyond exhibiting a handful of works and forging ties with artists who catered, in large measure, to women's vanities and tastes, women played a negligible role within the antebellum art world. Born of male relationships and pursuits, America's antebellum galleries, academies, and art unions wedded business, professional, and political aims in ways that effectively precluded female participation. Some of the earliest were created as joint stock companies, a structural innovation that virtually excluded women who had little access to ready cash. The American Academy of Fine Arts, founded in New York in 1802, and its sister institution, the Pennsylvania Academy of the Fine Arts in Philadelphia (1805), were both the work of patrician sponsors. Begun as joint stock companies, with subscriptions selling at $25 to $250 a share, both were essentially closed societies, developed primarily for the edification of the wealthy and wellborn men who created them.

The National Academy of Design was wedded to more professional aims. Founded in 1825, it was the creation of a motley array of male painters, sculptors, architects, and engravers. Primarily in their twenties and thirties, these men came from a variety of backgrounds. Many had already mastered the engraver's trade, and some turned their hands to such diverse tasks as painting stage scenery, portraits, commercial signs, and even fire engines to earn the necessary funds to support their artistic careers. Most hailed from artisanal backgrounds, a common pattern of the time. Thomas Cole began his career as a calico designer and engraver's assistant, serving briefly as an art teacher, wallpaper designer, and general artist-handyman. John Kensett learned the engraver's craft under his fa-

ther's tutelage, while Asher Durand had been apprenticed to the master engraver Peter Maverick, another charter member of the National Academy of Design.

While the academy promoted the cause of professional advancement, several antebellum patrons, such as James Jackson Jarves, Thomas Jefferson Bryan, and the friends of Luman Reed, sought to create permanent, public galleries from their collections. Jarves was born in Boston in 1818, the scion of a prominent clan: his father presided o٧٤٢ the glassmaking firm that developed Sandwich glass. He had an expatriate's taste for travel, spending much of his life in Hawaii, Paris, and Italy. His introduction to European culture at the age of thirty-two struck him with the intensity of a religious conversion. After settling in Florence, Jarves immersed himself in the affairs of the city's cultured expatriate community, forming friendships with the American sculptor Hiram Powers, the Brownings, and his erudite fellow Bostonian Charles Eliot Norton.

He also began to amass a formidable private collection of early Italian paintings that eventually tallied 130 canvases worth an estimated $60,000. Like Gilmor, Jarves acquired his holdings with an eye to establishing a permanent gallery. And, like Gilmor, he was ultimately frustrated in his intent. Jarves initially offered to sell $20,000 worth of the paintings to any individual or association willing to make it the nucleus of a permanent collection in Boston. When the desired funds failed to materialize, he lowered the price to $15,000. Even so, the highest bidder, the Boston Athenaeum, managed to raise only a third of the anticipated funds, and the deal fell through. Although Jarves's collection did eventually make its way to an American repository (at Yale University), the troublesome negotiations revealed the problems inherent in trying to make a museum of a private collection.

Bryan's experience proved equally abortive. Born into a wealthy Philadelphia family, he spent almost twenty years on the Continent, where he amassed a collection of paintings designed to illustrate the evolution of art history from early Byzantine to contemporary American works. Like others before him, Bryan hoped that his collection would one day form the nucleus of a national gallery of art. In 1855, he opened the Bryan Gallery of Christian Art in New York, featuring over two hundred of his paintings. Unfortunately, the venture was short-lived, unable to sustain the anticipated level of public interest, and the canvases were eventually transferred to the repositories of the New-York Historical Society.

Luman Reed's collection met a similar fate. After his death, several of his friends and associates pooled their funds to launch the New York Gallery of Fine Arts (NYGFA) from his collection in 1844. Charter members ranged from Jonathan Sturges, Reed's business partner and a noted collec-

tor in his own right, to literary figures such as William Cullen Bryant. When the $13,000 subscription proved insufficient to secure a permanent gallery to house the collection, Sturges and another friend and collector, Charles M. Leupp, contributed the necessary funds to secure the National Academy of Design's former gallery at Bond Street and Broadway. Perhaps inspired by Reed, Sturges and Leupp ultimately became important patrons as well. In addition to his role with the NYGFA, Sturges was a member of the Sketch Club, the Century Association, and the American Art-Union. As the father of J. Pierpont Morgan's first wife, he may also have had a role in whetting the artistic appetites of one of the leading collectors of the next generation. Like Sturges, Leupp was a friend of such painters as Francis Edmonds, Asher Durand, John Kensett, and Thomas Cole, leading their paintings for exhibitions in Brooklyn, Boston, and Manhattan.

Their intention was to use Reed's collection as the nucleus for an American counterpart to England's National Gallery. As the catalogue explained, the gallery was also intended to serve as a source of popular "refinement; nay, more, it is a stronghold of virtue. It opens a fountain of pure and improving pleasure to the stranger, to the idler, to the young, to our families, to our children. Call it a lounge, if you please, let it catch the idle hours or arrest the weary step; yet idling and relaxation here can hardly fail to be improvement." Noble intentions notwithstanding, the venture proved predictably short-lived. Despite the lure of additional canvases lent by leading artists and connoisseurs, public interest remained lukewarm. Only a thousand memberships could be sold, much less given away, leaving little surplus cash for continued operations. Sturges shouldered the expenses for a few years, after which the gallery was closed and its holdings transferred to the New-York Historical Society, where they can still be seen today.[44]

The American Art-Union (AAU) represented one of the most imaginative attempts to create a permanent art gallery and develop audiences and buyers for the works of living American artists. The idea originated with James Herring, a jack-of-all-trades who dabbled in publishing, portraiture, and art sales. After an unsuccessful attempt to create a permanent exhibit of American art at his Apollo Gallery, Herring decided to borrow the techniques of the Edinburgh Association for the Promotion of the Fine Arts in Scotland. Aided by a group of prominent businessmen and connoisseurs, the Apollo Association—later rechristened the AAU—was officially launched in 1839.

Their plan was elegantly simple. In return for a nominal $5 fee, subscribers were guaranteed a high-quality line engraving of a contemporary American painting and a chance to win an original painting at the associa-

tion's annual lottery. Since the organization was run primarily by volunteers, the bulk of the revenue was used to buy as many paintings and statues as possible, which were then distributed at the end of the year. Despite the best intentions, however, the venture quickly began to founder over rivalries with the National Academy of Design (NAD), which competed for original works for its own exhibits. By the end of 1841, membership was on the wane and the association seemed ready to disband.

It was saved by Leupp, Sturges, and William Cullen Bryant. Within a year they persuaded the city to provide exhibition space in the Athenaeum building, an agent was hired to enroll additional subscribers, and membership tallies topped the one thousand mark for the first time, including business firms, literary societies, and volunteer fire companies among scores of individual donors. In the process, Bryant, Sturges, and Leupp placed the AAU on a solid business basis, distributing shares, advertising and exhibiting its artistic goods, and hiring agents and clerks to extend its operations to the far corners of the country. Regional "honorary secretaries" were also appointed to handle out-of-town subscriptions in return for a 10 percent commission.

Their promotional literature revealed the extent of their ambitions, promising to break the shackles of the past and America's lingering subservience to the cultural traditions of the Old World. Rather than copying European masterworks, American artists would be encouraged to probe the subtleties of their own country's character, literature, scenery, and historical events. Prospective subscribers were assured that their spirits would be lifted, their tastes refined, and their intellects nourished by depictions of "American scenery and American manners."[45]

Unruly political passions would be soothed as well. Politics, "president-making and money getting stir up all that is bitter, sectional or personal in us," noted the union's publication, *Transactions,* in 1844. As balm, the country needed "some interests that are larger than purse or party, on which men cannot take sides. . . . Such an interest is Art. And no nation needs its exalting, purifying, calming influences more than ours. We need to supplant the mean, utilitarian tastes, which threaten to make us a nation of shopkeepers. We need to soften the harsh features of political zeal, and party strife, and the other engrossing business of this people." In effect, art would promote the civilizing influence of the home—without the home. It would quell the passions and competitive spirit of men, and "make the country whole."[46]

Ironically, the AAU failed because it succeeded too well. Although rivalries with the NAD were mitigated, latent hostilities remained. The AAU's lotteries were declared unconstitutional when the New York State

Supreme Court ruled against them in an 1852 case lodged by a disaffected painter. Following the court decision, the AAU finally closed its books, transferring its remaining revenues and artworks to the ill-starred NYGFA.

Despite its untimely demise, the AAU played an undeniably important role in shaping American tastes and professional opportunities for the nation's artists. Over twenty-four hundred original works of art were distributed during its brief existence, and comparable ventures were initiated in Cincinnati, Philadelphia, Boston, Newark, St. Louis, and Chicago.

Women and Cultural Institutions

Women played a negligible role in institutions such as these. None sat on the boards of the AAU or comparable spin-offs in Philadelphia, Cincinnati, Chicago, or St. Louis. Women constituted a minority of the AAU's subscribers and account for only 1 of the 150 honorary secretaries listed in the association's 1847 report. Nor did they appear among the lists of founders, officers, or trustees of the American Academy of Fine Arts, Pennsylvania Academy of the Fine Arts, NAD, NYGFA, or Boston Athenaeum. And although they occasionally appeared at private soirees or in studios to have their portraits painted, they were absent from the rosters of the Lunch, the Sketch, and the Century Association.[47]

On those rare occasions when their assistance was more formally sought, women were invariably assigned a marginal role. In 1845, for example, the trustees of the Pennsylvania Academy invited local matrons to contribute "works of fancy and female skill" for a Grand Bazaar to raise funds in the wake of a fire that had consumed many of the academy's holdings. Products of "pencil or pen, needle, spindle or shuttle, braiding or bead work, embroidery, feather or shell work, in short, all the Sister Arts" were welcomed. Women were also conscripted to run the bazaar's activities. During the course of a week in October, over $9,000 was raised through lotteries and sales. Some were more impressed with the results than others. Sarah Josepha Hale, who had helped to publicize the fair in the pages of Godey's, noted in disgust that "the great proportion of FANCY (in other words, USELESS)" articles had proven unsalable and had to be raffled off.[48]

Although useful in the short-term, events such as this were regarded with a tinge of contempt. Many years later one of the men who oversaw the festivities, John Sartain, suggested to a young artist that she move her painting from the Woman's Pavilion of the Philadelphia Centennial Exhibition to the galleries of the main building. As he loftily explained, "The Art Bu-

reau of the Centennial has nothing whatever to do with the Woman's Pavil-
ion or its contents" since it was "an exhibition, and not a Bazaar."[49]

The closest most women came to the comforts and challenges of in-
stitutional development and club life was in salons. Only a few women con-
vened such gatherings, and few of their efforts provided the basis of more
substantive institutional or professional ventures. One of the most success-
ful was New York's Anne Lynch Botta, a popular writer who had a gift for
choreographing social gatherings. During the course of her career, Botta
managed to assemble an illustrious entourage of prominent intellectuals,
including Bronson Alcott, Bayard Taylor, Margaret Fuller, Ralph Waldo
Emerson, and Henry Clay.[50]

Although Botta's salon failed to produce much more than conversa-
tion, Sarah Worthington King Peter's soirees served as the seedbed for the
lone gallery founded and managed by women prior to the Civil War. Born
in Chillicothe in 1800, Sarah Worthington was the daughter of Ohio's first
governor. At sixteen, she married Edward King, son of Senator Rufus
King, who would later serve as ambassador to the Court of Saint James's.
Over the course of their fifteen-year marriage, she bore three children and
assumed an active role in Cincinnati's charities and intellectual life. Ini-
tially, she confined her attention to church work, sewing circles, and stud-
ies of French and art with a small group of like-minded friends, hosting
elegant rounds of parties, conversazioni, recitals, and literary groups. In
the cholera year of 1833, after the sudden death of one of her sons, King
founded the Cincinnati Orphan Asylum with a small group of friends. Like
many benevolent women of the period, she and her coterie visited the
asylum almost daily, overseeing the care of the children themselves.

Her first marriage ended abruptly in 1836 with her husband's death at
the age of forty-one. Shortly afterward, King moved to Cambridge, Massa-
chusetts, where her circle of friends included Washington Allston, John
Quincy Adams, and Henry Wadsworth Longfellow. Five years later, she
married the cultured Englishman William Peter, who was then serving as
his country's consular representative in Philadelphia. Once again, Sarah
Peter turned her energies to social and charitable pursuits, hosting a local
salon adorned with Biddles, Binneys, and Whartons, and participating in a
welter of local charities.

Her efforts on behalf of local seamstresses and the inmates of Phila-
delphia's Rosina House for Magdalens sparked her interest in widening the
range of acceptable female employments, a passion shared by her friend
the editor of *Godey's Lady's Book,* Sarah Josepha Hale. In response, Peter
opened the nation's first school of design for women on the third floor of
her home in November 1848. Through her husband's connections, she was

undoubtedly aware of a comparable venture initiated six years earlier in England to improve that country's competitive edge in industrial design. Armed with orders from local textile manufactures and donations from her husband and other male acquaintances, Peter hired a drawing master and conscripted the first crop of twenty students herself. The venture continued to flourish over the next two years, and by 1850 she was ready to hand it over to public support, seeking a merger with the Franklin Institute to effect the transition.

Unlike the courses at the Pennsylvania Academy or the NAD, Peter's hybrid venture featured a blend of charitable and artistic aims. Her primary goal was to create new jobs for women thrown upon their own resources. As she explained in her missive to the Franklin Institute, while men had ample job opportunities, women were "confined to the narrowest possible range of employment; and owing to the increasing drain by emigration to the West and elsewhere, of young and enterprising men, we have a constantly increasing number of young women" in need of suitable jobs. Industrial design seemed to offer an ideal solution. It was an underpopulated field, and designing carpets, fabrics, and wallpapers was deemed a "graceful and essentially feminine employment" well suited to women's tastes and skills. Moreover, like writing and quilt making, it could be practiced within the privacy of the home without materially interfering with the routine of domestic responsibilities. By wedding artistic activities to charitable aims, Peter cast her new venture in comfortingly familiar terms. Rather than directly challenging the cultural prerogatives of men, her school of design for women was presented as a benign mutation of traditional, feminine charity work.[51]

Nonetheless, her association with the Franklin Institute proved to be a rocky alliance. Many of the trustees were offended by her "strong personality" and equally pronounced ideas about how the school should be run. One even resigned rather than contend with her demands. After a brief and troubled alliance, the institute finally divested itself of the project, leaving the school to be independently incorporated in 1853.[52]

Peter's second cultural foray ventured more directly into the artistic sphere. Like her efforts on behalf of the Cincinnati Orphan Asylum two decades earlier, the inspiration was borne of grief. After losing a second son in 1851, Peter's husband sent her on a tour of Europe accompanied by her widowed daughter-in-law. This was Sarah's first trip to the Continent, and her growing fascination with art became increasingly palpable during the course of her stay.

Although the journey itself was "utterly disgusting," the rigors of the voyage were soon forgotten amid the allurements of Britain's Crystal Pal-

ace, Munich's galleries, and Italy's ecclesiastical treasures. During her month in Rome, Peter studied art history and the work of the city's expatriate American artists. As she travelled, the list of her acquisitions lengthened, including copies of statuary and works of the Old Masters. In the process, the idea for a gallery gradually began to take shape. "I will bring home a catalogue for you," she enthusiastically wrote from Florence, adding that "if the Cincinnati people had any idea of how beautiful a collection they might make for four or five thousand dollars, they would make haste to collect such a sum in order to enjoy the result!" When her second husband died shortly after her return, Peter went back to the Midwest to put these notions into practice.[53]

Cincinnati seemed the ideal place for her experiment. The city had long contended for cultural leadership in the Midwest, from the inception of the city's first exhibit in 1818 through the founding of the Western Art Union three decades later. Her son, Rufus King, was one of the city's intellectual leaders and among the local art union's founding members. Yet despite these efforts, Cincinnati had neither a permanent collection of European art nor a school of design for women. Peter took it upon herself to provide both.

Rather than starting the gallery herself or initiating it in her home as she had the Philadelphia school, Peter conscripted a band of female acquaintances to aid in the work. Many were drawn from the same small group that had founded the orphan asylum, a group of experienced trustees noted for their social standing and good works. Nonetheless, the idea and the enthusiasm were clearly Peter's. Under her guidance an exhibition was planned and fund-raising activities were set in motion. Opened in 1854, the Ladies Academy of Fine Art (LAFA) was to serve as a repository for copies of leading works of European art and loaned exhibits from local collectors, as well as providing a "ladies" art reading room and a school of design for the self-supporting poor. Funds were to be raised through modest subscriptions and the standard charitable format of poetry readings and fairs.

Bolstered by a substantial gift from a local male philanthropist, almost $10,000 was pledged in the first months. Most of the funds were set aside for the purchase of copies of important European works. An early report outlined the logic behind the board's decision to acquire copies rather than original works, since "from evidence already before the Association, it is ascertained that copies, all but equal to their wonderful originals, can be obtained at such moderate charges, that for a sum varying from $40,000 to $50,000, absolute facsimiles may be procured of all, or nearly all, in painting or sculpture that is most worthy of regard in the Old World." Peter's

own experiences clearly lay behind this reasoning, as well as her fondness for copies of foreign works.[54]

Not surprisingly, her colleagues willingly deferred to her expertise when she offered to go to Europe at her own expense to acquire the nucleus of the gallery's collection. Armed with their promise to forward $5,000 in donations, she set sail shortly after plans for the academy were approved. Commissions were subsequently given for replicas of Raphael's fresco *The School of Athens,* Van Dyck's portrait of Charles I, and works of Murillo, Michelangelo, Rembrandt, and Poussin. Statues were also purchased, although, much to Peter's disgust, the board insisted that fig leaves be added in strategic places.

Despite a promising beginning, plans for the gallery quickly faltered in her absence, crippled by financial difficulties that culminated in the bankruptcy of the bank in which the gallery's funds were deposited. Many of the pledges also failed to materialize. Faced with a rapidly worsening financial situation, the women on the board plaintively advised Peter not to purchase more copies, since "the Treasury is nearly empty and it is impossible to replenish it this winter." Unfortunately, Peter was not easily deterred. "I am spending, I know, a good deal of money, but I am so persuaded of the beneficence of bringing works of art into our country that I am willing to make some sacrifices," she snapped in response. When necessary, Peter advanced the additional sums out of her own pocket, since "if we stop now, Heaven only knows who will have to courage to start again." By 1855, however, it had become increasingly clear even to Rufus King that the venture was nearing an end. "The Managers of the Academy have come to a *dead stand,*" he informed his mother with ill-concealed contempt. "I don't even hear of them. They believe any effort vain and . . . they decline to fight against what they have decided to be fate."[55]

In his opinion, they were "a shabby set" who had "lost their sense of honor and responsibility." The women, of course, saw it somewhat differently. At first, Peter's enthusiasm had been sufficient to persuade them that "there is money enough, in Cincinnati, to do great things, if only we can obtain the public confidence." But their subsequent fund-raising efforts ended in repeated failure. Despite Peter's optimistic prediction that "our men will do their duty in this emergency [and] come to OUR help, just as WE always fly to THEIR assistance when they have need of us," the solicitation campaign among the members of the local Mercantile Library Association yielded a scant $6, and efforts to raise funds through the Mechanic's Institute proved equally fruitless.[56]

Faced with an empty treasury and an increasingly chilly public response, the trustees concluded that "[o]ur experiment . . . is considered

by some a superfluity, something we can do without, others look upon it with jealousy and distrust. . . . The mass of our community live for the 'Almighty dollar' so much that . . . it is almost impossible to enlist them in any cause, least of all such an one as ours." In effect, LAFA was "a luxury that had not yet grown to be a necessity." By 1856, its operations were at a standstill. Eight years later, the project was formally abandoned and the holdings transferred to McMicken University.[57]

Sarah Peter's determined cultural proselytizing left a mixed legacy. Both of the institutions she developed blended charitable and cultural aims. LAFA, which was more clearly rooted in artistic ends, was the less successful, operating only briefly. Although it seemed feasible while Peter was there to guide the operations and marshal local support, as soon as she left, the trustees began to falter in their resolve. Experienced in asylum and charitable management, they were timid and out of their depth in cultural affairs, and they knew it.

The format that she sought to promote was interesting as well. The hanging of copies was waning in popularity in most of the male strongholds of culture in the East. By the end of the antebellum era, the American Art-Union, the Pennsylvania Academy, the NAD, and the Artist's Fund Society all sought to promote the works of living artists and American themes. Peter's infatuation with copies of European masterworks had a decidedly archaic ring in the populist fifties.

On the other hand, the Philadelphia School of Design for Women provided a viable template for female-sponsored arts institutions, serving as the prototype for several similar ventures in Boston, Baltimore, and New York. Although the Baltimore school was founded by men, the one that eventually affiliated with Cooper Union was created by Susan Carter in 1854, and the noted reformer Ednah Dow Cheney helped to found a similar venture in Boston. That these initiatives flourished and were reproduced is a profound testimony to Sarah Peter's vision, determination, and skill. Unlike male efforts, women's art institutions received a more hospitable reception—and had a better chance of survival—when they were grounded in charitable aims that cast them as a logical extension of traditional female benevolence.

Yet the rhetoric of antebellum benevolence proved to be a double-edged sword, providing a sound rationale for women's participation in charity and reform but affording few sanctions for those who sought to move beyond those roles, even in the name of community service. Nor did the notion of "sisterhood" that lay at the heart of women's benevolent campaigns provide a viable bridge between middle- and upper-class female patrons and painters. Neither colleagues nor clients, women artists

unwittingly placed themselves beyond the pale of women's networks by virtue of their unconventional careers.

As a result, few women assumed a leading role in the creation of public art institutions in the decades prior to the Civil War. Men dominated the country's fledgling cultural organizations. Their efforts were rooted in a complex system of monetary and nonmonetary exchanges in which women had little to offer. Male painters and patrons studied together in their lyceums and debating societies, travelled together on hiking trips and European tours, dined together in each others' studios, clubs, homes, and salons. Professional considerations strengthened these social ties. Men such as Jonathan Sturges, Robert Gilmor, and Luman Reed played an important role in providing opportunities for artists to study both at home and overseas. They helped to broker new commissions among their business acquaintances and friends, and contributed valuable business skills to keep their institutions alive, issuing stocks, commissioning consignments, hiring agents, advertising goods, and when necessary, providing additional funds from their own pockets to keep these agencies in operation. The men who participated in these organizations publicly certified their middle-class status in the process, while leveraging professional opportunities for their colleagues and themselves. In effect, galleries, academies, and art unions constituted a new form of masculine space that provided a respectable alternative to the workplace, the home, and the saloon.[58]

Impeded by popular prejudices, a lack of ready cash, and the dictates of proper feminine behavior, most women chose instead to confine their artistic energies to the domestic sphere. As a result, female artists and would-be patrons often worked in isolation. Unlike the women who engaged in charitable work, those who aspired to be patrons found few clerical or social props to justify their work. Hampered by the lack of professional opportunities and popular prejudice against female intellectuals, the promotion of cultural endeavors offered few allurements outside the home.

Those who refused to accept their circumscribed cultural status were cast in a far different role than their male peers were. Female artists were more bound by family ties, less active in professional organizations, less likely to find enthusiastic and reliable patrons among either sex, and frequently overshadowed by their more famous male mentors and kin. Women who ventured beyond the simple prints the public expected them to buy were similarly isolated, occasionally forming friendships with the artists who specialized in feminine themes, but generally cut off from the rest of the artistic community. Nor could they offer the same rewards. Women seldom sent their protégés on European tours, exhibited their

holdings, opened their galleries to the public, or joined in schemes to foster artists' professional careers. Nor did they pay as well as men. For the few intrepid souls like Sarah Peter who forged their cultural aspirations into institutional designs, the rewards were fewer still. Unlike the American Art-Union or NAD, LAFA in Cincinnati was a lone venture, quickly quelled and never copied. Even its aims went against the grain of the cultural temper of the times. Although women would begin to carve out a distinctive cultural sphere for themselves in the decades after the Civil War, most would follow Peter's quasi-charitable model, adopting the tenets of her School of Design for Women while ceding responsibility for the development of major community-wide museums to the stewardship of men.

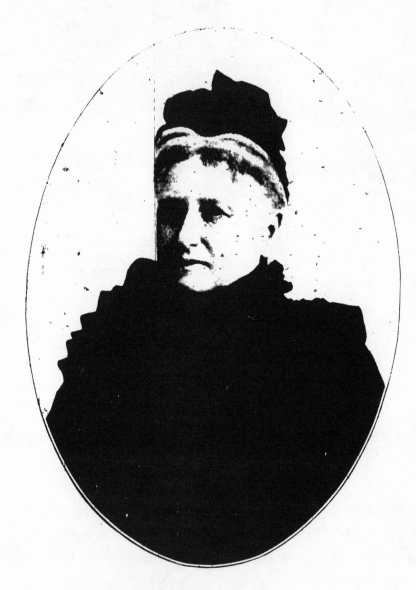

CANDACE WHEELER

2

CANDACE WHEELER AND THE
DECORATIVE ARTS MOVEMENT

C andace Wheeler was the cultural heir of Sarah Worth-
ington King Peter. When Wheeler was born in 1827, Pe-
ter was still a young wife, Thomas Cole and Asher
Durand were just mastering the painter's craft, and Luman
Reed was learning firsthand about the perils of investing in
"Old Masters." Both men and women assumed new stature as
cultural proponents after the Civil War. But while men would
make their most significant contributions through the creation
of multipurpose museums in individual cities, Wheeler sought
to develop a female cultural consensus across the broad sweep
of the nation's cities and towns. The decorative arts movement
that she founded constituted the first major artistic crusade
created, managed, and promoted under female control.
Rather than joining in the rites and rituals of men, women were
encouraged to claim an artistic sphere of their own, rooted in
domestic imperatives and the "minor" arts. Unlike museums,

the decorative arts movement catered to female constituencies and needs by linking household decoration to the creation of new career opportunities, echoing the mandates of Peter's Philadelphia School of Design for Women. Rather than demanding artistic parity with men, it produced a national cultural agenda scaled to the contours of the home. In the process, the decorative arts movement blended an array of secular initiatives with a host of older models and ideals, encouraging women to claim increased cultural responsibilities in the name of charity, domesticity, and the doctrine of separate spheres.

At first glance, Wheeler seemed an unlikely candidate for such an ambitious role. While Peter's social credentials were impeccable, Candace Thurber Wheeler's origins were relatively humble. Wheeler was reared in upstate New York, during the great revivals and the feverish religious enthusiasms that swept that region. Wheeler viewed her father as a "saint," the type of man who was always ready to lend a helping hand. He was something of a religious zealot as well, and although she admired his generosity, she privately despaired of the "many guests in the shape of straggling missionaries collecting funds for special missions," and other "religious loafers and freeloaders" who regularly partook of her family's largesse. A lively child, she much preferred the excitement surrounding her parents' abolitionism, which flagged their house as a way station on the underground railroad.[1]

Years later, she recalled her mother's beautifully crafted linens, many of which undoubtedly made their way into local antislavery fairs to be sold to raise funds for the abolitionist cause. The embroideries, quilts, and homespun linens that women produced for these activities may have helped to school Wheeler in the ways in which domestic artistry could be used to bolster an array of larger social, political, and charitable goals.

Hers was a stern and morally righteous household, which afforded scant leeway for more general cultural pursuits. The family's reading materials consisted of the Bible (which was read "continually") and inspirational works like *Pilgrim's Progress* and Milton's *Paradise Lost.* Novels, on the other hand, were strictly forbidden. Music was their one "indulgence," particularly devotional hymns. Occasionally, popular songs were permitted as well, since "lighter music was not under the same ban as light literature. . . . Novels and romances were forbidden." As a result, "music in its simpler forms" remained a source of childish delight for her, since it was "the one enjoyment which, according to the Puritan standard, was without sin." Years later, Wheeler still instinctively recoiled at the memory of the barren cultural milieu in which she was reared. As she explained, "I am conscious of something like a shudder when I try to fancy one of my grand-

daughters shut up in a primitive farm-house with a library composed of Biblical literature."[2]

She ultimately escaped by marrying Thomas Wheeler, a college-educated engineer from New York whom she met through their local minister. Wheeler was only seventeen when she took her vows, but she clearly was ready to move on to a new environment. As she later recalled, "In those days a girl MUST marry. There was nothing else for her to do, and the sooner the better." However precipitous her decision might have been, it proved a fortunate choice. "Some one had said that a woman begins her life when she marries," noted Wheeler, "and with those who marry early this is true." Under her husband's tutelage, she was suddenly free to explore the works of Shakespeare and "the torrid journeyings of Dante. . . . It was like stepping over a century, leaving behind me the habits and thoughts of early Puritan life and coming into a new world of advanced thought and intellectual freedom."[3]

Her husband also introduced her to the city's local cultural scene, including a lively array of artists' receptions. For much of the antebellum era, studio life had been a decidedly male preserve. Beginning in the 1850s, however, New York's artists began to open their ateliers to the public on a regular basis, hosting elaborate soirees in a bid to increase the audiences for their works. Years later, Wheeler still thrilled to the memory of "the joyful excitement of the first occasion when [she] first met real artists and real poets." It was an exhilarating experience, particularly after the cultural asceticism of her youth. "Our familiarity with the painters themselves, with their studios, their work, and their talk of art, was a constant education," she recalled. The Wheelers proved especially popular guests at these occasions, since they came to buy paintings rather than simply to admire them. Eventually, they managed to accumulate an entourage of artists as well, with such well-known painters as Albert Bierstadt, John La Farge, and Frederic Church regularly making appearances at their salons.[4]

Wheeler's autobiography fails to mention specifically whether she interrupted these activities to serve in the Sanitary Commission during the Civil War, although she does point out that "we supported [it] whole heartedly, giving our labor and substance without stint." Formed in 1861 as an outgrowth of the organizing activities of the Women's Central Association of Relief, the Sanitary Commission was designed to systematize the outpourings of war-related benevolence, including camp inspections, nursing services, and the distribution of donated goods. It also helped to nationalize women's traditional charities, providing fresh models for postwar organizational reforms. Among the activities that it helped to regulate were women's sewing societies, coordinating their efforts so that "not one un-

needed stitch may be set." One of the most prominent Sanitarians, Chicagoan Mary Livermore, captured the commission's emphasis on efficiency, likening its activities to those of "the best business houses."[5]

Its ministrations extended to women's fund-raising activities as well. Antebellum women had been particularly adept at raising funds for local charities and reform organizations through their festivals, fairs, and bazaars. The Sanitary Commission refashioned these activities into massive "sanitary fairs," raising women's traditional fund-raising activities to new levels of coordination, efficacy, and returns. Because of their radicalism, antebellum moral reform and abolitionist crusades often stood at the far end of the spectrum of local philanthropic activities. The Sanitary Commission took the national organizational precedents these groups had set, systematized them, tightened their coordination, and heightened their visibility. Aided by a soon-to-be-completed transcontinental railway system, the commission highlighted the benefits and the possibilities for national philanthropic coordination on a new scale. Because the emphasis was on cooperation rather than competition, local units were subsumed into a cohesive whole. In the process, the Sanitary Commission helped to formulate new models for postwar female largesse that would soon be adapted to other purposes by women like Wheeler.[6]

It also inadvertently helped to popularize the fine arts. American women had developed a long and venerable tradition of vending their household crafts to bolster their charitable aims, so the idea of enlisting art in the service of charity was not necessarily new. What was novel about the Sanitary Commission art fairs was that separate galleries were set aside for representative samples of the "fine arts," which required some tactical rearrangements as well. Livermore outlined the division of labor. While women canvassed their cities for paintings and statuary to fill the exhibition galleries, the more aesthetic tasks of sorting and hanging their gleanings were entrusted to special art committees of male artists and connoisseurs. It was an old dichotomy, and one that was destined to linger well into the remainder of the nineteenth century. While women were deemed suitably equipped to manage the disposal and display of their own domestic handicrafts, the visual arts remained the province of men.

While the Sanitary Commission fairs piqued the country's interest in the visual arts, the Philadelphia Centennial Exposition generated a new interest in decorative artifacts intended to beautify the home—furnishings, ceramics, textiles, and a range of related household exotica. Exhibits ranged from furniture displays to rooms richly hung with silken tapestries and brocades from the looms of foreign manufacturers. Ceramicists were particularly well represented, with displays from over four hundred over-

seas exhibitors that ran the gamut from English faience to Japanese porcelains and Haviland china from France. For many Americans, the fair marked their first introduction to foreign cultures and foreign art. Rather than highlighting the wares of a single nation, the Philadelphia Centennial Exposition gave rise to a new cosmopolitanism that blended objects from differing eras and continents into an aesthetic ideal that transcended nationalistic bounds. Rather than touting the simplicity of the antebellum parlor, cultural pundits now placed a new emphasis on rampant eclecticism. The ornate "palaces" of America's Gilded Age "robber barons" and "society queens" epitomized the legacy of the Centennial Exposition, as did the decorative arts movement that it ultimately helped to inspire.[7]

England's exhibits were particularly influential in kindling America's enthusiasm for decorative design and material display. In part, the new materialism stemmed from international commercial rivalries. As one observer explained, the British had made remarkable strides in upgrading the quality of their industrial wares. Prior to the Crystal Palace Exhibition in 1851, England's situation was "little better than barbarism." The objects that cluttered the hearths of the country's middle and upper classes were deemed "nondescript" and artistically inferior to "many of the works of the Sandwich Islanders. They were simply barbarous imitations of animal forms" that were "a disgrace to any civilized people."[8]

Yet, within a scant quarter of a century, an extraordinary change had taken place. The 1851 exhibition sparked a new interest in upgrading the quality of British craftsmanship, particularly through the South Kensington Museum, which afforded samples of both the best and worst in international taste. According to one source, it featured six chambers in various styles, the last of which was a "Chamber of Horrors," where the most egregious outcroppings of industrial art were warehoused. Duly educated and inspired, the British had taken the lead in international industrial design by 1870, and many contemporary observers predicted that Americans might soon make comparable strides if suitably instructed and inspired.

One of the fair's most popular exhibits featured the lavish embroideries created by "poor and painstaking gentlewomen" at the museum's Royal School of Art Needlework. These displays not only netted one of the exhibition's most prestigious awards, but also helped to accord women a more prominent role in discussions about the social implications of contemporary design. Founded under the presidency of Princess Christian of Schleswig-Holstein in 1872, the school endorsed the dual aim of finding "suitable employment for gentlewomen, and restoring ornamental needlework to the exalted high place it once held among the decorative arts." In

VICTORIAN HOUSEHOLD DECORATION: A "MOORISH PAVILION"

many respects, these discussions echoed Sarah Worthington King Peter's pioneering efforts developed a quarter of a century before. The Centennial Exposition marked the debut of the Royal School's products, featuring an array of meticulously stitched silk panels, wall hangings, and upholstery. Designed by prominent Pre-Raphaelite artists such as William Morris, Walter Crane, and Edward Burne-Jones, the embroideries were hailed as "a revelation." Rather than domestic busywork, noted one commentator, this was "real work, to be faithfully performed and duly paid for."[9]

The South Kensington Museum's needlework displays caught the attention of visitors like Candace Wheeler for several reasons. On one level, they represented a new avenue for female artistry and self-support. They also embodied many of the ideas of the British art critic and philosopher John Ruskin, who had called for a revival of craftsmanship to mitigate the horrors of rapid industrialization and the sterility of modern life. In Ruskin's scenario, beautiful household objects, pleasurably made, would enrich the lives of both consumers and the workers whom they patronized. Moreover, he regarded household decoration as a particularly feminine responsibility. His cautionary treatise *Sesame and Lilies* urged women readers to adorn their homes in ways that would safeguard their families from the corrosive influences of urban life. In the process, Ruskin's injunctions encouraged American women to claim this area of expression as their own.[10]

Wheeler had an additional incentive, one that was far more personal in tone. Shortly before the fair, one of her daughters, Mrs. Lewis Stimpson, died suddenly at the age of thirty-two. Wheeler was devastated. As she later recalled, the loss of her daughter "changed my whole attitude toward life and taught me its duties, not only to those I loved but to all who needed help and comfort." Gradually, the "plan grew in my mind, for the formation of an American 'Kensington School,' which should include all articles of feminine manufacture." The fair was particularly helpful in crystallizing her designs, since it also provided "old and new examples of woman's handiwork." Shortly before she left the city, she drafted a circular to outline her plan, sounding a clarion to join in "woman's awakening duty of self help."[11]

Although intrigued by the South Kensington models, Wheeler felt that they could be improved upon. She strongly approved of the way in which the school had helped to prove that high quality needlework could be "a means of artistic expression and a thing of value," but she thought that some of its specimens were "very simple and almost inadequate." Yet the Royal School and Wheeler's decorative art society ultimately shared many common elements. Both exhibited a blend of charity and artistic aims,

seeking to raise traditional household crafts to the level of fine art in order to foster female self-support, and both would seek to fulfill these aims by entrusting the most aesthetic tasks to the artistic judgment of men.[12]

The next step was to begin to build a base of support. Toward this end, Wheeler convened a small group of prominent women, several of whom were former Sanitarians, to launch the new venture in February 1877. Formally christened the New York Society of Decorative Art (NYSDA), the organization began operations later that year. Its founders espoused a threefold aim, vowing to sponsor courses in art needlework and related crafts, to market high-quality decorative goods produced by women, and to upgrade the caliber of household decoration through exhibitions, lectures, and library development. It was an immediate success, attracting hundreds of members during the 1870s and 1880s. Those who joined included Sanitarians and social reformers like Wheeler, prominent clubwomen and society matrons, and an array of artists, collectors, and connoisseurs. Despite their diversity, however, all shared a commitment to the task of widening women's career opportunities—and the scope of women's cultural authority—through the decorative arts.

In many respects, their cultural mandate closely resembled that of women's clubs. Although her autobiography does not mention any specific affiliations, it is likely that Wheeler belonged to at least one of the growing array of women's clubs developed during this period. The club movement dated from the late 1860s, following a generational pace behind the precedents set by men, but antedating Wheeler's efforts by only a few years. While men's clubs sought to exclude, women's were borne of exclusion. The first major women's club, Sorosis, was founded by Jenny June Croly, a New York reporter who coined the idea in response to "the somewhat churlish treatment" she received in her attempt to gain entrance to a dinner hosted by local businessmen for the English novelist Charles Dickens. The novelty of Croly's venture lay in its secular aims. Tied to neither charity nor church, it brought together housewives and professional women from a variety of fields in the common pursuit of culture, enlightenment, and scholarly discourse. In effect, it became "a finely equipped training school, wherein . . . women absorb the knowledge which is power." Like antebellum lyceums and men's clubs, the emphasis was on self-education and self-help through mutual aid among like-minded peers. Many Gilded Age women's clubs included art committees, art study classes, and lectures on painting, sculpture, and decorative artifacts among their regular programmatic fare, efforts complemented by the decorative arts. By drawing women into the cultural arena on intellectual grounds, both institutions

served to bolster the base of female artistic expertise, lending a new patina of self-assurance to women's public cultural pronouncements.[13]

Society leaders may have been attracted to Wheeler's designs for somewhat different reasons. Several charter members of the NYSDA figured among the country's most prominent, most aggressive social leaders. Mrs. John Jacob Astor was a "very grande dame" known for her lavish entertainments as well as her philanthropic activities. Her sister-in-law, Mrs. William Astor, another New York society queen, is best remembered for her aggressive attempts to reorganize the city's social set with the aid of her snobbish minion Ward McAlister. Less wealthy but no less ambitious, Mrs. John Sherwood supplemented her husband's modest salary with the royalties from her popular etiquette books. For social arbiters such as Mrs. Sherwood and Mrs. Astor, participation in the decorative arts movement provided yet another theater in which to exercise their growing authority over American aspirations and tastes.[14]

Many undoubtedly joined the NYSDA because of their own plans to begin decorating on a grand scale. The first private "palaces" began to appear in American cities shortly after the Civil War; many were built by the Astors, Belmonts, and Vanderbilts who peopled the society's rosters. Echoing the lush eclecticism of the fair, their mansions often featured rooms from different periods and lands, promiscuously mingling the styles of the Italian Renaissance with those of the Bourbon court or imperial Japan.[15]

The third contingent of the society's charter members included artists, artisans, collectors, and connoisseurs. Some, such as Augusta Astor and Mary Cadwalader Jones, became avid collectors of ceramics, laces, and fans, while others, like Catharine Hunt, were related to prominent artists and architects. Hunt was the niece of the antebellum art collector Philip Hone; the ward of another connoisseur, William Aspinwall; and the wife of the architect Richard Morris Hunt.

The presence of members who were well versed in the arts was important, since aesthetic issues were crucial to the society's mission. Wheeler believed that art needlework, in particular, was ideally suited to female tastes, talents, patronage, and skills. As she explained, it promised to convert "the common and inalienable heritage of feminine skill in the use of the needle into a means of self-expression and pecuniary profit." It also built on a traditional form of female artistic enterprise, affording "an endless and fascinating story of the leisure of woman in all ages and circumstances, written in her own handwriting." Thus, Wheeler noted, "we can deduce from these needle records much of the physical circumstances of

woman's long pilgrimage down the ages, of her mental processes, of her growth in thought."[16]

American women had traditionally taken great pride in their needlework, whether in colonial samplers or in the intricate stitchery of antebellum quilts. By the 1870s, however, these practices had fallen into decline, supplanted by technological innovations and a growing array of more challenging pastimes. Wheeler later recalled that, by the time the NYSDA was founded, "the needle had been so far superseded by the sewing-machine that needlework—as a fine art—was almost utterly lost, and specimens of fine handwork done by our grandmothers were treasured almost as curiosities." In effect, "it had died, branch and stem and root, vanished as if it had never been." In her opinion, the 1876 fair inaugurated "another era of true decorative needlework, perfectly adapted to the capacity of all women."[17]

The movement's promoters were careful to point out that needlework and china painting were minor rather than major arts, suggesting their reluctance to invade the more "elevated" bastions of male artistic endeavor. As Wheeler explained, "Where architecture LEADS, decorative art follows. Its first principle . . . is SUBORDINATION. To be itself it must acknowledge its dependence, and be not only content but proud to be secondary." She was particularly careful to underscore its secondary status when describing the society's mission. Thus, she contended that it "was easily within the compass of almost every woman," requiring "far less ability than painting . . . pictures."[18]

Here, then, was a solution to Peter's dilemma. Rather than emulating men's cultural pursuits, the decorative arts movement raised traditional household crafts to a loftier, but still subordinate, status among the fine arts. Rather than fostering exclusively aesthetic aims, it also highlighted more familiar charitable goals. Rather than addressing the needs of the community as a whole, it steeped its appeal in the interests of women and the imperatives of the domestic sphere in an ingenious reiteration of women's traditional roles.

And rather than touting feminine "genius," it sought to make women's traditional needlework skills more "scientific" by subjecting them to the aesthetic ministrations of men. In New York, as in England, decorative arts organizations commissioned patterns from male design committees and individual instructors such as William Morris. This in turn reflected—and condoned—enduring societal biases about women's inferior role in the arts. As art historian Isabelle Anscombe explains, "It was crucial for the suitability of those crafts [practiced by women] that they did not entail

the supposedly unfeminine traits of personal ambition or the egotism of the fine arts. . . . In the vast majority of cases, women were merely executing designs created by male artists," procedures that did little to challenge popular notions that "men create and women copy."[19]

To her credit, Wheeler assembled a distinguished roster for the NYSDA design committee, most of whom were culled from her salons. Louis Comfort Tiffany was tapped to teach the society's first pottery decoration class, ultimately becoming one of the most celebrated designers of the Gilded Age. Other committee members included such luminaries as the painter Samuel Colman, who persuaded Tiffany to join the NYSDA; the architect Richard Morris Hunt; Lockwood de Forest, a noted authority on South Asian crafts; and John La Farge, a skilled interior designer and one of the country's leading masters of stained-glass techniques.

Like the members of the Sketch Club before them, Tiffany, La Farge, de Forest, and their peers regularly met to draft and criticize new art needlework designs, the best of which were then turned over to the society's students for execution. As a result, noted the chairman of the needlework department, the NYSDA board believed that they were able to "furnish better designs, better material and better workmanship than has heretofore been possible." In effect, the NYSDA raised women's traditional handiwork to the status of a minor art by making it subservient to the aesthetic guidance of men.[20]

They had their work cut out for them. Many women were particularly adept at making a small universe of horrors known under the general rubric of "fancy work." *Godey's Lady's Book* was an enthusiastic promoter of these endeavors, publishing detailed instructions for making such unusual decorative objects as wax fruits and knitted berries. Societies of decorative art (SDAs) took a particularly dim view of contributions such as these, sternly warning potential clients that wax flowers, skeletonized leaves, and paintings on black panels would be rejected out of hand. Even with these strictures, however, Wheeler sheepishly admitted that the committee members were often "amused" by the quality of the work that was submitted.[21]

In addition to aesthetic issues, the organization's second goal was charitable: the quest to market women's products as a means of promoting self-support. Several types of ventures were undertaken in conjunction with this mission. In addition to providing commissions and jobs, the NYSDA encouraged auxiliaries in other cities to send their goods for sale in New York. Commissions were avidly sought, including orders from commercial manufacturers of ceramics and household goods. Classes were

also initiated in order to upgrade the caliber of the goods submitted for sale. The emphasis on effective marketing stemmed, in part, from Wheeler's earlier attempts to help impoverished acquaintances on an ad hoc basis. As she explained, "I found myself constantly devising ways of help in individual dilemmas, the disposing of small pictures, embroidery, and handiwork of various sorts for the benefit of friends, or friends of friends who were cramped by unwonted circumstances." The decorative arts movement was designed to mitigate these problems in a more sustained and systematic way. For Wheeler, the charitable element would always remain paramount.[22]

Most chapters included classes in china and pottery crafts, as well as art needlework. For those who could afford to pay, the New York chapter set its fees on a scale ranging from $13 for six china-painting lessons to $5 for six sessions in art needlework. Like more traditional charities, subscribers of $100 or more were entitled to nominate candidates for a year's free instruction, while donors at the $5 level could send a student for one free course. The genuinely destitute received instruction on a pro bono basis. At the bottom of the scale were the servant girls and charity cases drawn from city missions and asylums, who received instruction in "plain sewing" skills in classes carefully segregated from their middle-class peers. Like many other charities, the emphasis here was placed on teaching these future servants that "INTELLIGENT WORK in any trade or calling" might become "PLEASANT LABOR" if skillfully pursued.[23]

Wheeler and her associates were keenly aware of the need to help the growing numbers of "gentlewomen thrown on their own resources for self-support" in American cities after the Civil War. Few viable employment alternatives existed for middle-class women who had been widowed or deprived of suitable mates. Wartime casualties had been heavy among residents of cities like Boston and New York, considerably thinning the ranks of available men and leaving cadres of young widows to fend for their families and themselves.[24]

The career alternatives available to unattached middle-class women in the 1870s were extremely limited. Nursing schools were just beginning to be founded, and social settlements would not appear for another decade. Traditional needle trades had become increasingly casualized, offering only minimal, sporadic gains. For some women who were thrown on their own resources, prostitution offered a solution, albeit a brutal one. Others would be aided by women's groups such as the SDAs, which tested new modes of respectable self-support through the implementation of training programs, market development, and efforts to broker commissions from

commercial firms in order to eliminate the stigma normally associated with women's paid labor. As Wheeler explained, "All other activities were closed to women of education and refinement under the penalty of 'losing caste.'"[25]

Underlying these assumptions was a desire to protect middle-class women from direct association with their working-class peers. The young women who labored in factories and department stores often enjoyed far more personal autonomy than middle-class behavioral codes normally would allow. Working girls had their own money; they went where they pleased, when they pleased, indulging in sexual adventures if they so pleased. Working in unregulated settings beyond the control of parents and kin, they were free to act on their whims. As a result, the middle-class women who ventured into these settings risked a loss of status via both the nature of the work and the working-class camaraderie it implied. By shielding "ladies" from the need to work outside their own homes, the decorative arts movement condescendingly sought to protect them from the taint of moral contagion that many believed such work implied.[26]

In keeping with the society's avowed aim of encouraging female self-support, offerings from students and other women were placed on sale in SDA stores, with a 10 percent commission charged to cover a range of other charitable and artistic activities. The New York chapter's showrooms were particularly successful, generating supplementary summer sales in popular resorts such as Mount Desert, Saratoga, and Newport, a practice replicated by other chapters as well. Women volunteers ran the salesrooms, some of the classes, and the exhibits, thereby managing to operate their chapters through a combination of membership dues, commissions, modest donations, and substantial amounts of volunteer time. Unlike contemporary museums, the Gilded Age women's arts organizations received few large donations or endowments, a pattern shared by many other women's groups.

Chapters were also founded in other cities, both to spread the gospel of good taste and to facilitate the development of national marketing systems. Backed by the messianic zeal of the parent society in New York, Wheeler's dream of extending the movement to associated societies across the United States was quickly realized. The New York chapter listed almost five hundred subscribers within three years of its inception, and by the end of 1877, auxiliaries were operating in Chicago, St. Louis, Hartford, Detroit, Charleston, and Green Bay, Wisconsin. Two years later the list included outposts in such scattered locations as Baltimore, Boston, San Francisco, Buffalo, Rochester, Lincoln, Nebraska, and Casper, Wyoming. By 1880 over thirty chapters were in operation throughout the United

States and Canada, bolstered by a host of kindred women's exchanges and needlework, household art, and Blue and White societies.

In some instances, the movement spread to other cities through correspondence and publicity. Efforts were also made to maintain ongoing correspondence with comparable European societies, providing information on the latest international trends. In other instances, the lines of influence were more direct, with new chapters coalescing around alumnae from the NYSDA's classes. Graduates were sent to teach art needlework classes in such disparate places as Saratoga, Newport, Pittsburgh, and Cincinnati. In the process, the decorative arts movement assumed many of the earmarks of other national women's voluntary initiatives, forged along networks of chapters in much the same manner as the club movement and the Women's Christian Temperance Union (WCTU).

The New York chapter also invited men to serve on its advisory committee, in order to reassure the public of the quality of its wares. Wheeler made it a point to comb her salons and her husband's artistic acquaintances for men whose "professional reputations" might serve as a "guarantee to the public" of the caliber of the society's work. Much like earlier asylums, the society was managed by volunteer committees that oversaw everything from the classes to the exhibitions. While the house and needlework committees were entrusted to women, the design and exhibition committees were heavily populated by men. One of the most prominent figures in the history of New York's antebellum arts organizations, William Cullen Bryant, headed a distinguished exhibition committee that included collectors such as J. Pierpont Morgan, Cornelius and William H. Vanderbilt, August Belmont, Hamilton Fish, Metropolitan Museum of Art president John Taylor Johnston, and General di Cesnola, the museum's director. The extent of male participation varied from town to town. Thus, although the Chicago Society of Decorative Art (CSDA) precluded male participation on the board, its members eagerly sought men's donations. According to their president, Maria Scammon, the CSDA's first loan exhibition was initiated "to perform a sort of mission work . . . to enlist the sympathies and assistance of those gentlemen who could give substantial aid and advice, and arouse public interest in the project."[27]

Wheeler and her associates may have invited men to serve in this capacity as a means of ensuring that the society's products would receive fair recompense. Thus, the *New York Times* reassured its readers, the NYSDA was not conceived as "an establishment exclusively for women," since "the presence of women workmen only, tends to depreciate the prices given for their work, even if it has no effect on the quality of the work itself. If it be understood that the sales-room is for the work of women only,

people will enter it with the fixed determination to pay lower prices for what they buy." This was a particularly important point, since one of the society's key purposes was to promote the development of remunerative careers for middle-class women.[28]

Another key element of the society's mission was popular education, including a variety of efforts to upgrade the level of public taste through publications, lectures, exhibitions, and lending libraries. In addition to coordinating classes and sales, various chapters published accounts of their activities in the society's nationally circulated periodical, the *Art Interchange,* and sponsored local exhibits and lending libraries. For a nominal fee the New York chapter sent its books anywhere in the United States, to be returned by mail. Volumes covered all the decorative arts, from William Morris Hunt's "Talks on Art" to works on majolica, Persian crafts, ivories, and textile design. Nor were these techniques unique to the decorative arts movement. Women's exchanges and clubs also began to develop national travelling libraries for their members by the 1890s, and many other Gilded Age women's organizations disseminated information on their programs through national publications. For example, "all of the major women's foreign missionary societies began publication of their own magazines almost immediately after they first organized," yielding a crop of periodicals with such intriguing titles as *Heathen Woman's Friend.*[29]

The society's lending libraries proved to be an extremely popular initiative, as requests for books came in from across the nation. According to one report, "The constantly recurring expression in the[se] letters from the West [was], 'We have no opportunities to see anything artistic. . . . We want to know how to decorate our houses, and be able to send something to your Society which will be acceptable and accepted." As the directors explained, the women who wrote these letters were "longing for that outside assistance which is afforded by a well-selected library, and eager for glimpses of artistic decoration beyond that which their homes afford." In the process, decorative art societies took it upon themselves to instill "a knowledge of correct principles and . . . models of ancient and modern art" to "best illustrate the history, development and technicalities of the Fine Arts" among like-minded female peers.[30]

Rather than seeking large donations for permanent acquisitions, members hosted a variety of temporary exhibitions stocked with gifts in kind contributed from their own homes. Laces, jewelry, ceramics, and elaborately wrought textiles formed the nucleus of their displays. The New York chapter staged a travelling loan exhibition that toured the country in the 1880s, while others tapped the storehouses of local matrons. In some instances, the lists of the early SDA donors included women who would later

be numbered among the country's most celebrated art collectors. For example, the Boston Society of Decorative Art borrowed an ancient jewel box from Isabella Stewart Gardner, a Circassian head piece from Gardner's rival Susan Warren; and a yellow Chinese vase from the wife of the president of the Boston Museum of Fine Arts, Mrs. Martin Brimmer. Members occasionally displayed works of their own as well, such as the elegant embroideries lent by Mrs. Oliver Wendell Holmes. In the process, women began to master the aesthetic tasks formerly ceded to men, planning and staging exhibits of their own.

They were also encouraged to become collectors in their own right, and to decorate their homes with greater self-assurance, insight, and skill. As the directors of the Boston SDA unblushingly explained, they sought to help like-minded women who had "the instinctive desire to decorate their homes" but lacked "the culture to do so with grace and charm." For women such as these, the society provided "the clue that has guided them to the result for which they had been dimly groping."[31]

Wheeler's crusade grew to national dimensions as quickly as it did because it tapped into a variety of social, as well as aesthetic, concerns. In addition to a desire to help middle-class women earn a viable living, urbanization, postwar materialism, and the "feminization" of consumerism contributed to the movement's popularity and the growing acceptance of women's enlarged cultural responsibilities after the Civil War. Popular insecurities about correct taste were inextricably linked to postwar industrialization and the changing tenor of city life. The Gilded Age was a time of extraordinarily rapid change, as the compact walking cities of the antebellum years melted into sprawling metropolises, spreading into the hinterland along complex webs of streetcar lines. The centrifugal forces of urban growth and suburbanization contributed to the increasing anonymity of city life, while immigration attracted new waves of foreigners, the poor, and the dispossessed.

Cyclical economic insecurities added to the uncertainties of urban life. In 1873 and again two decades later, growing armies of the unemployed filled city streets, raising the specter of mob rule. Poverty bred discontent, as did the rigors of industrialization, giving rise to waves of riots and strikes. Haymarket, Pullman, the great railroad strikes of 1877—each left a lasting legacy of mistrust and fear among the citizens whose lives they touched. Photographs heightened public awareness of these clashes, underscoring the disparities between poverty and wealth. These who could afford it insulated themselves from the perils of the city by withdrawing into the comfortable sanctuary of their homes, their clubs, and their resorts.

Within this milieu, the middle-class family home was increasingly ex-

pected to serve as a buffer against the harsh realities of the world outside, the grit and grime of the industrial city, and the specter of the slum. It was also viewed as an important bulwark of social control. Many believed that the properly appointed household would uplift spouses and acquaintances and educate the young. In the words of Candace Wheeler, the "perfectly furnished house is a crystallization of the culture, the habits, and the tastes of the family, and not only expresses but MAKES character."[32]

Many held that domestic art could convey spiritual lessons as well. Women were therefore encouraged to acquire even "the smallest example of rare old porcelain, of ivory carving, of ancient metalwork, of enamels, of Venetian glass, of anything which illustrates good design and skillful workmanship. . . [since] an Indian ginger-jar, a Flemish beer-mug, a Japanese fan, may each become in turn a valuable lesson in decorative form and colour." Assembled from the gleanings of past civilizations, these random artifacts could then be rearranged within the domestic context to provide an aura of stability and grace to counterpoint the increasingly unstable world outside.[33]

There were economic considerations as well. While the thrifty antebellum housewife was urged to save, her Gilded Age counterpart was encouraged by a growing array of commercial institutions to invest in expensive household goods. Department stores provided a particularly important impetus to female consumerism. Unlike their more utilitarian predecessors, the palatial commercial emporiums that appeared in American cities around the time of the Civil War placed a new emphasis on luxury, taste, and material display. A. T. Stewart built his first Marble Palace at the intersection of Broadway and Chambers Street in 1846, to be followed by his equally ambitious competitors Samuel Lord and George Taylor in 1853. As the carriage trade moved uptown, so did department stores, becoming increasingly ornate with each move.

Many were richly decorated, suggesting models for what the domestic sphere might become. A. T. Stewart's House Palatial featured twenty-two sample rooms and a summer garden. Wanamaker's increased the number of its period rooms to forty-four, enabling ambitious homemakers to select the chronological era best suited to their family's tastes. Unlike the old-style dry-goods store, the country's major Gilded Age emporiums eagerly vied for the attentions of female shoppers, adding ladies' rest rooms, ladies' waiting rooms, ladies' lunch rooms, and even nurseries to attract women's business. In the process, they forged a new definition of women's culture rooted in luxury, consumerism, and style. To quote one historian, they "fixed the very meaning of femininity as consumption."[34]

Just as business success placed a man among the "fit," so the ability to

decorate with a modicum of elan became an important yardstick of women's success and family status. Women were therefore urged to fill their houses with bits of art as a means of "distinguishing" their families in the eyes of the outside world. Set within this context, every vase, every jar, and every fragment of old lace became a statement of respectability, stability, and wealth.

The key to taste lay not only in the ability to consume, but in the manner in which objects, once accumulated, were displayed, a theme constantly reiterated by SDAs. In the process, the recontextualization of the artifacts snatched from other countries and times took on an ideological significance that transcended any historical connotations they might have previously borne. The ability to acquire the object in the first place was in itself a tribute to America's commercial power, as well as to the buying power of the individual consumer. But the real measure of success depended on the manner in which these treasures were juxtaposed in their American setting, be it a museum, a mansion, a department-store display, or a middle-class home. Always the emphasis was on "harmony": no matter what sorts of objects were being reassembled, or how diverse their points of origin might have been, they were expected to contribute to a pleasing and unified whole.[35]

In a country torn by strikes, economic fluctuations, industrial tensions, and a growing gulf between rich and boor, in a land where city life was increasingly anonymous and city streets increasingly threatening, the materialistic ethos of the decorative arts movement offered an assimilationist vision of what the country might eventually become. Like the myth of the melting pot, the rampant variety of the richly decorated home visually declared a faith in the country's powers of absorption, its ability to shape the fragments of other societies into a harmonious whole. This, then, was the underlying appeal of the ornate eclecticism promoted by the decorative arts movement: it provided a symbolic resolution to many of society's deepest fears. In the process, the appropriately decorated American home was designed to provide a mute reaffirmation of American economic superiority and assimilationist norms. And the task of promulgating this message increasingly fell to women.

The society's efforts, backed by popular anxieties and aspirations, were publicly applauded and eagerly patronized. Popularized by the Philadelphia Centennial Exposition, the decorative arts movement sought to forge a common consensus on female taste during the 1870s and 1880s, linking middle- and upper-class women across the country in a shared aesthetic crusade. It succeeded as well as it did precisely because it blended social salvation through consumption, self-support for the deserving poor, and a

means of regenerating society through the home. For Wheeler, as for many of her colleagues, the charitable aspect was "the most interesting one," proving that "even art-work may receive a new halo from human sympathy and personal interest."[36]

For the members who participated, SDAs afforded a variety of gains. Like women's clubs, they helped to broaden the parameters of women's duly appointed sphere well beyond the more familiar charitable, religious, and domestic prerogatives of the antebellum years. They opened the door to a fresh array of cultural responsibilities, overcoming the old proscriptions against "bluestockings" that had dogged the efforts of Sarah Worthington King Peter's generation, by educating women to new levels of self-assurance and authority through their lecture, exhibit, and library programs. They also helped to shatter the cultural isolation that Peter's contemporaries could only endure, encouraging members to claim increased prominence as public arbiters of social taste. Women had traditionally been responsible for art in the home. The decorative arts movement projected that responsibility onto the larger community. And, like women's clubs, it helped to channel female interests and energies into new lines of secular endeavor. To quote Candace Wheeler, it opened "the door to honest effort among women . . . and if it was narrow it was still a door."[37]

In many ways, it was a profoundly conservative movement, a means of deflecting women's interest from more fundamental demands for artistic or social equity. Although SDAs helped to establish a presence in the "minor arts," they did little to dispel prevailing prejudices that art "in its highest form, [is] almost impossible to women." Like contemporary charity organization societies and nursing schools, SDAs proved more effective in amplifying women's traditional, domestic roles than in achieving professional parity in fields already dominated by men. The movement also harbored subtle caps to female ambition. Although a few practitioners of art needlework became celebrated for the quality of their wares—most notably Wheeler, her daughter Dora, and gifted needlewomen like Mrs. Oliver Wendell Holmes—most of those who marketed their products through the society's networks remained fairly anonymous. Indeed, the emphasis on charity undoubtedly reinforced their reticence to step into the limelight, since to do so would have entailed identifying themselves as women in need.[38]

The women who spearheaded the movement addressed the issue of their circumscribed aesthetic domain with arresting candor. In the words of the NYSDA's annual report, they were "educating women in the minor arts": those industries deemed best suited to women's interests, talents, and tastes. Despite its emphasis on creating new opportunities for gainful

employment, the decorative arts movement reinforced the sexual division of labor and long-standing divisions between men's and women's separate cultural spheres.[39]

Some chapters eventually foundered on their quest to balance charitable and cultural concerns. As Wheeler admitted in retrospect, "Philanthropy and art are not natural sisters." Constantly "importuned to receive things which were good in their way, but which did not belong in the category of art," members were ultimately forced to choose between charitable and aesthetic priorities. Wheeler resolved the problem by leaving the society to found the Woman's Exchange, with the more general aim of marketing all types of women's work. It was a difficult decision. "Everyone disapproved of me," she recalled. "I remember the stony glare of Mrs. John Jacob Astor when I tried to explain my defection," leaving the chapter to work out its own balance between its charitable and artistic missions.[40]

As Wheeler's dilemma indicates, the results were strikingly mixed. Originally, her aim was to confine women's handiwork to the traditional arena of the home, shielding impoverished middle-class gentlewomen from the necessity of accepting jobs in more public occupations. While women plied their trades at home, some of the male members of the NYSDA, such as Louis Comfort Tiffany and John La Farge, began to move their efforts to the atelier. Men in this field occupied a deeply ambivalent position, hedged in by a host of nettlesome issues. Were the decorative arts to be the province of "lady amateurs" or a "serious" profession under the aesthetic stewardship of men? Would the presence of male practitioners eventually crowd out their female colleagues, thereby undermining the society's charitable mission, or would the men's reputations be diminished through association with a "feminized" craft? These issues were further muddied by the genuine professional advances accorded to a few of the movement's more prominent women practitioners, including Wheeler. As she proudly reported, because of the society's popularity "the day of women designers for manufacturers had come."[41]

Through its educational efforts and undeniably public nature, the decorative arts movement provided an opening wedge into the broader cultural arena, encouraging women to form schools of design and craft industries and even to participate in the promotion of new museums. And yet the old dichotomies persisted, as women continued to make their greatest impact in the areas that lay closest to the prerogatives of gender, charity and craft.

DORA WHEELER, APHRODITE TAPESTRY

Art needlework produced by Associated Artists

3

SEPARATISM AND
ENTREPRENEURSHIP

C andace Wheeler's decorative arts movement stemmed
from charitable and cultural concerns, as well as gender-
related imperatives. Like more traditional charitable
endeavors, it shaped women's artistic initiatives to the manage-
able scale of sororal self-help and domestic reform. Rather
than treading on male prerogatives, it claimed new territory
in the idiom of women's time-honored roles. By stressing
the subordinate nature of its activities, the movement's backers
sought to make it their own. In the process, they shaped
women's cultural prerogatives around comfortably familiar
separatist strategies. Whether in the asylum, the nursing
school, the social settlement, or women's schools of design,
Gilded Age women philanthropists worked to enlarge career
opportunities for their sisters and themselves under the ban-
ner of separate spheres and separatist organizations.

Decorative art societies were one example of this ap-

proach; women's medical colleges were another. As one contemporary ob-
server proudly noted, "In the medical department, women have done more
than in any other of the learned professions." In her opinion, they had suc-
ceeded as well as they had by creating independent institutions specifically
tailored to female constituencies and needs. Women's hospitals generally
addressed a threefold mission, providing "medical and surgical assistance
to women and children in need, . . . train[ing] an efficient body of nurses
for community service, and provid[ing] a clinical atmosphere where newly
graduated women physicians could receive bedside instruction." This in
turn was bolstered by dense networks of female service and moral support.
The women who created these institutions supported medical training for
aspiring women physicians, promoted their hospitals, administered them,
and raised money to keep them running. They served as patients and of-
fered their friendship to help the women doctors through difficult points in
their careers. Some offered more material support as well, bequeathing rel-
atively modest donations from their own estates. Firmly rooted in "solid
feminist ties," organizations such as the New England Female Medical Col-
lege promoted women's careers while ministering to women's needs.[1]

Other organizations emulated their results. For example, Boston's
Women's Educational Association promoted a variety of new resources for
middle-class women seeking employment opportunities, from diet
kitchens and nursing schools to a chemical lab at MIT where pupils could
learn to become "practical chemists, dyers and assayers." While YWCAs
developed vocational courses for their clients, churchwomen parlayed
their fund-raising skills into new career opportunities for female mission-
aries in the belief that "women had a special and natural responsibility for
reaching out to their heathen sisters" in exotic lands. In the process, they
opened new career possibilities without overtly challenging the preroga-
tives of men.[2]

The spin-off organizations that women fashioned around the tenets of
the decorative arts movement shared many of these aims and institutional
designs. Although men also collected decorative artifacts, women were
particularly active in promoting activities associated with needlework
skills, textiles, laces, and ceramics. By concentrating on what were deemed
the "minor" arts, they opened a new field of feminine endeavor that paral-
leled the male-dominated realm of the visual arts. Women's exchanges,
schools of design, arts and crafts societies, and even women's earliest ef-
forts to promote museum development were all steeped in the idiom of the
decorative arts. There were symbiotic alliances as well. Women's entrance
into the decorative arena reflected their growing importance as consumers,
as well as their growing interest in taste, household decoration, and style.[3]

Entrepreneurship was another common theme. Although separatist efforts in opening new careers via the creation of single-sex, quasi-domestic institutions such as nursing schools and social settlements have been well studied, the role of women's voluntary associations in fostering professional opportunities through commercial enterprises has received scant attention. Yet, to borrow a modern term, "nonprofit entrepreneurship" (i.e., commercial ventures carried out by nonprofit organizations that distribute the resulting revenues for charitable, cultural, and educational purposes rather than to investors) was a crucial element of many female cultural ventures in the decades after the Civil War. They were so effective, in fact, that by the century's end even male-dominated cultural organizations began tapping into the marketing networks developed by women's auxiliaries and clubs. Thus, the Philadelphia Orchestra launched a women's auxiliary to promote out-of-town concerts and line up new subscribers through women's groups in other cities and states. Similarly, the Chicago Symphony Orchestra "organized tours through host-city women's clubs" as an alternative to relying on commercial concert managers "who offered only a percentage of the gate." Although frequently overlooked, nonprofit entrepreneurship lay at the heart of many Gilded Age women's cultural and charitable concerns.[4]

These techniques resonated through a variety of institutions, from needlework guilds to the more charitably oriented women's exchanges that began to appear in the late 1870s. Designed to broker the sale of "any marketable object which a woman can make," women's exchanges drew their inspiration from the decorative arts movement, but relaxed the movement's artistic standards in a bow to their stated desire to help women in need. Even these groups had their aesthetic threshold, however, as evidenced by their refusal to accept such handcrafted atrocities as "calico patchwork, wax, leather, hair, feather, rice, spatter, splinter, and cardboard work." Restrictions notwithstanding, their quest to find remunerative work for "gentlewomen suddenly reduced to abject penury" proved an extremely popular cause, giving rise to nearly one hundred chapters nationwide by 1892.[5]

Along with the more staid SDAs, some of these organizations were highly profitable ventures. In 1904, the Boston Society of Decorative Art was still running a workroom for "the production of high-grade embroideries" and a salesroom to market these wares. Twenty to twenty-five women did piecework at home for the society on a regular basis, including (as one observer bluntly put it) "a few cripples who make their living by fine needlework." The society also continued to stage regular exhibits, as well as promoting sales through the better hotels in fashionable summer resorts.

The NYSDA was still active as well, netting estimated annual revenues around the $40,000 mark after the turn of the century. Nor were incomes such as these limited to the more aristocratic SDAs. According to estimates published in 1894, the New York Exchange for Woman's Work distributed revenues of $51,000 to its clients; the Boston chapter, $35,000; Cincinnati, $27,000; and San Francisco, $23,000.[6]

Efforts such as these provided not only employment opportunities for struggling "gentlewomen" but a chance to participate in commercial pursuits as well. Cloaked in the cover of "nonprofit" activities, Gilded Age women philanthropists created a respectable outlet for their entrepreneurial instincts that far exceeded the short-term gains offered by more traditional charity fairs and bazaars. In an article penned in 1892, Vassar historian Lucy Salmon dissected the drawbacks as well as the benefits embodied in these efforts. Despite their often substantial revenues, Salmon castigated the women's exchanges for their haphazard commercial standards: "Viewed purely as a business enterprise, the Exchange is a failure." Although a few chapters had lifted themselves into the sanctified realm of self-support, many others continued to rely on a motley array of traditional fund-raising schemes, ranging from calico balls and flower shows to picnics and bazaars, in order to bolster their receipts. "This fact alone separates the Exchange from other business enterprises," she complained. More important were the inherent limitations of the nonprofit form. As Salmon explained, "Having no capital to invest, [the Exchange] must pursue a hand-to-mouth policy, and employ means for increasing its resources which would never be considered by other business houses."[7]

In Salmon's view, charity and business goals were clearly incompatible. Since the modest 10 percent commissions they charged for marketing their contributed wares was usually insufficient to cover their ongoing operating expenses, "the Exchange becomes poorer as its business increases." More annoying still was "the persistence with which different Exchanges iterate and reiterate the statement that their object is charity 'to needy gentlewomen,' and not financial return," rhetorical practices that underscored their "ambiguous position." The point that Salmon missed is that this paradox lay at the heart of women's separatist philanthropic strategies. Much as they gravitated toward the "minor," decorative arts in lieu of claiming the more respected painter's craft as women's natural sphere, women became practitioners of "nonprofit entrepreneurship": generating profits, but on a more modest scale than those gleaned via men's commercial pursuits.[8]

The most nettlesome aspects of their activities, according to Salmon, were the "hard and pernicious conditions" that surrounded them, particu-

larly the stipulation that "all consignments shall be made by women." Salmon fairly bristled at the implications of such segregated practices. As she explained, "Valuable industrial competition is thus shut out." Furthermore, the "exclusion of men from the Exchange is as unreasonable as the exclusion of women from competition in other occupations."[9]

Salmon felt that this diminished women's roles as producers by suggesting that "work for remuneration is honorable for all men," but that "work for remuneration is honorable only when necessity compels it" for women. It also placed a premium on "mediocre work," by lowering standards to help those in need. In the process, exchanges placed "the whole idea of [women's] work on the wrong basis," by emphasizing the imperatives of charity over skill.[10]

Salmon's critique has a surprisingly modern ring, anticipating the debates that would surround the issue of nonprofit entrepreneurship almost a century later. Within the context of her own time, it served to highlight some of the tensions inherent in separatist strategies. Even while they promoted "sisterly" spirit between clients and trustees, these agencies rhetorically assured the world that the gains they made would be appropriately limited, their commercial ambitions held in check.

Schools of design for women shared many of these inherent contradictions, fostering new employment options even as they espoused a carefully circumscribed arena for female creativity and skills. Following Sarah Worthington King Peter's lead, a variety of women's design schools were founded in cities such as Cincinnati, St. Louis, Boston, Philadelphia, and New York. Not surprisingly, many were created and managed by women. The New York School of Design for Women (NYSDW) was founded in 1892 by Ellen Dunlop Hopkins. It began with a strongly charitable slant, echoing Peter's venture founded almost half a century before. As Hopkins later explained, "Many women came to me for assistance, and I [was] determined to think of a way to aid my sisters less fortunate than myself, without offering them charity. I concluded that my energies should be devoted to teaching them to help themselves, thus inculcating self-respect and independence."[11]

The coursework created under Hopkins's watchful stewardship blended historical studies of the models of the past with practical training in drawing from ornamental casts. As she explained, "Many a woman who could not paint a portrait could draw a design." Backed by a staff of male instructors and a prominent board of aesthetically inclined women and men, the venture quickly became a success. Hopkins aggressively marketed the products of her more promising students, submitting over five hundred examples of their work to the Columbian Exposition, where they

netted five medals. She also managed to put the institution on a paying basis by charging modest fees for the classes. After only two years of operation, Hopkins returned $7,500 of the initial $10,000 subscription to the donors. Nonetheless, she was careful to emphasize that the school was self-supporting, "but not on a money-making basis." [12]

Hopkins's efforts garnered international attention when Princess Christian, one of Queen Victoria's daughters, heard of the scheme and resolved to replicate it on British soil. Although she had been involved in the activities of the South Kensington Museum's Royal School of Art Needlework for many years, the princess was captivated by the New York institution because it broadened the roster of women's trades to include drafting and architectural design. A contemporary journal reported that one of her objects in founding the London school was to utilize "talents now being frittered away in the production of second-rate pictures." In effect, it was designed to mitigate women's desire to emulate male aesthetic endeavors by luring them back to their appropriate sphere with more varied fare. [13]

Another institution in which women figured prominently, the Rhode Island School of Design Education (RISDE), became one of the country's major educational institutions in the fine arts. Like the decorative arts movement, RISDE was a spin-off of the Philadelphia Centennial Exposition. However, the idea was much older, tracing its roots to the Rhode Island Art Association. Founded in 1854, the association listed 141 charter members—all men—who sought to create a "permanent Art Museum and Gallery of the Arts of Design." Like many similar ventures, the effort faltered when the anticipated endowment failed to materialize. Three decades later, the idea was revived by Helen Metcalf, the wife of a prosperous textile manufacturer. Metcalf had headed the state chapter of the Women's Centennial Committee, an auxiliary appointed to raise funds for the 1876 exposition. Like many of its sister chapters, the Rhode Island group exceeded its fund-raising quotas for the fair, leaving a tidy nest egg of $1,675, which was promptly invested in a new art school. [14]

Incorporated in 1877 and opened the following year, RISDE was initially very much a family affair. Although a board of local women ostensibly oversaw the school's affairs, Helen Metcalf managed the school's day-to-day operations herself, a responsibility she ultimately bequeathed to her daughter, Eliza Radeke. While Metcalf took care of the daily administrative chores, her husband assumed the financial burdens. In addition to subsidizing the school's operating costs, Mr. Metcalf donated a building to house its expanding operations in 1893 and built three new exhibition galleries as a memorial to his wife after her death two years later.

A skilled china painter in her own right, Metcalf was keenly interested

in industrial design. As such, she helped to found an industrial museum as part of the school in 1880. She was also an avid administrator. In the words of one historian, "She was, in fact, [RISDE's] un-named Director. No detail of management or item to be purchased was too insignificant for her personal attention. She was known on occasion to sweep the dust of the classrooms. In a very special sense, RISDE was Helen Metcalf's creation." It was also an excellent example of Gilded Age female entrepreneurship. Like many of the organizations founded by women during these years, RISDE operated without an endowment; it drew its sustenance, its institutional identity, and its strength from the intense commitment of women volunteers. Ironically, Metcalf's passing marked the beginning of a new era of prosperity and broadened aims, which eventually embraced the visual, as well as the decorative, arts.[15]

Given the division of labor that women such as Hopkins and Metcalf had so carefully etched, men entered the more feminized areas of the decorative arts with profound misgivings tempered only by their desire for material gain. Their most important collective foray into this area was mounted under the auspices of the Tile Club, founded in 1877. Its members included a surprisingly distinguished sampling of the era's leading painters and sculptors, including Augustus St.-Gaudens, J. Alden Wier, Stanford White, William Merritt Chase, Elihu Vedder, and Winslow Homer. Although the idea of Winslow Homer decorating tiles strikes a somewhat incongruous image, he was apparently quite proud of his ceramic handiwork, displaying samples in his studio and at the Century Club.

Like earlier artists' groups before them, Tile Club members fashioned their association around a variety of time-honored male rituals. Members were welcomed to meetings with steins of beer before the glow of an open fire. "As each member enters the cozy room he is greeted with the customary shout of welcome. These shouts vary from a dismal groan to a chorus. Sometimes snatches of old songs with new words are interwoven with the Tiler's name, and often rhyme without reason." The members also organized excursions, including a canal journey on what was described as a "potato boat" in 1880. Despite its rather humble origins, the boat was quickly camouflaged to suit the members' aesthetic sensibilities, draped with rugs and tapestries "until it might have been mistaken for the barge of Cleopatra as it took its place among the other potato boats in the tow up the river."[16]

Other amenities were added as well, including a piano, a "wagon load" of beer, easels and paints, pipes and tobacco. When they docked, the painters disembarked, setting up their easels along the towpath or in open

fields. Members with musical leanings serenaded local residents along the route, and impromptu balls were staged along the towpath. For some, these high jinks represented a revival of the bachelor culture that had dominated the antebellum art scene; for others, the excursion marked a significant turning point in their careers. According to Chase's biographer, for example, his interest in plein air painting dated from his summer Tile Club excursions.[17]

Other members stressed the purely pecuniary nature of their interest. As Edward Strahan condescendingly explained,

> [When] the decorative mania . . . had fallen like a destructive angel upon the most flourishing cities of America, turning orderly homes into bristling and impenetrable curiosity-shops, and causing the loveliest and purest maidens in the land to smell of turpentine, certain youthful artists began to notice the goings-on of their sisters, their sweethearts, and their wives. Stealing without remorse from these ladies their colors, their china plaques, and their laced and embroidered paint-rags, and using the mighty brushes heretofore dedicated to more sublime tasks, they began experimenting upon potsherds and Spanish tiles. . . . They took credit in bending to this frivolous material their knowledge of effect, their experience, the workingman's craft gained in wider fields; so that many a deserving idea that had come knocking at an artist's brain in the firm expectation of being promoted to canvas in a gallery-picture, or to a fresco in a cathedral, found itself constrained to an installment on a tile, degraded to consort with a kettle on a hob.[18]

Although Strahan rhetorically cringed at the spectacle of "an artist's commission of his best inventions to vehicles so frivolous or despised," others adopted a more pragmatic view. F. Hopkinson Smith pointed out that artists who were content to "live in a garret and wait until some Dives of a Diogenes climbs up your rickety staircase with a connoisseur's lantern to discover you" were far less likely to garner commissions than the entrepreneurs who were willing to "go where there is somebody to buy." Successful decorative arts practitioners such as Louis Comfort Tiffany underscored the link between pecuniary success, decorative artwork, and the faltering market for American paintings and statuary, a trend that became increasingly marked amid the cosmopolitan enthusiasms that followed the Philadelphia Centennial Exposition of 1876. "As for those who cling to the view that art lies only in the hands of painters and sculptors," he noted, "their patrons today are tending to become relatively fewer as time goes on. No

profession is more overcrowded. Clients do not keep increasing; it is rather the other way."[19]

The success of Tiffany's decorating firm, Associated Artists, gave added credence to his comments. Tiffany's taste for decorative design stemmed from his days with the NYSDA. Although originally a painter and watercolorist of some skill, he turned his attention to industrial design after joining the NYSDA. Two years later, he became restless and decided to strike out on his own. When he submitted his resignation in 1879, he persuaded Samuel Colman, Lockwood de Forest, and Candace Wheeler to join him in the new commercial venture. Unwilling to sever their ties to the society entirely, the firm continued to commission embroideries based on its designs.

Wheeler handled the textile commissions, while de Forest took responsibility for the agency's wood-carving work, returning to India to found the Ahmedabad Wood Carving Company to execute the firm's designs. They catered to an impressive array of clients, from Chicago's leading society matron Bertha Palmer, to Cornelius Vanderbilt and the author Samuel Clemens (Mark Twain). Perhaps their most important commission was the redecoration of the White House, in 1882. When the firm disbanded the following year, Wheeler set up an independent agency of her own, specializing in tapestries and textiles and staffed entirely with women. Yet even as she helped to pioneer a new field of professional endeavor for women—interior decoration—Wheeler clung to her separatist aims, urging women decorators to subordinate their own artistic leanings and tastes to the superior aesthetic wisdom of the architect.

Wheeler was also involved in the fin-de-siècle arts and crafts movement. Predictably, the movement attracted her attention because of its potential to blend women's artistic endeavors with new forms of self-support. Like its predecessor in the decorative arts, the arts and crafts movement soon quickened into a national, aesthetic crusade. Between 1896 and 1915, thousands of chapters were founded in cities and towns across the nation to upgrade the caliber of American crafts. Many were unabashedly steeped in charitable aims and messianic zeal. The movement began in Chicago, one of many spin-offs of the city's leading social settlement, Hull-House. Although Jane Addams headed the settlement, her associate Ellen Gates Starr was the author of this particular campaign. Organized in 1897, the Chicago Society of Arts and Crafts traced its origin to Gates's Ruskinian leanings and her concern with the preservation of immigrant crafts. As part of its innovative fare, the settlement hosted the Hull-House Labor Museum, a living museum where neighborhood women demonstrated their

CANDACE WHEELER, MIRACULOUS DRAUGHT
OF FISHES TAPESTRY

Produced by Associated Artists

traditional textile and lace-making techniques. Nothing went to waste, with the linens, woolens, and rugs they produced marketed at Hull-House and through local craft fairs. In a sharp reversal of the aesthetic and economic hierarchies inherent in the decorative arts campaigns, local immigrant women were also enlisted to teach lace-making classes to the Hull-House residents and local society women who constituted the bulk of their students.

Although men such as Charles Eliot Norton of Boston and Chicagoan Oscar Lovell Triggs took the lead in individual chapters, women played an important role in creating new institutions under the movement's auspices. Wheeler, for example, established a small rug-making industry for the farm women who lived near her summer home in Onteora, New York, efforts inspired by the appalling state of some of the handicrafts she had seen near another popular summer watering spot, Bar Harbor, Maine. As she explained, the rugs there were "so ugly . . . that only the most sympathetic person interested in the maker could induce one to purchase them." In an article published in 1899, she urged other women to follow her lead in upgrading local crafts. "The subject of our domestic industries is one which should fall naturally within the objects of women's clubs," Wheeler urged. "If every woman's club in the country . . . [had] a committee on home industries, the committee's reports would soon become the absorbing interest to the club, and the productions made under the protection, so to speak, of the club, would have an advantage that any commercial business would consider invaluable."[20]

Farm wives were especially in need of help, according to Wheeler, since they lacked extensive economic resources and "the mental stimulus incident to the management of [such] resources." Moreover, their "isolation from neighborly or public interests" during the winter months left them ripe for reform. Wheeler even went so far as to suggest that insane asylum statistics provided an accurate measure of the degree of their torment during the long, cold, lonely winter months. Rug hooking, lace making, and comparable crafts could provide an appropriate anodyne for these blighted lives, bringing these unfortunate souls "into a bond of common interest with other women." Of course, not everyone was willing to supinely accept such aid. In a tart reply to Wheeler's essay, one rural woman snapped, "We do not know much about woman's clubs in this benighted region, but from all I hear of them, their members waste a great deal of sympathy on that 'poor, forlorn creature,' the farmer's wife." In this woman's opinion, at least, club members were best advised to confine their charities closer to home.[21]

However tactless Wheeler's presentation may have seemed, it under-

scored once again the strongly commercial, charitable, and sororal slant that surrounded many of the cultural ventures that women promoted during these years. Many played an important role, not only in fostering women's crafts industries, but in marketing their wares. Some, like Wheeler's rug-making schemes, were fairly tame. Others were a little more unusual. For example, Susan Chester Lyman left the comforts of Hull-House in 1894, to found the Log Cabin Settlement for mountaineers and their children near Asheville, North Carolina. As part of her ministrations, she helped to revive the local craft of coverlet weaving, which had almost expired, marketing the coverlets through the Asheville Exchange for Women's Work. Since Asheville was a fashionable winter resort, she was able to extend her customer list to northern cities as well, exhibiting the works of some of her most gifted students at such respected institutions as Teachers College at Columbia University and the National Arts Club in New York.

Some worked through women's missionary networks. Founded to help native American women on the White Earth Reservation in Minnesota, the Sibyl Carter Indian Lace Association was created by an enterprising missionary who sold the laces with the aid of prominent church women in the East. Patterned on seventeenth-century Italian models and church communion clothes, these objects were highly prized and apparently beautifully made, netting gold medals at the Paris Exposition of 1900 and the Australian Exhibition of Women's Work seven years later. Some women, like Lyman, orchestrated their burgeoning commercial empires out of log cabins, living like the impoverished mountain women they sought to aid. Some turned to settlement houses for help in selling their wares, some to women's clubs, some to charities, some to the church. But all focused on aiding women through women's networks, and used their nonprofit status to effect commercial gains.

Although it eventually lost its momentum around the time of the First World War, the arts and crafts movement provides an interesting link between the antebellum generation, the decorative arts movement, and the handful of women who promoted twentieth-century museums. With the decorative arts in the nineteenth century, and nonacademic American art and the avant-garde in the twentieth, folk art was one of the areas where women took a pronounced leadership role. Cultural entrepreneurs such as the Greenwich Village gallery owner Edith Halpert would later help to legitimize American folk art as a respectable branch of American craftsmanship within museum walls, working with prominent collectors to launch a number of important folk art repositories such as the Abby Aldrich Rocke-

feller Museum of Folk Art at colonial Williamsburg, and Electra Havemeyer Webb's museum at Shelburne, Vermont. Not every woman shared this enthusiasm—Webb's mother, the celebrated art collector Louisine Havemeyer, dismissed her daughter's enthusiasms as "American trash"—but the contributions of those who did ultimately elevated traditional female handicrafts to the level of fine art in new ways.[22]

And, like many of their Gilded Age sisters, they did so by celebrating the homely artifacts of the domestic sphere. The emphasis on household art provided an opening wedge into Gilded Age museum development as well. The history of the Cincinnati museum is a case in point. Cincinnatians had a long history of cultural achievement, including the brief tenure of Peter's LAFA. LAFA's successor, the Women's Art Museum Association (WAMA), was an outgrowth of women's efforts to raise funds for the Philadelphia Centennial Exposition. Cincinnati's centennial chapter dated from 1874 and included many of the city's most prominent matrons. In return for their fund-raising efforts, they were invited to furnish two rooms in the Women's Pavilion at the 1876 fair, to showcase carvings and decorative artworks made by local women. The city already had an unusually strong base for the development of women's crafts. The noted American wood-carver Benn Pitman opened his women's carving and needlework classes in 1872. Louise McLaughlin, a prominent china painter, and her rival, the aristocratic Maria Longworth Nichols, were also active on the Cincinnati scene, developing new techniques that would soon change the quality of American ceramic production.

Nichols is an especially interesting figure. The granddaughter of the Cincinnati art patron Nicholas Longworth, Maria Nichols founded one of the nation's leading ceramic firms, Rookwood Pottery, shortly after the fair. Although she probably never formally joined a decorative art society, her work embodied many of the movement's ideals, helping to shape American tastes, to upgrade the quality of household decoration, and to provide new employment opportunities for women, a combination echoed in the programs of a number of other female-sponsored potteries founded during this period. For example, Mrs. James G. Storrow's Paul Revere Pottery was founded to provide employment for immigrant women in Boston's North End, while the Newcomb Pottery afforded opportunities for female potters and decorators in New Orleans. By the end of the century, women's pottery clubs were operating in cities across the nation, providing yet another example of a mass-based artistic movement rooted in the decorative arts. In addition to the quality of its wares, Rookwood attracted national attention because its workers were mainly middle- and upper-class women.

Like Sarah Worthington King Peter and Candace Wheeler, women such as Nichols and Storrow blended aesthetic reforms with a quest to create career opportunities for other women.

Pitman was another articulate advocate for female labor and aesthetic skills. "Let men construct and women decorate," he advised. Aided by Peter's son, Rufus King, and Alexander McGuffey of reader fame, Pitman established one of the country's first women's wood-carving classes. Several members of the Women's Centennial Committee were students at Pitman's school, while others were enthusiastic clients. As such, they stocked their exhibit space at the fair with gleanings from Pitman's classes, from wood carvings to stylish embroideries, as well as china painted by Nichols and McLaughlin. All exemplified the talents of female artisans, highlighting the sophistication and quality of women's creative efforts.[23]

The Philadelphia Centennial Exposition increased women's enthusiasm for decorative work. Nichols and her husband were impressed by the Japanese exhibits. Although theirs was not a particularly happy marriage, both shared a taste for decorative art and collaborated on a number of guides to different techniques and styles. Upon their return, both Nichols and her fellow Cincinnatians set about looking for ways to strengthen the city's cultural offerings. The Women's Centennial Committee was accordingly reorganized as WAMA in January 1877, shortly after the closing of the fair, to help in the creation of a local equivalent of the South Kensington Museum and to advance "women's work . . . in the direction of industrial art." "Our aim is to give practical encouragement to the women of our city and country who are trying to apply their art work to use," the founders explained, comparing their "practical work" to that currently "being accomplished under the auspices of decorative art societies." Rather than "a society of artists or connoisseurs," the trustees pointedly described themselves as "an association of women working to help those who would make their artistic work of use."[24]

Born of many of the same interests and goals as other decorative art societies, the Cincinnati association developed along similar lines. Loan exhibits of decorative artifacts were regularly staged to raise funds, embroidery classes were initiated, and a gallery was established for the sale of decorative works. Lectures by luminaries such as Charles Eliot Norton of Boston also helped to spread the gospel of decorative artistry, as did the ladies' reading room stocked with contributions from the members' private holdings. By 1881, WAMA began to amass its own collection of decorative artifacts as well, ranging from ancient Etruscan pottery to laces loomed at the South Kensington School.

The loan exhibit held in May 1878 illustrated the breadth of WAMA

interests, featuring a heterogeneous array of bronzes; mosaics; armor; gold, silver, and brass work; antique furniture; jewelry; artistic embroideries; pots and laces; tapestries and antique fans. Following the pattern of NYSDA, the board members ceded responsibility for sifting and displaying the works to "an efficient committee of gentlemen," who sorted through over two thousand objects culled from the city's homes. Over thirteen thousand Cincinnatians attended, attesting to the quality of the exhibits and the extent of local interest.[25]

Men played an increasingly prominent role in these proceedings. An auxiliary committee of male advisors was appointed at the outset, "to inspire confidence in those who wish to contribute to the support of the enterprise." Joseph Longworth was a charter member, as were George Nichols and the spouses of several other trustees. In addition to serving as a guarantee of the association's fiscal reliability, these men were often called upon in other capacities as well. In one instance, Nichols was asked to present a speech on the commercial value of industrial design. His comments highlighted the dichotomy between male and female sponsorship of the decorative arts. While women tended to emphasize the charitable nature of their endeavors and their efforts to upgrade domestic tastes, men generally stressed the commercial benefits instead, outlining the potential windfalls for local manufacturers who supported such work. International competition and local financial gain—these were the leitmotivs of male support for what they termed the "industrial arts."[26]

Women occasionally echoed their themes. In describing why the city needed a permanent museum (most probably to a mixed audience peppered with wealthy businessmen), WAMA's president, Mrs. Perry, warned that "unless we have museums of our own, where original specimens or accurate copies of the work of the master of painting, sculpture, woodcarving and decorated art are constantly before the eyes of our higher workmen, we shall have only imitations of the work of other countries—servile imitations—for no designer will have the courage to deviate from his pattern. The makers of beautiful designs for manufactures are somewhere: why in Europe? Why not here, as well as in any other part of America?" Unfortunately, the composition of Perry's audience was not recorded. But her call for a museum filled with casts, engravings, and photographs as well as decorative artifacts contrasted sharply with the rhetoric that surrounded most types of female cultural advocacy. Clearly, this was an argument intended to capture the imaginations—and the financial backing—of men.[27]

Perry and her fellow directors were careful to avoid the appearance of overconfidence in their aesthetic judgments or managerial skills. The closer

they came to museum development, and the further they moved from the comfortable sanctuary of decorative artistry and female needs, the more guarded they became. "As an association of women we may fairly take the position that we are not beggars for unwilling gifts," they noted, "but simply aiming to present an instrumentality through which those who wish to give may do so." The tone of this comment is interesting, emphasizing their passivity and their determination to concentrate on traditional, female fund-raising roles.[28]

Nor was their caution misplaced. The *Cincinnati Commercial* lauded their activities not only because they "appreciated the magnitude of the proposed work," but also because they did not presume to shoulder the financial and managerial burdens of managing the museum themselves, "responsibilities to which they are unequal." WAMA's directors were keenly aware of the limitations of their role and were willing to publicly adopt a subservient pose in order to achieve their ends. Yet this approach also had the potential to bolster popular misgivings about women's ability to responsibly manage large sums of money, despite the scope and sophistication of the national cultural and charitable infrastructures that they developed during these years. Because they were so careful to emphasize that their ambitions were limited, and therefore within the bounds of ladylike behavior, activists such as Mrs. Perry may have unwittingly contributed to the notion that voluntary associations and fund-raising campaigns were well suited to female stewardship, but responsibility for more affluent institutions such as museums was the appropriate province of men.[29]

However, even the sternest critic would have conceded the importance of women's fund-raising skills. One of WAMA's most important aims was winning financial backing from local businessmen. As early as 1878, WAMA had begun to wonder how to find "a few public spirited gentlemen" who could be persuaded to "authorize the purchase of a little collection." By 1880, a music festival produced the first major windfall, when Charles West volunteered a $150,000 matching gift, contingent upon local subscriptions of a comparable amount. WAMA quickly set about raising the necessary subscriptions, and West's pledge was "more than fulfilled." Sizable gifts were raised from Joseph Longworth; Reuben Springer, a local merchant who also constructed the city's music hall; and West, who generously added another $150,000 for the endowment. A small number of women contributed unusually large donations in the $1,000 to $2,000 range.[30]

Once the money was raised, management of the new institution was formally passed to a board of male trustees in March 1881. The new direc-

tors dissuaded WAMA from disbanding entirely, encouraging the women to continue collecting works for the museum's exhibits. Influenced by the innovative local work already underway, they decided to specialize in pottery collecting, with a secondary interest in old lace. By the time WAMA was formally disbanded in 1886, thousands of dollars worth of objets d'art had been collected and passed to the new museum, along with gifts in kind from the members themselves.

A similar pattern developed in Detroit. That city's museum movement originated with the Detroit Art Loan. Created in 1882 by a local journalist, W. H. Brearley, the scheme was forwarded primarily by local women, who helped to stage a series of public exhibitions with holdings gleaned from Detroit's collectors. Within a year, over two hundred local citizens had been conscripted, most of them women, who collected the paintings, statuary, and objets d'art from local connoisseurs. They also helped to raise the nearly $50,000 deemed necessary to back the new venture, and four contributed $1,000 subscriptions themselves, while many others donated paintings and examples of decorative art.

In return, they gained an opportunity to participate in the staging of a series of exhibitions, as well as a chance to tout the benefits of enlightened household decoration. To quote an article from the *Detroit Art Loan Record,* "An oft-repeated and true assertion is that a neat and pretty home, however humble, is one of the surest safeguards against evil and vice . . . and surely, with so worthy an object in view, no one is too poor to give a few moments every day to the beautifying of their home surroundings." Although not specifically a decorative arts society, the Detroit Art Loan established cordial relationships with chapters in other cities, through which they culled additional artifacts for display. They also set aside a special "bric-a-brac" room for articles lent by the Decorative Art Society of Detroit.[31]

Despite a series of successful exhibits, the Detroit Art Loan was disbanded on July 11, 1885. Within a year, plans were under way for the development of a full-fledged museum. Predictably, women were absent from the resulting board. As in the case of Cincinnati, women helped to foster a favorable climate for the creation of a local museum, but were expected to step aside when their plans came to fruition.

Despite the limited roles generally accorded them in the nation's Gilded Age museums, a few women sought to create museums of their own. Perhaps the most important repository founded under female sponsorship before the turn of the century was the Cooper-Hewitt Museum in New York. As in the case of other Gilded Age women's cultural ventures,

Cooper-Hewitt was wedded to the imperatives of decorative design. It was also a distant relative of NYSDA, since its founders were the daughters of one of the society's charter members.

Amelia and Eleanor Hewitt were heiresses born of a distinguished clan. Their grandfather Peter Cooper was an inventor and one of the city's most celebrated philanthropists, the founder of Cooper Union. Their father, Abram Hewitt, served as the city's mayor in 1887 and was well known as a implacable foe of the notorious urban boss William Marcy Tweed. Neither sister married, and a third sister bowed out of the museum's plans when she wed. Reared in an atmosphere of comfortable elegance, all three began collecting while still in their teens, amassing stores of textiles, laces, drawings, and prints, and Eleanor (or Nelly, as she was called) became a skilled needlewoman in her own right.

The inspiration for their venture came largely through the process of self-education: conversations and correspondence with dealers, subscriptions to art journals, and a growing familiarity with important European repositories, including the South Kensington Museum and the Musée des Arts Décoratifs in Paris. Together, Amelia and Eleanor Hewitt created America's first public museum devoted solely to the decorative arts in 1895. Housed in Cooper Union, it fulfilled their grandfather's dream of a teaching museum to augment the format of free art instruction he had introduced when the institution was founded. Their family ties also provided an unusually hospitable institutional framework for starting such a venture. Although the sisters' rhetorical mandate echoed the aims of many of the contemporary multipurpose museums founded by men, pledging to upgrade standards of American artisanry and taste, Cooper-Hewitt assumed a far more personal cast. According to art historian Russell Lynes, the sisters initially thought that they could run it out of "their own pocket money." As a result, they did most of the manual labor themselves, classifying, arranging, and labelling their exhibits with the help of friends and "volunteer ladies of well-established families."[32]

Like Helen Metcalf, they visited the museum daily, avidly cutting, filing, and mounting photographs of the artifacts they did not have in stock. They also raided their family's holdings for "contributions" to stock the museum's shelves, augmenting them with collections of their own in much the same manner that their mother's generation had filled the exhibitions of their decorative art societies. A few outsiders, such as J. Pierpont Morgan, made donations as well. A friend of Abram Hewitt, and himself one of the world's great collectors of decorative artifacts, Morgan graciously donated three major textile collections that placed the museum's holdings on a par with those of the South Kensington Museum. Others, such as former

NYSDA member Mrs. William Tilden Blodgett, proffered monetary dona-
tions, helping to place the venture on a more substantial financial footing.

Another connoisseur, George A. Hearn, was drawn into the sisters'
sphere because his wife was one of their mother's former classmates. The
association with Hearn took the Hewitts' plans in an unanticipated direc-
tion. In 1904, he took it upon himself to form a council—composed en-
tirely of male lawyers and businessmen—to oversee the museum's
operations and its growing resources. The sisters resisted the takeover for
three years but finally acquiesced in 1907 with the proviso that the mu-
seum's acquisitions be entrusted to a separate committee of artists. Despite
the overwhelming preponderance of female artists, art students, and de-
signers working in the field at that time, the artists who were appointed to
the committee were all men: Louis Comfort Tiffany, the painter John W.
Alexander, and sculptor Daniel Chester French.

The history of Cooper-Hewitt echoes a number of familiar themes.
One is the link between the women's efforts to develop arts organizations
and their allegiance to the decorative arts. Throughout the nineteenth cen-
tury, from Peter's Philadelphia school to Cooper-Hewitt, women shaped
their most successful institutional mandates around the arts of design.
Moreover, they were best able to maintain the institutions they created if
they were clearly oriented toward female constituencies, domestic ends,
and (rhetorically) limited gains. When they ventured into museum devel-
opment, they were generally expected to surrender control of their institu-
tions once they amassed substantial collections or funds. Even when
women banded together to launch local museum movements in Cincinnati
and Detroit, after the repositories materialized they were ceded to the man-
agement of men.

Women's efforts reflected a lingering reticence to speak on behalf of
the community as a whole when the subject was the visual rather than the
decorative arts. But they also reflected the expectation that women would
run their own organizations primarily with contributions of volunteer time
rather than substantial amounts of cash. To quote historian Suzanne Leb-
sock's remark about an earlier period, "Women were most likely to ex-
ercise control over resources when the stakes were small."[33]

More research is needed, but preliminary findings suggest that this no-
tion may have reached well beyond the cultural arena. Many of the most
prominent women's organizations lived a hand-to-mouth existence during
these years. At Hull-House, one of the country's foremost settlements, Jane
Addams supplied a major part of the operating costs out of her own
pocket, aided primarily by two close associates, Louise De Koven Bowen
and Mary Rozet Smith. Women's colleges appear to have subsisted on

equally modest revenues. Thus, notes historian Rossiter, "Vassar was so poor that it could not even subscribe to the major professional journals" in many fields. As a result, "even Bryn Mawr College, which maintained a small graduate school . . . provided no funds or released time for those professors who were engaged in research." Reliance on collegiality, voluntarism, small donations, and nonprofit entrepreneurship were the earmarks of many separatist organizations, including women's schools of design and their societies of decorative art.[34]

There were other similarities as well. Design schools and decorative art societies represented two of the major organizational forms created by female philanthropists in the arts during the decades after the Civil War. Like nursing schools and women's hospitals, design schools were specialized institutions that served the professional needs of women in ways that blended charitable concerns, career opportunities, and community service. Decorative art societies were mass-based voluntary associations that more closely resembled women's exchanges, clubs, and the WCTU. Yet even when they had a national mandate, these organizations reflected preindustrial models at the local level. Rather than building centralized, salaried, corporate-style hierarchies, they retained the collegiality and sororal spirit of agencies run primarily by volunteers, patterns reinforced by the more limited amounts of cash under women's control.

By legitimizing their participation in terms of specialized genres and constituencies, the women who sponsored these activities avoided more confrontational calls for professional parity within the wider artistic arena. Yet their efforts often obscured the full extent of women's contributions and creative talents, particularly as "nonprofit entrepreneurs." Antebellum women had experimented with small-scale capital formation in their charity bazaars and fairs. Participation in the Sanitary Commission taught them to coordinate these efforts on a national scale. During the Gilded Age, women parlayed these institutional networks into a subterranean economy that paralleled the national, commercial marketing systems being developed by men. Under the cloak of charity, culture, and reform, women's voluntary associations facilitated the production and sale of women's professional services and goods, marketing these products to other women through extensive organizational networks that crossed the nation. In the process, they helped to coordinate women's emerging roles as artisans, consumers, and volunteers.

By emphasizing that their profits were limited and rooted in charitable aims, women underscored their unwillingness to formally compete with men in the marketplace. But their diversionary tactics may have also reinforced the notion that women were inherently unqualified to manage more

heavily capitalized institutions, prejudices reflected in the development of Gilded Age museums.

This, then, was the dilemma of women's cultural philanthropy, and separatist strategies as a whole. In many instances, the entrepreneurs who created separatist institutions—including committed feminists such as Candace Wheeler—rhetorically embraced limited aims in order to achieve their goals. Whether by promoting the careers of female artisans or choreographing national commercial ventures in the name of charity and reform, they were careful to emphasize that they sought appropriately circumscribed gains. Yet despite their efficacy in widening women's cultural alternatives, their strategies ran the risk of perpetuating the stereotypes they sought to dispel, thereby isolating women philanthropists from the women who sought to forge careers within the professional and philanthropic domains of men. In effect, separatism and assimilationism were rooted in different, often competing, goals.

Part Two

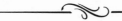

ASSIMILATIONISTS

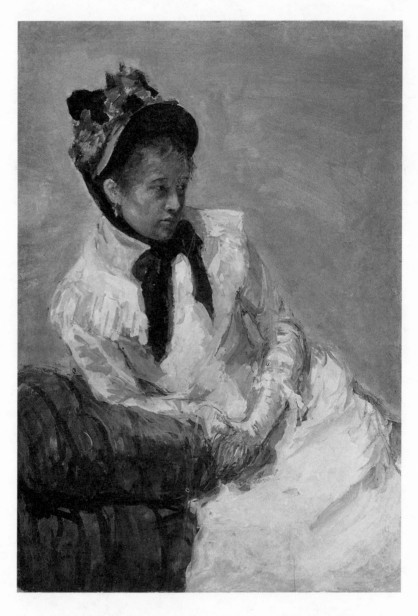

MARY CASSAT, *PORTRAIT OF THE ARTIST*

4

Artists and Mentors

C andace Wheeler held that her greatest achievement was her success in opening remunerative careers for other women in the field of art. "It is less than twenty years since American women began the study of art as a profession," she proudly recalled in 1897. Before that time, "it was a fixed idea in the general mind that it was the duty of a 'lady' to live in self-denying poverty, rather than to practice any . . . occupation for profit." Through the decorative arts movement and the institutions that it helped to inspire, women had made "daily and successful breaches in the invisible wall of prejudice and custom which had separated well-born and well-bred women from the remotest thought of money-gaining enterprise."[1]

Yet Wheeler's commentary missed the tensions inherent in these gains. She and her associates had performed an invaluable service by enabling women to enter public cultural ac-

tivities in significant numbers for the first time, both as artisans and as non-profit entrepreneurs. Given the constraints that served to hold antebellum women's artistic enthusiasms in check, it was a notable achievement. Yet, by emphasizing women's "gift" for certain crafts, decorative arts crusaders may also have inadvertently helped to fuel popular prejudices against women painters and sculptors. The problem was succinctly summarized in 1901 in E. A. Randall's article "The Artistic Impulse in Man and Woman." Like many of his contemporaries, Randall linked the dearth of great women artists to their much-vaunted talent for the decorative arts. As he explained, "China painting and decorative art in general are the specialty of woman, who excels in the minor, personal artistic impulses and in this way gives vent to her restricted life." More ambitious ventures were deemed inherently beyond women's ken.[2]

There were other problems as well. Women's charitable networks proved ill-suited to aiding those whose professional aspirations placed them at the margins of acceptable, "ladylike" behavior. Indeed, the ambitions that inspired the decision to become an artist often challenged the domestic ideologies that legitimized women's public, philanthropic roles. Women artists did not want charity, they wanted public recognition and acceptance on a par with men—ideas that often ran counter to the separatist dictum that women should cleave to their own distinctive cultural sphere.

Nor was this an isolated issue. Throughout most of the nineteenth century, philanthropy was one of the major tools that women had at their disposal for fostering new careers for other women, and in some fields, such as nursing, their efforts were a marked success. But they were less efficacious in others. As historian Margaret Rossiter points out, women scientists tended to be shunted into two kinds of jobs: the low-paying, low-status tasks avoided by men, and "those that involved social service, such as working in the home or with women or children (. . . which were often poorly paid as well)." Separatist strategies had the power to open new career opportunities, particularly in areas catering to other women and children, but they could also be far less beneficial for women who ventured into occupational areas that were already monopolized by men.[3]

Rather than relying on female mentors, most of the women who managed to eke out careers as professional painters during the Gilded Age were trained, socialized, and (sometimes) promoted by men. But there were problems here as well. A number of subtle tensions resonated through the painter's craft during the Gilded Age. One was the desperately complicated balancing act played by artists like Mary Cassatt, who managed to maintain their "ladylike" status and the access to potential female patrons

and support systems that it guaranteed, while still forging successful careers. In the process, they often lost as much as they gained, concentrating on the minutiae of domestic life while ceding the broadening canvas of urban subject matter—the cabarets and slums on which Henri de Toulouse-Lautrec and George Bellows based their fame—to their less restricted male peers. Even access to the anatomical training deemed necessary for painterly success posed an inherent threat to female respectability. The prospect of young, unmarried women drawing nudes in the presence of male instructors must have been a somewhat indigestible notion to many Victorian patrons and their wives.[4]

Another issue was the specter of "feminization." Prominent Gilded Age painters such as William Morris Hunt, William Merritt Chase, and Thomas Eakins consciously played the mentor to a host of women painters. Indeed, many took particularly promising students as their wives. As the older, apprentice-based modes of art instruction gave way to more democratically oriented art schools, women students quickly constituted a disproportionately large number of registrants. And yet, even a cursory glance at the standard art histories reveals a professional landscape peopled almost entirely by men. Beneath the placid surface of women's growing visibility in the field lay an inherent cross-pull between male mentoring and men's continuing monopoly over professional rewards.

While many antebellum painters shunned the task of training women students beyond their own kin, a number of their more prominent Gilded Age successors reversed this trend. One of the first men to open his studio to significant numbers of women students was William Morris Hunt. Unlike many of his antebellum predecessors, Hunt was wellborn and well wed. Born in 1824, he was the son of a Vermont judge. After his father's death eight years later, Hunt's mother helped support the family by taking in boarders, one of whom was an Italian painter who may have kindled Hunt's taste for art. Hunt's mother was a talented amateur painter as well, which may have also influenced his choice of career. After briefly attending Harvard, where he was elected to the prestigious Porcellian Club, Hunt moved to Europe with his family in 1842, pursuing his artistic bent under the tutelage of Henry Kirke Brown in Rome and Emanuel Leutze in Germany. Upon his return to Boston in 1855, he married one of the city's most prominent belles, Louisa Perkins, an alliance that placed him firmly at the center of Brahmin society.

Hunt proved an extremely popular addition to the city's social scene. The artist was actively courted for "his brilliant conversational powers, his originality of thought and action, and his rare wit." Hunt's impeccable so-

cial credentials and his personal wealth enabled him to do as he chose, and what he chose to do was to start a painting class for some of the city's most cultured and prominent young women. His classes filled a special place in the city's artistic landscape, providing training for upper-class students in a suitably refined milieu. In the words of one contemporary, it was "very much a private affair," set in the artist's studio, with his students learning the rudiments of their craft by copying his works.[5]

Part of Hunt's success stemmed from his unassailable position as one of the city's leading gentlemen of property and standing. The majority of the most prominent antebellum painters—men like Thomas Cole and Asher Durand—bore the marks of their artisanal origins throughout their careers. Conversely, many of their Gilded Age successors hailed from middle- and upper-class backgrounds, which may have encouraged society matrons and their daughters to associate with them more freely. As art historian Theodore Stebbins explains, during the Gilded Age "Boston's artists as a group were essentially Brahmins, and . . . like the class as a whole, the artists became very much of a closed society." Certainly, Hunt's classes would have been a good deal more refined than those of the Lowell Institute. Set in a "large, damp, and gloomy" room, with "lead-colored walls and a smoke-blackened ceiling," the Lowell classes must have constituted a singularly unappealing alternative to Hunt's instruction. Instead, his students learned their craft amid tapestries and decorative artifacts, providing a setting not unlike their own homes.[6]

There is an undercurrent of ambivalence that runs through some of the commentaries about Hunt and his school. Some suggest that he may have been "ridiculed for teaching women, and offered to teach men, but none came." The New York art critic Clarence Cook reputedly complained that Hunt's teaching "gave to school girls what was meant for mankind." Perhaps by way of a rebuttal, one of Hunt's admirers depicted the artist as a firm "believer in solid masculine work." This remark was bolstered by an anecdote about an incident when Hunt was asked whether he knew a young artist "of affected manner and foppish appearance." Hunt's reply is revealing: "I don't know him. I know his clothes. . . . I can have nothing to do with such a man when I meet him; I look right through and beyond him." This brief comment establishes two things: Hunt's own gentlemanly status and his public disdain for foppish behavior. At least one of Hunt's acquaintances—a man in this case—felt compelled to emphasize that Hunt was free of any hint of the effeminacy that his willingness to consort with women students might have implied.[7]

Hunt's teaching methods were apparently as unconventional as his choice of students. While other local art instructors, such as William

Rimmer, stressed rigorous, disciplined training—including anatomical training—Hunt emphasized "the primacy of the artist's impression or feeling." Once again, this is an interesting approach, given that he reportedly criticized women's inability to draw clothing properly because they were so poorly versed in anatomical training. Sidestepping the issue of life classes completely, he encouraged his students to copy the works of European masters "to inculcate lessons of exactness and precision." Thus, "they were told to trace them carefully, copy them exactly, and draw them from memory, making them a part of themselves." He also had them work in charcoals, to yield "easy and speedy results."[8]

Many of his students became ardent disciples, despite his occasionally condescending manner. In one instance, when one of his pupils staged a tantrum, dissolving into tears because "she could not paint like an expert," he curtly advised her to "go home and hem a handkerchief." Nonetheless, years later, students still recalled his "cordial" manner and stirring conversation. Thus, gushed one, "you thank the good stars that have led you to one of the elect, one of the few who make life interesting . . . for William Hunt hates sham in all its forms and is heroic in his treatment of hypocrisy. If Hunt never had painted a picture, we still would thank God for the man."[9]

Most of his disciples retained their loyalty and admiration for him throughout their careers. Indeed, some had trouble establishing their own artistic identities and styles, preferring instead to live in their mentor's shadow. Helen Knowlton was his student, his biographer, and possibly his mistress as well. That he liked and respected her is clear from the fact that he ultimately turned the class over to her stewardship. In addition to Knowlton, several of his students managed to pursue professional or quasi-professional careers, including Elizabeth Boott Duveneck, Maria Oakey Dewing, and Sarah W. Whitman.

Although best known as the author of a compilation of Hunt's lectures, *Talks on Art* (1875), and *Art-Life of William Morris Hunt* (1899), Knowlton continued to paint throughout her career, exhibiting her works with those of other alumnae from Hunt's course. In Knowlton's case, her literary successes were not matched by her painting ability. Although frequently exhibited, Knowlton's paintings suffered from her close association with Hunt, dismissed as pale imitations of his work.

William Merritt Chase was another prominent painter who taught large numbers of women students. Like Hunt, he was wellborn and well-to-do, projecting the necessary assurances of gentlemanly behavior to attract a sizable female clientele. He apparently was an extremely gifted tutor, numbering a coterie of distinguished men and women—painters as

diverse as Gifford Beal, Charles Demuth, and Georgia O'Keeffe—among his former pupils. Beginning in the late 1870s, when he returned to the United States after completing his own training in European ateliers, Chase held a series of teaching positions, from a post at the newly created Art Students League, which he accepted in 1878, to his own art school, founded in 1896.

Perhaps his most interesting assignment was at the summer art colony at Shinnecock, on Long Island. Art colonies had originally been regarded as a male preserve both in the United States and overseas. Hunt and Chase helped to open up these former bastions of male privilege to women students as well. Hunt founded one of the country's first open-air painting schools for his pupils in Magnolia, Massachusetts. Although the venture was short-lived, his students continued the tradition by taking to the road together each summer to paint and sketch in the countryside, echoing the antebellum forays of painters such as Thomas Cole and Asher Durand.[10]

Chase's venture was more elaborate. The open-air painting school that he helped to found in 1891 at Shinnecock came to be regarded as one of the most important schools of its kind. Designed to provide continuing coursework over the summer months, when most Manhattan art schools were closed, it was liberally backed by a group of Southhampton women led by Mrs. William Hoyt. In addition to Chase's studio, which was designed by Stanford White, the compound featured an "art village" of summer cottages for his students. The idea apparently was Hoyt's. Another Southhampton resident, Samuel Parrish, donated some of the land, while Hoyt mobilized a band of local women to raise funds. The roster she finally chose included several alumnae of NYSDA, such as Candace Wheeler and Mrs. August Belmont. Although not designed specifically for them, women constituted the majority of the students who studied there until the project ended in 1902.

The mentoring patterns adopted by Hunt and Chase and their women pupils were gradually copied by other male painters as well. While antebellum painters such as Jane Sully and Miriam Peale were often the daughters of prominent artists, female painters now were just as likely to be artists' wives. Thus, Elizabeth Jane Gardner married the famous French academic painter William Bouguereau; Mary Nimmo wed the American landscapist Thomas Moran; one of Hunt's protégées, Maria Oakey, married a leading Boston school painter, Thomas Wilmer Dewing; and the gentle, cultured Elizabeth Boott wed the rough-hewn Cincinnatian, Frank Duveneck. Eakins also married one of his most talented students, Susan MacDowell, who devoted the rest of her life to burnishing his reputation.

For most women, these alliances spelled the end of their careers. Eliz-

abeth Gardner Bouguereau's experience is a case in point. Gardner came to Paris in the 1860s with a fierce determination to succeed. When she found that none of the Paris art schools admitted women, she dressed in men's clothing to gain admission. She and three other women finally convinced William Bouguereau to open the Académie Julian to women, signalling a new chapter in female art education. Elizabeth Bouguereau was the first American woman to exhibit and to win a gold medal at the Paris Salon. Yet during the years of her marriage she stopped painting, returning to her easel only after her husband's death in 1905.

A few women were openly skeptical about the worth of such alliances. "An artist has no business to marry," snapped the American sculptor Harriet Hosmer. Hosmer's career and that of her fellow midcentury sculptor Vinnie Ream illustrate some of the problems that women faced in establishing viable professional careers. Both were members of the colony of American expatriate sculptors and artists who lived and worked in Rome in the years bracketing the Civil War. Hosmer was the more celebrated, Ream the more notorious, but both were recognized artists of talent.[11]

Born in Watertown, Massachusetts, in 1820, Harriet Hosmer was the daughter of a New England doctor with unusual educational ideas. After losing his wife and three other children to tuberculosis, Dr. Hosmer decided that his daughter could only keep her health, and possibly her life, if she were subjected to a strenuous regimen of vigorous exercise. As a result, Hosmer was encouraged to master the decidedly unfeminine skills of hiking, horseback riding, and mountain climbing at a tender age. This in turn was followed by a stint at Miss Sedgewick's school in Lenox, where she met such prominent figures as Nathaniel Hawthorne, Ralph Waldo Emerson, and Fanny Kemble. Kemble encouraged her in her unconventional desire to become a sculptor, while one of her classmates' father, Dr. Wayman Crow, generously offered to underwrite her training.

When her request to study anatomy at the Boston Medical School was denied, Crow took her into his St. Louis home and arranged for her to study privately with a colleague of his at the Medical College of St. Louis. Afterwards, she sailed for Rome with the actress Charlotte Cushman, where she joined a growing colony of female sculptors. The city boasted a thriving expatriate community of American sculptors and painters during the 1850s, including Elihu Vedder, Emma Stebbins, Edmonia Lewis, Augustus St.-Gaudens, and William Wetmore Story. Horatio Greenough led the exodus of American sculptors in 1825, drawn to Rome by the lure of ancient art, the ample supply of fine Carrara marble, and the ready availability of trained artisans to do the actual carving.

Women artists were less of a novelty in Europe than in the United

States in the nineteenth century, although female sculptors who sought to work on a fairly monumental scale were still "a rarity." Hosmer learned her craft in John Gibson's atelier, where she immediately began to attract attention. She was extremely dedicated, and extremely eccentric. Like the French novelist George Sand, Hosmer dressed in men's clothing, and she quickly became an outspoken individualist. "I honor every woman who has strength enough to step out of the beaten path when she feels that her walk lies in another," Hosmer proudly declared. In an era when most women married, she openly expressed a glowering disdain for the entire institution. As she explained to her mentor, Crow, "For a man it may be well enough, but for a woman, on whom matrimonial duties and cares weigh more heavily, it is a moral wrong . . . for she must either neglect her profession or her family, becoming neither a good wife and mother nor a good artist." Since her ambition was to become a good artist, she vowed to wage an "eternal feud with the consolidating knot."[12]

Hosmer's unconventional opinions and behavior cast her in a somewhat anomalous position. She derived a substantial amount of moral support from a few devoted women friends, such as Cushman, Kemble, and the American writer Lydia Maria Child. Child obviously admired Hosmer's independence and tried to gloss over her more eccentric qualities as best she could, depicting the diminutive sculptor as "a charming hybrid between a young lady and a modest lad." In describing Hosmer's work to American audiences, Child underscored Hosmer's determination to follow her own course: "Here was a woman, who, at the very outset of her life, refused to have her feet cramped by the little Chinese shoes which society places on us all and then misnames our feeble tottering, feminine grace."[13]

She captured the attention of others, as well. Tourists were drawn to the city's Anglo-American art colony, lured by tales of parties, theatricals, and balls and by information on the artists' studios listed in many popular guidebooks and travelogues. Hosmer had particularly good luck in winning the affection—and the patronage—of a variety of aristocratic women, from the queen of Holland to the empress of Austria. Lady Marion Alvord and Lady Louisa Ashburton proved especially faithful patrons throughout her career. She also received commissions from a number of prominent American men, including Wayman Crow and A. T. Stewart, and a handful of American women as well, such as Mrs. Samuel Appleton of Boston and Chicagoan Bertha Palmer.

However, not everyone shared Child's enthusiasm for Hosmer's flamboyant personal style or the success she enjoyed. Some of the city's male expatriate artists seemed particularly annoyed by her success. William Wetmore Story was extremely vitriolic at first, complaining to his fellow

Bostonian James Russell Lowell that he found her "very willful, and too independent by half." Although the two artists later became friends, Story's acrid comment that "it is one thing to copy and another to create" captured the prejudices—and the envy—of many of his male peers.[14]

These attitudes surfaced more stridently with charges by another artist that Hosmer's statue of Zenobia was "really executed by an Italian workman at Rome." The charge itself was absurd, since most sculptors produced only small models, which were then carved by craftsmen in their employ, but it evoked a fierce rebuttal from Hosmer, who countered by claiming that "a *woman* artist, who has been honored by frequent commissions, is an object of particular odium." Hosmer learned the hard way what her more conventional sisters already knew: to succeed too well, particularly when the prize was commercial success, was to invite reprisals.[15]

It was a lesson that Vinnie Ream learned as well. But there was one significant difference between the two women. Although Hosmer's career was helped at crucial stages by men—Crow and John Gibson—she lived her life with and derived the bulk of her commissions from women. Indeed, her eccentricities helped to underscore her virtue, at least in terms of her relationships with men. Few would have labelled Hosmer a flirt, particularly given her mannish affectations and fiercely independent ways. Vinnie Ream adopted a far more feminine persona; patronized and encouraged by men, Ream's career foundered on the sting of female censure.

The problems started when, still in her teens, she won a $10,000 commission for a statue of Abraham Lincoln to grace the Capitol's rotunda. Although several more-established artists submitted drawings, Ream had an advantage in that she was the only sculptor to gain an audience—and sittings—with the president before his death. The first sour note was sounded when Mary Todd Lincoln objected to the committee's choice. However, the commission went forward over her protests, and Ream sailed for Rome to complete the statue in 1869. Like Hosmer, she quickly came to be regarded as one of the city's more interesting personalities, forming friendships with artists such as William Wetmore Story and the painter G. P. A. Healy, as well as a flurry of male admirers that included Dante Gabriel Rossetti and Franz Liszt. She had also attracted a number of open admirers in Washington, including such powerful and well-placed men as Senator Thaddeus Stevens and the notorious railroad magnate Jay Cooke, a fact not lost on her detractors.

Even before Ream left for Rome, Mary Todd Lincoln's misgivings were amplified in print by Jane Grey Cannon Swisshelm, a prominent women's rights advocate and former abolitionist leader. Incensed that this "young

girl" who had "only been studying art a few months" had received such a distinguished commission, Swisshelm suggestively complained that Ream, with her "pretty face . . . upturned nose, bright black eyes, [and] long dark curls" did not deserve to triumph over more experienced sculptors such as Hosmer or Hiram Powers. "What are fame and success as an artist," she snarled, what are "talent [and] genius . . . when compared with black eyes and long black curls?"[16]

The attacks continued once the statue was finished, raising questions about whether Congress should release the final $5,000 payment of Ream's commission. Many of the articles echoed Swisshelm's innuendos. The *New York Tribune* complained that "it is so easy for men of deficient moral sense to give away money which does not belong to them, and so hard for men of a certain age to resist the voice and eyes of a young woman!" While the sculptor Hiram Powers dismissed Ream's work as "a caricature," many of the most vitriolic attacks came from women. Comments by a St. Louis woman captured the tenor of their charges, publicly censuring Ream for "decorating her studio with flowers, wearing long hair, attracting the men, and thereby lobbying. . . . No girl can keep chaste and pure with three hundred wretched men around her," one critic indignantly concluded.[17]

Swisshelm took up the cudgels again, claiming that the charges that she had helped to set in motion were proof in and of themselves of Ream's duplicity. "I have been young," Swisshelm recalled, "and now I am old, yet I have never seen a virtuous woman forsaken by her own sex, or her laudable efforts asking in vain for woman's sympathy." Whitelaw Reid scrawled similar innuendos in the columns of the *New York Tribune,* charging that the Lincoln statue was actually the work of Ream's Italian hirelings. In his opinion, Congress's action in granting her the commission was "a gross and inexcusable outrage," influenced by "persistent and shameless lobbying" from this "fair enslaver of the Senate."[18]

Ream was not without defenders. Harriet Hosmer immediately came to her defense, having suffered through similar charges of plagiarism. "The meaning of all this," noted another journal, "is that if a woman who imagines she has a genius for sculpture gets a contract from the government for a work, it makes her virtue, . . . her chastity, a subject 'for the scrutiny of the public, whose money she pockets.' And scrutiny means, in this case, to suspect and accuse." The brouhaha that surrounded Ream's commission was a somewhat isolated incident, but it illustrates the pitfalls that awaited any woman who worked too openly, and too successfully, through the patronage of men. It also illustrated some of the problems inherent in working through a system dominated by men, particularly (in this case) the political system. Set beyond the pale of more traditional women's mentoring sys-

tems by her ambitions, Ream's flirtatiousness, and ultimately her success, opened her to a barrage of vitriolic public censure. And it was particularly strident because the stakes were so high. Even though the funds were finally released, and the statue placed in the rotunda (where it still stands), Ream paid dearly for her success.[19]

Some of the problems that plagued the careers of Ream and Hosmer would be mitigated by increasingly liberal educational policies that permitted women artists to enter the profession on more equal terms. Access to life classes was one important victory; women's entrance into once segregated arts organizations was another. The anatomical training that Hosmer was able to gain only through the graces of her mentor was finally granted to women art students in the decades after the Civil War. The Pennsylvania Academy of the Fine Arts opened its life classes to women in 1868, and the National Academy of Design followed suit three years later (although they continued to bar women from anatomy lectures until 1914).

The leader in the movement to open life classes to women in Philadelphia was the brilliant American realist painter Thomas Eakins. Unlike Hunt, Eakins was something of a pariah and much more of a perfectionist, who urged his students to constant study and roundly discouraged them from copying his style. Pupils in his more advanced classes were expected to do dissections, as well as drawing from nude models, rigorous demands that left little leeway for delicate sensibilities. Eakins was publicly attacked for his methods and for opening the academy's life classes to women. An anonymous letter to the academy's board captured the spirit of many of these complaints: "Does it pay, for a young lady of a refined, godly household . . . to enter a class where every feeling of maidenly delicacy is violated, where she becomes so hardened to indelicate sights and words, so familiar with the persons of degraded women and the sight of male nudes, that no possible art can restore her lost treasure of chaste and delicate thoughts!"[20]

Eakins himself fanned these isolated sparks of public concern into a full-fledged scandal. His first mistake was to remove the loincloth from a male model who was posing for a women's class. Worse still were the scandals generated by his unconventional relationships with his students. As part of their training, Eakins encouraged his pupils to pose for each other in the nude and, occasionally, to take photographs as well, a few of which reportedly made their way onto the market. He also posed male and female nudes together and on at least one occasion asked a woman student to pose nude for the class when the regular model failed to appear. Eakins later admitted that he had "frequently used as models for myself my male pupils; very rarely female pupils and then only with the knowledge and

consent of their mothers." Once again, an anonymous letter was sent to the trustees demanding his resignation, and this time they complied. Despite student protests, Eakins was forced to resign in 1886.[21]

Women's access to life classes was the reward of a long-fought battle. However, once women art students were granted their entree, retaining their respectability must have posed an entirely new set of problems. And, given the stridency of the criticisms levelled against Vinnie Ream—most of which were penned *after* Eakins opened his life class to women—there must have been extraordinary incentives to do so.

Balanced against this was the growing popular sympathy toward the need for new career opportunities, including careers in art, for middle-class women who had been deprived of suitable mates by the carnage of the Civil War. During the ensuing decades, women art students flooded into the nation's ateliers and art schools. Ever vigilant for new employment opportunities, Candace Wheeler approvingly noted in 1897 that "there are today thousands upon thousands of girl art students and women artists, where only a few years ago there was scarcely one." European study was also becoming an increasingly viable alternative. Although barred from Paris's prestigious Académie des Beaux Arts until the end of the century, hundreds of women flocked to the less celebrated, but more accommodating, academies, Julian and Colarossi, in the decades after the war.[22]

The number of American art schools rapidly increased during these years, opening new opportunities for study outside the artist's atelier. Cooper Union began admitting women art students in 1860, and the number of training institutions multiplied at quantum rates thereafter, fuelled by the growing number of museum schools. In many instances, women quickly constituted the majority of their students, raising the specter of "feminization."

Biases against women's creative abilities lingered well into the Gilded Age, strengthened and refined by Darwinian tenets. While Enlightenment thinkers such as Jean-Jacques Rousseau had argued that women were closer to nature, more mired in biological imperatives, and therefore less given to rational, intellectual pursuits, Darwin gave these prejudices a scientific slant. As historian Rosalind Rosenberg explains, "Darwin postulated a hierarchy of mental functions ranging in descending order from reason to imagination, to intuition, to emotion, and finally down to instinct." According to this reasoning, "the more highly evolved male brain performed most efficiently at the higher range of mental functions, while the simpler female brain was adapted to the lower range." Women were thought to be limited by the demands of physical endurance as well. As one article explained, "Few ladies are physically able to endure for any length

of time the severe course of study, requiring daily several hours of intense application, in the heated rooms of the life classes."[23]

Many women echoed these misgivings. Although committed to a number of women's causes, Alice James was intensely skeptical when her friend Elizabeth Boott decided to pursue her studies with Thomas Couture in France. "I wish that her work would come to more than it does," James candidly confessed to a friend. "Feminine art as long as it only remains a resource is very good but when it is an end it's rather a broken reed. Matrimony seems the only successful occupation that a woman can undertake." Mrs. Jameson, the noted British art critic, added a similar note of doubt. "I wish to combat in every way that oft-repeated, but most false complement unthinkingly paid to women, that genius is of no sex," she asserted, adding that "you mush change the physical organization of the race of women before we [will] produce a Rubens or a Michael Angelo." "Moreover, if men would but remember this truth," she contended, "they would cease to treat with ridicule and jealousy the attainments and aspirations of women, knowing that there never could be real competition or rivalry. If women would admit this truth, they would not presume out of their sphere."[24]

This in turn led to a tug of war between the growing ranks of women artists and the men who continued to ply these careers. American artists were forced into an anomalous position after 1876. As collectors increasingly turned their attention first to the paintings of the French Salon and then to the Impressionists and the scramble for Old Masters, the market for American works rapidly contracted. At the same time, the country's art schools were filling with women students. Popular commentaries, including many by women, stressed the "taint" of female artistry. Although instinctively suited for the less rigorous, "minor" arts, so the argument ran, women were more inclined to copy than create when they turned to painting. The image of the artist was changing as well. As historians Joseph and Elizabeth Pleck explain, when "larger numbers of women entered previously all-male jobs, the few men who remained in them were then defined as effeminate and unmanly."[25]

The elaborately decorated studios of William Morris Hunt and William Merritt Chase provide a clue to the changing fortunes of America's Gilded Age artists. William Sidney Mount painted the antebellum artist's studio in terms of stark simplicity, showing only the painter, his easel, and a male colleague admiring his handiwork. Rather than a sparse setting for male creativity and camaraderie, the Gilded Age atelier began to assume the proportions of a "a SHOW studio, a museum of rare bric-a-brac and artful effects of interior decoration" that indicated the artist's financial status and personal tastes.[26]

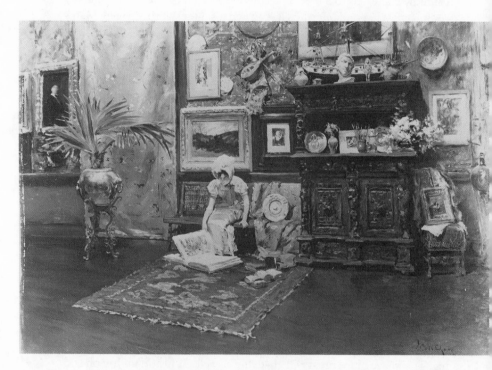

WILLIAM MERRITT CHASE, *IN THE STUDIO*

Courtesy of the Brooklyn Museum, Brooklyn, Gift of
Mrs. Carll H. De Silver in memory of her husband

The drift toward more elaborate studio decoration began in the late 1850s, when residents of New York's Tenth Street Studio Building began to embellish their rooms in distinctive styles that reflected their professional interests. In part, it reflected their rising fortunes. It may also have begun as a means of providing a more sophisticated backdrop for the artist's receptions that Candace Wheeler so enjoyed. The famous painter of western panoramas Albert Bierstadt adorned his quarters with the gleanings of his western sojourns, displaying Indian wampum, feathers, and clubs. His fellow landscapist Frederic Church enlivened his studio with exotic tropical plants acquired on his trips to South America. The architect Richard Morris Hunt peppered his rooms in the old University Building with a hodgepodge of antique bronzes and cabinets, musical instruments, ceramics, and medieval textiles acquired during his youth on the Continent.[27]

Chase took these trends to new extremes, filling his Tenth Street studio with artifacts from around the world. Looking to many of the older residents like he had "just escaped from the Latin Quarter," Chase moved into the building, black servant, red fez, and all, in 1878. Embellished with just the right degree of excess, his studio quickly became the center of a popular salon where actors and musicians jostled with painters and patrons amid a dizzying array of carpets, tapestries, and medieval armaments. Despite his gift for display, Chase was a serious and respected artist and one of the city's most sought-after art instructors. The opening of his studio and his subsequent success helped to bring a new tenor to the local art scene.[28]

It also symbolized changing attitudes about the place of artists in the larger society. Influential writers such as William Dean Howells viewed these antics with a tinge of dismay, castigating the moral vacuity of aesthetic salons. Howells's misgivings masked a deeper uncertainty about the place of the artist in American life. The Gilded Age was marked by what one historian has termed a "militant crusade for masculinity." Sparked by the savage tooth-and-claw competitiveness of Social Darwinism and growing qualms about the closing of the frontier, Americans began to celebrate "the strenuous life" and all that it entailed: athletics, ruthless business competition, and survival of the "fit." Fighting for national honor amid the markets of the world, the successful businessman became the literary icon of the age.[29]

Artists seemed increasingly marginalized in this scenario. Frank Norris captured the tone of popular prejudices in his 1903 novel, *The Pit:* The artist's hands were "unstained, his feel unsullied. He passed life gently, in the calm, still atmosphere of art, in the cult of the beautiful, unperturbed, tranquil; painting, reading, or, piece by piece, developing his beau-

tiful stained glass." Norris's artist was a far cry from an Andrew Carnegie, a
Jay Cooke, or even a William Sidney Mount. Delicate and ethereal, he re-
mained aloof from the brutish scramble for gain.[30]

Popular misgivings about the masculinity of the men who chose artis-
tic careers dated at least as far back as the antebellum years. But while the
virile outdoor life of landscapists such as Thomas Cole and Asher Durand
aggressively sought to belie such notions, many Gilded Age artists seemed
almost anxious to conform to the public's preconceived views. Oscar
Wilde was the archetypal Gilded Age aesthete. Satirized by Gilbert and
Sullivan and caricaturists around the world, he came to embody the image
of the effeminate intellectual. The expatriate portrait painter James
McNeill Whistler was also a notorious dandy, as was Chase. John La Farge,
too, often inspired a leering dislike because of what were perceived as his
snobbish, effete, almost delicate ways. Indeed, La Farge might easily have
served as the model for Norris's unworldly aesthete.

The comportment of these men helped to feed public mistrust of what
were viewed as the essentially feminine and passive leanings of the artistic
community. Once a virtue, now a vice, artists' intellectuality was also
turned against them. With aggressive behavior in the boardroom and on
the playing field, anti-intellectualism became a badge of masculinity in the
wake of the Civil War.

The Victorian preoccupation with economic success counterpointed
the situation of many American artists. Antebellum painters and sculptors
were an extremely ambitious lot, seeking to better themselves and their
profession through assiduous study, institutional development, and hard
work. By the end of the war, their efforts had begun to reap substantial
gains, as patrons paid unprecedented sums for their works. One of the
period's most popular artists, Albert Bierstadt, capitalized on the country's
growing fascination with the West. During the 1860s, men like James
Lenox and Marshall Roberts eagerly patronized his works, paying thou-
sands of dollars for a single canvas.

Ten years later, the scene had dramatically changed. By the late 1870s,
Americans began to abandon American artists for more cosmopolitan fare.
As the bottom began to drop out of the American art market, commercial
galleries became increasingly reluctant to stock American works, making it
harder to dispose of them. Although a few painters, such as George Inness,
still managed to command significant sums for their works with the help of
powerful backers, many did not. By the time Chase liquidated the holdings
in his Tenth Street studio, interest in American works had reached such a
low ebb that the heftiest sum paid for any of his paintings was a mere $610.

Given these circumstances, it is particularly interesting that men man-

aged to retain their professional supremacy in the field. They did so, in part, by retaining their hold over the systems of rewards that institutionally winnowed the nation's leading artists from their less fortunate peers. The policies of the Pennsylvania Academy of the Fine Arts are a case in point. Women continued to play a marginal role in the major academies, as they had in Lilly Martin Spencer's day. None graced the Pennsylvania Academy's board as of 1900 (the first would be elected in 1950), and few earned a place among the academy's members. Nor were many women granted the privilege of one-man exhibitions, to use the language of the time. Cecilia Beaux became the academy's first full-time woman instructor in 1895, and even then she remained in a somewhat ambivalent position. When the academy staged its annual exhibition in 1900, for example, Beaux was relegated to the reception line as a "hostess" with the trustees' wives, rather than serving on the selection committee to choose and hang the paintings.

Moreover, although women could and did occasionally win significant awards at these exhibitions, generally the medals they carried home were those for the best work by a *woman* artist. In the case of the Pennsylvania Academy, this prize was named for Mary Smith, established as a memorial to a young painter by her parents after her untimely death. Awards such as this proliferated during the Gilded Age, often with the backing of local women's clubs. Beaux and other women painters occasionally snared positions on major awards committees, such as the one that chose the recipients for the Carnegie Institute's prestigious annual award. But they could also receive a rude shock even when selected as winners on the basis of merit alone. In one particularly notorious instance, Anne Whitney was awarded an 1875 commission for a statue of Charles Sumner in an anonymous competition, only to see it withdrawn and given to her former mentor, Thomas Ball, when the Boston Art Committee learned that the sculptor was a woman.

By the 1870s, women artists were beginning to play a more prominent role in a few institutions, such as the Society of American Art and its school, the Art Students League. Founded in 1875, these institutions included artists such as Helena de Kay Gilder and Julia Baker among the charter members and trustees. Although the faculty was entirely male, the league's first report pointedly noted that "men and women stand in the school on terms of perfect equality. . . . Much of the best work in the school is done by women, and the school offers the greatest advantages to women who seriously desire to study art as a profession." As in other instances, the rhetoric sometimes outpaced the reality. One of the faculty members, Kenyon Cox, had the particularly nasty habit of dismissing women students by telling them, "You're a very pretty girl. You should take

up knitting." Nonetheless, women appeared both among the incorpora-
tors and the board from the outset.[31]

Selected clubs began to admit women members as well, in a reversal of
the penchant for masculine exclusivity that marked the antebellum years.
The National Arts Club accepted women members by the end of the 1890s,
as did the Copley Society. Founded as the Boston Art Students Association
in the 1870s by the first graduating class from the Museum of Fine Arts' art
school, the Boston group included women from its inception. By the end of
the century it was regularly hosting important exhibitions, such as the
retrospective of John Singer Sargent's works held in 1897. Boston's St.
Botolph Club also opened at least its exhibition space to local women.
Modelled on New York's Century Association, it was founded in 1879 to
provide a meeting ground for the city's "authors and artists, and other gen-
tlemen connected with or interested in literature and art." Charter mem-
bers included (among others) the architect H. H. Richardson, the writer
William Dean Howells, the sculptor Daniel Chester French, and local phil-
anthropist Henry Lee Higginson.[32]

Initially, the club's monthly exhibitions featured the works of men, in-
cluding a Tile Club exhibit held in 1881. Gradually, however, works by lo-
cal women artists were added as well, including paintings by Hunt's former
student Sarah W. Whitman and Lilla Cabot Perry. Many of the paintings
were for sale, and the club graciously waived its rights to any commissions.
Members were regularly reminded of "how important it is for the success
of the exhibitions that the Club should have the reputation of being able to
make sales in their gallery, as otherwise it is impossible to obtain the work
of the best and most representative men." Local women also occasionally
lent their paintings for special exhibitions. For example, Isabella Stewart
Gardner headed the list of donors to the club's 1894 exhibition of Italian
paintings, consigning seven of her prized canvases for the event. By 1898 a
few particularly talented women, such as Mary Cassatt, were even ac-
corded exhibitions in their own right. Initially, women's works were proba-
bly included because the artists were members' relatives, but by the end of
the century they were also being chosen on the basis of merit alone.[33]

Women's efforts to exhibit their works themselves often proved less
successful. Antebellum painters such as Lilly Martin Spencer often worked
in isolation, both from their male colleagues and from each other.
Spencer's contemporary Elizabeth Ellett hoped to solve this problem by
founding an international Society of Lady Artists in 1859, in order "to ex-
cite an interest in the works of our lady artists among people of wealth and
taste." Like the men who held public receptions in the Studio Building,
Ellett's plan was designed to include weekly salons where the "best

people" would see works lent by female artists such as Spencer. As Ellett explained, "The whole thing will be private, and have an air of privacy and fashion." Although she initially intended to bear the costs herself, she hoped to eventually enlist local "capitalists," to underwrite the costs of purchasing a permanent women's studio building.[34]

Although Ellett's plan failed to materialize, other ventures were more successful. Founded after the Civil War, the first women's art associations primarily sought to educate the public about the breadth of female artistry. For example, the Women's National Art Association was launched in 1866 by a group of artists in order to host a national exhibition and auction of women's art. According to their stated plan, both original and copied works were to be shown, as well as designs for carpets, wallpaper, and hand-colored photographs. In addition to members' works, artists and collectors throughout the country were invited to submit their holdings for exhibition or sale. "The object," noted a reporter in the *New York Times*, "is to stimulate and encourage women in the pursuit of art, to acquaint the public with the efforts they are making, and to enlarge the sphere of employment for them in the various directions art affords."[35]

Founded a year later, the Ladies' Art Association espoused an equally motley array of aims, seeking to promote everything from industrial art training for women teachers to increased visibility for women painters and designers. Members convened their own life classes, made designs for laces and embroideries, sponsored exhibitions of women's artworks, and introduced courses in pottery and china painting. Paintings and "bric-a-brac" were mingled promiscuously in their exhibits and sales. Descriptions of their 1877 exhibit reveal a heterogeneous melange of everything from tiles and decorated shells to wax flowers and gilded plaster casts. The list of items for sale "embraces a very wide range," one reporter tactfully noted. "There are oil paintings both in landscape and figure, crayons, pen and ink drawings, water-colors, and various objects connected with household decoration." In addition, "some models in plaster, and not a few examples of needlework" were also featured. Although bidding on the bric-a-brac was "brisk" and the items "quickly disposed of," the *Times* subsequently reported that prices for the paintings that were sold "were very low."[36]

The women's art gallery at the Philadelphia Centennial Exposition adopted an equally eclectic approach. Thus, Harriet Hosmer's statue stood side by side with engravings and an elaborately carved piano from the women in Benn Pitman's Cincinnati school. Cooper Union and the Lowell School of Design contributed gleanings from their students as well. Other areas of the Woman's Pavilion were filled with everything from household gadgetry to an index of women's charities worldwide. But the star of the

exhibit, and, unfortunately, the piece that captured the press's imagination, was a life-sized sculpture of Iolanthe carved in butter, submitted by a woman from the Midwest. In the words of one art historian, "Quality was bound to suffer when anything done by a woman was deemed suitable for exhibition and when there was no mechanism to refuse an aspiring contributor."[37]

Although a few artists, like Lilly Martin Spencer, hedged their bets by exhibiting works in both the regular art gallery and the women's building, many painters and sculptors refused to contribute works to the Woman's Pavilion gallery. Edmonia Lewis, Vinnie Ream, and Anne Whitney were among those who withheld their works.

Their reticence underscored the underlying tensions between women's traditional, separatist initiatives and women artists' assimilationist quest for professional acceptance on their own terms, issues that resonated through the Columbian Exposition of 1893 as well. Like the fair in 1876, the Columbian Exposition included plans for a woman's building. The project was coordinated by a Board of Lady Managers headed by Chicago's reigning society queen, Bertha Honoré Palmer. Palmer was a self-professed feminist who viewed her assignment as a means of forwarding the careers of women in a variety of fields, including the fine arts. Since the Woman's Building included plans for a gallery, Palmer was able to dole out commissions to leading women artists, including her friend Mary Cassatt. She also used her position to try to ensure that women would receive adequate representation on the selection panels for the fair's other exhibits. Certain minimal standards were instituted within the Woman's Building itself, with potential contributors sternly warned that "in FINE ARTS, copies will not be admitted."[38]

Part of the space was allocated for a historical survey of women's artistry, including etchings and engravings by Angelica Kauffmann and Rosa Bonheur loaned from the collections of Frederick Keppel, a leading New York print dealer. There were also the inevitable displays of stitchery, culled from the collections of decorative art societies and women's exchanges. Candace Wheeler netted the unlikely title of "director of color" for the Woman's Building, and the painter Anna Lea Merritt was persuaded to do a large mural, *Eve Overcome by Remorse.*

Mary Cassatt did a mural as well. As she later confessed to her friend Louisine Havemeyer, at first she was "horrified" by the idea, but she gradually wooed herself into accepting with the notion that it might be "great fun to do something I had never done before." Others warned her not to do it, including her mentor and close friend Edgar Degas. The results were disastrous. Her fifty-foot triptych, *Modern Woman,* took a year to com-

plete, only to be met by a jarringly lukewarm response when it was finally unveiled. The reporter from the *Art Amateur* labelled it "erratic," and some of the Lady Managers privately condemned Cassatt's painting as "uncouth." Moreover, when the fair closed, the mural mysteriously disappeared.[39]

Sara Hallowell's experience was even worse. Hallowell was one of the few women who managed to eke out a distinguished career as a professional art broker during these years. Her efforts began in 1873, when she was appointed secretary of the art department of Chicago's Interstate Industrial Exposition. Her gift for finding enticing contemporary paintings garnered additional commissions from some of the city's leading art patrons, including Bertha and Potter Palmer. Hallowell also helped Mrs. Palmer to locate women painters for the Woman's Building. By 1893, she was acting as the Paris agent for a spate of major American museums as well, and many thought that she would be appointed as director of fine arts for the exposition. Instead, she was tapped to be the secretary to the director, Halsey Ives of the St. Louis Museum of Fine Arts.

Palmer was furious. "There is no man in this country who has had her experience in securing exhibitions and returning pictures from all parts of this country and Europe," she angrily noted. Hallowell was angry as well, echoing the point that "there *is* no person in this country of equal experience with my own." Moreover, many felt that the decision had been based entirely on gender. According to the *Chicago Inter-Ocean,* despite "many strong endorsements . . . the fact that she was a woman appeared to militate against her."[40]

Aside from the shoddy way in which she was treated, Hallowell also had profound misgivings about the women's gallery. As she confided to Palmer, there were "too few fine women artists to warrant their making a COLLECTIVE exhibition worthy to compete with their brothers." Palmer, too, was soon voicing qualms that "the men's committee [had] already gobbled up the best things for their own exhibit." At one point, Hallowell tried to persuade Palmer to scale down her ambitions by limiting the exhibit to women's decorative arts. However, she reserved her gravest fears for the notion of separatism itself, prophesying that "no woman artist of ABILITY would I believe be willing to have her work separated from the men's."[41]

The ensuing negotiations also highlighted the personal rifts that separated philanthropists of Palmer's ilk from the artists they sought to aid. In a particularly telling exchange, Palmer confided to Hallowell that she had withheld one of the major commissions from a leading artist on moral grounds. As she explained, "I inferred from remarks that I heard, that her

character was not above reproach, and we could not afford to have any women about whom there could be the slightest doubt, as we would want to have social relations with her." As in the case of Vinnie Ream, an artist's moral standards were as important as the quality of her work, and women who fell beyond the pale of polite behavior placed themselves beyond the pale of sororal assistance as well.[42]

Hallowell's misgivings proved warranted, as many women artists such as Harriet Hosmer rebelled against the prospect of segregation. A number of prominent women painters placed their works in the main building. Anne Whitney reluctantly submitted samples of her work, with the stern proviso that it not be shown "in the same room as 'bed quilts, needlework and other rubbish.'" The artists who participated found their works intermingled with contributions from amateurs, including Queen Victoria's paintings of two of her favorite dogs. The resulting press coverage underscored the wisdom of Hallowell's concerns. Ellen Henrotin's review in the *Cosmopolitan* noted that, viewed as a whole, the collection seemed "comparatively inferior to the other exhibits." "The women themselves are somewhat ashamed of their fine arts exhibit, and excuse themselves by saying that most of the fine painting by women can be found in the Fine Arts Palace," noted the reporter for the *New York Times*.[43]

The painter Anna Lea Merritt captured the problem most succinctly. As she pointed out, "Recent attempts to make separate exhibitions of women's work were in opposition to the views of the artists concerned, who knew that it would lower their standard and risk the place they already occupied. What we so strongly desire is a place in the large field, [and] the kind ladies who wish to distinguish us as women would unthinkingly work us harm."[44]

Women's clubs also sought to help women artists through separatist campaigns. In science as well as art, they often raised subscriptions for fellowships for professional study, doing collectively what male mentors had traditionally done out of pocket for their protégés. Some adopted a more practical (and ultimately more useful) stance, buying the works of women artists for local settlements and schools. And some, like the Brooklyn Woman's Club, staged special exhibitions of paintings, sculptures, and tapestries by female artists.

In terms of their institutional legacies, however, the democratization of art training may have ultimately had a greater impact than either the women's buildings or women's clubs in fostering female artistic activities during these years. Hunt may have had this in mind when he opted for training female students, rather than men. One of his contemporaries later recalled that "he felt the necessity of awakening the community toward the

value of art and its influence, and he thought that he could do something to that end by appealing to the sensibilities and quickness of perception of women." The Gilded Age was an era marked by a growing reverence for expertise, and the kind of training offered by Hunt, Chase, Eakins, and the growing ranks of professional schools offered women a new level of cultural authority that transcended the earnest self-study programs promoted in clubs, and the separatist imperatives of the decorative arts. Moreover, unlike the majority of their antebellum predecessors, many of these female students were wellborn and richly wed, which gave them the necessary resources to collect and create new initiatives on their own.[45]

Some used their interests and training to create cultural institutions in smaller towns. Anna Richards Brewster, a professional painter, settled in Scarsdale, New York, after her marriage to a Barnard professor, later helping to launch a local art association there. Another artist, Alice Schille, moved to Columbus, Ohio, where she became the guiding spirit behind that town's art museum, which opened in 1931. Anne Evans, an alumna of both the Art Institute of Chicago and the Art Students League, played a major role in founding the Denver Art Museum in 1923. Similarly, Helen Bigelow Merriman, a former Hunt student, was one of the backers of the Worcester Museum of Art, which opened in 1896, while Marjorie Acker Phillips created the Phillips Gallery in Washington with her husband in the 1920s.

Some, like the Boston painter Lilla Cabot Perry, also became influential tastemakers. Perry was a prominent popularizer of Monet's works. Born of a Brahmin family, Perry studied art at the Cowles School and the Parisian academies of Colarossi and Julian after her marriage to Thomas Perry in 1874. In Boston, they hosted one of the city's most respected salons, attracting such luminaries as Henry James, William Dean Howells, and her brother-in-law John La Farge. But the man who made the greatest impression on her life was Claude Monet. Perry and her husband regularly summered at Giverny after she met the artist in 1889. Although not given to training students, the great French impressionist painter advised her, encouraged her, and criticized her work. In return, Perry became his leading publicist in the United States, tirelessly lecturing and writing about his works, and persuading her friends to buy his paintings. She also established a solid career in her own right, exhibiting at the Paris Salon and several well-received one-woman shows in Boston and New York.

Like Perry, a number of women artists established influential salons. Her fellow Bostonian Sarah Choate Sears was a collector, hostess, and cultural entrepreneur, as well as a talented artist. Born in Cambridge in 1858, Sarah Choate had the good fortune to marry Joshua Montgomery Sears, reputedly the richest man in Boston at the time. After her marriage,

she briefly studied painting at the Cowles School, later attending courses at the Boston Museum of Fine Arts as well. Sears was a skilled watercolorist, exhibiting her works internationally, and a gifted photographer. Needlework was another skill, an interest that ultimately led her to become one of the founding members of the Boston Society of Arts and Crafts.

While she pursued the visual and decorative arts, her husband honed his skills as an amateur violinist. Joshua Sears's musical interests set the tone for their soirées, which began as modest concerts by members of the Boston Symphony Orchestra but became increasingly elaborate with time. By the 1890s, their private programs featured such international stars as Ignacy Paderewski, Fritz Kreisler, and Dame Nellie Melba. Serge Koussevitsky conducted in their home, as did Walter Damrosch. By mixing Boston bluebloods with artists and performers, Sears and her husband managed to create an air of "intellectual bohemianism" rivalled by few of the city's other hosts.[46]

Like Sarah Choate Sears, several women artists became noted Gilded Age hostesses, using their entertainments to broker artistic careers. Cecilia Beaux met several important acquaintances at Helena de Kay Gilder's salons, from Isabella Stewart Gardner to Mrs. Theodore Roosevelt and Mrs. Andrew Carnegie, both of whom later commissioned portraits from her. While the Gilders helped to open doors for Cecilia Beaux, Sears made her greatest impact as a patron by helping men. Aided by the advice of Mary Cassatt, she began to collect the work of Impressionists such as Manet and Degas in the 1890s. She financially supported Alfred Stieglitz's Photo-Secession gallery, collecting modernist paintings under the photographer's tutelage. Although a few of the paintings she owned were by women, including Marie Laurencin and Berthe Morisot, the bulk of Sears's holdings consisted of the works of men, such as John Singer Sargent, Maurice Prendergast, Arthur B. Davies, and Paul Cézanne. She took a particular interest in Prendergast's career, arranging for his Boston debut at the Watercolor Club and paying his way to Europe in 1898, much as Gilmor and Reed had done half a century before.

Mary Cassatt evinced a similar pattern. Although Cassatt is now considered to be one of the great American painters of the nineteenth century, she won scant recognition in this country during much of her lifetime. The daughter of a wealthy Philadelphia family, she became an artist over her father's objections. Much of her training consisted of copying from casts and paintings in the Pennsylvania Academy of the Fine Arts and the Louvre. She ultimately spent most of her career in Paris, where she exhibited her works as part of the Impressionist circle.

Cassatt joined the Impressionists in 1877, at the invitation of Edgar

Degas. When he asked her to join their ranks, she was overjoyed: "At last, I could work with absolute independence without considering the opinion of a jury. I had already recognized my true masters. I admired Manet, Courbet and Degas. I hated conventional art."[47]

Despite her initial exhilaration, however, Cassatt had to tread a very fine line between maintaining her personal and professional independence, and staying within the parameters of ladylike behavior. Many Frenchmen harbored a sharp disdain for female intellectuals, and painters such as Berthe Morisot were sometimes publicly castigated for exhibiting their works. Another pitfall was the question of marital status. While the women who married their mentors often abandoned their careers, single women faced a different set of constraints. The burden of constant chaperonage limited their personal and artistic freedom. In Cassatt's case, she moved her parents and her unmarried sister to Paris in 1877, where they served as her live-in chaperones. Constantly monitored by family and friends, women painters were effectively isolated from much of the spontaneity of the artist's life.[48]

Another American painter, May Alcott, later recalled a visit to Cassatt's rooms. Hung with Turkish rugs, tapestries, and fine paintings set in "splendid frames," her studio exuded an aura of middle-class propriety and wealth. However, the constraints of respectability limited Cassatt's subject matter, narrowing her range of vision to the domestic sphere. What she lost in diversity and mobility, she gained in alliances. Because Cassatt was so obviously a "lady," she won the friendship and trust of a number of prominent American society women such as Sarah Choate Sears, Bertha Palmer, and Louisine Havemeyer. In her capacity as their advisor, she helped to popularize Impressionist painting in the United States, providing windfalls for several of her male colleagues.[49]

Her association with Havemeyer represented one of the great collecting alliances of the nineteenth century. Born in 1855, Louisine Elder Havemeyer was the daughter of a wealthy sugar refiner. The two women met in Paris, while Louisine's family was there on an extended sojourn in 1874. The Elders had fortuitously chosen a boardinghouse favored by several women art students, one of whom introduced Louisine to Cassatt, initiating a nearly lifelong friendship. Although Cassatt was almost ten years older, both women shared a common enthusiasm for art, as well as similar backgrounds. To quote Havemeyer's biographer, "If either had been in the least bohemian, she would have horrified the other."[50]

Cassatt subsequently became Havemeyer's inspiration and her guide, encouraging her to begin her collecting career by buying Edgar Degas's *Répétition de Ballet.* Purchased for the modest sum of 500 francs (about

$100) in 1875, this painting was soon followed by other Impressionist examples, including Claude Monet's *Drawbridge, Amsterdam,* and the first of many Cassatts.

After Louisine married Henry O. Havemeyer in 1883, both became avid collectors. In an odd reversal, Louisine yearned for more paintings, while her husband initially amassed Japanese porcelains and Chinese textiles, a taste encouraged by his cousin Samuel Colman. He began to shift his attention to canvases in the 1880s. Although initially unable to interest him in the work of the Impressionists, Louisine managed to discourage her husband's leanings toward the French salon, edging him toward Old Masters instead. While he continued to collect Old Masters, she set her sights on more contemporary fare. Eventually, he succumbed to her interests as well, turning his acquisitive spirit to the Impressionists.[51]

Beginning with several Monets in 1894, they began to collect in tandem, with Louisine eagerly pursuing any work that interested him. This in turn opened a new career for Cassatt. The painter initiated her efforts as an art broker with her brother, formally adding the Havemeyers in the 1890s. It was an alliance forged in mutual respect. As Louisine candidly admitted, "The best things I own have been bought upon [Cassatt's] judgment and advice."[52]

This in turn provided commissions for the artists that Cassatt knew best, particularly her mentor, Edgar Degas. As Havemeyer's biographer explains, "Cassatt's enthusiasm for Degas's work knew no bounds. Before meeting the artist herself, she had already become his disciple, and remained so all her life. Her commitment to Degas was the most important and enduring element of her artistic career." She often took the Havemeyers to his studio or to Durand-Ruel, one of the major purveyors of Impressionist works. They found the aristocratic Degas more to their liking than the other painters in the Impressionist circle, "who may have been too bohemian for their taste," giving Degas an additional advantage.[53]

Unlike many women patrons, Havemeyer actively promoted Cassatt's career as well, lending her paintings for exhibitions along with those of the other Impressionists she collected. Nonetheless, the greatest beneficiaries of her largesse were men. The collection that Louisine Havemeyer ultimately bequeathed to the Metropolitan Museum of Art in 1929 included fourteen oils by Degas, eight by Monet, and six by Manet, but only two by Cassatt. Rather than promoting her own works, or those of other women painters such as her friend Berthe Morisot, Mary Cassatt used her influence to steer wealthy American patrons toward the works of her male colleagues within the Impressionist circle.[54]

This, then, was one of the legacies of the Gilded Age training system.

As artistic training became increasingly available to American women after the Civil War, it not only opened professional opportunities but also provided a new basis for female cultural authority. As painters such as Sears, Perry, and Cassatt became influential brokers and connoisseurs, they helped to undermine earlier misgivings about women's intellectuality and cultural arbitership. In addition to bolstering women's cultural authority, professional training also provided a number of benefits for the men who opened their ateliers to female students. From Helen Knowlton to Mary Cassatt and Lilla Cabot Perry, female artists loyally promoted the works and reputations of the men who helped them at crucial points in their careers. Rather than forwarding women artists, they consistently mentored men.

The woman artist was therefore caught in a double bind. The middle-class female philanthropists who collectively sought to aid her generally did so within the distinctive idiom of separate spheres. By associating female creativity with the decorative arts and crafts, would-be reformers strengthened the negative associations that automatically linked female artistry with amateurism and domestic artisanry. By segregating women's paintings in separate galleries and mingling their canvases with knitted novelties and homemade goods, they heightened these associations. And by sponsoring prizes specifically designated for women artists, they automatically relegated the winners to a special category, based on criteria other than quality alone. In effect, these well-intentioned initiatives helped to fuel the very stereotypes that women artists so earnestly sought to dispel.

As a result, Gilded Age women artists made their greatest professional advances under the tutelage of men. Here, too, the path was strewn with pitfalls. Some, like William Morris Hunt, opened new opportunities for women's study, but on a less rigorous scale. Others, like Thomas Eakins, offered excellent training, but in ways that jeopardized their students' reputations. The trials of Vinnie Ream clearly illustrated the dangers of relying too heavily on the kindness and commissions of men. But the alternatives had their perils as well. While great painters, such as Mary Cassatt, traded a measure of artistic freedom in order to stay within the bounds of women's networks, those with more modest talents, such as Sarah Choate Sears, sacrificed potentially promising careers for the pleasures of the dilettante, the cultured amateur. Even when they used their training to influence the acquisitions of the emerging group of women art collectors, they did so for the benefit of men. Despite the growing ranks of women art students, women's clubs, and women philanthropists, and the increasing sympathy of men like Eakins and Hunt, female painters and sculptors remained at the periphery of the Gilded Age professional arena, still deferring to the aesthetic superiority of men.

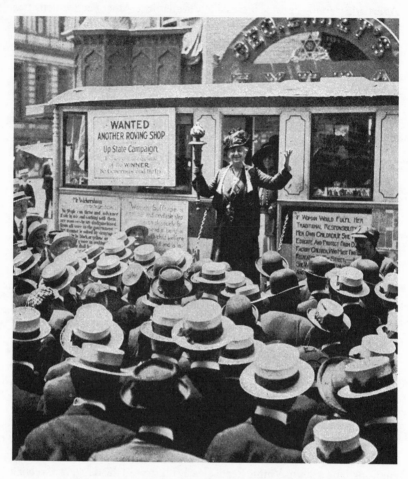

LOUISINE HAVEMEYER DELIVERING

A SUFFRAGE ADDRESS

5

MUSEUMS AND
MARGINALIZATION

ouisine Havemeyer's career embodied many of the para-
doxes that surrounded the assimilationist's role. Both she
and Mary Cassatt were feminists and outstanding figures
in the arts. While Cassatt was one of the great American
painters of the nineteenth century, Havemeyer was one of the
century's most insightful collectors. Yet despite their feminist
leanings, both ultimately used their gifts to bolster the careers
of men. In Cassatt's case, her efforts in steering patrons like
Havemeyer to the ateliers of her male colleagues stemmed
from the mentoring systems through which Gilded Age
women painters learned their craft and achieved professional
acclaim. Havemeyer bought on her advice, ultimately donat-
ing her acquisitions to the Metropolitan Museum. Her munifi-
cence was a boon to New York and to the nation as a whole.
But it also helped to strengthen an institution—and an artistic
canon—that paid scant homage to women's contributions,

whether as artists, as curators, or as potential trustees.

Women began to play an increasingly prominent role as collectors and connoisseurs by the 1890s. Many were far richer than their antebellum predecessors, due, in part, to the passage of married women's property laws and to the simple demographic fact that wives tend to outlive their husbands. After the Civil War, the number of wealthy men—and by inference, women—grew rapidly, as did the scope and quality of their private collections. By the 1870s, many women had begun to invest their growing resources in decorative artifacts such as ceramics, laces, and fans. By the 1890s, however, they increasingly presided over important collections of paintings as well. Yet within museums even the wealthiest, most generous female patrons generally remained isolated from substantive policy-making processes, and strikingly passive in rendering of their gifts.

By strengthening the Metropolitan's holdings, Havemeyer's bequest also contributed to what scholars such as Lawrence Levine and Paul DiMaggio have deemed the "sacralization" of art. The notion of sacralization has to be treated with some care, since the degree of exclusivity these institutions espoused often varied according to the heft of their endowments. Nonetheless, it provides a useful concept for understanding the differences that increasingly separated women's philanthropic ventures from those of men in the decades following the Civil War. It also provides an important clue to the inherent limitations that surrounded assimilationist designs.[1]

One of the earmarks of sacralization was the "legitimation of elite aesthetic opinion." To quote DiMaggio, this entailed the creation of "a differentiated, strongly classified high culture, . . . broad enough to embrace several art forms within one conceptual frame," in ways that distinguished them from more popular, commercial amusements. The role of museums in choreographing the sacralization of America's artistic canon differed from the activities of women's groups in several significant ways. While women relied on nonprofit entrepreneurship to promote their artistic ventures, museums increasingly sharpened the perimeters between "fine art" and more commercial pursuits. They also established new boundaries between professionals and amateurs, a distinction that decorative art societies were never able to achieve, much to Candace Wheeler's chagrin. Moreover, while decorative art societies promoted the cause of middle-class women artisans in the pursuit of charitable, as well as cultural, aims, museums presumed to speak for the community as a whole in purely aesthetic terms. While women built their organizations laterally, drawing their strength from the numbers they attracted to their ranks, museums became increasingly hierarchical, consolidating the riches of their communities into a highly diversified whole. Museums also lionized the arts of Europe and of

the past, often at the expense of living American artists. In the process, these institutions helped to solidify emerging definitions of what constituted "fine art."[2]

There were other differences as well. One concerned scale. Women's organizations captured the collegial spirit of the family and the congregation, casting their ventures on a preindustrial scale at the local level, even when they spread to national dimensions through myriad cities and towns. Large, urban multipurpose museums, on the other hand, increasingly emulated the structure of the corporation. While women's organizations subsisted primarily on small donations, voluntarism, and quasi-commercial marketing schemes, museums sought to build a large and diversified portfolio of paintings, artifacts, membership dues, donations, and municipal support. And while museums became increasingly professionalized, women's arts organizations remained primarily the province of the volunteer.

Like business corporations, urban repositories replaced the informality of market mechanisms with a more coordinated approach, gathering cultural capital from all corners of the community, sifting it, systematizing it, categorizing it, and making it available to the public in new ways. Earlier projects, such as the ill-starred galleries created by Thomas Jefferson Bryan and Luman Reed, foundered on the static nature of their collections. Postwar Americans had more money, more paintings, and more artifacts to invest in their repositories. Museums emerged in response to this growing level of cultural capital, collecting and displaying it on a new scale.

These "nonprofit corporations" were among the emblems of their age. Although decorative art societies and women's design schools were also formally chartered, and therefore might legally be deemed nonprofit corporations, they differed significantly from the elite stratum of well-endowed, hierarchically structured "nonprofit corporations" founded by wealthy male philanthropists after the 1860s. Foundations, orchestras, the great research universities—all mirrored the latter organizational form. And all contributed to the sacralization of professional standards within their fields, serving as staging grounds for the recruitment, socialization, and training of managerial elites, most of whom were men. While museums contributed to the sacralization of art by gathering, sifting, and ranking the aesthetic riches of the world, foundations sifted and ranked proposals, setting national agendas for reform. Universities played a similar role, gathering the world's knowledge, ranking it qualitatively, and winnowing the most talented scholars from their less fortunate peers. Each of these legitimating institutions "certified recognized spheres of cultural authority" in

ways designed to transcend "any public dispute." Amply funded, and often amply endowed, they were managed by growing bureaucracies of salaried experts, and almost invariably entrusted to the stewardship of men.[3]

They were also part of a network of institutions that helped to choreograph the bureaucratic reorganization of American society after the turn of the century. Many of these institutions lay at the heart of what would later be termed the "American Establishment," part and parcel of a network of "institutional hierarchies" over which political, professional, and corporate leaders presided. As C. Wright Mills noted in his classic study *The Power Elite*, "The greater the scale of these bureaucratic domains the greater the scope of their respective elites' power." In effect, they were mechanisms through which a network of ambitious fin-de-siècle male elites consolidated their authority on a national scale.[4]

Andrew Carnegie highlighted the managerial ethos that undergirded these activities in his 1889 treatise on wealth. "The problem of our age is the proper administration of wealth," the industrialist confidently noted. Rather than merely volunteering to meet community needs, Carnegie believed that the country's growing crop of millionaires had an obligation to invest their surplus profits, and their "superior wisdom, experience and ability to administer," in philanthropic ventures to promote the communal weal. The steelman disliked traditional charities, since they aided "the unfit." Instead, he urged his fellow millionaires to build institutions to enable the "aspiring poor" to help themselves. Libraries, museums, universities: all fell within Carnegie's definition of enlightened philanthropy. In the process, his dictum helped to codify the emerging managerial philanthropic ethos, and cast it in decidedly monetary terms.[5]

Carnegie's "Gospel of Wealth" was one of a welter of panaceas drafted in response to the country's Gilded Age "search for order." As historian Robert Wiebe explains, fin-de-siècle America was a "society without a core." Although the completion of the transcontinental railway system and the rise of modern business corporations gave the impression of an integrated culture, the country still lacked genuinely national centers of information and authority. Foundations, museums, and research universities were among the organizations devised to fill this void.[6]

Participation on their boards served as a badge of refinement, taste, civic responsibility, and elite status for the men who backed them. They also served as an index of financial success. To quote Wiebe again, this was "the era when the very wealthy were transforming philanthropy into a type of purchase," forwarding "unprecedented sums" in order to consolidate their control over the nation's educational system, its policy-making capacities, and its artistic resources. The point that Wiebe's analysis

missed, of course, is that these agencies were also designed to promote the "institutionalization of authority" of selected male elites, first within their own communities, then on a national scale. In the process, the men who built and staffed these institutions consolidated their authority over professional rewards as well, determining which works would be shown, which books most widely read, and whose voice given additional stature in national debates about policy-making, education, and art.[7]

The process of sacralization was intimately linked to the process of professionalization, occurring in two stages within museums. The first came with the development of the "nonprofit corporation" itself, and the attendant decisions about what would be included in the museum's exhibitions and what would not. The businessmen, connoisseurs, and amateur art historians who created the nation's first major repositories worked out these organizational details, forging preliminary definitions of what would, and would not, constitute "fine art."

By the turn of the century, most of these repositories were becoming increasingly professionalized. Aided by growing staffs of salaried managers, museums took it upon themselves to systematize their holdings, winnowing copies from originals, good art from bad. They also became more careful about accepting gifts, rigorously excluding any offerings that failed to measure up to their "acknowledged standards." In the process, catchwords about "scientific development," "systematic arrangement," and "business management" began to echo through museum reports with increasing regularity, evoking a growing concern with system, order, and professional expertise. As Lawrence Levine explains, "Sacralization increased the distance between [the] amateur and [the] professional. . . . More and more it was asserted that it was only the highly trained professional who had the knowledge, the skill, and the will to understand and carry out the intentions of the divine art." Rather than relying on the talents of self-educated connoisseurs, museums began to bolster their authority by tapping into a growing national and international network of experienced museum men. Many of those who netted important curatorial positions also held advanced degrees in art history, archeology, or related fields such as library science (a useful skill for tracking and systematizing accessions). By 1919, one museum report was moved to proclaim that "the art museum curator is finding his place with the university professor and other investigators in the world of scholars."[8]

Women played a marginal role in these processes. Rather than founding or managing the nation's great Gilded Age museums, they remained "on the borders," neither "fully at home in male houses of power, though seeking to live there," nor fully in command. This, then, was the assimila-

tionist legacy. Rather than directly shaping the nation's artistic canon, women's munificence reinforced the cultural authority of cadres of male professionals and elites.[9]

The Metropolitan Museum of Art

The history of the Metropolitan Museum of Art is a case in point. The Metropolitan was born in one of New York's more exclusive men's clubs. A by-product of the wartime Sanitary Commission, the Union League Club numbered some of the city's most prominent male artists and cultural proponents among its members, including the statesman John Jay, the collector John Taylor Johnston, artists such as John Kensett and Worthington Whittredge, prominent Sanitarians such as Henry Blodgett and Henry W. Bellows, and the art dealer Samuel Avery.

Like their antebellum predecessors, clubs such as these played an important role in promoting cultural endeavors. Some actively encouraged artists to join through "artistic memberships" offered at cut rates; others accepted original artworks in lieu of dues. Many served as quasi-public art galleries as well, displaying and even selling paintings and objets d'art to members and local connoisseurs. As art museums became increasingly cosmopolitan in their tastes, men's clubs continued to provide a forum for the works of local artists, occasionally opening their galleries to the public and press as well. In the process, they formalized the fraternal practices of the antebellum years at a time when art schools and professional dealers were steadily eroding the symbiotic bonds that previously linked painters and the men who patronized their works.[10]

The Metropolitan Museum traces its inception to a Fourth of July speech given in Paris by the Union League Club's president, John Jay, in 1866. Perhaps inspired by the Louvre, Jay called for the creation of a national gallery of art in the United States. It was an old dream, which had previously met with scant results. Jay was undoubtedly aware of at least some of the earlier attempts to found a national repository for the arts, and so proposed a new approach. Rather than institutionalizing the holdings of a single connoisseur or professional coterie, he recommended the creation of a collectively endowed institution, more accessible than earlier academies, that would be managed by successful businessmen for the benefit of the community as a whole. Slave to neither professional rivalries nor the static vision of a single donor, it would feature both individual collections and contemporary works. And, because it would be open to all, the museum would serve as a magnet for new donors, particularly those with notable collections who sought a more public arena for their display. In effect,

it would pull together the resources of the entire community, forwarding the cause of art on a new scale.

Upon his return to New York, Jay helped to form a committee of his fellow club members to consider the logistics, which led in turn to a public forum held in 1869. The resulting Committee of Fifty served as the museum's first board. It was a distinguished group, including a mix of millionaires, artists, and connoisseurs. Clubmen predominated: at least four-fifths held memberships in the Century Association, and two-thirds belonged to the Union League as well. And, of course, all were men.[11]

The inclusion of seasoned lawyers such as Joseph H. Choate proved to be a decided asset during the museum's infancy, since they contributed valuable legal and political skills as well as cash. Although the trustees did not intend to brook political interference in running their museum—this was the heyday of William Marcy Tweed's detested political ring—they coveted public funding and public land to give their stripling venture a permanent home. And Choate was just the man to couch their request in terms that Tweed would understand. Tapping into his extensive network of clients, clubmen, and fellow trustees, Choate put together a petition signed by many of the city's most influential businessmen and landholders, a strategy that immediately captured the politicians' attention. Although the city eventually contributed approximately $500,000 in property and construction costs, the museum board retained control of the building's contents, thereby protecting them from being sacked by Tweed.

Public support remained an important issue, particularly in New York. One of the factors that served to distinguish museums from contemporary women's arts organizations was the diversity of their funding base. The Metropolitan was particularly blessed in this respect. In addition to privately generated revenues, it received significant sums from the public purse, which covered up to a third of its annual operating costs. In tandem with a range of other cultural institutions such as the public library, the museum of natural history, the botanical gardens, and the local zoo, the Metropolitan received not only its building and land from the city, but regular municipal appropriations as well. In return for these public subsidies, the trustees agreed to "provide the collections, pay a small part of the cost of exhibiting them, and undertake the responsibility of management." Although women's groups also garnered municipal funds for some of their charitable ventures, especially asylums, their cultural organizations tended to be privately supported and backed by far smaller sums.[12]

Private donations were another important source of museum incomes and endowments. Before the 1890s, women played an extremely limited role in rendering these gifts. Only one, Catharine Lorillard Wolfe, signed

her name to the Metropolitan's roster of 105 charter subscribers. Heiress to a fabled tobacco fortune, Wolfe was reputedly the country's richest spinster, to borrow a contemporary term. In addition to a wide array of charitable interests and a taste for sponsoring archeological digs, she was also an art patron of some note. Aided by her cousin John Wolfe, who chose her acquisitions for her, the heiress amassed an extensive collection of contemporary paintings, primarily from the French Salon and the Düsseldorf school of genre painters. Over one hundred of these works would eventually find their way into the museum's holdings when she died in 1887, along with $200,000 for additional acquisitions.

Wolfe's generosity was unique. Very few women made donations to the Metropolitan Museum during the Gilded Age, and those who did tended to give decorative objects rather than cash. Nor were they encouraged to take a more active role in the museum's management. Although the appointment of a separate "ladies'" committee to raise funds was briefly considered by the trustees, the idea was quickly vetoed, leaving few alternatives for female participation beyond the donor's role.

Although, like most museums, the Metropolitan managed without an endowment for much of its youth, surviving on loans, dues, public appropriations, and donations from public-spirited citizens such as Wolfe, it began to receive spectacular windfalls at century's end. Between 1900 and 1930, Harry Brisbane Dick, George F. Baker, Isaac D. Fletcher, George and Florence Blumenthal, Anna M. Harkness, Frederick C. Hewitt, John Stewart Kennedy, Francis L. Leland, Frank Munsey, John D. Rockefeller, Jr., Jacob S. Rogers, and Olivia Sage gave gifts of a million dollars or more. Many were trustees, but some of these gifts came from wholly unanticipated sources. One of the most surprising was Jacob S. Rogers. A singularly unappealing individual, Rogers was the eccentric owner of the Rogers Locomotive Works in Paterson, New Jersey. Apparently he was universally disliked. Both a miser and a misanthrope, Rogers took a macabre delight in pointedly cutting the local charities out of his will. One obituary called him an "animal," devoid of "human love or human sympathy"—harsh words, indeed, when the common custom was still to praise the dead. Rather than lavishing his $5 million estate on his local community, Rogers left it to the Metropolitan Museum in 1904, where he was unknown by visage or by name.[13]

There were other large bequests as well. Frederick C. Hewitt was an upstate farmer who made the Metropolitan his residuary legatee, netting the museum another $1.5 million bequest. The greatest surprise, however, was Frank Munsey's $10 million bequest, given in 1925. Munsey's

posthumous gift was "most unexpected," since the publisher had shown scant interest in the museum during his lifetime. As the *Literary Digest* pointed out, "the puzzle of the living Munsey was nothing to the enigma of Munsey dead."[14]

Although women also gave donations to the museum, both in cash and in kind, they did so on a more modest scale. Data on almost one hundred male and female benefactors who gave cash or in-kind contributions of $25,000 or more from the time of the museum's inception until 1930 reveal that women donated roughly a tenth as much as men. Thus, seventy-six men donated approximately $41 million, while twenty women donated slightly over $4.5 million. The ways in which women were drawn into the museum's sphere were distinctive as well. Rather than becoming involved by virtue of their club ties, service on the board, or (primarily) their collecting interests, the majority were related to male benefactors or trustees, a pattern replicated in other cities as well. Of the twenty female donors listed as benefactors during this period, seven were wives of trustees, and eight more were either the wife or mother of another major donor.

For example, Anna M. Harkness was the mother of one of the museum's trustees, Edward Harkness, with whom she also founded the Commonwealth Fund in 1918. Born in Dayton, Ohio, in 1837, Mrs. Harkness was the widow of one of John D. Rockefeller's partners. She inherited an enormous fortune of $50 million upon her husband's death in 1888. By 1892, she had transplanted her children (who collectively inherited another $100 million) to New York, where she devoted herself to good works. Although religious, social welfare, educational, and health organizations received the bulk of her largesse, the Metropolitan netted a hefty $1 million from Harkness in 1923 as well. Like many of even the most generous female patrons, she apparently asked little in return for her gifts, "in keeping with her firm belief that donations should not be ostentatious."[15]

Her daughter-in-law continued her interest, donating textiles, costume accessories, laces, embroideries, and Chinese paintings. Women's fascination with textiles was particularly strong, carrying Candace Wheeler's legacy into the twentieth century. In 1921, for example, former decorative art society member Mrs. J. Pierpont Morgan donated what was described as "a remarkable collection of seventeenth-century tassels." The extensive collection of laces of another member, Mrs. John Jacob Astor, also eventually made their way into the museum's collections, augmented by similar gifts from women like Georgina Schuyler. Both of the Harkness women were extremely wealthy—Anna M. Harkness left almost $36 million in bequests in 1926, over and above the $40 million she had already contributed

to her foundation—and both were quite generous toward the museum. Yet almost no correspondence exists from them, and there is little or no evidence of their involvement in the institution's management or policies.[16]

Emily de Forest was the wife of one of the museum's presidents, and the daughter of an earlier president, John Taylor Johnston. Together, Emily and Robert de Forest donated the museum's American wing. She was also a noted collector of Italian majolica and Pennsylvania folk art in her own right. Her gift of American folk art—including everything from furniture and textiles to elaborately scripted fraktur—made the Metropolitan one of the leading repositories of such items in the 1930s. Given these multiple connections, both to the board and as a donor in her own right, the nature of Emily de Forest's dealings with the museum's staff is revealing. Most consisted of modest requests for housekeeping tips. In 1909, for example, she asked the assistant secretary, Henry Kent, whether he thought it advisable to brush fine tapestries. "They certainly should not be beaten with a stick," she noted. "How does one care for them so that moths do not accumulate?" Perhaps because she was so well connected, Kent took the time to politely suggest that she try pine sawdust, adding that "nothing but constant patting will keep out the moths." She also tapped him for advice on attributions and on the care of sundry artifacts. At one point she apologetically confessed, "It seems as if I should never quite stop bothering you."[17]

De Forest's husband was undoubtedly responsible for the $1 million bequest from Olivia Sage. Mrs. Russell Sage became one of the nation's wealthiest women when her misanthropic husband died in 1906. Although apparently extremely unpleasant, Russell Sage was undeniably an astute businessman, leaving a hefty $63 million estate to his childless widow. De Forest, her attorney, helped her to set up the Russell Sage Foundation, one of the nation's first modern multipurpose grant-making institutions, which quickly became a leading force in city planning and the professionalization of social work. She was also a staunch feminist and a veteran of numerous charitable and social campaigns, from home and foreign mission work and the WCTU to antivice crusades. Sage's interest in the Metropolitan began in 1886, with a modest $200 gift for a life membership. Twenty-three years later, she donated an Italian painting that she and her husband had acquired.

Perhaps inspired by de Forest's interests, she also bought and contributed the Bolles collection of early American furniture in 1909. Valued at $100,000, it contained over six hundred pieces, ranging from furniture to clocks and candlesticks. The gift was given unconditionally, enabling the museum to sell any or all of the pieces at its discretion, as long as the proceeds were used to purchase other American artifacts. In fact, Sage's gift

may have generated the need for the American wing that the de Forests donated. Her other gifts were somewhat more typical, including bits of lace, netsuke, pottery, and textiles that she had come across on her travels.[18]

Whenever possible, Sage asked for the museum's advice before purchasing an item for donation, an approach that sometimes caused problems. In one instance an overzealous curator told the long-suffering Henry Kent that he did not think that a collection of Japanese prints that Sage was offering should be accepted. Kent conferred with de Forest and reported that "he says just as we thought he would, to let him deal with the matter himself." Several other gifts—including the Italian painting—were returned to her relatives in 1928 after her death. But during her lifetime, de Forest was careful not to embarrass her. Thus, when a staff member sought to reject an old English teapot that she offered in 1914, de Forest instructed him instead to accept it by messenger. "I have not attempted to pass judgment upon the teapot," he calmly explained. "It may or may not be something we care for, but I clearly want to accept any gift from Mrs. Sage." His strategy in gently humoring his client ultimately paid off when she left a $1 million bequest in 1918.[19]

Some women, like Mrs. Morris K. Jesup, donated their husband's collections along with their own. Since Jesup's husband had been an enthusiastic devotee of the Hudson River school, Mrs. Jesup added another $100,000 for "the encouragement of American Art in any way the Trustees may think best." She also emphasized that both the trust and the labels on the paintings should be in his name, not hers, a self-effacing practice common even among such celebrated connoisseurs as Bertha Palmer and Louisine Havemeyer.[20]

Although women donated works by Old Masters, as well as American paintings, the Metropolitan's greatest acquisitions in this area were given by men. Lauded as one of the most discriminating connoisseurs of his time, Henry Marquand willed his collection to the Metropolitan, where he had served as president since 1889. By the time of his death in 1902, this included an exquisite group of seventeenth-century Dutch, Flemish, and English masterpieces liberally peppered with works by Rembrandt, Hals, Vermeer, and Van Dyck. Donated eleven years later, Benjamin Altman's bequest included over four hundred items, ranging from gold cups (one of which was attributed to Benvenuto Cellini) to fifty paintings, including thirteen Rembrandts, all of which the department-store magnate had catalogued on his own. Backed by an additional $150,000 for its care, the collection was valued at $12 million. According to historian Winifred Howe, "From every point of view," the Altman bequest was "the most

splendid gift ever received by the museum from an individual." His contemporaries were equally impressed, touting it as "the greatest art bequest . . . ever made to a public art museum in any country."[21]

While men such as Marquand and Altman rendered the museum's most prestigious collections of Old Masters, women like Havemeyer helped to popularize more contemporary works. Patronizing contemporary painters was a canny strategy, particularly in an era when attributions were still made "on an optimistic, rather than a scientific basis." Two of Altman's purported Rembrandts were subsequently demoted to lesser attributions, as were two alleged Rembrandts in the Havemeyer bequest. Louisine Havemeyer was keenly aware of the pitfalls that the scramble for Old Masters entailed. Her advice to aspiring collectors was to "believe nothing that you hear and still less of what you see, and then pray to the gods to protect you. . . . He who relies on his own judgment, or on the appearance of things, or in the proofs of seals or dates, or on style, or on the texture of fabrics or the composition of color, or any other test under the sun, will in ninety-nine cases out of a hundred be taken in." Particularly when their choices were guided by connoisseurs of the caliber of Sara Hallowell and Mary Cassatt, the women who invested in the works of living artists significantly reduced the threat of fraud. They also acquired these works at relatively reasonable prices, especially when they were willing to gamble on artists in the early stages of their careers. In 1889, for example, Bertha Palmer snared Degas's painting *On the Stage* for a scant $500. Three years later, she acquired four more of his paintings for a total of $5,000. In the process, women like Havemeyer and Palmer managed to gather collections of extraordinary value in previously untested fields.[22]

Men collected impressionist works as well. Chicagoan Martin Ryerson, for example, amassed a superb collection with his wife. But the record of women's contributions in this area is striking. Havemeyer, Palmer, Mrs. L. L. Coburn, Evaline Kimball, and Julia Cheney Edwards all created sizable collections that were subsequently donated to local museums, while Lilla Cabot Perry, Sara Hallowell, and Mary Cassatt proved extremely influential in broadening the American audience for Impressionist works. Ironically, although both Havemeyer and Palmer relied heavily on the tastes and talents of Mary Cassatt, the collections they donated overwhelmingly paid homage to the works of men. In the process, they helped to win artists like Monet and Degas, Manet and Renoir a central place in America's emerging aesthetic canon, while Cassatt and other women painters achieved a far less visible role.

Most female museum patrons also deferred to male curatorial authority. The evidence suggests that only one woman, Mrs. J. Crosby Brown, ag-

gressively sought to claim a more meaningful role at the Metropolitan through her donations during these years. Brown was an unusual woman, to say the least. The daughter of the president of Union Theological Seminary, Mary Ellen Brown used her family's ties to missionary networks to assemble a massive collection of musical instruments. Her husband, a banker who also sat on the museum's board, must have contributed the necessary cash, while Mrs. Brown clearly supplied an extraordinary amount of zeal. By the time she delivered her first installment of 270 instruments in 1889, the collection already spanned the gamut from European and Oriental specimens to those of, as she put it, "savage tribes."[23]

Her passion for acquisition was matched by a great deal of self-acquired expertise. Her gifts came carefully catalogued, illustrated by drawings and descriptions co-authored with her son. She was also keenly aware of their ethnological significance. As she explained in the initial deed of gift, "The intrinsic value of many of the individual instruments is not very great, but the collection is of value as a whole, as illustrating the musical habits and tastes of different peoples." But their greatest impact lay in their uniqueness. Thus, she prophesied, the collection "will become more valuable every year, as many of the instruments of savage tribes now in the collection are rapidly disappearing and [even] now some . . . cannot be replaced."[24]

The string surrounding Brown's lavish gift was her stipulation that she and her son should have lifetime access to the instruments in order to study them and to eliminate inferior samples and duplicates as better pieces became available. In return, she proved a generous and faithful patron. By 1906 the collection had grown to over thirty-five hundred pieces, including many extraordinarily lovely examples of European craftsmanship. Every continent and almost every culture was represented. On the other hand, although her expertise was clearly admired and her generosity appreciated, Brown's somewhat overbearing personality must have been profoundly annoying to men like the museum's misogynistic director, General di Cesnola, who sought to run the institution with an iron hand.

At one point she dismissively advised, "I really think something should be done about the catalogue," instructing him to send her a copy to review for suggestions. "That at all events will be making a beginning," she grumbled. In other instances, Brown wrote to demand hundreds of additional invitations for openings, suggesting representatives from the press whom she felt that Cesnola had overlooked.[25]

Of course, this kind of behavior was certainly not unknown among male donors and trustees. Bashford Dean, for example, supplied and managed his enormous collection of arms and armor, and the connoisseur

George A. Hearn was extremely possessive about his gifts. In addition to a significant number of American and European paintings, Hearn also donated a purchase fund for American works of art. He managed to retain control of its acquisitions as well, buying paintings that he then offered to the museum, with the expectation that they would be purchased with the proceeds from the Hearn Fund. His relationship with the erudite curator of paintings, Roger Fry, was particularly icy. When Fry ignored his admonition that he did not want "any hints," Hearn curtly informed the curator that "your advice and assistance, appear presumptuous. . . . [I] do not want your assistance and advice, nor do I want you to alter the arrangement of [the] pictures or change the frames. . . . If this is not satisfactory I will lay the matter before the Board of Trustees."[26]

However, Brown's assertiveness must have seemed particularly jarring, given that she was a woman. Still more daring was the way in which she parlayed her authority over her gifts into a niche for one of the first women to join the museum's curatorial staff. Frances Morris first came to the Metropolitan as Brown's employee. Even the formidable Brown began to slow with age, and in 1897 she hired Morris to help in the task of organizing and cataloguing the avalanche of instruments that she continued to bestow. A former secretary, Morris was well enough versed in instruments to win Brown's respect. After the first part of the catalogue was finished, Morris was offered a full-time position in organizing the museum's lace collection as well, a job for which there were apparently no male volunteers. Aided by women collectors and volunteers, she ultimately expanded her responsibilities to include a textile study room, and in 1910 she was formally named assistant curator in the Department of Decorative Arts. Eleven years later, she was appointed associate curator for textiles, one of the few women curators to hold a post above the level of assistant on the staff of a major American museum.

Historian Margaret Rossiter has called this sort of strategy "creative," or "coercive," philanthropy. Rossiter's examples center on the ways in which women philanthropists used their donations to leverage new training and career opportunities for other women within scientific fields. For example, Mary Garrett gave her $307,000 gift to Johns Hopkins University with the proviso that women be admitted to the university's medical school on an equal footing with men. Garrett also offered a pledge of $10,000 per annum to Bryn Mawr to entice the trustees into selecting her longtime companion, M. Carey Thomas, as president. Mary Ellen Brown was one of the few women to use her contributions to provide an employment opportunity for another woman within a major museum. Despite their sizable gifts, and their ardent feminism in some cases, most of the women who gave

significant donations to the country's major museums during these years adopted a far more passive role.[27]

Morris was extremely fortunate to have Brown's backing, particularly since she had so little formal training. Her promotions placed her among a small group of women who held professional positions in major American museums during these years. Most remained clustered at the bottom of curatorial hierarchies, and those who did ascend the curatorial ladder generally did so at a glacial pace. For example, Gisela Richter, the Metropolitan's first woman curator, took a quarter of a century to finally reach a position of complete control over her Department of Classical Antiquities in 1929. Even wartime exigencies failed to speed the process. Although the First World War opened new career opportunities to women in some fields, institutions such as the Metropolitan filled the slots left vacant by enlistees with other men, while women remained firmly entrenched on the lower occupational rungs.

Many of the women who held these positions managed to create careers for themselves within the familiar terrain of the decorative arts. Florence Paull Berger began her career as an assistant to the director of Boston's Museum of Fine Arts, which enabled her to participate in organizing exhibitions of American silver and musical instruments. By 1918 she had moved to an administrative position at the Wadsworth Atheneum, where she was finally named the curator of textiles and costumes over thirty years later, in 1951. Richter began her career with the Metropolitan by cataloguing collections of jewelry and American ceramics for $5 a day. Similarly, Bessie Bennett, the first woman curator at the Art Institute of Chicago, was appointed director of its decorative arts department in 1915 after serving for more than twenty years on the museum's staff; and Gertrude Townsend was named curator of textiles at the Boston Museum of Fine Arts in 1929.[28]

Women undoubtedly gravitated most readily to these areas because this was the easiest terrain to claim from male competitors. In many instances, such "distaff" arts as lace collections were initially catalogued and cared for by women volunteers. Thus, when the Metropolitan's new study room for laces and textiles opened with only a few hundred samples in 1909, Emily de Forest was drafted to write an appeal in the museum's *Bulletin,* calling for additional donations. Collectors such as Catherine Newbold and Mary Parsons volunteered to do the work of sorting and cataloguing "as a labor of love" before Morris was hired. This in turn spurred new initiatives, such as the Needle and Bobbin Club. Founded in 1916 as an alliance of collectors and donors, the club eventually registered over two hundred members.[29]

Clubs such as this may have provided the necessary support systems that a woman like Morris would have needed in order to survive in an increasingly hierarchical, male-dominated milieu. General di Cesnola reputedly had a glowering dislike for the museum's female employees. As a result, Morris founded the Ladies Lunch Club, a group of women employees who lunched in her office in the attic, so that they would be out of Cesnola's sight. In the words of historian Winifred Howe, Morris "had known of General Cesnola's aversion to woman assistants and asked no favors." Even after Cesnola's death, she continued to benefit from Brown's watchful patronage. In a letter to Henry Kent penned a few years before her death, Brown asked if he could arrange for Morris to have a longer vacation that summer, "for it seems to me she has earned it by her long years of faithful work."[30]

Brown was not quite so fortunate. After her death, the trustees apparently lost interest in her collection and considered giving it to the Juilliard School of Music in 1931, but ultimately demurred. Shortly afterward, an ethnomusicologist examined the collection and warned that, if it continued to be neglected, "the instruments are condemned to death." Fortunately, the trustees heeded his advice. Many of the instruments can still be seen today, housed in a special suite of rooms adjacent to the American wing.[31]

The Pennsylvania Museum

Women played a more significant role in Philadelphia, for several reasons. The Pennsylvania Museum began with an almost exclusive emphasis on the decorative, or industrial, arts. Later rechristened the Philadelphia Museum of Art, it would not become a fully diversified repository until the mid-1920s, when it was reorganized under the directorship of Fiske Kimball. Because the museum was a direct outgrowth of the Philadelphia Centennial Exposition, the women's committee that helped to raise funds for the fair was in an unusually strong position to make demands. Moreover, the institution lived a hand-to-mouth existence in its early years, when it was heavily dependent on municipal appropriations and the women's committee's fund-raising skills. Men still donated more than their female counterparts. The fragmentary information contained in the museum's annual reports suggests that, prior to the reorganization, twenty-eight men donated approximately $450,000, as opposed to only $70,000 from the eighteen women who contributed. Because the level of donations was low, the funds solicited by the Associate Committee of Women often supplied the necessary margin to keep many of the museum's programs in operation.[32]

The trustees of the 1876 Centennial Exposition appointed a women's committee in 1873, after it became apparent that their own efforts to raise the necessary funds through stock sales had fallen short of the mark. Initially, thirteen women, symbolically representing each of the original states, served on a committee chaired by Mrs. E. D. Gillespie. A woman of great ingenuity and spirit, Gillespie quickly mobilized comparable committees in scores of cities and towns across the nation. Within a year, chapters were operating in nearly every state, selling stock subscriptions and hosting parties and bazaars that netted over $100,000 of the needed funds. In return, Gillespie extracted a pledge from the board that her committees would have space in the main exhibition hall for an exhibit to highlight women's social, intellectual, and cultural achievements. The men initially agreed. However, once they had the cash in hand, they reneged, informing Gillespie that, if women wanted exhibition space, they would have to build a building of their own. Which is precisely what they did.

As in Cincinnati and Providence, Philadelphia's delegates to the Women's Centennial Executive Committee were loath to disband at the fair's end, looking for new ways to apply their talents to civic needs. They also donated some leftover funds to the city's new museum, which was founded as a permanent repository for examples of industrial design gleaned from the fair. In May 1878 some of the members were invited to join a new Advisory Committee appointed by the museum's trustees to help with the fund-raising and to oversee the museum's newly initiated art needlework courses. Renamed the Associate Committee of Women (ACW) in 1883, Gillespie and her co-workers also received space in one of the museum's pavilions, as a permanent, national memorial to their efforts during the fair.

Because of Gillespie's role in raising funds for the fair, the museum's first president, William Platt Pepper, offered her a chance to comment on the charter and bylaws before they were approved. On reading them, she was horrified to note that "there was not the slightest allusion to the work the women of the country had done for the Exhibition," even though the museum was a direct legacy of the fair. "The compilers had even decreed that the Trustees of the proposed institution would be males."[33]

Gillespie's response was indignant and swift. Her "earnest remonstrance" firmly pointed out that "our women had gladly given time, money and energy to the [fair]," and therefore "they should not be quietly put aside." Her missive had "the desired effect." The bylaws were revised to state that "the position of Trustee is open to any woman nominated and elected by the corporators at their annual meeting, the corporators consisting of both men and women who are subscribers." Even though the prom-

ised gains took years to materialize, it was a substantial victory, and unique among the country's major Gilded Age museums.[34]

Committee members bolstered their position within the museum by staging exhibits of American porcelain, pottery, and glass, following the practices of contemporary decorative art societies but in a different institutional setting. Samples were also amassed from leading manufacturers, to illustrate improvements in American designs initiated since the fair. In return, the members offered to sell goods on commission, much as they would in their decorative art societies and women's exchanges. However, they predictably deferred to the aesthetic guidance of men, using the designs of the Committee on Instruction headed by John Sartain for patterns stitched in their art needlework classes. Emulating comparable efforts in other towns, they emphasized that their interest in sponsoring these classes hinged on their search for "an appropriate means of support for women," rather than purely aesthetic ends.[35]

Although none attained the coveted status of a regular board position during the nineteenth century, several women made important donations. Clara Bloomfield-Moore donated a collection of objets d'art. A highly successful writer, she achieved prominence as the author of a number of best-selling etiquette books. Like many of her peers on the ACW, Bloomfield-Moore was also a veteran of the wartime Sanitary Commission. After her husband's death in 1878, she travelled extensively in Europe, amassing paintings and decorative artifacts. Hailed as "an immensely valuable collection" when it was given to the museum in 1882, Bloomfield-Moore's contributions ranged from pottery and paintings to assorted jewelry, laces, and embroidered goods. By the 1890s, Susan Barton had also bequeathed over $5,000, Mrs. Thomas Scott made a comparable donation, and Mrs. C. A. Janvier signed over several pieces of art presented to her father, an old China hand, by the kind of Siam. Although in the minority among the museum's donors, women nonetheless made their presence felt through cash and in-kind donations.[36]

However, it was the ACW's fund-raising activities, rather than the gifts of individual donors, that constituted a major force in the museum's early years. The committee's importance waxed as the city and state appropriations wavered. In 1896, for example, the state withheld $40,000 of its appropriation, immediately casting the museum into hard times. With the state's share suddenly whittled to $20,000, the women were asked to help raise the remainder of the museum's projected budget. Individual donors such as Mrs. William Wrightsman, Jr., were also roused to action, contributing gifts in the $5,000-to-$10,000 range to tide the institution over its sudden dilemma. Wrightsman's husband had also offered a $100,000 chal-

lenge grant for a new building for the school at the height of the depression of 1893, with the proviso that the ACW raise another $50,000, which they nearly met despite the economic downturn, securing the donation.

Most of their efforts centered on the school. In 1903 the ACW helped to launch a new Department of Pottery; five years later, their goal was to raise funds to house the women students. While women raised the funds, local manufacturers donated gifts in kind such as looms, shuttles, fulling and washing machines, yarns, and dies for the textile classes, providing early examples of corporate largesse.

Because many of the students were women, ACW members placed a special emphasis on the need to provide a suitably homelike environment for what they termed "our School Family." They also created a number of scholarships, a popular item among women donors in many museums. The ACW occasionally sponsored special exhibitions and lectures as well, including a 1900 showing of works from Cincinnati's Rookwood Pottery, and a benefit lecture, "Italian Lace and Its Artificers," by the Countess di Brazza.[37]

Because the museum's funds were limited, several women also served as guest curators. Thus, Mrs. W. D. Frishmuth was made an honorary curator of musical instruments in 1902; three years later, Mrs. Jones Wister earned a slot as honorary curator of oriental pottery. Mrs. John Harrison became the museum's honorary curator of textiles in 1893. Harrison began her tenure with the ACW in 1887, serving as its president between 1905 and 1913. She began her curatorship with an exhibition of laces, subsequently donating valuable collections of textiles and occasionally lending portions of her collections of antique silver and jewelry. When the committee took up a collection to buy some of the laces exhibited at the Columbian Exposition, Harrison's $100 donation headed the subscriber's list. She also helped to establish the museum's textile department, augmenting its holdings with her own. In 1907 Harrison became one of the first women to join the board, capping years of informal service on the museum's staff.

Similarly, Sara Yorke Stevenson coordinated the museum's furniture exhibitions and developed one of the country's first museology courses in the decorative arts. Stevenson was active in the University of Pennsylvania's museum as well, where she served as an unsalaried curator for their Egyptian holdings. An ardent suffragist, she had the further distinction of being one of the founders of the American Exploration Society.

Women like Harrison worked their way onto the board gradually, first as fund-raisers, then as unpaid curators, then as representatives of the ACW on board committees, and finally as full board members. Four women held that position by 1915, and two were on the executive commit-

tee. They managed to achieve these positions in large measure because the museum's emphasis on the decorative arts complemented their more traditional cultural roles, and because the sorry state of its finances made the trustees more willing to accept whatever services women were willing to provide. The history of the Pennsylvania Museum is distinguished by the scope that it provided for ambitious women volunteers, enabling them to fashion unpaid careers as museum curators in the decorative arts. In the process, it allowed several talented women to hold posts that their social position and their lack of formal training would otherwise have denied them. Like nonprofit entrepreneurship, this was considered a legitimate sphere for female enterprise because it offered so little in the way of tangible financial returns.

The Art Institute of Chicago

Women's scope was more limited in the Art Institute of Chicago. Chicago's cultural traditions were a good deal younger than Philadelphia's and New York's, if no less earnest. Local exhibitions dated from 1859, to be followed in turn by a short-lived art union and two highly successful exhibitions at the Northwestern Sanitary Fairs. Professional artists sought to create their own institutional base in the 1860s, with the development of the Chicago Academy of Design. Cast in the mold of its more established eastern counterparts, the Chicago Academy provided art training, a focus for collegial spirit among the city's practicing artists, and a means of kindling public interest in the fine arts. Local collectors participated as well, stocking the academy's galleries with the obligatory casts and helping in its management.

Like many of the city's charitable and cultural institutions, the Chicago Academy never fully recovered from the fire that devastated most of the city in 1871. The academy lost its collections, many of the artists' studios burned as well, and most insurance policies proved uncollectible. The financial panic of 1873 further dimmed the academy's hopes for recovery, and in 1878 the members appealed to the city's businessmen for help. The board was accordingly reorganized under the presidency of James H. Dole, a local business leader, backed by an array of prominent businessmen that included (among others) P. D. Armour, Marshall Field, Charles Hutchinson, and railroad magnate George Pullman. Hutchinson and his fellow trustee lumberman Martin Ryerson would come to play a particularly important role as the museum matured, dominating its activities well into the twentieth century.

While the artist contingent had gotten along well with the antebellum

businessmen and boosters who helped them launch the venture, they were clearly out of their depth in dealing with the city's postwar generation of nouveaux riches. Ruthless centralizers in their business dealings, these men used the fire relief funds to tighten their grasp over the city's charities, and the invitation to join the academy's board offered an irresistible incentive to cultural centralization as well.

Predictably, the businessmen quickly lost patience with the artists' rivalries, their quarrels, and their bad debts. In the words of one disenchanted trustee, the agency was "rotten to the core." Rather than trying to reform the unreformable, they broke away to create a separate institution in 1879, condemning the academy to a quick demise. Nor would they brook public confusion between the two institutions. As Charles Hutchinson was quick to point out, "The Academy of Fine Arts is on a good, solid, substantial basis, while the Academy of Design is entirely bankrupt."[38]

Later rechristened the Art Institute of Chicago, the new venture had a threefold aim: to foster a school of art and a public gallery and to upgrade the arts of design "by any appropriate means." It constituted a sharp break with the past in that none of the city's leading antebellum stewards participated in its creation. One of the city's prewar civic leaders, Ezra B. Mc-Cagg, was invited to join the board but declined, suggesting that the work should naturally "devolve upon younger men than I am, and to a large extent upon men who have not had their enthusiasm burned out of them. The fire of 1871 destroyed whatever I had set my heart on. . . . Lame and hopeless and weary I dropped out, and I think may not begin again." As a result, the Art Institute's creators were younger men born in the 1830s and 1840s, who had arrived in the city on the eve of the Civil War and positioned themselves well enough during the hostilities to take advantage of the vast profits to be made as a result of wartime needs, postwar urbanization, and the country's growing appetite for consumer goods.[39]

Women were largely absent from the early history of the Art Institute. Like their counterparts in Philadelphia, they first entered the museum's sphere under the banner of decorative artistry and a separate auxiliary of their own. Between 1887, when the first major donation from a woman was recorded, and 1930, Chicago's female patrons amassed a record of surprising generosity. As of 1930, sixty-one male donors had given the museum a total of approximately $4 million, as opposed to $2.7 million donated by forty-four women; and almost all of those who donated $5,000 or more before the turn of the century were either veterans of the Chicago Society of Decorative Art (CSDA) or members of their families. In fact, the society itself provided an important opening wedge into the museum's affairs. After years of juggling the twin imperatives of charity and art, the CSDA's

board turned exclusively to collecting in 1888. Under their new name, the Antiquarian Society, they dedicated themselves to raising funds to purchase decorative artifacts for the museum's holdings, echoing the pattern set by the Women's Art Museum Association in Cincinnati. By the 1890s, the CSDA was well on its way to legitimizing a new role for Chicago's women within the once exclusively male preserve of the Art Institute.[40]

The Antiquarian Society initially broached the subject of a formal relationship with the museum in 1889, with an offer to bolster the Art Institute's textile collections. Although its requests were modest, asking only occasional access to the museum's private rooms for lectures and meetings in return, the trustees nervously voted to leave the final decision to "the discretion of the President." Despite their initial hesitation, the society's proposal was ultimately accepted, breathing new life into its activities. Within a year, its membership lists had increased tenfold, providing additional dues to fund new acquisitions, from pottery to laces.[41]

In addition to purchases of laces, china, tapestries, and embroideries, the Antiquarian Society staged lectures, loan exhibitions, and special fundraising events. Its rosters included an array of distinguished local matrons, including the wives of several Art Institute trustees, such as Mrs. Martin Ryerson and Mrs. Charles Hutchinson. Many members were wed to the city's millionaire businessmen, and a few, such as Bertha Palmer and Evaline Kimball, were already becoming known as outstanding art collectors in their own right.[42]

In 1896, the society formally petitioned the museum's director, William French, to have their gifts "exempted from examination by the Art Committee of the Art Institute," in order to bypass "the delay often incurred by waiting for [their] decision." The board's initial response was revealing. As recorded in the minutes, "After careful consideration, the trustees were unanimously of the opinion that the Art Committee could not relinquish its authority, but would undertake to give a decision on the articles submitted by the Antiquarians within twenty-four hours." Although the trustees were initially unwilling to surrender their control, the Antiquarians persisted, meeting to discus the matter further with Hutchinson, Ryerson, and French. Afterward the trustees finally conceded their willingness to "accept anything" that the "Antiquarians choose to present."[43]

Like other women's cultural voluntary associations, the Antiquarian Society ran its programs with relatively modest revenues. By the turn of the century, it had recorded $20,000 in purchases, augmented by gifts from individual members. It was still unendowed, subsisting on their annual $5 membership fees and fund-raising events. Ten years later, Ryerson marked

her presidency with a campaign to secure "larger funds from which to make purchases of really desirable objects." As she explained, "Every day lessens the opportunity of securing such objects, while the prices are continually becoming higher," making increased support "imperative." Ryerson backed her call to action with her own $1,000 gift. Within a year, over $10,000 had been raised for new acquisitions, a limited but still significant sum.[44]

And yet, the disparity between the modest revenues that financed the society's operations and the amounts that many of its members donated to the museum was notable. In many respects, their gifts suggest that many elite women may have maintained a double standard, volunteering in their own societies but saving their largest donations for institutions controlled by men. For example, two Antiquarians, Mrs. E. S. Stickney and CSDA president Maria Scammon, together bequeathed over $100,000 to the Art Institute at the turn of the century, while their own organization remained unendowed and financially starved. Isabella Blackstone, who like Scammon briefly served as the society's president, subscribed $5,000 toward the purchase of a Flemish tapestry on the society's behalf in 1911 and gave a number of gifts in kind, including fine examples of fourth-century Etruscan gold and amber jewelry. Yet she pledged a much greater sum directly to the museum, matching her husband's 1901 bequest of $25,000 with an additional $50,000 for the construction of Blackstone Hall. Similarly, Evaline Kimball, Mrs. Martin Ryerson, and Bertha Palmer offered nominal support for the CSDA and the Antiquarians, but endowed the Art Institute with extremely valuable collections of French impressionist paintings.

As in other museums, a certain amount of expertise about decorative artifacts, combined with sufficient wealth, provided an opportunity for a handful of women to assume more substantial roles. Kate Buckingham, who created a Gothic room as a memorial to her sister, was the first woman to join a formal committee in 1915. Bertha Palmer's daughter-in-law later joined the decorative arts committee, as did Emily Crane Chadbourne following her $25,000 donation to the decorative arts department. Yet although women also served on the committees on prints and on Oriental art, they were not invited to join the board, or the committee on accessions, or the committee on painting and sculpture. Even on the eve of the Great Depression, women donors remained locked in their traditional association with the more artisanal pursuits.

The fortunes of female artists were equally instructive. The Art Institute's aggressive takeover from local artists signalled one of the leitmotivs of Gilded Age museum development. Unlike earlier cultural ventures, few artists graced the boards of these institutions, and their numbers di-

minished with time. However, although the drift toward cosmopolitanism minimized their roles, museum responses to the needs of American artists varied considerably from town to town. Perhaps because it was less richly endowed than its sister institution in New York, the Art Institute proved unusually receptive to the needs of contemporary artists, opening its galleries to a variety of local and national exhibitions. Not surprisingly, the primary beneficiaries were men. Most of the major prizes, the slots on juries, and the individual shows were awarded to male artists, with women constituting a decided minority.

One of the Art Institute's most important initiatives in this area was Friends of American Art (FAA). Founded in 1909, this auxiliary consisted of 130 charter members, each of whom paid an annual subscription fee of $200 to create a yearly fund of $30,000 for the purchase of works by American artists. Eighteen of the original subscribers were women, including Edith Rockefeller McCormick, her sister-in-law, Anita McCormick Blaine, and several Antiquarianas such as Isabella Blackstone, Bertha Palmer, Harriet Pullman, and Florence Lowden. Although two briefly served on the FAA board, none were tapped as officers. Most FAA purchases were made at the Art Institute's annual exhibition for American painters, which drew submissions from artists across the country. The list of FAA purchases spanned the gamut from paintings by Ashcan realist Robert Henri and the impressionist Childe Hassam, to works of relative unknowns. Lorado Taft, who sat on the board, had the pleasure of seeing his statue *Solitude of the Soul* purchased for $3,500 in 1910. Ralph Clarkson, another FAA member, sold one of his paintings for $2,700 two years later.

Women received little attention in this group, either as policymakers or as recipients of the association's largesse. Although the number of female subscribers had risen to sixty-four by 1919, none were added to the purchasing or executive committees, and only one was listed as ever having attended the meetings during the association's early years. By 1917 women had entirely vanished from the board. Moreover, although a few women artists such as Pauline Palmer, Katherine Dudley, and Anna Lea Merritt received individual exhibitions at the Art Institute or served on the selection committee for its annual exhibitions, they were decidedly in the minority among the painters whose works were selected by the FAA.

Moreover, those women that did sell to the FAA often received significantly smaller sums than their male counterparts. The FAA acquired its first painting by a woman from Elizabeth Sparhawk Jones in 1913 for $550, while its first piece of sculpture by a woman artist was Janet Scudder's bronze fountain, which they bought for $1,500 in 1912. The $200 that it paid for Grace Ravlin's painting was the lowest sum paid out in 1914, as was

the $200 it offered to Katherine Dudley the following year. Moreover, the FAA directors went back to Dudley in 1919, asking her to provide a better example of her work in exchange for the painting they had purchased four years before. In 1921, they offered her $59.34 for another of her paintings, the same year that they lavished $3,500 on a pair of portraits by the antebellum genre painter Samuel Waldo. They also offered only $150 for a painting by Mary Cassatt. The highest amount the FAA paid for any work by a woman artist during this period was the $4,000 Cecilia Beaux netted for her painting *Woman and Child,* which had just won one of the major prizes at the exhibition. Two years later, the FAA paid $3,800 for a painting on the same theme by a relative unknown, Ralph Earl. None of these prices approached the $16,000 fee offered to John Singer Sargent.[45]

Although women had come to play an increasingly important role as donors as the Jazz Age reached its close and although they had managed to institutionalize their work as volunteers within the familiar terrain of the decorative arts, they still commanded little decision-making power within the Art Institute's bureaucracy. The major aesthetic decisions, particularly within the visual arts, remained the province and prerogative of men.

The Museum of Fine Arts, Boston

The situation was much the same in Boston. Perhaps the most striking difference was that Boston's Museum of Fine Arts traced its inception to a woman's gesture of largesse. By 1869 the gallery of the Boston Athenaeum was filled to bursting, generating local sentiment for the development of a separate museum. The cause received a significant boost with the death of Colonel T. Bigelow Lawrence, an avid collector of medieval armaments. Lawrence's widow donated his massive collection to the athenaeum, supplemented by $25,000 to house the gift. Unfortunately, her motives were not recorded. Whether she acted out of a desire to memorialize her husband or simply wished to rid herself of the vestiges of his martial enthusiasms remains a matter of speculation. Whatever her motives, the Lawrence bequest provided the needed incentive to start Boston's museum movement. Moreover, after her husband's armaments were destroyed in the great Boston fire of 1872, Lawrence generously allowed the trustees to use the insurance money to purchase a collection of textiles, embroideries, and woodwork at the Philadelphia Centennial Exposition, later augmenting her gifts with pieces of Italian majolica and an elaborately carved Tudor period room.

Yet despite Lawrence's generosity, neither she nor any other woman was invited to serve as a trustee. Instead, when the museum opened its

doors on Copley Square in 1876, it did so under the guidance of a small but very prominent band of male trustees. Two-thirds of the original board were Harvard graduates; by the 1890s, almost nine-tenths held degrees from the city's leading university. Not surprisingly, almost all hailed from wealthy Yankee families, with the usual ties to Harvard, Massachusetts General Hospital, and the athenaeum rounding out their service on the museum board. Historian Ronald Story has traced the ways in which participation in this cluster of institutions defined the contours of Boston's upper class. Here, as in other cities, service in museums became a visible symbol of status and caste.[46]

Men like President Martin Brimmer and his fellow trustee Charles Perkins stood at the apex of the city's social life. Each had special skills, ranging from a gift for restoration work to an unusually good eye for industrial design, that helped to bolster his claims to cultural authority. Women, on the other hand, played an extremely limited role in the trustees' vision of what their museum should become. Aside from Lawrence's initial gift, female donors remained in the minority during the nineteenth century, both in terms of paintings and cash. Although they made substantial contributions of decorative artifacts, these efforts failed to win them a comfortable place in the museum's management.

The trustees' minutes provide little in the way of concrete allusions to the founders' decision to bar the appointment of female trustees, but they do contain some intriguing references to an Association in Aid of the Museum of Fine Arts, which numbered women among its members. Founded in 1871, the association offered its fund-raising services to the museum's trustees, with plans for a music festival, a fair, a bazaar, and an exhibition illustrating the relationship of American paintings to the country's industrial arts. Mrs. Martin Brimmer was a member, as was Mrs. G. Howland Shaw, who had just donated $5,000 to the museum's charter subscription campaign. In return for the use of the museum's buildings and a small loan for the construction of a pavilion to house the exhibition, the members promised to donate any revenues gleaned from the exhibition and the fair. Despite the lure of additional revenues, their proposal failed to strike a responsive chord among the trustees. Plans for the music festival were rejected in 1872, and the other proposals were effectively tabled. A permanent women's auxiliary would not be formally appointed for nearly ninety years.

Women also briefly contributed to the museum's school. Founded with a format of painting and drawing courses in 1876, the school soon included art needlework, carving, and china and porcelain painting among its courses as well. As in other cities, many of these craft-based activities

were transferred from the management of the Boston Society of Decorative Art. Several members of the Committee of the School of Art Needlework were wives of the museum's trustees, relationships that underscored the divisions that separated male and female responsibilities within the museum's walls.

Familial ties notwithstanding, the needlework school's alliance with the museum proved tenuous. Although the directors of the school were allowed to use the museum's rooms free of charge, they were denied a more formal place within the institution itself. Thus, the trustees made no appropriations for the instructors' salaries and refused to release any other funds for this work. As they explained, "The classes hitherto established have been temporary and tentative, without permanent endowments, and the Trustees have not considered it necessary to do more than to satisfy themselves that the direction of these classes was in good hands, [and] not likely to bring discredit upon the museum."[47]

However, if a permanent endowment had been received, the women would have found their position considerably changed. In such an event, the trustees noted that they would feel it incumbent upon themselves "to assume the care of the funds and to take the responsibility of the general direction of the instruction, inasmuch as it would not in their judgement be advisable to have permanent institutions established under their roof . . . unless such institutions were within their own control." The endowment was not forthcoming, but had such a windfall appeared the trustees were more than ready to claim the work—and the money—as their own.[48]

Since the anticipated funds failed to materialize, Boston's women were spared the shock of having their work expropriated, but they proved unable to sustain the courses themselves. Hobbled by a "lack of enthusiasm," the needlework, ceramics, and porcelain-painting courses were erased from the school's list of offerings by the end of 1882. From the ill-starred Association in Aid of the Museum to the equally abortive courses in the decorative arts, women's activities received short shrift. Although the trustees cheerfully appropriated women's cash and their donations, their ideas and their time, they held female patrons at arm's length when considering more substantial roles.[49]

Women continued to remain on the margins of the museum's policy-making structure, despite the accelerating generosity of their gifts. While thirty-eight male benefactors of $25,000 or more had contributed approximately $6 million by 1930, thirty-five women donors had contributed almost $5 million by that date. Many women initiated their relationship with the museum through their gifts of paintings or objets d'art. Echoing a familiar pattern, those who donated paintings tended to be the wives and

widows of trustees, some of whom had pursued their taste for collecting with their husbands. Along with Isabella Stewart Gardner, Susan Warren was frequently cited as one of Boston's most important collectors. While Gardner turned to Bernard Berenson to help in her collecting, Warren leaned most heavily on William Morris Hunt and on her expatriate son, Edward. As the wife of one museum president and the mother of another, Warren also had access to a random array of experts who fell within the institution's sphere.

Despite the growing importance of her donations, Warren's correspondence with the museum's director, Charles G. Loring, reveals a fairly haphazard relationship with the museum. In 1889, for example, she asked that a painting she had hung on loan not be available to students for copying. Another letter brought a query on some Arabic tiles that she acquired at the Centennial Exposition of 1876. Two years later, her offer of a triptych and an oil painting was declined. By 1892, Warren had begun to invite students from the museum's school to visit her private gallery. She also used the institution as an extension of her home, temporarily lending paintings and artifacts, then retrieving them. Warren occasionally tapped Loring for advice on acquisitions, asking him in one instance how much a Rembrandt might be worth, "not that I have any idea of buying so expensive a painting as it must be, i.e., unless it should go for much less than its value, which is not probable." In none of these letters, however, does she hint at any sort of policy-making role beyond the routine decisions concerning her own benefactions.[50]

Although denied slots on the board, women were occasionally asked to serve on the museum's committees. Established to provide "a means for creating a better public understanding" of the work of the museum's various departments, the visiting committees eventually added a number of women to the museum's rosters. The trustees were explicit about their aims in creating these auxiliaries. As they explained, each committee was expected to "befriend" the department to which it was assigned. This in turn implied a special sort of relationship. Thus, just as "intimate friends may be trusted not to interfere except in real emergencies, but to be ever ready to give sympathy and help according to their resources," committee members were "not inspectors, not directors, not even a body of experts, although there may be experts among them—merely wise and kind friends." This was also an ingenious means of conscripting individuals to raise funds while keeping them at arm's length from the policy-making responsibilities of the trustees. Although Warren accepted a slot on the Plate, Jewelry, Fans, Miniatures, Snuff-Boxes, and Armor Committee, Isabella Stewart Gardner declined the museum's invitation to serve on the Committee on

Installation. Never one to suffer a secondary role gladly, Gardner may have balked at the notion of "benevolence at a distance" that such service naturally implied.[51]

The relationship between the imperious Gardner and the Boston museum was an interesting one. Her husband, John Lowell Gardner, was a member of the board from 1886 until his death in 1898. Initially, the director, Charles G. Loring, was fairly curt in his dealings with her, despite the fact that she was married to one of the trustees. Thus, in 1890 he wrote to complain that he had heard she had been circulating a story that a painting that she had lent them had been damaged by exposure to heat in one of their galleries. "That the injury could not have happened from *that* cause is patent," Loring snapped, adding that "the photo shows that it hung eighteen feet from the nearest register. And pardon me if I claim in behalf of the Museum that it went back in no worse condition than when received."[52]

As her collection grew and became increasingly famous, the trustees' attitude softened, and several attempts were made to draw her into their programs. They sometimes got more than they bargained for in the process. When President Samuel Warren solicited Gardner's opinion about the aesthetic value of the museum's casts, she quickly became involved in a highly factionalized internal dispute. As might be expected, Gardner led the "progressive" assault to oust the casts, while the scions of several Brahmin clans rallied to the defense of the copies that their families had helped to endow. Gardner's faction triumphed, and the casts were exiled from the museum's galleries.

The question of acquisitions was a particularly thorny one. Gardner was one of the country's most prominent collectors, a woman of unquestioned aesthetic authority. When the museum tried to influence some of her acquisitions, she quickly, albeit tactfully, put it in its place. "You are very kind to let me know of the beautiful things as they come along," she wrote to Loring, "but please *don't!* I must not be tempted."[53]

The museum proved equally adept at shunning her advice. In one instance, she informed it that Charles Ffoulke was about to put three sets of Brabant Brussels tapestries from the Barberini collection up for sale. Gardner had already decided to buy one for her own collection but suggested that the museum might want to acquire one of the others. Ffoulke was willing to sell them for approximately $70,000, which was a fraction of what such hangings would command a decade later. The museum's representatives met with Ffoulke but rudely informed him that they did not have the funds to make such a purchase, "and if they wanted tapestries, they would not buy these." Although Gardner had a reputation as an extremely shrewd judge of art and a wily bargainer, and had assured the trustees that

Ffoulke's asking price "is the lowest possible," they were loathe to follow her lead.[54]

While Gardner and the museum kept a wary distance, others gladly acquiesced in the trustees' designs. One of the most important early bene-factors was Maria Antoinette Evans, who donated the Evans wing as a me-morial to her husband in 1911. The museum was a likely choice for Evans's beneficence, since her husband, rubber magnate Robert Dawson Evans, had been a trustee at the time of his death. Like many trustees, Robert Evans had also collected paintings, which made Mrs. Evans an especially appealing prospect.

When the trustees approached her with the idea of funding a new wing as a memorial to her husband, she initially demurred, offering to con-tribute a nominal sum toward curatorial salaries instead. By 1911, however, they had extracted her pledge to underwrite the museum's new painting gallery, a promise that ultimately cost over $1 million to fulfill. Her gift was one of the most generous in the museum's history. The new building in-cluded twelve halls as well as a marble tapestry gallery and additional rooms for offices and lectures. The museum later inherited fifty of her best canvases as well, providing a substantial mix of Barbizon paintings and Old Masters.

In return, Evans was invited to join several committees and to decide on certain aspects of the new wing. In one instance, swatches of wall cover-ings for the galleries were submitted for her approval. In another, she was allowed to set the date for the projected opening. Evans was also asked for her opinion about whether her husband's portrait was hung at the correct height. And she faced a flurry of decisions about the women's rest rooms. "Will you find [an] opportunity some day soon to visit the new building with me," one museum official plaintively queried, "and visit the ladies' rest room? There are one or two points on which I should like your opin-ion." These included decisions about the furnishings and whether the women employees should be allowed access to these facilities. She said yes, evoking an enormously relieved response from the women in question. And that was the extent of the policy-making leverage she received in re-turn for her gift.[55]

Assimilationists and Marginalization

Women in the upper economic strata—women such as Maria Antoinette Evans—were beginning to enjoy increasing power in the years after 1890. The passing of the kingmakers of the industrial revolution meant that there were suddenly some extraordinarily wealthy women on the American

scene. Harkness, Sage, Havemeyer, Palmer, each in turn inherited sizable fortunes from their husbands, as well as the power and the responsibilities that these multimillion-dollar estates entailed. But within museums, their fortunes and even their gifts failed to provide access to significant policy-making positions.

Instead, the country's major Gilded Age museums were created and managed by men. In New York, local clubmen led the drive for cultural consolidation. Philadelphia's museum was a direct legacy of the 1876 Centennial Exposition, while Chicago's museum movement was led by a small group of male nouveaux riches intent on centralizing their authority in the wake of the Chicago fire and the Civil War. Boston's Brahmins, on the other hand, had already consolidated into a cohesive group around a set of older institutions such as Harvard University. For them, museum development marked an extension of their authority, rather than an opening gambit in a bid for recognition. Yet in each instance, the repositories became part of a network of male social, philanthropic, and business ventures that served as building blocks in the emerging citadel of the American Establishment, as elements in a nest of legitimating institutions that spanned the philanthropic spectrum from education to reform.

Women remained at the margins of the decision-making processes that surrounded these efforts. In part, their absence from positions of direct authority may have been a happenstance of timing. When multipurpose museums began to be founded in the 1870s, women were just beginning to establish a modicum of public, cultural authority through decorative art societies and their clubs. Not surprisingly, the one institution in which they claimed a role from the outset was the Pennsylvania Museum, which was dedicated primarily to the arts of design. Moreover, although married women's property acts had begun to be written into law in many states, husbands still controlled the purse strings of the great industrial fortunes. Indeed, most of the major collections and gifts donated by women were given after the First World War, including the contributions by Palmer, Havemeyer, Harkness and Sage. By the time women were in a position to become substantial donors in their own right, most museum staffs had ossified into professional hierarchies that accorded scant leeway for even the most cultured amateur.

The majority of those who forwarded the largest gifts were the contemporaries of Candace Wheeler. Born before the Civil War, they were reared in an era in which the cult of domesticity and its inherent prescriptions for wifely subservience still held sway. Because they were usually related to trustees or other benefactors, they tended to eschew confrontational tactics in their desire to enrich museum holdings. These

were their husbands' institutions, and those of their fathers and sons, and they adjusted their behavior accordingly.

Their reticence to assert themselves may also have stemmed from a lingering ambivalence about publicly airing their views on the visual arts. Louisine Havemeyer's career is a case in point. After her husband died in 1907, Havemeyer became an ardent suffragist. She participated in demonstrations and took to the podium on the movement's behalf. In the process, she became not only a skilled orator but also something of a performer, enlivening her lectures with a battery-powered model of the *Mayflower* that exploded into the brilliance of thirty-three tiny light bulbs as she described the enlightened future that women's votes would bring, a tactic that inevitably elicited roars of startled approval from her audiences. Perhaps encouraged by her success, she became increasingly militant, to the point of being jailed for her role in a demonstration at which an effigy of President Wilson was burned before the White House gates.

Havemeyer's enthusiasm for the suffrage cause eventually incorporated her artistic talents as well. In one instance, she arranged a special loan show of Degas paintings with Durand-Ruel in New York as a benefit for the Women's Political Union, one of several suffrage exhibitions mounted with her aid. Only once, however, did she deign to publicly speak about art before a mixed audience, a concession made in order to justify charging a higher admission fee. Her topic was the art of Degas and Cassatt, a subject in which she was intimately versed, by virtue of her long-standing friendship with Cassatt, and the fact that she had brought Degas's "first picture to America and had been his friend and champion for over a generation." Nonetheless, Havemeyer was "very much frightened at this new field of oratory so very different from anything [she] had ever attempted before." As she explained, "It was very easy to talk about the emancipation of women, but art was a very different and difficult subject," particularly since she feared that "every art critic in America would be ready to challenge [her] remarks." Like other women of her generation, Havemeyer was comfortable speaking from the safe ground of separatist campaigns, but far more diffident about publicly forwarding her intellectual views before mixed groups.[56]

The moment that the majority of these women passed through museum portals they became markedly more docile and more deferential. And this was as true of the most fiery feminist—women like Palmer and Havemeyer, who had the money and the will to make their presence felt, if they so chose—as it was of the most self-effacing collector of fans and lace. This in turn may have influenced women's unwillingness to demand greater

parity, either in professional terms for women artists and curators, or for themselves.

Because museums, foundations, and universities played a pivotal role in setting national professional and artistic standards, women's roles within these institutions assume added interest. Foundations tended to be protected from outside pressures (and pressure groups) by virtue of their endowments, but museums and universities, which rely on a constant stream of donations, were less so. In some instances, this vulnerability provided an opening wedge for philanthropists like Mary Garrett and Mrs. J. Crosby Brown, who used their donations to win other women more substantial professional roles. Of course, there were failures as well. For example, when a group of Boston women raised $100,000 in order to persuade Harvard to award its degrees to Radcliffe students in 1893, their offer was summarily rejected. But Garrett's grant and Brown's success in winning a place on the Metropolitan's staff for her protégé provided isolated examples of the ways in which women could and did use "coercive" philanthropy to accord other women a larger role within the country's major "nonprofit corporations."[57]

The history of America's largest museums suggests that the more munificently funded these institutions were, the less responsive they were to female ministrations or to the claims of the community as a whole. While the Metropolitan Museum conformed to the stereotype of the cathedral of culture, the Art Institute was more of a three-ring circus than a temple. Although its permanent collection remained fairly impenetrable and meticulously defined, the institute's galleries were constantly abuzz with exhibitions of local painters, ceramicists, and even school children. "Sacralization," with the growing professional legions on which it depended, was a fairly expensive proposition. The greater a museum's revenues, the more options it had at its command, including the option of cutting itself off from outside groups and exhibitors of uncertified quality.

The Metropolitan stood at the far end of the economic spectrum. The country's richest museum, it was also its most exclusive. Born in a men's club, its board continued to echo a clubby atmosphere well into the twentieth century. The extent of the trustees' insularity was anecdotally captured by urban planner Robert Moses in the late 1940s. As Moses recalled, when he asked the assembled members of the board why they had not appointed a single woman trustee, he was "politely informed" that the board "could obviously not elect one until it could elect two, because one would be lonesome, and it was also hinted that the jolly informal stag atmosphere would never be the same." Despite their contributions, the question

of adding women to the Metropolitan's board continued to be dismissed internally as little more than a jest.[58]

As a result, men not only founded, directed, and staffed these institutions, they also retained majority status on purchasing committees, juries, and influential auxiliaries such as the FAA. In the process, women artists received short shrift, were accorded limited rewards, and often were poorly compensated for the few gains that they received. Nor did they receive much support from other women. While benefactors like Palmer and Havemeyer donated collections that helped to build the reputations of male artists, female painters and sculptors fared less well. Despite Palmer's impassioned attempts to promote the cause of women artists and advisors at the Columbian Exposition, within the precincts of the Art Institute she was surprisingly silent on this theme.

Women curators had problems as well. Although some made inroads on the curatorial staffs of major museums by 1930, they remained at lower occupational rungs and in areas such as textiles, which decorative art societies had claimed as particularly "feminine" terrain. There were some striking parallels between women's roles in museums and other fields, such as education and science, where they occasionally held assistant professorships but rarely, if ever, captured chairs at the major research universities. Nor did many women win the major grants, fellowships, and exhibition prizes offered by the big foundations and museums, benefits that would have helped to confer the kind of professional recognition that scholars, painters, and researchers needed to bolster their careers. Instead, they tended to cluster in assistantships in the areas most closely associated with traditional women's activities—areas that in many fields were automatically accorded lower salaries and less prestige. To quote historian Nancy Cott, "By self-definition, professionals were male, except in areas peopled by women before the era of professionalization, namely primary school teaching and nursing, and in some (similarly low paid) fields aspiring to professional recognition, such as social work." In effect, the rise of the "nonprofit corporation" signalled not only a new form of philanthropy but also a new set of professional imperatives that often accorded women a secondary role.[59]

The historian Mary Beard once complained that "higher education on the male model" had deepened women's "intellectual cowardice," turning them into "spokeswomen for the institutional and cultural priorities defined by men." It had reduced women's influence "to a whisper." The history of women's roles within museums evinced a similar pattern. Assimilationist strategies were riddled with contradictions. The same women who took a leading public role in promoting decorative artistry

often shrank from the limelight when the topic turned to painting, even when they ranked among the country's most respected collectors and connoisseurs. Feminists shed their convictions within the sanctified realm of the museum, often meekly rendering their gifts without strings, under a husband's name. Women who volunteered in separatist enterprises saved their largest gifts for the museums that often discriminated against women artists, curators, and trustees. In the process, they helped to bolster a definition of "fine art" in which women's contributions were largely absent or unsung.[60]

The individualistic philanthropists who began to appear at the turn of the century rejected these prescriptions, creating new institutional alternatives of their own. Unlike many of the most prominent women museum patrons, most were born after the nation's Gilded Age museums had opened their doors. Their efforts mirrored the growing array of philanthropic and professional alternatives that surrounded the rise of the "new woman." Rejecting the collectivism of both separatist and assimilationist campaigns, they forwarded a new set of aesthetic priorities. In the process, they helped to recast the parameters of the nation's artistic canon as well, challenging established museum methods, models, and imperatives in pioneering ways.

INDIVIDUALISTS

ANDERS ZORN, *ISABELLA STEWART GARDNER*

6

ISABELLA STEWART GARDNER
AND FENWAY COURT

Despite women's limited roles in the creation and management of museums, the myth of female cultural custodianship emerged full blown at the turn of the century. The debut of the "new woman," the closing of the frontier, the bureaucratization of American commercial and industrial life—all contributed to the national redefinition of gender roles during these years. While women's negligible position within museums was hidden from public view, the efforts of prominent patrons such as Isabella Stewart Gardner seemed to confirm the popular belief that American culture was becoming "feminized." Gardner received as much attention as she did because she approached the cultural arena in such flamboyantly individualistic terms. "C'est mon plaisir!" she gleefully proclaimed, tossing the mask of feminine self-abnegation and cultural deference by the wayside in pursuit of her highly personal aesthetic vision.[1]

Emblazoned on the lintel of Fenway Court, her motto, "It is my plea-
sure," perfectly encapsulates the spirit of this remarkable woman. She was
a strong personality, and few remained neutral in her presence. Moreover,
Gardner was regarded as an eccentric. An early harbinger of the "new
woman," she was both admired and abhorred for her unwillingness to
bend to more traditional female roles.

She also served as the harbinger of a new philanthropic style. Rather
than gravitating toward Boston's cultural mecca, the Museum of Fine Arts,
Gardner created a unique institution of her own. She embraced neither
separatist nor assimilationist norms. Instead, she stormed the male citadels
of culture and taste in her own way, on her own terms, setting the stage for a
string of individualistic women who collectively helped to transform the
contours of the American art world in the opening decades of the century.
On the crest of the twentieth century, then, the stage was cleared, the spot-
light narrowed. Shunning the collectivist enterprises of the past, individu-
alists such as Gardner began to change the world on their own.

Their efforts were counterpointed by a growing national concern with
the "feminization" of American culture. As an article, "The Feminizing of
Culture," explained in 1912, women were "steadily monopolizing learn-
ing, teaching, literature, the fine arts, music, the church, and the theater."
Many such jeremiads had an almost elegiac tone. Commentators com-
plained that women were "fully in possession of formal education," that
they "fill[ed] nearly all the teaching positions," and that "our elementary
schools are being feminized." Others contended that "the whole higher
culture is being feminized." Observers noted that the nation's theater, lec-
ture, and concert audiences had come to be filled primarily with women,
who constituted an even higher percentage within the nation's galleries,
where "one sees *less than five percentum* of men present." Thus, "the germ
of feminization is firmly planted in the whole national intellectuality," one
source sternly cautioned, adding that "woman has the practical monop-
oly." For some this prophesied disaster, eliciting predictions that "if the
entire culture of the nation is womanized, it will be in the end weak and
without decisive influence on the progress of the world."[2]

The intensity of these concerns and the vigor with which they were
debated is striking, particularly given the limited roles that were actually
accorded female painters and patrons. Concerns about the perils of "femi-
nization" masked a deeper ambivalence about the role of cultural en-
deavors in American life. Many Gilded Age Americans were afraid that the
country was losing its "vigor," its combativeness, its ability to compete.
And cultural pursuits, with their emphasis on the cloistered life of the intel-
lectual, were seen as a mark of this decline.[3]

Theodore Roosevelt's ringing 1899 endorsement of "the Strenuous Life" both captured and helped to create the spirit of his age. Published shortly before he became president, Roosevelt's clarion emphasized the need for active pursuits rather than passive intellectuality, nature rather than culture, and the controlled confrontation of the playing field rather than the polite gentility of the parlor. The new interest in physicality suggested by Roosevelt's dictum struck a responsive chord precisely because it held the key to sharpened gender distinctions. Despite their advances in education and art, women were biologically predestined to be the weaker sex. As one article explained, "One reason for the present rage for athletics is that the boys have been driven from the classroom to the football field by force of feminine competition. It is the only place where masculine supremacy is uncontestable."[4]

The Gilded Age enthusiasm for sports spilled over into the twentieth century, as baseball became a national pastime and college football a national passion. Even the prize ring became an increasingly respectable spectator sport for gentlemen of property and standing. Although the sport was tempered by the introduction of boxing gloves and a new emphasis on standardized rules, the public's growing captivation with the ring echoed a "powerful upsurge of interest in male physicality." In the words of one historian, the "upper-class fascination with prowess was stimulated in part by fears that modern living rendered males intellectually and emotionally impotent; men emphasized the importance of vigor because, rather suddenly, they were terrified of losing it." In effect, "sports taught manliness in a violent world. All that was feminine, sentimental or romantic . . . was expunged on athletic fields of battle."[5]

As the sportsman's popularity waxed, the intellectual's waned. As women became more literate and more cultured in the decades after the Civil War, anti-intellectualism increasingly became a badge of masculinity. Some attributed this growing rift to men's "mental laziness and lack of ambition"; others cited an increased reverence for practicalities and the notion that "women are more interested in the humanities; [while] men more readily pursue the sciences." Some observers, such as President Lowell of Harvard, felt obliged to vote "a vigorous affirmation of the value of culture." Others demurred. Shortly after Lowell issued his endorsement, it was countered by a series of articles in *Popular Science Monthly,* which detailed the physiological perils inherent in studying nonutilitarian subjects such as Latin, "which afterwards became a drag upon the whole nervous and psychic economy."[6]

Although some commentators clung to the notion that America still needed "men of quiet tastes and keen intellectual interests," others were

more skeptical. Thus, an 1897 article warned of the dangers of being "over-sophisticated and effete," since men such as these ran the risk of being "paralyzed or perverted by the undue predominance of the intellect." In a reversal of Enlightenment biases, men were now urged to draw closer to nature, leaving the artificiality of cultural pursuits to the ministrations of women. As one observer explained, "Every step in civilization is made at the expense of some savage strength or virtue." As an antidote to the cloy-ing atmosphere of overcivilization, men were urged to "leave the close air of the office, the library or the club, and go out into the streets and the highway. Consult the teamster, the farmer, the wood-chopper, the shep-herd or the drover. You will find him as healthy in mind . . . [and] strong in natural impulses, as he was in Shakespeare's time. . . . From his loins, and not those of the dilettante, will spring the man of the future." Nature, rather than culture, held the solution to modern ills. Marked by a prefer-ence for the peace of the country rather than the din of the city, for fresh air and sunshine rather than the artificial comforts of steam heat, the "natural man" chose to "buffet wind and weather, and to wander alone in the woods." Only a man such as this could reclaim the masculinity that civiliza-tion had denied.[7]

Cultural endeavors ranked at the bottom of the agenda in these Whit-manesque scenarios. As early as 1892, one commentator was inspired to ask whether "art has any more hold on the American mind, or any more share in American culture, than alchemy or astrology." While some warned that "to take literature seriously is in itself almost a sign of decadence," others resolutely maintained that "the number of men who privately culti-vate the fine arts is insignificant." "If the truth were told," noted yet an-other essay, "most young American men" were clearly bored "when it comes to music, to art, to literature; nor do many of them take any of these things at all seriously." Another contended in 1914 that "probably four out of five active 'men of affairs' in their hearts look upon art as some remote, queer occupation, rather beneath serious attention from a man capable of doing really useful and well paid work; and their view of the artist is . . . [expressed] with a scornful curl of the lips." Given this bleak sce-nario, "if emancipated women had not applied themselves since 1870," the arts would have suffered "serous neglect and probable deterioration." While men were deemed the natural proprietors of such "practical" fields as "engineering, manufacturing, commerce, and other fields of pure and applied science," women were appointed the nation's cultural custodians by default.[8]

Whatever rhetorical gains might have been accorded them, the reality was quite different. Cultural repositories such as research universities and

museums remained firmly under male control, part and parcel of the emerging elite male power structure. For buccaneering centralizers like J. Pierpont Morgan and Henry Clay Frick, art patronage provided a point of access to institutional power, the trappings of gentility, and favorable publicity. In effect, fin-de-siècle misgivings about the feminization of American culture reflected a growing popular paranoia about changing gender roles, rather than recording an institutional fait accompli.

These misgivings were heightened by the careers of women like Isabella Stewart Gardner. She shocked her contemporaries to the extent that she did precisely because she so skillfully transgressed the prerogatives of men. Rather than a purely "feminine" creation, Fenway Court anticipated the institutional designs of some of the nation's wealthiest and most ambitious twentieth-century male connoisseurs. And like the collections of the "princes" of American industry and finance, it publicly celebrated the acquisitive prowess of American capitalism in decidedly competitive ways. Fenway Court and the institutions that followed it, such as the Morgan Library and the Frick Museum, marked the advent of a new philosophy among American collectors. Earlier civilizations had acquired their cultural dowries through two means: war and patronage. The opening of the Louvre in 1802 was a significant political nod toward the earlier approach. Stocked with the booty from Napoleon's military campaigns, it served as a paean to France's military might. Fin-de-siècle Americans opted for a different approach, embarking on an extended campaign of commercial plunder. Within this context, each act of cultural consumption was deemed a major victory for the capitalistic ethos, a subtle statement of the economic superiority of the American way. International fairs such as the 1876 Philadelphia Centennial Exposition reinforced these trends, heightening the country's curiosity about the outside world. Newly enriched with the spoils of wartime expansionism and widening international markets, Americans came to view the rest of the globe as their bazaar. As one of the characters in Emile Zola's tale of artistic genius and depravity, L'Oeuvre, wistfully noted, "all the best paintings are liable to be dispatched to America."[9]

In the process, foreign art became a commodity, to be traded to the highest bidder. Uprooted from their ancient sites and shorn of their religious and political connotations, the paintings and statuary that were imported to America took on new meaning, trophies in a highly acquisitive game. In his brilliant treatise The Bourgeois and the Bibelot, art historian Remy Saisselin underscores the philosophical differences that separated the Gilded Age collector from the aristocratic patrons of the past: "In the old regime possession by nobility conferred cachet upon the work; in the

bourgeois world it was the other way around." Steeped in an aura of no-
bility and privilege, prized canvases and objects d'art lent authority to the
pretensions of America's nouveaux riches. In the process, the mere act of
possession became a sign of cultivation; the act of acquisition became an
end in and of itself. To quote Saisselin again, these people "needed art as
only a nineteenth-century bourgeois could need it—as only a glutton can
require food—quantitatively."[10]

What began as a trickle in the decades before the Civil War became a
flood after the Columbian Exposition. Fed by the growth of enormous for-
tunes, collectors and connoisseurs reached into the world's bazaars and
made them America's own. Thus, as art critic Frank Mather explained, al-
though "the United States produces her own art more readily than did
Rome, . . . the art that gives her prestige in the world is still that which her
dollars have wrenched from Europe and Asia." Mather charted this steady
drift of the world's great art to American shores with the comment that,
whereas before 1893 it was difficult to find authentic European artworks of
fine quality in the United States, by the 1920s it was only by "chance that
any very desirable object of art will be sold elsewhere than to America."
The underlying reason stemmed from simple economics. "There is such a
thing as an immensely wealthy and powerful nation not wanting art," he
explained, "but there is no such thing as a wealthy and powerful nation
wanting art and not getting it."[11]

The growth of America's store of artistic riches was faithfully tracked
and celebrated in the press. Even the sternest critic admitted that artistic
endeavors had the power to burnish the country's reputation as the home
of "a wealthy and cultured people." "To possess great museum and pic-
ture galleries is one of the marks of a great nation; every Rembrandt or
Velazquez" was met by "a thrill of patriotic pride." Artworks also helped to
justify the capitalistic system. President Coolidge elaborated on this theme
in an uncharacteristically eloquent address at the Carnegie Institute. As he
explained, "Our industrial life" was often depicted as "the apotheosis of
selfishness." Yet "the rattle of the reaper, the buzz of the saw, the clang of
the anvil, the roar of the traffic are all part of a mighty symphony, not only
of material but of spiritual progress. Out of them the nation is supporting
its religious institutions, endowing its colleges, providing its charities, fur-
nishing adornments . . . organizing its orchestras, and encouraging its
painting." Art and commerce, philanthropy and capitalism went hand in
hand.[12]

These attitudes also helped to legitimize individual collecting on a new
scale. Frank Mather limned the distinction between American collectors
and connoisseurs in 1910. While connoisseurs such as Henry Marquand

were temperate and well informed, collectors were often simply rapacious. Beyond this, their motives ran the gamut from "the finest connoisseurship, through grades of inspired audacity, to the sheer omnivorousness of plutocratic vanity." Their cravings represented "an ideal, if at times ruthless, expression of our new capitalism," a genre of "capitalistic idealism as expressed in art." Quantitatively, as well as qualitatively, the country's collectors and connoisseurs eventually netted remarkable gains. According to Mather, one Rembrandt in thirty was held in American repositories in 1893; by the 1920s the ratio had risen to one in seven. By 1900, the drain of European treasures had become so severe that countries such as Italy, England, and France began to pass restrictive legislation to stem the flow. While some shuddered at these trends, others cheered. "It is frequently said that America is rapidly absorbing the world's best art, and this view is generally held in Europe," the *Nation* noted. As a result, "we are feared by those whose condescension we formerly endured."[13]

Mather took a particularly dim view of these activities, arguing that "a mere handful of . . . amassers . . . have demoralized the art market." As he explained, "They spend lavishly, and spoil the game for poorer people." In Mather's opinion, this sort of unbridled passion for acquisition was little more than a vice: "Morally considered, the art collector is tainted with the fourth deadly sin; pathologically, he is often afflicted by a degree of mania. His distinguished kinsman, the connoisseur, scorns him as a kind of mercenary, or at best a manner of retrograde." Despite Mather's misgivings, many of the country's great collectors received a considerable amount of favorable publicity for their activities, which were faithfully chronicled in the press, counterpointing popular misgivings about the "feminization" of American culture. Just as the mixed record of women's efforts in building arts institutions belied public assumptions about the extent of their cultural authority, so the aggressive acquisitiveness of rapacious collectors like J. Pierpont Morgan belied the notion that cultural patronage was an increasingly feminized pursuit. In the words of another cultural philanthropist, Otto Kahn, "the day of the pioneer of culture and idealism [had] come," and in many of the most prominent instances, that pioneer was a banker, a lawyer, or a corporate chief. Indeed, many of these men may have been lured into donning the patron's mantle precisely because the sensual pleasures of acquisition were so acute, and the stakes so high.[14]

J. Pierpont Morgan may have been one of the collectors that Mather had in mind when he penned his critique. Born in 1837, Morgan was the grandson of a successful Connecticut innkeeper and the pampered son of a still more successful international financier. His father, Junius Spencer Morgan, traded in his Hartford dry-goods business for a post with George

Peabody's firm in London, where J. Pierpont was raised. From there the boy was sent to the Continent, schooled in a private institute in Switzerland and the University of Göttingen. Morgan's taste for art may have been kindled by his association with his first father-in-law, the New York collector Jonathan Sturges, or it may have come from his schoolboy companion William Riggs, a Washingtonian with a strong collecting bent. Unlike many American collectors, Morgan was a cultivated cosmopolite, blessed with a keen eye for quality.

By all accounts, he was a formidable physical presence as well, with a gaze of stunning intensity and a disconcertingly roseate nose. Morgan's business acumen was legendary, as was his imperiousness. He and a handful of equally wealthy associates consolidated the nation's railroad system in the wake of the depression of 1893, and helped to stem a national financial panic in 1907. He was respected by some, feared by many, and loathed as a symbol of capitalistic arrogance and excess by still more. Morgan's railroad empire became the target of the government's ire in 1902 and was disbanded by the Supreme Court two years later. Although the fortunes of industrialists such as Andrew Carnegie and John D. Rockefeller exceeded Morgan's holdings by a considerable margin, the financier was still among the icons of his age.[15]

He was also a collector of legendary proportions. Hailed in one obituary as "the greatest collector of all time," he had "a love, almost a passion for beautiful and interesting things." Although restrained during his father's lifetime, Morgan devoted the last twenty years of his life to a veritable orgy of acquisition. He was particularly attracted to Renaissance art and the old, the beautiful, the rare, buying European and Asian treasures by the lot. In the process, he helped to escalate art prices across the board. In one instance, he bought Gainsborough's painting of the duchess of Devonshire for $150,000, even though the canvas had changed hands for a third of that price just sixteen years earlier. In 1907 he paid $1.275 million for five pieces from Rodolph Kann's collection, including Rogier van der Weyden's painting of the Annunciation and three canvases by Hans Memling. Enamels and ancient porcelains, manuscripts and Old Masters, all made their way into Morgan's holdings, often for record amounts that may have increased art prices as much as threefold over the two decades during which he collected.[16]

He delegated the responsibility for finding these treasures with the efficiency of a corporate CEO, often drawing flocks of expectant dealers in his wake. Those with insufficient credentials were brusquely turned away. To quote an essay from the *London Daily Mail* describing one of Morgan's Egyptian sojourns, "Waves of these amateur art dealers . . . [swept] upon

the hotel from early morning to late at night and [were] repulsed with the regularity of surf on the beach." Instead, he relied most closely on the advice of his nephew, Junius Morgan, his librarian, Belle da Costa Greene, and the celebrated dealers Henry and Joseph Duveen.[17]

During his lifetime, Morgan was more noted for his acquisitions than his beneficence. However, several of his biographers emphasized that one of his motives for collecting on such a massive scale was to build one of the world's great museums in New York. Toward that end, he joined the board of the Metropolitan Museum of Art in 1888, assuming the presidency in 1904, a position that he held until his death nine years later. Morgan ruled the museum like his business ventures, with an authoritarian hand. Under his presidency, the board was revamped and filled with his fellow millionaires, and the staff was augmented with such notable additions as the acridly witty British connoisseur Roger Fry. Although Morgan had planned to bestow most of his collection on the museum, the plan foundered when the city refused to appropriate the necessary funds for a new wing to house his gifts in 1911. Instead, the collection, which was reportedly worth $60 million, passed to his son. Some of the pieces, such as Morgan's superb collections of French decorative and Gothic art, stayed with the museum, but most were briefly lent for one massive exhibition after his death in 1913, and then dispersed. Some of his holdings were given to the Wadsworth Atheneum, and his priceless collection of manuscripts formed the nucleus of the Morgan Library, but the bulk of his collection was ultimately sold.[18]

Many of the most desirable pieces were purchased by rival collectors who later featured them in museums of their own. For example, Henry Clay Frick paid $1.25 million for a series of Fragonard panels that later became one of the major attractions of his Frick Museum. The son of a Pennsylvania farmer who parlayed his family's holdings into a small coke and coal empire, Frick later became one of Andrew Carnegie's partners in the United States Steel Corporation. As his fortunes improved, he became one of the nation's leading collectors as well. Frick began collecting in the 1890s and may have developed the idea for using his holdings as the nucleus of a museum after his visit to Sir Richard Wallace's collection in England. With this end in mind, his purchases accelerated after 1900, yielding an enviable cache of Rembrandts, Holbeins, and Vermeers. Twelve years later, he invested $2.4 million in the site of the old Lenox Library, adding another $1.6 million for a mansion to house his collection. When he died in 1919, Frick bequeathed his house, his collection (which was then worth an estimated $50 million), and an additional $1.5 million for its upkeep to the City of New York. By the time the Frick Museum finally opened

to the public, following the death of his wife in 1931, the endowment fund had reached a hefty $25 million.[19]

Others followed a similar pattern. Charles Lang Freer amassed an outstanding collection of Oriental art with the aid of the painter James McNeill Whistler and the noted connoisseur, Ernest Fenollosa. In an unusually patriotic gesture, the industrialist offered his collection to the Smithsonian Institution. Since federal support for the arts was almost nonexistent during these years, the trustees initially wavered, but accepted his offer under presidential duress. Freer ultimately contributed not only his collection but an additional $1 million to ensure that it would be adequately housed, with the provisos that the building bear his name and that "his collection should never be added to or diminished."[20]

Similarly, Morgan's attorney and fellow Metropolitan trustee John G. Johnson bequeathed his holdings and his mansion to the city of Philadelphia as a public museum. Johnson was one of the country's most prominent lawyers, counting Morgan, Frick, and John D. Rockefeller among his clientele. When he died, he left a collection of almost twelve hundred items, ranging from paintings by the Italian Renaissance master Giotto to contemporary works by James McNeill Whistler. The house, which was crammed with "old masters on both sides of the doors, on the stairways, high on every wall, and even over his bathtub and above the rows of his shoes in his dressing-closet," was eventually deemed a firetrap, and the paintings were transferred to the Philadelphia Museum of Art.[21]

The notion of creating a public museum from a private collection was a time-honored idea. While antebellum patrons Luman Reed, James Jackson Jarves, Robert Gilmor, and Thomas Jefferson Bryan failed to create permanent institutions around their collections, later efforts often succeeded. The Corcoran Gallery in Washington began with the generosity of a single man, as did the Walters Gallery in Baltimore and the Barnes Foundation in Pennsylvania. In many respects, these ventures institutionalized the more informal practice of opening private galleries to public view that dated from the days of Luman Reed. As these examples suggest, most of these initiatives were forwarded by men. During the Gilded Age, especially, women were urged to guard the privacy of their homes, rather than flinging them open to the public in the name of art.

Isabella Stewart Gardner was the first female patron to challenge those prohibitions in a serious and systematic way. She defied easy categorization. Indeed, Gardner evoked the strong reactions that she did because she managed to sidestep contemporary prescriptions for feminine demeanor for women of her class. In many respects, her career seemed to exemplify the growing prerogatives of the "new woman." Caroline Ticknor captured

the essence of these changes in her 1901 essay, "The Steel Engraving Lady and the Gibson Girl." In it, she limned a imaginary conversation between the two archetypal females. It begins with the aggressively individualistic Gibson Girl proclaiming—in words that echoed Gardner's actions—"I can do everything my brothers do; and do it rather better, I fancy." College, sports, professions: all fell within the Gibson Girl's purview, since, as she explains, "each woman owes a duty to herself, to make the most of her Heaven-given talents."[22]

"In place of your higher education, I had my music and languages and my embroidery frame," the Steel Engraving Lady softly counters, "your public aspirations, your independent views, your discontent are something I cannot understand." Nor could she fathom the notion of female competitiveness. "Do your brothers approve of having you so clever that you compete with them in everything?" she queries. "We don't require their approval," snaps the "new woman." "We're not a shy, retiring, uncomplaining generation. We're up to date and up to snuff," and that was all that mattered.[23]

Yet Gardner's career appears to be a slightly uncomfortable fit in this scenario, resting somewhere "betwixt and between" the positions assigned to her generation by custom and convention and the self-assured aggressiveness of the Gibson Girl. While the Gibson Girl was college educated and planned to have a job, Gardner was a self-educated connoisseur who limited her profit-making ventures to the charity benefits staged in her salon. Gardner frightened and fascinated her contemporaries precisely because she refused to fit any mold. Born to privilege, wealth, and a stern set of expectations about upper-class feminine demeanor, she defied the conventions that she was bred to revere. Her career was a premonition, a signal of the inexorable drift toward female individualism that began to accelerate with the opening decades of the twentieth century, and as such it grated against the norms of many of her contemporaries and peers.[24]

Unlike the cultural individualists who succeeded her—women such as Gertrude Vanderbilt Whitney and Edith Halpert—Gardner would prove to be a transitional figure. Historians have borrowed the anthropological notion of "liminality" to describe the fortunes of the "new woman"— particularly the professional lives of the first generation of college graduates who moved into nontraditional careers such as settlement work at century's end. Briefly, this idea describes the transitional state embodied in rites of passage. The liminal figure "wavers between two worlds," caught in limbo between one system and another. To quote Arnold van Gennep's classic study, during this precarious "novitiate, the usual economic and legal ties are modified, sometimes broken altogether. The novices are outside

society, and society has no power over them," making them "untouchable and dangerous, just as gods would be." By virtue of their special status, these novices are able to create new models beyond the bounds of traditional constraints.[25]

Gardner would use her museum as a novitiate for the new woman. Neither fully of the twentieth century nor obeisant to the precedents of the nineteenth, she presaged the activities of both an emerging group of highly individualistic women patrons and a coterie of aesthetically competitive male connoisseurs. As such, she managed to elude the rigid classifications that served to distinguish most Gilded Age female patrons from their male peers. And she did so by domesticating the "sacralization" of art and translating it into highly personal, highly public, and resoundingly unbureaucratic terms.

Gardner delighted in flaunting conventions, including the notion that men collect, while women privately display. Like Candace Wheeler, she was the indirect heir of Sarah Worthington King Peter. While Wheeler blended charity and art into a national, women's aesthetic crusade, Gardner finally brought Peter's vision of an American gallery, stocked with Old Masters and developed under female stewardship, to fruition. Yet there were some striking revisions in Gardner's design. While the Ladies' Academy's limited budget decreed that Peter would only aspire to copies, Gardner captured some of Europe's greatest masterpieces. And, because of legislative gains passed in the interim, she was able to do so with her own funds. Freed of the constraints of having to depend on the fund-raising skills of her less ambitious peers, Gardner finally gave substance and form to Peter's most radical designs.

Isabella Stewart was born in 1840, a full twelve years before Peter's plans for her Ladies Academy were set in motion. Isabella was the only surviving daughter of David Stewart, a wealthy New York ironmaster. Like many of her female contemporaries, she had a spotty education, taught by private tutors and brief stints in finishing schools in the United States and France. She met a number of Americans while in Europe, including Julia Gardner and Ida Agassiz (later Mrs. Henry L. Higginson), who became a lifelong friend. These friendships subsequently led to an extended stay in Boston, where she met and married Julia's brother, John Lowell Gardner, in 1860.

The early years of her marriage seem to have been rather conventional. The Gardners had a son in 1863, which may have accounted for her lack of involvement in wartime charities. The baby's death two years later, coupled with the news that she was unable to bear children, sent Isabella into a deep depression. She and her husband soon turned to travel as a cure, occasion-

ally interspersing their regular trips to Europe with more exotic fare. In 1874, for example, the Gardners wintered in Egypt, and embarked on an ambitious around-the-world junket in 1882.

Jack Gardner was well suited to indulge his wife's taste for travel. The scion of one of Boston's wealthy Brahmin clans, he was a prominent socialite who served on the board of the Museum of Fine Arts. His money and his social position allowed Isabella a greater degree of freedom than many Gilded Age matrons enjoyed, and he seems to have been a fairly accommodating spouse. By the 1880s she had begun to come into her own, publicly displaying an increasingly vivid personality. "Mrs. Gardner is one of the seven wonders of the world," enthused one reporter. "There is nobody like her in any city in this country. She is a millionaire Bohemienne. She is eccentric, and she has the courage of eccentricity. . . . She often leads where none dare follow."[26]

Many of Gardner's pranks became the stuff of legends. In one instance, she apparently decided to take Rex, one of the lions in the Boston zoo, for a stroll through the zoo's main hall, using his mane as an impromptu leash. The visitors in the hall were terrified, the press delighted. Another celebrated incident concerned a prize fight. Although attendance at the ring was becoming increasingly fashionable among middle- and upper-class men in the 1880s, it was considered a far less appropriate pastime for their wives, providing just the sort of challenge that Gardner most enjoyed. According to the story that later circulated, Gardner arranged for a private match between Knucksey Doherty and Tim Harrington, putting up the $150 purse out of her own pocket. Staged in one of the studios in the old Studio building, the contest was fought before an audience of her more adventurous women friends.

Whether or not the story is true, it certainly set the tone for Gardner's subsequent pursuits. In this instance as in others, she shocked and delighted her Boston compatriots by repeatedly transgressing male terrain. Her desire to challenge convention was as vivid in her cultural forays as in her most spectacular staged events. At a time when most women were expected to confine their ministrations to women's networks, Gardner assembled an entourage of male mentors, friends, and protégés. She indulged in male pastimes with impunity, from swilling beer and staging fights to cheering for the local baseball team. Her collecting brought her into a highly competitive male sphere, and she responded competitively. Her motto, "C'est mon plaisir," flew in the face of the notion of female self-sacrifice. As such, Gardner's "eccentricities" anticipated the advent of the "new woman," encapsulating the aspirations, anxieties, and fears of an entire age.

Henry James said she was "of an energy." Another admirer deemed her "the Boston end of the Arabian nights." Others assessed her exploits more coolly, noting that "in the inner circle of a concentric society, her eccentricity stood out in bold relief." As did Gardner's taste for cultural pursuits. Although many proper Bostonian women adopted quasi-professional careers as painters and domestic impresarios, Gardner framed her ventures more flamboyantly and on a grander scale. "Everything she does is novel and original," noted a local reporter. "She is the patron of art, music and the drama, she is the female Maecenas of Boston. She 'brings out' geniuses of all sorts. Poets, artists, Buddhist priests and Siberian political exiles—she is their refuge and their strength."[27]

Gardner's cultural interests were indeed eclectic. She was an avid opera buff and well versed in the theater and ballet. Anna Pavlova was one of her acquaintances, as was Lady Gregory, who was invited to lecture on her method of playwriting in Gardner's Music Room when she brought the Irish Players to Boston on tour. Gardner also patronized the Boston Symphony Orchestra and the Boston Pops, inviting favored musicians to play at her soirees. She regularly attended the performances of the Boston Musical Association and Charles Eliot Norton's lectures on art history. The range of her charitable enthusiasms was equally varied, encompassing everything from Massachusetts General Hospital to the New England Home for Little Wanderers. Gardner combined many of these interests when she opened the new music room in her Beacon Hill mansion in 1880, where she hosted everything from vaudeville shows to performances by international celebrities. Nellie Melba sang at one of her soirees, and Ruth St. Denis did her renditions of "The Cobra" and "Radha, a Hindoo Temple Dance" at another, in order to raise funds for the Holy Ghost Hospital for Incurables.

Of course, domestic benefits such as these were regularly sponsored by many of Gardner's contemporaries as well. Nonprofit entrepreneurship was one way in which middle- and upper-class women used their charitable ventures to engage in commerce; household benefits were another. Charity events that might once have been staged in the parlor took on new possibilities with the rise of the Gilded Age "palaces" of the rich and wellborn. Houses like Gardner's often included elaborate music rooms and private theaters. Ambitious society matrons used these household auditoriums to stage charity events with some of the most celebrated performers of their time. In return for a purchased ticket, they enabled local socialites to bask amid the talents of stars like Ignacy Paderewski, Walter Damrosch, Fritz Kreisler, and Nellie Melba, all of whom plied the domestic concert circuit during these years.

However, while Gardner may have mirrored conventional practices

with her household benefits, she sharply diverged from them in other ways. Some of the popular biographies of her life have tended to exaggerate her alienation from other women. Yet although she did attract the loyalty of a select group of strong-minded, accomplished matrons with a pronounced cultural bent, she shunned most traditional, separatist ventures. Julia Ward Howe and her daughter, Maude Howe Elliott, were two of her closest friends, as was Ida Agassiz Higginson. Howe was one of the founders of the New England Woman's Club, and her daughter was a professional painter, writer, and art critic who won the Pulitzer Prize in 1915. Cecilia Beaux, Vernon Lee, Annie Fields, and Sarah Orne Jewett—all of whom were professional writers and painters—were other friends in Gardner's circle. Many of these women were members of the It Club, a women's luncheon society founded by Gardner and Howe. But Gardner could be extremely competitive as well. She apparently actively disliked Louisine Havemeyer, an animus fed by both Mary Berenson and Mary Cassatt. Thus, while Berenson cattily reported to Gardner that she had visited the Havemeyer's "awful Tiffany house! Rembrandts, Monets, Degases ad infinitum—no real taste. . ." Cassatt maliciously dismissed "Donna Isabella" as a "poseur."[28]

Rather than relying on women's networks and separatist initiatives, Gardner gravitated most comfortably toward the company of men. By the 1880s she had begun to sweep a growing array of artists, musicians, writers, and scholars into her entourage. Henry Adams was an admirer who regularly attended her salons, as were Oliver Wendell Holmes and Henry and William James. She apparently supported several young musicians at crucial stages in their careers and used her private soirees to debut their talents among her rich and prominent friends, providing another twist to her role as domestic impresario. These friendships added other luminaries to her circle as well. Thus, Henry James introduced her to Whistler and Sargent, who became avid devotees.

Other women, including antebellum hostesses such as Sarah Worthington King Peter and Anne Lynch Botta, had attracted male luminaries to their salons. Candace Wheeler took these practices a step further, using her male contacts to lend legitimacy and artistic authority to her separatist campaigns. Gardner incorporated her male acquaintances and friends into her institutional designs in different ways, forging a network of symbiotic returns that echoed the activities of Luman Reed. Thus, while Gardner proved a ready patron for Sargent's paintings, he served as one of her scouts overseas, alerting her to opportunities to buy everything from Persian rugs to paintings by Watteau. She also persuaded her friends to patronize some of her protèges, such as the portraitist Anders Zorn. Sev-

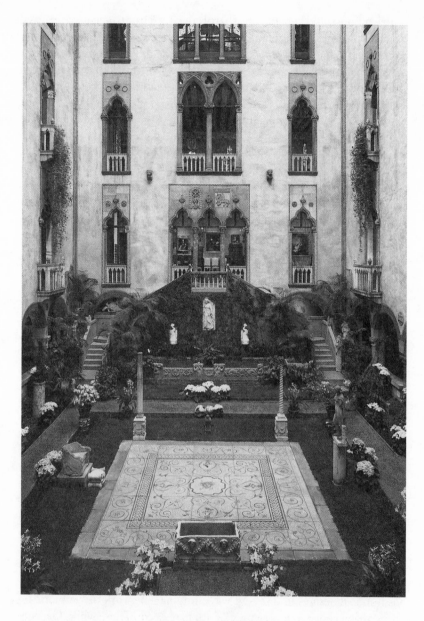

FENWAY COURT

eral years later, when his career was well established, Zorn reciprocated by finding a Bellini drawing for her collections. And, like earlier stewards, Gardner opened her private collections to interested painters and craftsmen. Thus, John La Farge was allowed to copy some of the ornamental borders at Fenway Court before the museum was formally opened. In return, he introduced her to the Japanese artist and connoisseur Okakura-Kakuzo, who became one of Gardner's closest friends.

Although women artists figured far less prominently in these proceedings, Gardner did occasionally notice their work. In fact, Sarah W. Whitman's painting *Dawn, Newport* was one of the first paintings Gardner acquired. Gardner later donated another of Whitman's works, *The Haycock* to the Worcester Museum of Art. She also tried to garner commissions for Julia Ward Howe's husband and may have helped him to gain a contract for a mural, *The Triumph of Time,* which he painted for the Boston Public Library. She visited Lilla Cabot Perry and Monet at Giverny in 1906, and lunched with Cecilia Beaux. Nevertheless, there is little evidence that she ever patronized Perry or Beaux, or lent them studio space (as she did for Sargent), or sought additional patrons for their works. Unlike Havemeyer and Palmer, Gardner relied more heavily on the advice and talents of men.

Like many Gilded Age patrons, Gardner began her acquisitions with prints and Salon paintings to decorate her house. She was a quick study, and by the mid-1880s her tastes were becoming increasingly sophisticated under the tutelage of local cultural authorities such as Harvard's noted art historian Charles Eliot Norton. Gardner made her first major acquisition in 1888, when she purchased a painting by the Spanish master Francisco de Zurbarán, in Seville. Another major find was Vermeer's *The Concert,* which she bought in 1892. By the 1890s she was well on her way to becoming a gifted connoisseur in her own right.

Gardner's acquisitions accelerated in 1891, after she received a $1.75 million bequest from her father's estate. This modest fund underwrote the bulk of her purchases, financing the Vermeer and several Botticellis, Titians, and Holbeins. The acquisition of Botticelli's *Lucretia* in 1894 was her first great coup, making Gardner "the envy of Boston." By 1896, she had added a Tintoretto, a Rembrandt self-portrait, and Titian's *Rape of Europa.* Originally painted for Philip II of Spain, the Titian had been celebrated by Peter Paul Rubens as "the greatest picture in the world." Gardner managed to acquire it after the Boston Museum of Fine Arts considered but ultimately declined placing a bid on it. As her biographer explains, "This crystallized Mrs. Gardner's opposition to the purchase of works of art by a committee" and strengthened her determination to "only work single-handed, and never [serve] on committees; she was so sure of

herself and her judgments that she would not waste her time trying to coop-
erate with a number of people who could outvote her." In the process, she
consciously eschewed the collective activities of the separatists and the as-
similationists who preceeded her.[29]

The Titian was an immediate success, to be followed in turn by a
Giorgione, a Rubens, and several additional Rembrandts (only one of
which proved to be a faulty attribution). Despite the quality of her acquisi-
tions and the warmth of their reception by local connoisseurs, by 1898 the
ever-indulgent Jack Gardner was beginning to question the wisdom of al-
lowing his wife to dissipate her inheritance. Isabella Gardner was a shrewd
bargainer who acquired many of her canvasses at a fraction of what they
would cost in a few years when collectors such as J. Pierpont Morgan en-
tered the scene. For example, she paid £20,000 for Rubens's portrait of the
earl of Arundel in 1898. Shortly afterwards, Jack Gardner's reluctance
forced her to decline a Rembrandt from Lord Carlisle's collection for half
that sum. Nonetheless, when Gardner scented the possibility of acquiring
a major portrait by Velázquez, she confided to her collaborator Bernard
Berenson, "Let us aim awfully high. If you don't aim you can't get there."[30]

"Few women in Boston have done so much for young men as has Mrs.
Gardner," a local newspaper admiringly reported, and few of her protégés
benefited more from her attentions than Bernard Berenson. Like Gardner,
Berenson was an alumnus of Charles Eliot Norton's lectures, and counted
himself among Norton's disciples. Gardner befriended him in 1887, while
he was still an undergraduate in Harvard. She was also one of several
backers who paid his way to Europe. Although their expectation at the
time was that Berenson would become a novelist, he increasingly turned his
attention to art instead, with the idea of developing a more "scientific" ap-
proach to attribution. Not one to tolerate violations of confidence lightly,
Gardner abruptly ended her correspondence when she realized that
Berenson had strayed from his original intent. He reentered her life five
years later, when he sent her a copy of his first book, *The Venetian Painters,*
in 1894. His initiative was well timed. As his biographer, Ernest Samuels,
explains, Gardner had recently begun collecting on a major scale and had
an "urgent need for guidance in the raging competition for the art treasures
of the Old World."[31]

She already numbered approximately twenty contemporary paintings
and several classical works such as the Zurbarán canvas in her collection by
the time that she and Berenson began their formal partnership in 1894.
Under his guidance, her purchases rapidly accelerated. With her usual
skill, Gardner negotiated the best possible terms, keeping Berenson's com-
mission to 5 percent in lieu of the 10 percent that dealers normally charged.

Most of their collaboration was conducted by mail. Gardner would send Berenson photographs of paintings that she had come across, asking him to assess their value. He in turn offered her the gleanings of the Continent, cabling to notify her as soon as a promising canvas appeared. It was a relationship rooted in symbiotic returns. Gardner gave Berenson the commissions and the opportunity to gain the experience he needed to further his career. In return, she increasingly relied upon his tastes and talents as "the most knowledgeable connoisseur of Italian Renaissance painting in Europe, one who was acquainted with the contents of nearly every significant public and private collection." And, as Samuels notes, the idea of helping Gardner to build a major museum for "his beloved Boston, stirred his ambition as nothing else could have done."[32]

Berenson shamelessly fed her ambition to possess a collection "of masterpieces and masterpieces only." To quote Gardner, she wanted "only the greatest in the world—nothing less need apply." As her expectations rose, so did the prices that she was prepared to pay. In 1897, she paid $200,000 for Van Dyck's *A Lady with a Rose* and acquired Crivelli's *St. George and the Dragon.* The following year, she added three Rembrandts, including the master's painting of a *Storm on the Sea of Galilee;* a Ter Borch; and a Cellini bronze from the Hope collection. Canvases by Raphael and Fra Angelico and a pair of Holbein portraits followed in turn, as did a portrait by Albrecht Dürer purchased in 1900. Between 1894 and 1904 alone, almost forty Old Masters were added to her holdings on Berenson's recommendations. A tally of the American owners of Rembrandts in 1910 placed Gardner near the top of the list with four of the Dutch master's paintings, a figure exceeded only by Louisine Havemeyer (8), P. A. B. Widener (6), John G. Johnson (6), and Benjamin Altman (6).[33]

The relationship that developed between this remarkable pair of gifted, egocentric connoisseurs often tested Berenson's patience and Gardner's credibility. Gardner was adamant in her insistence that he never offer a painting to someone else at the same time that he offered it to her. This happened only once, when both she and Susan Warren were offered a chance to bid on the Titian. "In future and for all time," she sternly admonished, "PLEASE don't let me and some one else know of the same picture at the same time. It may only be a prejudice of mine—but it is disagreeable to me to be put EN CONCURRENCE in these things." And yet, her loyalty to Berenson was unshakable. When word got back to Jack Gardner her protégé had been padding some of Isabella's bills, he angrily passed the news on to his wife. Surprisingly, the normally canny Isabella refused to believe his revelations, writing instead to warn Berenson that "you have enemies, clever and strong." She even shrank from describing the nature of her hus-

band's charges, adding apologetically that "every word I write seems cruel and unnecessary." Samuels provides some insights into the willingness of this ordinarily astute bargainer to allow herself to be duped: "Craving affection as she did, and never sure of it in Boston society, whose taboos she loved to flout, she found [Berenson's] flattering protestations irresistible."[34]

Yet in her dealings with other people and institutions, she could be relentlessly competitive, actions that flew in the face of accepted contemporary canons of feminine demeanor. Gardner developed a particularly strong sense of rivalry with the Boston Museum of Fine Arts. In one instance, she instructed Berenson that "if our stupid and impossible Art Museum does not get the Giorgione . . . please get it for me. . . . They won't move quickly enough to get it I fear." Although she insisted that "I don't want to take it away from them," she decided to place a bid on the canvas because she felt that they might "lack the courage to get it—and lose it by delaying." When her Titian was triumphantly unveiled, Gardner coyly informed Berenson that "I am having a splendid time playing with *Europa*. She has adorers fairly on their old knees—men of course." Gardner later gleefully added that "many came with 'grave doubts'; many came to scoff; but all wallowed at her feet."[35]

Another theme was Gardner's constant concern about money and her incessant admonitions to bargain down the price. In describing her determination to have another Rembrandt, she asserted that she would have to "sell my clothes [and] eat husks" to do so. When she agreed to place a $150,000 bid for Gainsborough's *Blue Boy,* she predicted that she would be "steeped in debt—perhaps in crime—as a result. . . . I shall have to starve and go naked for the rest of my life and probably [die] in a debtor's prison." By 1896 her playful jibes took on a more serious note as she confessed that she was "selling little by little my stocks" and that her husband was pressuring her to reduce her expenditures. Thus, she told Berenson, "I have not one cent and Mr. Gardner (who has a New England conscience) won't let me borrow even one more! I have borrowed so much already. He says it is disgraceful." Two years later, she confided that "I can't borrow any more from outsiders, as I have used up all my collaterals [*sic*]." And yet, throughout this period, her ambition to build a truly great collection remained undiminished. "I am now forced to buy only the GREATEST things in the world," she announced, "because they are the only ones I can afford to go into debt for. And that is what I am obliged to do now."[36]

Fortunately, by the time that American collectors began to pay the inflated prices of the Morgan era, most of Gardner's collection was already in place. Given the prices that some of these paintings would soon fetch, she

did remarkably well. A 1917 inventory of her holdings reveals that she paid a scant $19,300 for her Fra Angelico, $57,000 for one of her Botticellis, $53,531 for the Dürer portrait, $36,455 for Raphael, and $62,275 for one of the Rembrandts. The Titian, which cost $100,000, was one of her most extravagant acquisitions. Gardner complained to Berenson in 1899 that, despite her increasingly difficult financial situation, people mistakenly believed that she was fabulously wealthy because "I am the only living American who puts everything into works of art . . . instead of into show and meat and drink."[37]

By 1900 Gardner's acquisitions began to slow as she was increasingly unable to raise the necessary funds. She reported to Berenson, "My trustees tell me I have positively nothing as security, left to borrow on, and unless some friend can and will lend; all is up." The turning point came with her husband's death in 1898. Although her biographer Morris Carter contends that Jack Gardner left his estate in trust but "authorized her at any time to demand the payment to herself of any part of the principal she might wish," Gardner's letters suggest a much different arrangement. As she plaintively explained to Berenson in 1899, "I have to go through an enormous amount of red tape now, besides the usual money difficulty. So I can't *say* Yes or No, to anything." A little over a week later, she noted that she and her business manager had almost come "to blows—for apparently, no red tape can be cut yet. All sorts of legal questions and demands have to be settled, and that means time." When Berenson offered her a chance to buy Titian's *Sacred and Profane Love* for $818,000 later that year, she predicted that her husband's executor, George Gardner, would withhold the funds, since "such a price would seem an insanity to him." A subsequent missive confirmed that he had declined her request by saying that "no one in their right mind would ever think of such a thing. And that it is his duty to keep me from doing just such things." Rather than controlling her inheritance, the redoubtable Gardner apparently was at the mercy of her late husband's trustees.[38]

Perhaps because of these constraints, she began to display "an unreasoning fear of poverty" as she aged. In one instance, she even entertained guests in midwinter with neither a fire nor heat. As one Boston wit described the occasion, she "put the last touch to her decorations with a frieze of eminent Bostonians." Although slow to perceive the gravity of her situation, even Berenson finally admitted that he had "always more than suspected that you were really spending all your fortune on works of art."[39]

Nonetheless, Isabella Gardner relentlessly pursued her plans to create a public museum after her husband's death. It was probably Jack Gardner's idea that it be located on the Fenway, rather than in their less spacious quar-

ters on Beacon Hill. Their friends had dubbed her collection "Musée Gardner" by 1896, adding fuel to the notion of permanently institutionalizing it as a public museum. By 1899 Gardner had already begun to open her Beacon Street gallery to the public for short periods of time, with the proceeds earmarked for charity. Her friend Ida Higginson traced the museum's inception to their student days in Europe and Gardner's vow that, if she ever inherited any money, she would buy "a house like the one in Milan, filled with beautiful pictures and objects of Art, for people to come and enjoy." Whether Higginson's memory is correct, or whether the idea was born with Gardner's acquisition of a Rembrandt self-portrait in 1896 as she herself later suggested, by the time of Jack Gardner's death in 1898 the notion was firmly in place.[40]

Within a year, the deed to a parcel of land on the Fens had been secured, providing an open construction site in a pleasant area that had been landscaped by Frederick Law Olmsted. With characteristic vigor, Gardner quickly took control, personally directing the project's execution and design. Not only did she select every decorative and architectural detail, she managed to blend the gleanings of years of foreign acquisitions into a harmonious whole. While she commandeered the aesthetic details, her architect assumed a more subordinate role, sifting through the engineering problems.

The extent of Gardner's involvement was impressive. All of the artifacts were kept locked in a warehouse, and nothing could be removed to the construction site without her consent. Once on the premises, she superintended the unpacking and placement of each item. Gardner, rather than her architect, dictated the placement of every pillar, every arch, and every stone. She also kept a vigilant watch over the workmen, firing any man whose efforts failed to meet her standards. In some instances, she even showed them how to do the work herself. As her biographer noted, Gardner "not only enjoyed working with her hands, but particularly enjoyed showing skilled workmen how she wanted them to work." When the painters failed to produce the marbled effect that she had envisioned for one of the rooms, Gardner scrambled up the scaffolding to show them how to do it. She even took an axe to one of the beams for the Gothic Room, demonstrating how it should be cut while the workmen nervously huddled around her, "begging her not to cut herself."[41]

She took on the municipal authorities as well. Gardner had vetoed the use of a steel frame construction with the logic that if marble columns were strong enough to provide an adequate infrastructure for Italian buildings, they should suffice in Boston as well. When a local building inspector challenged this idea, Gardner's response was brief and to the point: "I am well aware that you can stop my building," but if "Fenway Court is to be built at

all, . . . it will be built as *I* wish it and not as *you* wish." The resulting museum was a mosaic straight from Gardner's imagination, blending examples of medieval stained glass with Mexican tiles and portions of a Florentine palazzo. The final inventory listed "290 paintings, 280 pieces of sculpture, 60 drawings and 130 prints, 460 pieces of furniture, 250 textiles, 240 pieces of ceramics and glass," and a host of architectural details. The end result was "the most personal of all personal museums," an unchanging testament to Gardner's "theories of what a museum should be." Fenway Court took the integrated ideal embodied in Gilded Age museums, fairs, department stores, and household decoration to its fullest realization, piecing together a unified work of art from the architectural fragments of a cosmopolitan past.[42]

Begun in 1899, Fenway Court was publicly opened for the first time on New Year's Day, 1903. The museum's debut was staged with Gardner's usual flair. She must have taken extreme pleasure in watching the scions of Boston's leading families line up to pay court to her as she received them at the top of the grand staircase. Demurely clad in black, her dress enlivened only by two diamond antennae bobbing above her hair, she greeted each in turn. The sense of suspense was deliberately heightened by the program, with guests contained in an anteroom for a full musical performance before the doors to the garden were finally opened.

Although some reportedly chafed at the etiquette of the receiving line, the evening was a stunning success. William James wrote to praise the "aesthetic perfection" of Gardner's design, and the "extraordinary and wonderful moral influence" it exerted upon the guests. Henry Adams called it a "tour de force." The press was equally entranced. Hailed as "the greatest collection of paintings in America" and a "faultless environment," Fenway Court was described as one of "the real triumphs in museum making." "This creation is no slavish copy," one report admiringly noted, "but a noble, deeply felt reproduction on American soil of the picturesque beauty which charms one in the Old World." The New York art critic Frank Mather later underscored the point that her collection was more uniform in quality than either that of the Boston Museum of Fine Arts or the Metropolitan Museum of Art, the result of "a dominating personal taste with either no organization or the very simplest."[43]

Mather was absolutely correct. Although Gardner formally chartered the institution in 1900 with a small board that consisted of herself and three male trustees, she managed to retain complete control. By the 1920s the board had grown to include seven men, but the pattern remained the same. Gardner, not the board, hired the staff, luring Morris Carter from his position at the Museum of Fine Arts to become the first director of Fenway

Court in 1919. Even after her death in 1924, she refused to relinquish control of her creation. Under the terms of her will, if the trustees stage an exhibition of paintings other than her own or change the general arrangement of the furniture or displays, the museum and all its contents will pass to Harvard University, and the university will be charged with its dissolution.

She maintained her grasp over the project, and her commitment to its completion, against sometimes formidable odds. Perhaps the most unpleasant incident was the brouhaha over the unpaid customs duties demanded by the federal government in 1903. Until 1909, when legislation was passed to allow artworks over one century old free entry, imported objets d'art were subjected to punitively high *ad valorem* duties at rates that doubled their cost. During Jack Gardner's lifetime, these duties had been paid automatically, "without question." Afterward, as Gardner saw her resources dwindling, she began to take risks, asking Berenson if some of her purchases could be "sent to me *smuggled . . .* so that I may get [them] as soon as possible without any duties?" In 1903 the government finally clamped down, demanding $200,000 in duties on the articles she had imported since her husband's death.[44]

Moreover, the Customs Service levied the penalties by claiming that Fenway Court failed to qualify as a museum. The works in question had been brought in at reduced rates under the "public exhibition and museum law." However, because Gardner still lived there and opened her house to the public only four days per month, the government declared that it was a private residence rather than a museum. Gardner valued her money less than her privacy, and surrendered the sum. Several years earlier, she had prophetically complained to Berenson that "this ungrateful America with its tariff and building laws and petty ignorant officials, is fast persuading me to give up the whole Museum idea. Every man's hand is against me." Her friends and admirers were extremely supportive during her ordeal. Charles Eliot Norton labelled the government's campaign "evidence of our national semi-civilization" and commended the "spirit with which you bear the trials and disappointments which result from the lack of due appreciation of your work and your intentions." Henry Lee Higginson was more humorous, but no less sympathetic, advising her that "if you think that you are to have a peaceful life, die at once!" Others asserted that Gardner was a "public benefactor who would be decorated, not taxed, by the Government, if we lived in a truly civilized country."[45]

In 1908 government officials confiscated the series of Ffoulke tapestries that had been smuggled into the country by her friend Emily Crane Chadbourne as household goods valued at $8,000. Gardner had lent the

tapestries to Chadbourne for her London apartment before bringing them into the United States. Ironically, Gardner may not have even known of her friend's plans. Since Americans who lived abroad for more than two years could bring in their household goods at reduced rates, Chadbourne undoubtedly made the gesture as a favor in return for the use of the hangings. Unfortunately, customs officials found them and called in the director of the Art Institute, William M. R. French, who placed their value at $82,000. Chadbourne graciously offered to pay the duties, but Gardner declined, paying the fines herself. As she confided to a friend, "My life is as usual— Music, people, and constant persecution from our government."[46]

Given the magnitude of her creation, the final tally of Gardner's expenditures was surprisingly small. The museum's holdings were estimated at slightly over $6 million at the time of her death, to which she added a $1.2 million endowment for its maintenance and approximately $450,000 in real estate. The rest of her bequests were relatively modest, with three animal protection organizations and a local school for crippled children heading the list at $180,000 apiece. Thus, at the time of her death, her entire estate was valued at less than $9 million, a figure slightly below the valuation placed on John G. Johnson's collection several years earlier, and a fraction of the amounts spent by Morgan and Frick.[47]

One of the reasons for these discrepancies is that women such as Gardner inherited their fortunes rather than earning them themselves. As a result, they had smaller amounts of money under their direct control, the sums were fixed, and the use of these funds could often be restricted by their husbands, their fathers, and the advisors who handled their estates. Gardner outlined the nature of these constraints in a letter to Bernard Berenson, penned shortly after her husband's death. As she explained, "I had two fortunes, mine and Mr. Gardner's. Mine was for buying pictures, jewels, bric-a-brac, etc. Mr. Gardner's was for household expenses. The income from mine was all very well until I began to buy big things. The purchase of Europa . . . was the first time I had to dig into capital, and since then those times have steadily multiplied. All that reduces the principal, and then the income gets smaller and smaller, and leaves very little chance to replenish the capital."[48]

Men like Morgan and Frick derived a steady (and often munificent) flow of income from their businesses, funds that were augmented in Morgan's case by a substantial inheritance as well. Because of lingering proscriptions against female employment, most middle- and upper-class women avoided paid jobs. Indeed, this was one of the lures of nonprofit entrepreneurship. But it also meant that they often derived their money— including the sums they spent on art collecting and institutional develop-

ment—from static sources: inheritances from their parents and husbands, their dowries, and conjugal gifts. As a result, they had much smaller amounts of cash with which to collect or create new institutions in their own right, all of which underscored Gardner's brilliance as a collector and the depth of her determination in building Fenway Court.

In addition to the $1.75 million trust inherited from her father, Gardner inherited another $2.3 million from her spouse after his debts were paid, which provided her with an annual income of about $100,000. Added to the problem of a fixed and limited income was the additional challenge of dealing with the executors of her husband's estate. According to Ernest Samuels, after Jack Gardner's death "her advisers had succeeded to some extent in bridling her extravagance." As a result, Gardner's acquisitions quickly tapered off. Morris Carter later recalled that, "as the years went by, she gradually reduced her establishment and her scale of living. There were times when her friends thought she did not have enough food. . . . It was her determination that nothing should interfere with the fulfillment of the purpose which was now the centre of her life."[49]

Samuels estimates that Berenson helped her to spend over $1 million on forty paintings at the height of her buying between 1894 and 1903. The difference between this amount and the estimated $60 million that Morgan lavished on his pursuits, or even the $1.25 million that Frick reportedly paid to buy his Fragonard panels shortly after Morgan's death, serves to highlight a more fundamental difference between male and female largesse. From Girard College, to Peter Cooper's original $900,000 investment in Cooper Union at midcentury, to the $35 million that John D. Rockefeller paid to turn the University of Chicago into a world-class university, male philanthropists distinguished themselves by the munificence of their gifts. Because women traditionally had less control over their earnings as well as their inheritances, they tended instead to create their institutions with small donations of cash, backed by heavy infusions of volunteer time. This in turn limited the range of their options, and undoubtedly heightened the appeal of voluntary associations and fairly specialized institutions. Until recently, very few American women created grant-making foundations, universities, or major museums with their gifts. The efforts of women such as Isabella Stewart Gardner, Olivia Sage, and Anna M. Harkness were the exception rather than the rule.[50]

Moreover, even those with substantial amounts of cash firmly under their control—women like Catharine Lorillard Wolfe—tended to scatter their gifts among countless charities, rather than building a single institution. Although Olivia Sage created one of the country's first modern foundations during her lifetime, even she split her bequest into countless gifts

for colleges, charities, and missionary and tract societies. The extent to which male advisors encouraged these trends is an important question, albeit one that falls outside the scope of this study. To cite just one example, when the aging, unmarried Sophia Smith first broached the subject of creating a women's college with the presidents of Harvard, Williams, Amherst, and Yale, each in turn sought to dissuade her from her plans. Like Gardner's advisors, they urged her to adopt more modest aims.[51]

Because she chose to ignore these admonitions and to build her own museum even at the risk of dissipating her fortune during her own lifetime, Gardner achieved a degree of notoriety like few other women of her generation. Berenson captured a sense of her enormous energy and indomitable will when he wrote that "she lives at a rate and intensity, and with a reality that makes other lives seem pale, thin and shadowy." Other assessments were less kind. In the words of one historian, "She was a dominating, ruthless woman, intolerant of opposition, and determined to get her own way." Surely the same could be said of Morgan and Frick as well, but these qualities were far more noticeable, and far more jarring, in a woman, particularly during Gardner's era. Unlike the sororal schemes forwarded by decorative art advocates, or the deferential largesse represented by the contributions of Bertha Palmer, Louisine Havemeyer, and Maria Antoinette Evans, Fenway Court celebrated the individualistic aspirations of a highly competitive woman. Willingly deferring to no one, Gardner staked her small stack of chips in the game of international connoisseurship and won. More than most museums, Fenway Court remains a mute testimony to the acquisitive skills and self-assured aestheticism of a single individual.[52]

Fenway Court differed from its neighbor, the Museum of Fine Arts, in several respects. Rather than building a diversified funding base, it was the creation of a single donor, who retained complete control over its contents and design. Rather than being governed hierarchically by male curators and trustees, it remained the vision of a single woman. Rather than emulating the modern corporation, it distilled the essence of the great museums into a comfortably preindustrial, domestic scale. And, like many women's ventures, it was brought to fruition with a limited amount of cash, reflecting the larger social and economic constraints that continued to surround women's philanthropic activities, as well as their personal lives.

Gardner was also atypical in that she successfully competed with leading businessmen and museums on their own terrain. Rather than choosing a neglected area, she insisted on buying the best, the most coveted Old Masters. Henry James termed her passion for collecting a "sacred rage." Very few women collected Old Masters on the scale that Gardner pursued, and fewer still created their own museums to house them. Nor did she will-

ingly bend to curatorial authority. Unlike Louisine Havemeyer or Bertha Palmer, Gardner openly bristled at the Boston museum's policies, its attempts to woo her, and the way in which the staff cavalierly brushed aside her recommendations. Sure of her own tastes, Gardner effectively presented herself as a public cultural arbiter, and she pursued this role with greater authority and elan than almost any other female patron of her time, with the possible exception of Gertrude Stein. Nor did she feel compelled to couch her efforts in charitable terms. Fenway Court was her institution and hers alone, an enduring monument to the aesthetic aspirations of her age.[53]

Gardner's efforts formed an interesting counterpoint to prevailing notions about the changing nature of American cultural enterprise. Despite popular fears about effeminacy and the "feminizing" influence of culture, most American museums remained firmly under the stewardship of men. Gardner's efforts were the exception rather than the rule. Indeed, the very fact that she was so exceptional underscores a deeper aspect of America's fin-de-siècle identity crisis. Women never dominated American art or American education. The fact that a few, like Gardner, managed to assume prominent roles triggered a host of popular fears that women were invading male cultural terrain. At the same time, wealthy male philanthropists were developing a national institutional network—including foundations, museums, and research universities—that not only belied these misgivings but also inadvertently helped to ensure that they would not come to pass. In effect, fin-de-siècle philanthropic initiatives paved the way for both the myth of female cultural custodianship and the professional stumbling blocks that impeded women's quest for educational, artistic, and cultural parity.

The Gardner museum was an aberration, albeit a magnificent one. Hemmed in by trusts, a disapproving spouse and nay-saying trustees, only a woman with Gardner's extraordinary determination could have created an institution like Fenway Court at the turn of the century. "If Mrs. Gardner had been merely a departure from the common pattern she would not have captured the popular fancy," noted one of the more observant reporters who followed her career. "She was unique in a grand manner, sensational without being grotesque, perhaps the most extraordinary Bostonian of her day." While Gardner captured the leitmotiv of male largesse, reiterating it in an idiom uniquely her own, many of her equally individualistic successors set their sights on more uncharted terrain. Rather than joining in the scramble for the treasures of the past, they embraced the avant-garde.[54]

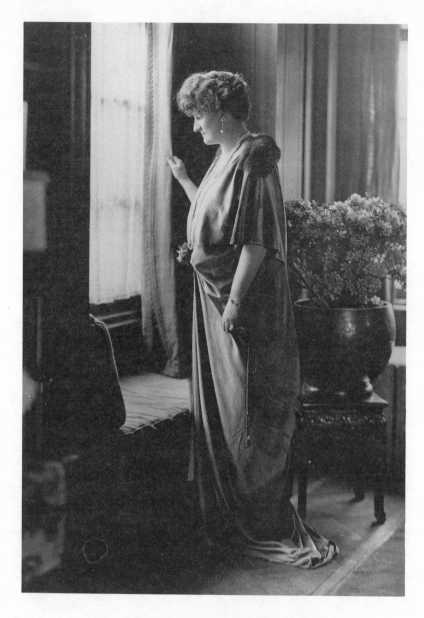

ABBY ALDRICH ROCKEFELLER

Courtesy of the Rockefeller Archive Center, North
Tarrytown, New York

7

WOMEN AND THE
AVANT-GARDE

sabella Stewart Gardner's achievements notwithstanding, women made their most influential contributions by legitimizing new and neglected areas of artistic endeavor, rather than by paraphrasing the cultural activities of men. The decorative arts and, after the turn of the century, folk art and the avant-garde all benefited substantially from women's campaigns to win them a more central place within the nation's artistic canon. Several common denominators linked the avant-garde to other areas in which women successfully adopted a pioneering role. One was the strategy of filling gaps. The women who championed these causes promoted forms of artistic endeavor that had failed to win the respect or the backing of most male connoisseurs. In an era when cultural activities were increasingly viewed as women's pursuits, the promotion of neglected fields offered few incentives to wealthy male connoisseurs. Disdained by established mu-

179

seums and often derided in the popular press, modern art afforded neither the cachet nor the access to powerful institutions accorded to those who amassed the acknowledged masterpieces of the past.

Another common denominator was economic. One of the disadvantages of competing with wealthy male connoisseurs was that they could drive prices far beyond women's acquisitive range, if they so chose. Folk art, laces, textiles, ceramics, and modernist paintings were all relatively inexpensive compared to the prices that men like Morgan were willing—and able—to pay for the masterpieces that they so avidly pursued.

The history of women's involvement in the avant-garde is marked by a progression from Gertrude Stein's salon to the founding of the Museum of Modern Art. Rather than creating a permanent gallery, Stein orchestrated her campaigns from the comforts of her home. She was a woman little given to conformity. Born in Allegheny, Pennsylvania, in 1874, Stein was the youngest of seven children, the daughter of a Bavarian merchant who made a modest fortune selling clothes. She had a cosmopolitan upbringing, spending portions of her childhood in Austria and Paris, as well as in the United States. Unlike many of the female patrons who preceded her, Stein was college-educated, having studied at the Harvard Annex (later renamed Radcliffe College) and the medical school that Mary Garrett helped to open to women at Johns Hopkins University.

Stein ultimately scrapped her plans for a medical career to follow her brother Leo to Paris shortly after the turn of the century. The two were extremely close, and his enthusiasms served as the catalyst that first interested Gertrude in the visual arts. A talented dilettante, Leo moved to Paris to study painting. He was soon joined there not only by Gertrude but also by his brother Michael and Michael's wife, Sally, who was a professionally trained artist. Leo's artistic leanings led the family into a growing array of friendships with local dealers, as well as with some of the century's most innovative painters. This and his collecting forays in the galleries of the Salon d'Automne brought painters such as Henri Matisse, Pablo Picasso, and Paul Cézanne into the Steins' circle of acquaintances and friends.

By 1905 the family was regularly hosting salons, adding dancers and writers such as Isadora Duncan and Mabel Dodge (later Luhan) to their artistic protégés. Leo dominated these early sessions, singing, performing, and pontificating about modern art while Gertrude watched from the sidelines. He apparently had an extremely charismatic personality, bolstered by an engaging oratorical style and a gift for mimicry that included "an extraordinary imitation of Isadora Duncan" as part of his repertoire. Never one to mince words, Luhan later recalled that "buying those distorted compositions and hanging them in his apartment, [Leo] felt the need for

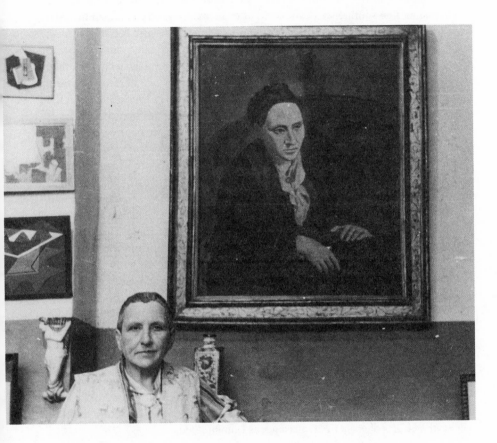

GERTRUDE STEIN

making others see what he found in them, and this turned him eloquent."[1]

The center of attention shifted to Gertrude after Leo's rift with Picasso began to sour his enthusiasm for the avant-garde. Although initially one of Picasso's most important backers, who bought and exhibited the Spanish painter's works himself and actively encouraged other collectors to do the same, Leo's influence diminished after Picasso turned to cubism in 1907. As his backing began to taper off, Gertrude's enthusiasm for and support of Picasso's work increased. According to one biographer, she was able to accept the growing abstraction of Picasso's style "precisely because, unlike Leo, she didn't really *care* about the principles of art. . . . Gertrude's taste was totally personal and arbitrary." Indeed, she may have applauded the change precisely because it was so nettlesome to her brother. After years as Leo's understudy, Gertrude emerged as a personality in her own right. The more her brother disliked Picasso's work, the deeper her friendship with the artist became. As the avant-garde began to bypass Leo's range of vision and taste, she quietly assumed the lead.[2]

She had a remarkable setting in which to do so. By 1906 Gertrude and Leo Stein had already amassed a superb collection of Gauguins, Cézannes, Picassos, Matisses, and Renoirs, spiced by an occasional El Greco and Manet. Their household museum served a particularly important role before 1910, when few other collectors were purchasing the work of modernists such as Picasso and Matisse. Its importance was increased by word-of-mouth publicity and, indirectly, by the San Francisco earthquake. Sally Stein had continued her artistic training with Matisse, whose works she and her husband collected. When they hastily returned to their San Francisco home to assess the damages from the earthquake, they took several of Matisse's paintings with them. As word of the strange new paintings spread, American tourists began to visit the Steins' Paris galleries with increasing regularity. At a time when few dealers or collectors were showing these works, the Steins' salon served as an impromptu museum, echoing the efforts of earlier patrons such as Luman Reed.

After the First World War, the composition of Gertrude's salon gradually changed, filled instead with composers and expatriate novelists such as Ernest Hemingway and F. Scott Fitzgerald. But in the early 1910s, it stood squarely at the center of some of the Continent's most innovative artistic trends, from cubism to the fauvist movement led by Matisse. Although Stein played a minimal role in American institutional developments during these years, her salon established a female presence at the forefront of the international avant-garde.

Stein's generosity and her skill in drawing luminaries to her salon helped to bolster the professional careers of her male devotees. Women

painters fared less well. Even in her college days, Stein remained singularly "uninterested in the questions of female suffrage and sexual equality." Although her salon attracted a variety of female writers and performers such as Duncan and Luhan, women artists remained in the minority. Thus, the painter Marie Laurencin may have been invited because she was the mistress of the popular poet Apollinaire, rather than because of any inherent talents of her own. In the final analysis it was Picasso and Matisse, not Laurencin, who benefited most from Stein's attentions.[3]

On the other hand, the Steins' salon served as a school for a number of prominent women patrons. Etta and Claribel Cone, Agnes Meyer, Mabel Dodge Luhan, and Katherine Dreier were all alumnae of these soirees. Indeed, many of the Picassos and Matisses that the Cone sisters collected and later donated to the Baltimore Museum of Art were acquired as a result of acquaintances made in the Steins' salon.[4]

Agnes Ernst Meyer visited the Steins' apartment during her student days in Paris. Meyer financed her way through Barnard College with a string of fellowships and became one of the first women reporters with the *New York Sun* after receiving her degree. Initially she was interested in philosophy and the works of John Dewey, but after a 1907 interview with Alfred Stieglitz, her interest turned instead to art. Stieglitz was the country's leading prophet of the avant-garde at the time, using his innovative gallery at 291 Fifth Avenue as a podium for promoting the works of Picasso, Matisse, Rodin, Brancusi, and his own coterie of American modernist painters. Meyer was immediately attracted by the photographer's iconoclasm and his taste for the new. As he once passionately confided to his sister, "I hate the half-alive; I hate anything that isn't real. . . . I find that as I grow older a hatred . . . against customs, traditions, superstitions, etc., is growing fast and strong."[5]

Her friendship with Stieglitz may have helped to persuade Meyer to study art in Paris, where she visited Stein's salon and came under the influence of a number of leading artists, including the sculptor Auguste Rodin, Henri Matisse, and the photographer Edward Steichen. Her career took another turn in 1910, when she married Eugene Meyer, Jr., a wealthy New York financier who provided the resources that enabled her to shift to the patron's role. After Meyer's return to the United States, she became an important financial backer of Stieglitz's gallery, as well as supporting several of the painters in his circle. Some of the projects that she funded at 291 Fifth Avenue included Brancusi's first American one-man show and an innovative exhibition of African art. Later, she founded the avant-garde periodical *291* with Stieglitz and several others, and cofounded the Modern Gallery with the caricaturist Marius de Zayas in 1915. Although she subse-

quently broke with Stieglitz, until she and her husband moved to Washington in 1918, Agnes Meyer remained an important presence within the New York avant-garde.

The Armory Show

Mabel Dodge Luhan was another vivid personality who embellished Stein's salon. While Meyer subsidized Stieglitz, Luhan contributed to the success of the Armory Show. Held in 1913, the Armory Show exhibition served to popularize the works of the avant-garde in ways that Stieglitz's single gallery never could. The show was put together by a group of artists headed by Arthur B. Davies. Although their original intention was to highlight the works of the American painters who had been ignored by the conservative National Academy of Design, Luhan was one of several people tapped to help bring together samples of the work of leading European avant-garde painters and sculptors as well. By the time the exhibition opened in New York's Sixty-ninth Regiment Armory on February 17, 1913, almost a third of the thirteen hundred collected works were by Europeans, and it was these pieces that captured the public's imagination. Most Americans had heard only "vague rumors of unusual artistic happenings abroad" and were completely unprepared for the impact of the postimpressionist, cubist, and fauvist paintings that greeted them. Over seventy thousand viewers crowded in to see the show during its one-month run in New York, a presence bolstered by the press reviews that sent shock waves across the nation.[6]

Former president Theodore Roosevelt captured the spirit of many of the reviews when he labelled the futurist canvases "the lunatic fringe." Others crafted poems to describe the event, or offered tongue-in-cheek instructions for how to approach the strange new art. One Chicago paper instructed viewers to "whirl around three times, close your eyes, bump your head twice against the wall, and if you bump hard enough the picture . . . will be perfectly obvious." Another responded in doggerel: "I called the Canvas *Cow with cud* and hung it on the line; Altho' to me 'twas vague as mud, 'Twas clear to Gertrude Stein." Stieglitz watched the proceedings with delight, cheerfully proclaiming that "the dry bones of a dead art are rattling as they never rattled before."[7]

While the New York showing was greeted with enthusiasm, shock, and surprise, the reception in other cities was a good deal more chilly. The *Boston Herald* captured that city's disdain with the comment that "from Munch to Matisse, the art of European painting has degenerated into buffoonery . . . [and] caricatures of fine art." Marcel Duchamp's painting

Nude Descending a Staircase was burned in effigy by students of the Art Institute, who accompanied their "cubist funeral" with the strains of a honky-tonk dirge. The review in the *Chicago Examiner* was succinct and to the point, complaining that "our splendid Art Institute is being desecrated." But whether the response was hostile or celebratory, no one could deny that America had suddenly become aware of the avant-garde.[8]

In addition to garnering paintings and providing cash, Luhan helped to publicize the Armory Show through newspaper interviews and articles in periodicals. Other women made significant contributions as well. The interior decorator Clara Davidge did some last-minute fund-raising among her wealthy clients and friends, getting donations from women such as Gertrude Vanderbilt Whitney and Florence Blumenthal. Sally Stein lent two Matisses, Sarah Choate Sears contributed a Cézanne, and Gertrude Vanderbilt Whitney, Katherine Dreier, and Emily Crane Chadbourne lent additional modernist works from their collections. A substantial number of women also exhibited their works, including (among others) Dreier, Cassatt, Laurencin, and Marguerite Zorach.

Mabel Dodge Luhan later recalled "the excitement of new experience in these men and what they were doing." As she explained, "Most people see as far as the eye permits—Picasso came along and used his optic nerve as an instrument that seemed to overcome the natural boundary and brought new experience to the psyche. Seeing freshly, and putting down on his canvases what he saw, he actually extended the field of vision for the whole world. A new vision captured is a gift of a god." Although Davies and his male colleagues coordinated the show, women such as Luhan, Davidge, and Dreier also played an important, albeit unheralded, role in its success.[9]

The Armory Show was one of the key turning points in American cultural history. According to historian Henry May, it marked one of a series of events that heralded "the end of American innocence" and the "complete disintegration of the old order, the set of ideas which dominated the American mind so effectively from the mid-nineteenth century until 1912." Yet despite the exhibition's undeniable importance, the country's acceptance of modernism was not as abrupt as these interpretations might suggest. Although the Armory Show helped to stimulate American interest in the avant-garde, the battle for acceptance was far from won, and most of the major museums remained icily aloof to the art of the new throughout the 1920s. Although postimpressionist exhibitions were held at such conservative repositories as the Pennsylvania Academy of the Fine Arts and the Metropolitan Museum in 1920 and 1921 and Matisse won the prestigious Carnegie Institute prize at mid-decade, these were fairly isolated events.

Indeed, the Metropolitan's postimpressionist show was hardly daring, filled with the works of such popular artists as Degas, Renoir, and Monet, as well as Gauguin and Cézanne. Staged at the behest of a small group of collectors that included Agnes Ernest Meyer, Lillie Bliss, Arthur B. Davies, John Quinn, and Gertrude Vanderbilt Whitney, it featured the tamer examples of French modernist works.[10]

Moreover, it was a loan exhibition. Although the Art Institute accepted Helen Birch Bartlett's magnificent collection of Van Goghs, Matisses, Gauguins, and Seurats in 1925, the Metropolitan was strikingly reluctant to add such works to its permanent collections. John Quinn's offer of a Gauguin in 1915 was summarily dismissed, and Bryson Burroughs, the museum's curator of paintings, "nearly lost his job for buying a Cézanne from the Armory Show" in 1913. Even as late as the 1940s, the Metropolitan's trustees clung to "the dictum . . . that nothing significant ha[d] been painted, molded or wrought since 1900," a notion that seemed to increase in authority with time.[11]

Although French art managed to achieve a modicum of acceptance by the 1920s, the status of modernist fare from other countries was less certain in an era of postwar isolationism and the anti-immigrant Red Scare. Modernism challenged the old verities in ways that went against the grain of American culture, promoting a set of imported ideas that the country's isolationism implicitly sought to reject. Some critics were vitriolic in their opposition to the works of the new painters, labelling them "the Freak modernist school," or "Freakists for short." The depth of these misgivings was captured in the brouhaha surrounding Constantin Brancusi's sculpture *Bird in Space*. When photographer Edward Steichen returned from an extended expatriate sojourn in Paris in 1926 with Brancusi's statue in tow, customs officials refused to accept his explanation that it was a work of art. Instead, they categorized it under "kitchen utensils and hospital supplies," which upped the duty another $240. Additional duties that were subsequently levied were successfully challenged in court with backing from Gertrude Vanderbilt Whitney. But this very public debate about whether or not Brancusi's work should be considered art encapsulated many Americans' lingering skepticism about the value of modern art.[12]

Moreover, definitions of art that largely excluded the more advanced contemporary works were popularized by the art-appreciation crusades of groups such as women's clubs. Women's clubs had evinced an interest in art from their inception, often complementing the proselytizing activities of societies of decorative art. Despite a growing drift toward social reform, art education continued to hold an honored place in their programs well into the Twenties. In the 1890s, local clubs were still hosting lectures that

spanned the topical gamut from "Fans and Their History" to "The Place of the Madonna in Art." By the 1910s they began to branch out to civic beautification campaigns as well, adding an artistic twist to the notion of "municipal housekeeping" popularized by Progressive reformers of Jane Addams's ilk. As the president of the Chicago Woman's Club explained, "The home is the center of life, and if we take art into the homes and then . . . into the neighborhood, and then from one neighborhood to another, we shall soon make our whole city beautiful."[13]

Schools provided particularly appealing targets in the quest to engineer "the salvation of our country from the sin of ugliness." Vowing to "augment the work of men in reclaiming our cities and towns from the general stigma" of industrial grit and grime, club members fastened their attention on municipal statuary and attempts to foster the "homelike aspects" of the nation's schools. Architecture, color schemes, landscaping, drawing lessons, and acquisitions of high-quality copies of paintings, prints, and statues to adorn classroom walls: all fell within the ambit of the clubs' aesthetic mission during the Progressive years.[14]

By the 1920s self-improvement was once again an ascendent theme, as the General Federation of Women's Clubs promoted the development of art appreciation classes through its publications and prepackaged study guides. Like antebellum ladies' academies, women's clubs also sponsored 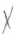 courses in drawing and composition, in the belief that art should be "for everyone" and not just "the talented few." Working in tandem with the American Federation of Arts, they assembled a list of travelling lecture-exhibits, which were circulated through their national networks in much the same fashion as decorative art exhibits had travelled through women's networks half a century before. Subjects ranged from "the educational value of museums" to prepackaged sets of "Art Institute prints." There was even one packet on "modern American paintings," to showcase the works of "younger artists under the influence of modern tendencies," such as the fin-de-siècle urban realists of the Ashcan school. Most, however, centered on the more familiar themes of civic beautification, historic tendencies, and art in the home.[15]

The Société Anonyme

Katherine Dreier's Société Anonyme took an entirely different approach, challenging the country's complacency by forwarding a highly cosmopolitan vision of the avant-garde that went far beyond the accepted French and American modernist fare. Her career exemplified another important watershed in the history of American art. Prior to the Armory

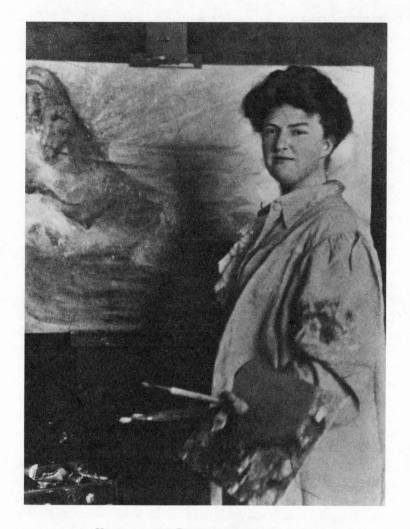

KATHERINE DREIER AT HER EASEL

Show, both the cause of nonacademic painting and that of the avant-garde were promoted primarily by men, as was the exhibition itself. Alfred Stieglitz, Robert Henri, and Arthur B. Davies have all been amply hailed as pioneers. Afterward, however, the mantle of leadership quietly passed to women such as Katherine Dreier, and by the 1920s a striking share of the major institutional initiatives was in their hands.

There was another subtle difference as well. Stein, Meyer, and Luhan were essentially publicists. Professional writers by training and inclination, they used their craft to promote the modernist cause. During the 1920s, professionally trained artists assumed the lead. Rather than asserting their connoisseurship through the kind of certification that surrounded curatorial work—publications, museum experience, and college degrees— they staked a presence in fields in which museums had little interest, on the basis of their artistic qualifications. As gallery owner Edith Halpert explained, since "there were few publications" in these fields, "one had to rely almost entirely on instinct and visual experience," making the artist's impressions an invaluable guide. In the process, professionally trained women artists, patrons, and gallery owners solidified a new basis for female cultural authority, addressing the community as a whole on artistic matters in ways that the women of Sarah Peter's generation could not. Artistic training, rather than college attendance or participation in self-study programs, formed the basis for women's growing cultural leadership in the 1920s.[16]

While Luhan helped to stock and publicize the Armory Show, Dreier carried the message of the avant-garde into the 1920s, inheriting Stieglitz's mantle after 291 closed in 1917. Like Luhan, Dreier had come into contact with Gertrude Stein on one of Dreier's many trips to Europe, which bolstered her early taste for modernist fare. The daughter of a prominent and markedly philanthropic Brooklyn clan, Dreier had followed her older sister, Dorothea, into a painting career, and her other sisters into reform. By the time that Dreier was in her early twenties, she was already a trustee of the German Home for Women and Children and the Manhattan Trade School for Girls, and the veteran of several suffrage campaigns. Another sister, Margaret Dreier Robbins, was also prominently involved in a variety of suffrage and settlement house movements and became a leader of the Women's Trade Union League.

Dreier was a lifelong student of art, beginning with private tutors at the age of twelve. These were followed by terms at the Brooklyn Art Students' League, the Pratt Institute, and the Art Students League in Manhattan, as well as extended sojourns studying in the museums and ateliers of Paris, London, Holland, Germany, and Italy. Her first contact

with the avant-garde may have come in the Steins' salon, where Matisse's paintings struck her like an "aesthetic shock [that] . . . left one gasping." The Armory Show also helped to influence Dreier's taste for modernist works. In addition to showing two of her paintings, she lent a Van Gogh, bought a Gauguin, and began to develop an interest in Brancusi's work. Her subsequent friendship with Marcel Duchamp, the French painter whose work so shocked the visitors to the Armory Show, cemented her interest in the avant-garde.[17]

Dreier was a talented woman who sought to blend her professional pursuits with a messianic zeal inherited from her family. Toward that end, she helped to found the Cooperative Mural Workshops in 1914, gathering a number of men and women artists to make murals, pottery, and needlework designs under the rubric of the arts and crafts movement. She also translated *The Personal Recollections of Vincent Van Gogh* as a means of popularizing the Dutch artist's works. Her most important venture, however, was the Société Anonyme, which she cofounded with Duchamp and the photographer Man Ray in 1920.

Formally chartered as the Société Anonyme, Inc., Museum of Modern Art, the venture was dedicated to the task of broadening the audiences for modernist works. Although it habitually operated on a shoestring budget during its twenty-year existence, the society achieved a remarkable record, providing such luminaries as Paul Klee, Wassily Kandinsky, Fernand Léger, and Joan Miró with their first American one-man shows. It began operations in rented galleries on the third floor of an old brownstone in midtown New York. Guided by the irreverent Duchamp, the society initially attracted sizable audiences for exhibits by featuring such outrageous touches as paintings nonchalantly framed in paper doilies.

However, its tenor grew considerably more somber when Duchamp and Man Ray departed in 1921, leaving Dreier to manage its activities on her own. Although Duchamp is occasionally miscredited as the society's sole originator, he did continue to play an important role in its development long after his departure. In a striking mésalliance of temperament and style, Duchamp and Dreier became close friends, and he remained among her few trusted confidantes throughout her career. Both exhibited at the Armory Show and later became habitués of the salon of the collector Walter Arensberg. Their acquaintance deepened into friendship after the brouhaha surrounding Duchamp's submission of a urinal to the Society of Independent Artists' Exhibition in 1917. Labelled "Fontaine" and signed "R. Mutt," Duchamp submitted the piece as an example of dadaist creativity. The hanging committee was not amused and hid his "sculpture"

behind a partition to shield it from public view. Duchamp in turn withdrew
it and tendered his resignation to the group.

Dreier begged him not to resign, explaining that she had voted against
his offering because, as she delicately put it, she thought it was a "ready-
made object" and had therefore failed to fully appreciate its artistic merit.
Duchamp was undoubtedly struck (and perhaps delighted) by the ab-
surdity of the exchange, initiating an enduring friendship with the nor-
mally dour Dreier. Together, they made a compelling team, blending her
determination with his wit in ways that brought out the better qualities in
both. Years later, she still sought to lure him back to New York, to bolster
the society's lagging fortunes. As she explained, "If you came over
again . . . we might build it up very quickly," adding somewhat patheti-
cally, "I am very anxious to paint again."[18]

Her relationship to Man Ray was more strained, highlighting some of
the negative aspects of her personality that undoubtedly undermined her
success as an administrator. Apparently, the photographer had a greater
flair for creativity than for managing details, a fact that constantly grated on
Dreier's nerves. In one instance, she caustically rebuked him for misspell-
ing her sister's name on one of the society's programs; later, she com-
plained that the white ink he used to correct the mistake was applied in "an
amateurish way." From missed deadlines to errors in their promotional ma-
terials, May Ray proved a constant source of irritation. "Every now and
then I am puzzled by you," Dreier critically informed him. "I do not know
of a single artist who is more exact as to his own work than you are, yet in
connection with the work you do for others, you slip up in the most sur-
prising manner." Apparently he finally decided that he had had enough,
and left.[19]

With his departure, Dreier assumed complete responsibility for the
society's fortunes. Her dream, which was captured in the organization's ti-
tle, was to create a permanent museum filled with avant-garde paintings
and statuary gleaned from the far reaches of the Continent, as well as the
United States. To quote Dreier, she wanted to "build up something which
[would] take hold of the community." Sometimes she cast a longing eye at
the Metropolitan. As she explained in a missive to one of her backers, "I
feel that we are doing the work which the Metropolitan Museum ought to
be doing, and I hope the time will come when we will be embodied in the
Metropolitan, and lose our identity in it." As she confided to Duchamp, the
lone lecture that she delivered there was one of "the most thrilling experi-
ence[s]" of her career. Denied the legitimacy of a permanent museum set-
ting, she nonetheless argued that "museums should have experts on the

extreme modern subjects as well as on the Old Masters" and continued jousting at windmills over long years of neglect.[20]

In other instances, she rejected the idea of joining with an established institution, in order to promote the idea of a freestanding museum. As she explained to Arensberg, "The only way to become well known is to have our own building, with [a] permanent exhibition" in addition to special one-man shows. Instead, she was forced to abandon the rented galleries due to declining revenues and to take to the road with a series of peripatetic exhibitions held in everything from museums and clubs to trade schools and department stores. Dreier's mission was considerably complicated by the fact that most major American museums still shunned modernist works, as did many galleries. A few of the more adventurous repositories, such as the Worcester Museum of Art, opened their doors to Dreier's exhibitions with works that spanned the stylistic range from Juan Gris to Piet Mondrian. Most, however, resolutely held her at arm's length.[21]

Even in the face of indifference, she was an indefatigable crusader. In 1921, for example, she spent several months courting a trustee of the Art Institute, Arthur Aldis, to gain access to the museum's exhibition space. In return for nominal packing, mailing, and insurance fees, Dreier offered to collect and coordinate the exhibit, which would be sent ready for showing. Thus, she noted, "the museum directors need not take any responsibility except the educational responsibility of opening the doors to modern art." Although Aldis was obviously sympathetic and took the matter up with Robert Harshe, the museum's director, her offer was refused on the grounds that the museum's exhibition calendar was already full.[22]

Aldis then suggested that she try her luck with the local Arts Club. Founded by Mrs. John A. Carpenter, the Arts Club was "a semi-social, semi-professional organization" that provided the primary stronghold for modern art in Chicago during the 1920s. Carpenter used her connections to secure one of the Art Institute's galleries for the club's exhibitions, which provided an added lure. As Aldis reassuringly explained, "The officers of this club have plenty of courage and are anxious to show the best phases of European and American art." Although several paces behind the Société Anonyme in its tastes, the Arts Club was "practically the only gallery" in Chicago that was open to the works of artists such as Georges Braque, Rockwell Kent, and Henri de Toulouse-Lautrec.[23]

Perhaps because their definitions of modernism differed, Dreier's negotiations with the club's officers were tinged with ire. She found their insistence on featuring the works of better-known artists particularly nettlesome. As she condescendingly explained, "I do not go by name, but by quality. The pictures I would send would be of high standing, quite regard-

less as to name." In one particularly abrasive exchange, she complained that the Arts Club's members had "antagonized" several New York collectors, who refused to lend them works. "I do not know what you did out in Chicago," she barked, "I only know the results." Her ill-tempered misgivings about the Arts Club may have also stemmed from her disappointment over Harshe's refusal to allow her to deal with the museum directly. Especially in the early years, the collection's spotty exhibition record must have been frustrating, even to a toughened reformer such as Dreier.[24]

The high point of the Société Anonyme's program came in 1926, when the Brooklyn Museum allowed her to stage a massive exhibition of European and American paintings. Since the Dreiers were among the museum's most prominent and most loyal contributors, the Brooklyn Museum proved more hospitable than many other leading repositories. The resulting exhibit featured works by artists from twenty-three countries, including such unlikely outposts as Iceland and Romania. American artists such as Alfred Stieglitz and Georgia O'Keeffe were invited to submit works for display, while Duchamp and Wassily Kandinsky helped to secure samples from leading European artists, including members of the German Bauhaus group. Although a few important works were omitted—for example, Walter Arensberg refused to lend Duchamp's historic painting *Nude Descending a Staircase* for fear that it might be damaged en route—the exhibition was a resounding success. Over three hundred pieces were seen by over fifty-two thousand viewers, including representative works by many of the leaders of the European avant-garde.

Although the tenor varied considerably, the exhibition was extensively reviewed, with articles in the *New Republic,* the *Nation,* the *New Yorker,* and a number of newspapers. Some focused on the content of the exhibition, others on Dreier herself. She was an inveterate proselytizer. In addition to coordinating the exhibition, she used the Brooklyn exhibit as a podium for her ideas about the spiritual nature of modern art. From the catalogue, *Modern Art,* to the accompanying lecture series, she infused the event with her belief that art was "a fundamental necessity of life," driving home her themes with the tone of "an inspired religious leader guiding her people toward their long-awaited salvation." Often her prose was tortuous. Thus, on one occasion she proclaimed, "We have grown beyond the desire of having on our walls paintings of beautiful cows and landscapes. We feel it was right for these to be painted in the past, for they emphasized the beauty of nature, but that they have served their purpose and we now want to have on our walls those paintings which point out new worlds of thought and make us go deeper into life, because of their power."[25]

Dreier's heavy-handed proselytizing served to alienate as many people

as it converted. The conservative art critic Royal Cortissoz took a particular dislike to her, ridiculing her insistence that modernism was tied to "cosmic forces." "Cosmic forces," he exclaimed. "Forsooth! We wonder what the modernists would do without their verbal aids." A more veiled reference warned readers to "beware of the talking painter and the talking sculptor, the painter or sculptor with a theory; he may be a successful imitator, but seldom a creator."[26]

The Société Anonyme was hobbled by its tenuous financial situation, as well as Dreier's messianic zeal. Her growing concern over the society's precarious finances echoed through her correspondence with the Brooklyn Museum's director, Henry Fox, and undoubtedly helped to stoke Fox's growing antagonism. Initially, she was elated at the prospect of the exhibition. As she wrote to Duchamp, the trustees had accorded her "absolute freedom of expression" in mounting the show, which she deemed "a tremendous compliment." However, her jubilation was quickly tempered when Fox curtly brushed aside her request for office space while the exhibit was being coordinated, on the grounds that it would set "a precedent which might cause trouble in the future."[27]

After the exhibition closed, he sent her a $115 bill for packing and shipping some of the paintings for exhibition in Buffalo, ignoring their agreement that the museum would handle this part of the costs. Undoubtedly exhausted from her work as coordinator and disillusioned by the way in which she had been treated, Dreier refused to release the funds. As she explained, "I used to be so hurt that I always took everything upon myself and paid," but the society's dwindling accounts no longer permitted her to do so. She was doubly stung by Fox's insensitivity, since the society had run up a sizable deficit in staging the exhibition. Added to that was the fact that she had just given the Brooklyn Museum a painting valued at $10,000 out of her own collection. Fox paid the bill but acridly reported that he had not viewed "the fact that you gave us a painting . . . as compensation. Had that been the understanding, I should have . . . submitt[ed] the matter first to our Museum Committee, who would have passed on its importance as a purchase." Thus, despite the success of her exhibition and the visibility it garnered not only for the society but for the Brooklyn Museum, Dreier continued to be treated like a poor relation, a beggar at the cathedral door.[28]

The society's uncertain finances did little to strengthen her suit. As she candidly confessed, "Since we were a small organization with little means at our disposal in a field which demands untold resources, we were naturally limited." Since the bills for even a modest one-artist show could run as high as $2,500 for shipping, insurance, and advertising costs, constant

fund-raising was imperative and, of course, extremely time-consuming, particularly when individual donors sometimes had to be courted for months or even years to yield a single $100 gift. Dreier's sister Mary donated $1,000 toward the building fund, but most of the other donations were sporadically rendered and usually quite small. Like others before her, Dreier financed many of the expenses out of her own pocket in order to keep the organization alive. She also continually tracked potential donors, relentlessly importuning prominent philanthropists such as Gertrude Vanderbilt Whitney and A. E. Gallatin for funds. Sometimes her appeals were quite ingenious, as when she tried to convince Walter Arensberg's wife that a five-year, $500 pledge would constitute a sound "business investment" since they owned so much modern work. "The more it is desired," she noted, the more its market value would increase. By 1926 she wearily confided to Duchamp that she was "getting desperate, for everything is so high and so little is coming in."[29]

The Brooklyn exhibit marked the high point of the society's activities and was followed by months of tedious work in shipping the paintings back to their European owners. Although Dreier briefly rented an office on Fifth Avenue to disseminate her short-lived journal, *Brochure Quarterly*, in 1928, most of the time she worked alone, with neither volunteers nor staff, from her apartment on Central Park West. By the 1930s the society's subscription lists had dwindled to a trickle and its activities had almost ceased. After an attempt to turn her West Redding, Connecticut, home into a permanent gallery failed for lack of funds, Dreier managed to institutionalize the collection by donating it to Yale University. After two decades of hard labor and dedicated struggle, the Société Anonyme closed its books in 1941.[30]

The society's programs, and its demise, underscored several recurring themes. One was the role of women artists. Although Dreier was an artist herself and a committed suffragist, women artists received short shrift in the society's collections. Georgia O'Keeffe, Anne Goldthwaite, Marguerite Zorach, Dreier, and her sister figured among the small group of women whose works were collected under the society's auspices, but most of the featured works were by men. Unlike Candace Wheeler, Dreier set her feminism aside when it came to art.

Money was another important issue. The Société Anonyme suffered from a chronic lack of cash. Its subscribers provided barely enough to cover its ongoing operating expenses, and although Dreier put together a small board, most of the responsibility for raising funds and coordinating the exhibitions and lectures was hers alone. Unable to marshal the necessary funds or to support the venture herself, she amassed a sophisticated

collection but never realized her goal of creating a permanent museum. In effect, she sought to run a museum project like a voluntary association. But because it lacked a separatist ethos, the society also lacked the ready pool of female volunteers that helped to keep a spate of earlier women's voluntary associations alive. Art patronage was an inherently expensive proposition, and even with the best professional alliances, it fell beyond the parameters of middle-class sponsorship when fashioned as a lone crusade.

The Museum of Modern Art

Abby Aldrich Rockefeller and her associates were more successful. The Museum of Modern Art (MOMA) was founded in 1929 by three women: Abby Aldrich Rockefeller, Lillie Bliss, and Mary Quinn Sullivan. The common denominator that united them was their shared commitment to the avant-garde. Beyond this, their personal lives differed markedly.

Sullivan hailed from a surprisingly modest background. The daughter of an Irish immigrant, she was a professionally trained artist and art educator. She came to New York at the age of twenty-two to study art at the Pratt Institute, then went to the Slade School of Art at University College, London. Later she returned to Pratt as an instructor of design and household arts and sciences, boarding with the Dreier family in their Brooklyn home. This brought her into contact not only with the efforts of the Société Anonyme, but also with Rockefeller, Bliss, gallery owner Edith Halpert, and Arthur B. Davies. Like Agnes Meyer, her transition to the patron's role was facilitated by her marriage in 1917 to the prominent New York attorney and collector of contemporary art Cornelius Sullivan.

Lillie (or Lizzie) Bliss also had a taste for modern art. Bliss was the daughter of a textile merchant who served as secretary of the interior during the McKinley administration. While Sullivan concentrated primarily on the visual arts, Bliss patronized a variety of cultural enterprises, serving on the advisory committee of the Juilliard Foundation as well as privately supporting a number of artists and musicians, including the Kneisel Quartet. She was also a talented musician who "played the piano well enough to have been a professional, but shied away from public performance."[31]

Painting became one of her consuming interests after she met Arthur B. Davies, who had headed the organizing committee of the Armory Show. Davies was a complex and interesting man. A rather owlish-looking artist who painted fairly conventional allegorical works, he apparently had quite a charismatic effect on a number of rich and influential women. He also led a secret life with two families and two wives, one in Manhattan, the other

upstate. This rather unpleasant fact obviously was shielded from Bliss, who followed Davies into the modernist arena. Beginning with the Armory Show, she increasingly collected Impressionist and Postimpressionist paintings on his advice. She never married, preferring to care for her parents instead. Her mother disapproved of her taste in art, and so Bliss's collection was initially stored in the basement of her Manhattan townhouse, where it was retrieved for interested visitors piece by piece. Schooled by Davies, Bliss maintained her interest in the avant-garde even in the face of public indifference and parental disapproval, becoming one of the country's most discerning collectors. As in the case of Gertrude Stein, her modernist enthusiasms were tinged with rebellion.[32]

As were Abby Aldrich Rockefeller's. While Sullivan and Bliss helped to found MOMA, Rockefeller became "the heart of the Museum, its center of gravity." At first glance, she seemed an unlikely patron for what many still regarded as radical terrain. Abby Aldrich was the daughter of a United States senator from Rhode Island, who was himself an art collector. Like many fashionable young women of her time, she was schooled by private tutors and at a local girl's academy. Miss Abbott's School, in Providence. Her formal education was capped with the first of several European tours in 1894. This, plus her father's enthusiasm and her frequent trips to the Corcoran Gallery in Washington, whetted her lifelong interest in art. As a girl, she collected drawings and watercolors by Degas, to which she added Old Masters and Italian primitives after her marriage to John D. Rockefeller's only son, John D. Rockefeller, Jr. (JDR Jr.), in 1901.[33]

Abby Rockefeller regarded art as "one of the great resources of [her] life," an interest that she shared with her husband. As in the case of the Havemeyers, she was clearly the more adventurous collector of the two, moving toward contemporary art while her husband resolutely clung to the art of the past. From the outset, her efforts reflected a sense of mission. As she explained, her interest in modernism initially stemmed from her fascination with the Japanese prints that she collected with her husband, as well as their early American prints, Buddhist art, and their extensive china collection. Although she enjoyed these acquisitions, she began to be nagged by questions about their relevance to the present and their impact on contemporary art. She also thought about the relevance relics such as these would have for coming generations. "Gradually there developed in my mind the thought that probably the coming generation would neither be able to buy the sort of things that we had, nor would they be particularly interested to do so," which in turn kindled her interest in contemporary art.[34]

Rockefeller found an able guide through this uncharted terrain in

the owner of the Downtown Gallery, Edith Gregory Halpert. On the surface, it seemed an odd alliance. Born at the turn of the century in the Russian seaport city of Odessa, Halpert was a full generation younger than Rockefeller. In fact, she was only a year old when the Rockefellers married. She was also the sort of self-made female entrepreneur that Jazz Age journalists loved to celebrate. Despite their differences, Mrs. Rockefeller's association with Edith Halpert proved a fortuitous match, one that promoted the cause of modernism in much the same fashion as Havemeyer and Cassatt had worked to popularize Impressionism nearly half a century before.

Born to wealth, Halpert was reared in poverty after she and her widowed mother emigrated to the United States in 1906, which stimulated her determination to forge a successful career. She was both a professionally trained artist and an adept businesswoman who worked her way up the corporate ladder from a job writing advertising copy for a local department store, to a position as an efficiency expert and personnel manager with the investment banking firm S. W. Straus and Company, and finally to a berth on Straus's board. By the time she was twenty-six, Halpert had saved enough money to start a gallery of her own.

Her resolve to found the gallery was indirectly strengthened by her marriage to another artist, Samuel Halpert, an early habitué of the Whitney Studio Club, as was she. As she explained, even the most talented artists rarely earned enough to cover their expenses, and so their wives inevitably sought jobs. By working to promote the careers of contemporary male artists, Halpert sought to ease the burdens on their wives as well.

When she created the Downtown Gallery in Greenwich Village in 1926, only six other New York commercial galleries were showing contemporary American art, and only Stieglitz's Intimate Gallery and one other handled it exclusively. Thirteen years after the Armory Show, Halpert noted, "modern art was still a delinquent and American modern art a family skeleton." The fact that she was a woman gallery owner was also novel. Although interior decorators like Clara Davidge had previously created thriving firms, Halpert knew of only one other female gallery owner, Marie Sterner. "All the rest were men," she later recalled, "and this continued for a long, long time."[35]

Fortunately, "practically all the adventurous collectors of modern art and the majority of the gallery visitors were women," including Dreier, Sullivan, Rockefeller, and Bliss. Halpert's ability to lure these women to her renovated townhouse gallery in Greenwich Village was a testament to her lively personality, her taste, and her entrepreneurial skills. Her block on West Thirteenth Street was peppered with speakeasies. Occasionally, the

clients of these establishments would wander into the Downtown Gallery by mistake, where they were "usually horrified" by the "distortions, abstractions, expressionist paintings, and voluminous nudes" that greeted them. The "carriage trade" first made their appearance in 1928, when she held an exhibition of American landscapes that featured a combination of more accessible works of men like Childe Hassam and George Inness with modernist offerings from Joseph Stella, John Marin, Max Weber, and William and Marguerite Zorach. To quote Halpert, the combination provided "an excellent come-on. Dignified, established collectors came to see the old masters and found [the] wild moderns less shocking in this unusual juxtaposition."[36]

Halpert also took a keen interest in the artists whose works she so avidly promoted. As she explained, when she opened the gallery in the 1920s few modern American artists were being exhibited and very little of their work was being sold. She also made it a point to display the works of women artists on the same footing with those of men and to ensure that they were adequately reimbursed for their works. At a time when the Friends of American Art was paying hundreds of dollars for women's paintings, Rockefeller's purchases occasionally ran into the thousands. According to one source, she even paid the (for her) unprecedented sum of $20,000 for a tapestried portrait of her family commissioned from Marguerite Zorach. She also bought substantial numbers of works by Peggy Bacon, Anne Goldthwaite, and Georgia O'Keeffe, many of which were subsequently donated to MOMA.[37]

Rockefeller proved a generous patron of Halpert's struggling coterie of artists, and an ardent enthusiast for the modernist gospels she preached. Occasionally, she even allowed herself to be persuaded to open her private gallery to help promote the work of some of Halpert's protégés. Perhaps the liveliest example was the special exhibition staged for the talented, but somewhat derelict, painter "Pop" Hart. Hart was the subject of the gallery's first monograph, which Rockefeller helped to launch with a small benefit featuring some of his paintings and prints that she had recently acquired. It was a calculated risk since, as Halpert delicately put it, Hart was "not the immaculate, tea drinking type." Overwhelmed by the honor of being invited to sup with the Rockefellers, he relentlessly polled his colleagues on the finer points of etiquette, practiced cleaning up his vocabulary, got a haircut, and bought a new suit. He arrived, "completely out of character," sober, subdued, and clean. Abby Rockefeller apparently put him at ease, and within half an hour Hart was cheerfully slapping society matrons on the back and telling bawdy tales. Halpert was much relieved to report that "it was great fun. The critics who were among those at the party

wrote lengthy reviews about the exhibition, and . . . the book was a sell out." Echoing earlier themes, Rockefeller played the role of the domestic impressario, bolstering Halpert's career as well.[38]

For her husband, JDR Jr., Rockefeller's growing enthusiasm for modernism was a bewildering transition. As he confided to his biographer, "I wasn't particularly interested in [Italian primitives] at first, but we kept them and studied them and finally commenced to buy them. And then all of a sudden my wife, who was very catholic in her tastes and loved all sorts of beautiful things, became interested in modern art." He responded with the plaintive complaint that "I have spent years trying to cultivate a taste for the great primitives, and just as I begin to see what they mean you flood the house with modern art!"[39]

Despite a shared interest in art, Rockefeller was never able to convince her more conservative spouse of the value of modern paintings and sculpture. Nor were other family members particularly encouraging. Her sister, Lucy, greeted her purchase of a Matisse with suggestions that only a flawed character could have inspired such a choice. Perhaps girded by their resistance, her interest in modern art became a rebellious and "consuming interest." As her biographer explains, Rockefeller "believed devoutly in her own time" and had "a passionate faith in the new and the untried," as well as a desire to aid young artists at an early stage in their careers.[40]

Her husband, on the other hand, continued to immerse himself in Chinese and medieval artifacts. While Abby had been reared in a cultured atmosphere, JDR Jr.'s upbringing was more "Spartan" and more rooted in practicalities. While she gravitated toward the visual arts, he was fascinated by Chinese porcelains and medieval tapestries. His interest in Chinese art began in 1913, with the purchase of two small vases to decorate a mantelpiece in their Fifty-fourth Street home. Two years later, when Morgan's collections came on the market, the wily art dealer Joseph Duveen offered JDR Jr. a chance to place the first bid on Morgan's porcelains. The asking price was over $1 million, a sum beyond even JDR Jr.'s means without a loan from his father. When he requested the loan, his father demurred. The son mounted a rebuttal, pointing out that "I have never squandered money on horses, yachts, automobiles or other foolish extravagances. A fondness for these porcelains is my only hobby. . . . Is it unwise for me to gratify a desire for beautiful things . . . when it is done in so quiet and unostentatious a manner?" Swayed by his son's unexpected eloquence, the senior Rockefeller relented and gave, rather than loaned, the money.[41]

JDR Jr.'s biographer and colleague Raymond Fosdick suggested some reasons why he might have been attracted to Chinese porcelains rather than modern art. Noting that there was "a certain impersonality about the por-

celains which must have appealed to Mr. Rockefeller," Fosdick added, "here was none of the 'self-expression' which he found so objectionable in modern art. Instead there were the formality and restraint of civilization." JDR Jr.'s inherent love of craftsmanship may also have been a deciding factor in fostering his taste for the decorative arts. He was particularly fond of tapestries. Some of his most important purchases included two tapestry series, the *Months of Lucas,* made by Gobelins for Louis XIV and Madame de Montespan, and the *Hunt of the Unicorn,* a series woven to celebrate the marriage of Anne de Bretagne to Louis XIII. He purchased the hangings a scant five minutes after first seeing them, and proudly installed his acquisitions draped from floor to ceiling along the walls of his favorite retreat in the couple's Manhattan townhouse.[42]

His interest in architectural restoration and medieval art merged in his museum, the Cloisters. JDR Jr. developed several major cultural projects during his lifetime, offering almost $3 million to the French government for the restoration of Versailles, Fontainebleau, and Rheims after the First World War and another $1 million to the Oriental Institute at the University of Chicago. The Metropolitan Museum of Art also received a $1 million gift from him for its endowment in 1924, as well as smaller grants to build up the museum's medieval collections. The idea for the Cloisters gradually took shape through his friendship with the eccentric American sculptor George Grey Barnard. Barnard had made a hobby of combing the European countryside for stray fragments of Romanesque and Gothic sculpture, which he pieced together in his collection in New York.

JDR Jr. was equally enamored of medieval art, and sometime after 1914 Barnard began to sell him assorted pieces from Barnard's collection, which JDR Jr. dutifully carted off to the family's estate in Pocantico Hills. When the sculptor put his entire collection up for sale in 1922, however, JDR Jr. acquired it as a nucleus for his medieval museum, the Cloisters, which opened in Fort Tryon Park in 1930. Unlike the Société Anonyme, this venture was well endowed from the outset. JDR Jr.'s initial $1 million donation was followed by several others, totalling an estimated $20 million over the course of his lifetime.

Immersed in his medieval collections, he regarded his wife's enthusiasms with "uneasy tolerance." As he explained, "We never lack material for lively arguments. Modern art and the King James Version can forever keep us young." To JDR Jr.'s "more conservative eye the cubes, splotches and distortions of modern art had little to do with beauty, and although he listened patiently to his wife's expositions and calmly observed his home being invaded by modern paintings, he remained unconverted." A friend later recalled a dinner at which Matisse was among the guests. The artist

soon was engaged in a spirited discussion with JDR Jr., explaining the similarities between modern abstractionism and the artistic principals of the artisans who crafted Chinese porcelains. To which JDR Jr. replied in impeccable French that, although he remained unconverted and "might still seem to be of stone, he suspected that Mrs. Rockefeller, thanks to her very special gifts of persuasion, would eventually wear him down to the consistency of jelly."[43]

Like her friend and fellow collector Lillie Bliss, Rockefeller deferred to her family's tastes and kept her modern pieces hidden from view on the top floor of their New York townhouse, in the children's old playroom, which she converted into her private gallery. She made her acquisitions from a separate pot of money as well; Rockefeller underwrote her modern art collection with the "Aldrich money" that she had inherited from her father. Her records reveal that most of these paintings were purchased for very small sums. The most expensive single painting was an Odilon Redon, purchased for $2,550 in 1928, followed by a Georgia O'Keeffe, which she bought for $1,900 in 1931. She paid $1,200 for a painting by John Marin and a like amount for a Maurice Prendergast. Diego Rivera was well represented, including a batch of forty-five small watercolors and one pencil drawing for which she paid $2,500. By 1933 her annual art purchases totalled almost $46,000, which was still a fraction of the over $1.2 million that her husband paid for the unicorn tapestries that he donated to the Cloisters.[44]

Despite the disparity in their outlays, JDR Jr. dismissed her plans for MOMA as "Abby's folly." And yet, to quote Raymond Fosdick, "nothing outside her family so captured her interest." Several histories trace the museum's inception to a chance meeting between Rockefeller, Sullivan, and Bliss on a winter tour to Egypt. Rockefeller's own description presents a somewhat different evolution. According to her version, the idea for MOMA was inspired by her visits to comparable European repositories, and her growing conviction that "the time had come when the people of the United States were sufficiently interested . . . to warrant a reasonable expectation that they would support a museum."[45]

She tested this idea in conversations with a number of prominent museum representatives who seemed unusually attuned to the contemporary works that their institutions excluded. Edward Harkness encouraged her "because he felt that the Metropolitan Museum was not the place in which contemporary art should be shown." Chicagoan Martin Ryerson was also an influential counsellor, as was William Valentiner at the Detroit Institute of Arts. "Then I began to think of women whom I knew in New York City, who cared deeply for beauty and bought pictures, women who would be

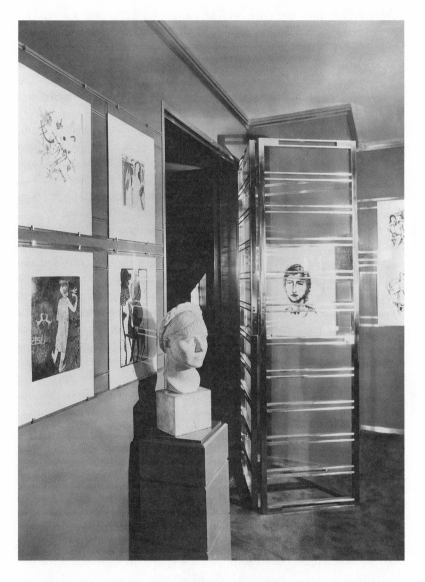

ABBY ALDRICH ROCKEFELLER'S PRIVATE GALLERY

Courtesy of the Rockefeller Archive Center, North
Tarrytown, New York

willing and had faith enough to start a (real) museum of contemporary art," Rockefeller recalled, eventually settling on two other Halpert clients, Sullivan and Bliss.[46]

Rockefeller admitted to being "still very much thrilled with the idea of our venture" when the plans were first drafted in 1929. Although the trustees tried to build a broad base of support from the outset, Rockefeller quickly emerged as one of the museum's key backers, regularly supplying a major portion of its operating expenses. She also guided its management, particularly after the other founders passed from the scene. Mary Quinn Sullivan resigned from the board in 1933, after the death of her husband, and Lillie Bliss died in March 1931. Although Rockefeller may have had misgivings about having the institution too closely associated with her family alone, MOMA quickly emerged as a Rockefeller "protectorate."[47]

One of the most surprising decisions in those early years was the selection of A. Conger Goodyear as president. Goodyear was a respected collector and a trustee (and briefly, president) of the Albright Gallery in Buffalo. He had attracted a fair amount of notoriety in his dealings with the Albright by authorizing the purchase of a Picasso and opening its halls to an exhibition from the Société Anonyme. The fact that MOMA began operations by putting a man at the helm remains somewhat puzzling. Most of the women who created museums sought to retain tight control, as did Gardner, or had it wrested from them, which was the case at Cooper-Hewitt. The answer may lie, in part, in Rockefeller's nature. Several sources maintain her aversion to publicity, which may have stemmed from the public attacks that were levelled at her father during his senatorial years and at her husband during the congressional investigations of Standard Oil. By putting a man in charge, she may have sought to deflect attention from her own actions and from the Rockefeller name.[48]

Another puzzling question is why, unlike almost all of the other specialized museums created by women, MOMA was cast as a small "nonprofit corporation" from its inception. Certainly, Rockefeller would have had ample precedents for this type of organizational form. Her father-in-law created (and her husband presided over) some of the country's earliest and most influential foundations; and the University of Chicago was another major Rockefeller project. Many of her most trusted advisors, such as Harkness, Valentiner, and Ryerson, were directors or trustees of major museums. Moreover, she was undoubtedly familiar with Katherine Dreier's efforts, which may have underscored the problems inherent in institutionalizing relatively unassisted campaigns. As a "nonprofit corporation," MOMA theoretically would have an entire board to garner collections and funds from all parts of the community, rather than relying solely on the

efforts of the three founders. Whatever their reasons, MOMA's founders shunned the limelight, preferring to help run their museum from the sidelines while publicly entrusting it to the management of men.

Despite Goodyear's appointment, the founders continued to exercise their control in other, more subtle ways. Goodyear constantly conferred with Rockefeller during the museum's early years, soliciting her advice on almost every decision. She occasionally overruled some of his. For example, Rockefeller suggested that Duncan Phillips might be a good addition to the board, one that could "strengthen our position with the younger artists of the country, for whom he has done so much." Goodyear sought to veto this idea, arguing that Phillips would not be active enough, since "he is so much interested in building up his own collection." Nonetheless, he was invited to serve.[49]

The founders and the organizing committee (which included, among others, Frank Crowninshield, the editor of *Vanity Fair;* Paul J. Sachs of Harvard's Fogg Museum; and Mrs. W. Murray Crane, the widow of the former governor of Massachusetts, and one of Rockefeller's friends) constituted the nucleus of the first board. An advisory committee of younger connoisseurs was soon added, headed by one of Rockefeller's sons, Nelson Aldrich Rockefeller. By 1931 Nelson presided over most of the museum's regular committees as well, and joined the Executive Committee the following year. Even before his graduation from Dartmouth in 1929, Abby confided to him that "it would be a great joy" to her "if you did find that you have a real love for and interest in beautiful things. We could have such good times going about together, and if you start to cultivate your taste and eye so young, you ought to be very good at it by the time you can afford to collect much." In effect, she used the museum as a means of encouraging her son to share her own enthusiasm for collecting and for modern art.[50]

Other slots were filled with the aid of the board. Paul J. Sachs nominated Alfred H. Barr, Jr., to serve as the director. Sachs first met his nominee when Barr was an undergraduate in his museum course at Harvard. In addition to his academic skills, Barr had helped to found the Harvard Society for Contemporary Art, Inc., using two rooms in the university's bookstore, "the Coop," for a gallery. Lincoln Kirstein was a charter member, as was Edward M. M. Warburg, who later served as a MOMA trustee. Barr also developed what may have been the country's first college course on twentieth-century painting, music, theater, and industrial design at Wellesley, which he was teaching when Sachs recommended him. After a couple of interviews at the Rockefeller's summer home at Seal Harbor, Maine, the appointment was approved, and Barr was added to the staff.

Backed by almost fifty charter subscribers, MOMA finally opened in

rented quarters in the Heckscher Building at Fifty-seventh Street and Fifth Avenue in November 1929. The "Founder's Manifesto" promised to hold regular exhibitions of the works of leading contemporary European and American artists, and to create a permanent public museum of modern art. The content of the first exhibition was determined after lengthy negotiations between Rockefeller, Bliss, Barr, Goodyear, and Sachs. While the men opted for a small show of American painters such as Ryder, Homer, and Eakins, to be followed by one of the European masters Seurat, Van Gogh, Gauguin, and Cézanne, Bliss and Rockefeller voted to open with the European group instead. As Rockefeller explained, the European exhibit would be more "chronologically appropriate" and less likely to become embroiled in the factions that surrounded the works of American artists. The "adamantine ladies" prevailed, and the museum opened with an exhibition of ninety-eight paintings by the four Europeans, many of which had been borrowed from private collections and never before publicly seen in New York.[51]

The reviews were almost uniformly enthusiastic. Lloyd Goodrich announced in his article in the *Nation* that "just as the great Armory Show of 1913 was the opening gun in the long, bitter struggle for modern art in this country, so the foundation of the new museum marks the final apotheosis of modernism and its acceptance by respectable society." The *Outlook* predicted that MOMA would serve as a "supplementary museum" to the Metropolitan, testing new art forms, after which the most enduring would be acquired by larger, more established repositories. Others criticized the Metropolitan Museum while lauding MOMA. Thus, noted an article in *Literary Digest,* "efforts to 'crash the gates' of the Metropolitan Museum by the modernists have proved so often a thankless and futile task that now the tide has gone elsewhere."[52]

Some predictions were more prescient than others. The review in the *Outlook* prophesied that MOMA's list of charter donors indicated "that it will be financially untroubled; more, that it will be free from factionalism." It was indeed an impressive list, headed by Edward Harkness and Sir Joseph Duveen, who contributed $10,000 apiece. By 1930, however, Goodyear had begun to realize that "the stock market break . . . will make it much more difficult for us to get in additional subscriptions." Nonetheless, they continued their $100,000 building-fund drive into 1930, with Rockefeller, Stephen Clark, and Goodyear heading the subscriptions at $10,000 apiece. Rockefeller, Clark, Harkness, and Duveen continued to top the list of subscribers in 1931, with comparable sums. By 1932, however, MOMA's finances had worsened to the point that it was cutting sal-

aries, as the annual budget dropped from a high of $100,000 in 1929 to $67,000.[53]

Wherever possible, Rockefeller covered the costs herself, as when she handed over an additional $3,500 in 1931 to guarantee a staff member's annual salary. The importance of her contributions was underscored by the unwillingness of many of her fellow trustees to support the museum as the Depression deepened. An internal tally from July 1932 revealed that, in addition to her $10,000 pledge, Stephen Clark had offered $5,000, Mrs. Crane $1,000, and John Spaulding a scant $500, while the rest pledged nothing at all. Rockefeller was particularly concerned about these developments, arguing that "we cannot ask other people to give to the Museum in large amounts without the trustees themselves having expressed their confidence in it by making substantial pledges for its future." Several foundations were also approached (in most cases abortively), including the Rockefeller Foundation, which declined their request for capital improvement funds in 1936. Within this milieu, Rockefeller's gifts played an important role in keeping the museum alive.[54]

Her donations remained relatively small until 1934, when her husband created seven individual trust funds for her and their six children. His decision was born of tax considerations, rather than a sudden desire to help MOMA out of its financial dilemma. He set aside $18.3 million in oil stocks for Abby, in an irrevocable trust that gave her complete control of the income but barred her from invading the principal. As a result, her gifts to the museum became increasingly generous.[55]

Aside from this, however, her husband remained fairly aloof from the museum's financial plight. When MOMA's lease in the Heckscher Building expired in 1932, the trustees began to look for more affordable quarters. One alternative was to take a five-year lease on a house owned by JDR Jr. at Fifty-third Street and Fifth Avenue, for $12,000 per year. At one point, Goodyear delicately asked Rockefeller if she would ask her husband to sell it to them, with the option to repurchase. Later, he asked her point-blank whether JDR Jr. could be persuaded to donate the house, rather than renting it to them. JDR Jr. remained unswayed, and the property was rented, not given. At one point, the harried president enviously pointed out that he had noticed "that the Fogg Art Museum has received $500,000 for general endowment from the General Education Board," one of the family foundations with which JDR Jr. was involved.[56]

The museum's financial situation was further muddied by Lillie Bliss's bequest. Bliss left her splendid collection to the museum with the proviso that her executors had to agree that MOMA was sufficiently endowed to

ensure its financial survival before the collection could be transferred. Her executors subsequently demanded that the museum raise a $1 million endowment before they would release her gift. Although it might have been possible to marshal such a sum in more prosperous times, it proved an exceedingly difficult task at the height of the Depression, particularly since the funds were being raised for art, rather than for relief. Nonetheless, $600,000 was eventually raised, helped by $200,000 given by JDR Jr. at Rockefeller's behest, in a rare show of sympathy toward the museum's plight, and another $100,000 gift from the Carnegie Corporation. When it became apparent that few additional funds would be forthcoming, the executors lowered their price tag at the urging of Bliss's brother, Cornelius, who was a member of the board, and the paintings were added to MOMA's permanent collection.

Rockefeller continued to serve as the museum's major donor through the 1930s, bolstering her gifts of cash with prints and paintings from her collection. In 1935, for example, she donated 36 oil paintings, primarily by Americans, and 105 watercolors and pastels. Five years later, she offered another batch of 150 paintings and drawings and 2,000 prints. Her generosity was inspired, in part, by her deference to her husband's lingering aversion to modern art. Since their children were grown and they no longer needed a mansion, their Fifty-fourth Street house was sold, and the couple moved into an apartment. By donating a major portion of her collection to MOMA, Rockefeller ensured that her husband would not be continually confronted by her collection when they moved to smaller quarters.

She remained committed to the promotion of American art both in her own collections and in the museum's dealings. Yet, although Rockefeller included the works of women painters such as Georgia O'Keeffe and Marguerite Zorach among her own acquisitions and paid quite handsomely for their works, women did not fare particularly well in MOMA's exhibits. O'Keeffe was the only woman to win a place in the "Nineteen Living Americans" exhibit, the museum's second show, which was publicly criticized for omitting the works of other artists such as Florine Stettheimer. Similarly, O'Keeffe was granted the museum's first retrospective by a woman at the museum in 1946, almost two decades after it was founded.

Abby Aldrich Rockefeller died of a heart attack in her Park Avenue apartment two years later, at the age of seventy-three. JDR JR. finally relented in his aversion to the museum after her death, donating over $4 million in securities and land as a memorial to his wife. Even then, he felt compelled to tell his son, Nelson, that modern art had "never greatly appealed to me" but that he had decided to make the gift "to preserve for the

future the important work of this institution which meant so much" to Abby.[57]

The 1920s are often viewed as an era when philistinism was paramount. However, the work of Abby Aldrich Rockefeller and Katherine Dreier reveals that it was also a key period of institutional experimentation, particularly within the avant-garde. Women were able to take the lead in these areas precisely because this type of art was undervalued among more traditional collectors, and still held at arm's length by the major museums. Excluded from decision-making roles within the country's major repositories and hampered by relatively limited resources, women cast their lot with contemporary art and artists, laying the groundwork for America's bid for international primacy within the avant-garde.

In many respects, the efforts of women such as Rockefeller, Edith Halpert, and Gertrude Stein constituted a form of rebellion. This was an era when modernism was still steeped in an aura of radicalism. Many contemporary artists such as John Sloan and Robert Henri cut their teeth on radical causes and socialist journals such as the *Masses,* espousing causes that carried over into the careers of other controversial painters such as Diego Rivera. With the advent of the Red Scare in the early 1920s, activities such as these became increasingly suspect. Even the internationalism embodied in avant-garde activities grated against the ethos of Jazz Age isolationism. As Alfred H. Barr, Jr., explained, "In her position, the outside world took for granted that [Rockefeller] could do almost anything her wealth and power would permit," but "few realize[d] what positive acts of courage her interest in modern art required." Not only was this field "artistically radical, but it is often assumed to be radical morally and politically, and sometimes, indeed, it is. But these factors, which might have given pause to a more circumspect or conventional spirit," did not deter her, "although on a few occasions they caused her anxiety, as they did us all."[58]

Their efforts also served as an index of the growing acceptance of female individualism. While Peter's generation was exiled to the periphery of the cultural arena, and women like Wheeler often acceded to the aesthetic prescriptions of male mentors and peers, patrons like Rockefeller challenged the old constraints in new ways. Their activities reflected the growing array of professional and philanthropic options that opened to women after the turn of the century. Thus, Edith Halpert not only studied art, but pursued a lucrative commercial career after she wed. And Rockefeller, Sullivan, and Bliss pooled their money, as well as their talents, to reshape the "nonprofit corporation" to fit the contours of a highly specialized new field.

Some women, like Isabella Stewart Gardner, had adopted the individualist's role with relish, revelling in their influence and the challenges inherent in their campaigns. Others, like Rockefeller, adopted the role more surreptitiously, quietly refusing to bear the yoke of familial constraints. Still others, such as Katherine Dreier, inherited it by virtue of the unpopularity of their causes, mounting lone crusades that would have been far more difficult in Wheeler's time.

While Candace Wheeler and her associates placed women's needs at the top of their institutional agendas, many twentieth-century female patrons forwarded purely aesthetic aims. As in the case of the assimilationists, this strategy often placed women artists at a disadvantage. One of the earmarks of individualism was its diversity. These women were no longer compelled to mask their cultural endeavors in the cloak of charity or to shape their institutions around female constituencies and the home. Nor did they have to defer to curatorial prescriptions, often challenging them instead. Some, like Dreier and Stein, opted not to use their ventures to win professional parity for other women. But a few, like Edith Halpert and Gertrude Vanderbilt Whitney, would. The essence of individualism was choice—the option to shape philanthropic priorities in new ways, rather than heeding the older cues of gender and class. And, in some instances, this freedom was purchased at the expense of feminist gains.

The new emphasis on choice was also reflected in the diversity of cultural endeavors in which women participated in the 1920s. Mass-based efforts such as those sponsored by women's clubs carried the separatist spirit into the twentieth century, with a lingering emphasis on women, children, and the home. The 1920s recorded an increasing splintering of women's cultural roles into separatist art appreciation campaigns, assimilationist gifts to museums, and the more solitary efforts of individualists like Katherine Dreier. The "women's culture" embodied in club work still held sway in many quarters after the First World War. But it lost its exclusive hold. In the process, individualists like Dreier achieved new scope in fostering alternative artistic movements aimed at the community as a whole on solely aesthetic grounds.

Their activities also differed from those of their male peers in several respects. Women like Dreier and Rockefeller shared their enthusiasm for modernism with a small number of seasoned male missionaries and connoisseurs such as Alfred Stieglitz, Arthur Jerome Eddy, A. E. Gallatin, John Quinn, Alfred Barnes, and Walter Arensberg during the opening decades of the twentieth century. Yet on the whole, their contributions tended to test the outer limits of even this group, in terms of both the scope of their connoisseurship and the importance of the institutions they created.

Quinn's collection, for example, remained essentially private and was dispersed upon his death, while Stieglitz's elitism limited his audiences, as well as the number of artists he was willing to help. And although Barnes's superb collection was, "without doubt, the finest collection of modern art in America, perhaps in the world," his idiosyncratic policies made it exceedingly difficult to gain access to his gallery, limiting the public impact of his institution.[59]

Gallatin's Gallery of Living Art perhaps most clearly paralleled the history of the Société Anonyme. Although some art historians have argued incorrectly that "there was no place to see even the masters of modern art" in New York before MOMA was founded in 1929, MOMA's forerunners lived an undeniably precarious existence. Gallatin created his Gallery of Living Art in a study room at New York University in 1927. Stocked primarily with his own holdings, it was designed to feature the "works of living men, or men who were living at the time of acquisition." In much the same fashion as Luman Reed or Robert Gilmor nearly a century before, he sought to create a public gallery from his own collection. Yet Gallatin's claim that his efforts constituted the first museum for modern art in the country was wrong. Strictly speaking, that honor belonged to Dreier and the Société Anonyme.[60]

There were other distinctions as well. Both Dreier and Gallatin failed to institutionalize their efforts in the way that they had originally envisioned. Gallatin's venture came to a particularly embarrassing end, when his gallery was summarily evicted from New York University in 1943 in order to clear the additional space for books. It eventually found a permanent home at the Philadelphia Museum of Art, just as the Société Anonyme came to rest at Yale.

What distinguished Dreier's efforts, and those of MOMA as well, was the catholicity of their definitions of modernist fare. While Gallatin opened his gallery with a collection of "rather sketchy and slight examples" of the works of the more acceptable modernists—men like Picasso and Matisse—Dreier cast her net much more widely and did so much earlier, within the isolationist shadow of the Red Scare. While Gallatin started with "a minor collection, which presented the tendency without the quality of modern art," Dreier's collection provided "a rallying point for all that was most radical." Even the Phillips Gallery, which opened in 1920, "had no pictures by the really advanced moderns" at the time. Thus, although crusaders like Dreier and Rockefeller shared the field with a number of talented and committed male connoisseurs, they took the lead in testing the most uncharted terrain. In the process, they helped not only to legitimize, but to redefine the avant-garde.[61]

Echoing a familiar theme, the institutions that they founded often sub-sisted on relatively modest budgets, including MOMA, which lived a hand-to-mouth existence during much of its infancy. Although men like Gallatin also sought to create new ventures with limited funds, the degree to which this problem historically typified women's efforts was striking. Thus, dur-ing MOMA's first five years, Abby Aldrich Rockefeller donated approxi-mately $45,000 to keep her museum running, while her husband lavished millions on the Cloisters. And yet she and Lillie Bliss and Mary Quinn Sullivan left an undeniably significant legacy, creating one of the nation's most important specialized repositories and helping to keep the cause of modernism constantly before the public eye. They also promoted the cause of contemporary American art, as did Gertrude Vanderbilt Whitney. Both artist and patron, Whitney would transform her studio into a series of ma-jor initiatives designed to spread the gospel of American creativity.

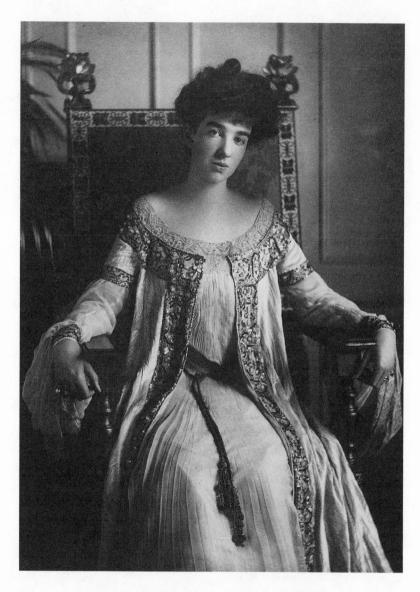

GERTRUDE VANDERBILT WHITNEY

8

GERTRUDE VANDERBILT WHITNEY: FROM STUDIO TO MUSEUM

B y the 1920s, women had become an important presence on the American cultural scene, finally claiming a role that observers had long suggested was their venue. Both Abby Aldrich Rockefeller and Gertrude Vanderbilt Whitney created major museums that quickly became leading institutions in their fields. Both women also shared an interest in promoting the works of living American artists and in fostering public appreciation for contemporary art. They were from the same social background and reared in similar settings of privilege and wealth. Each had married well, and both were keenly aware of the cachet that their endorsements could bestow. Yet the two were also very different, as were their institutions. While Rockefeller stood in the background, quietly orchestrating her campaigns through A. Conger Goodyear and the MOMA board, Whitney took the lead in everything she did. While Rockefeller crafted her designs from the comforts of a

happy marriage, Whitney embraced the cause of art as a refuge from her marital ills. And while Rockefeller's love of art, however deep, was an avocation, for Whitney it was a career.

Her work as a professional artist gave Whitney a special perspective, which threaded through all of her designs. She built her institutions from her networks of friendships and professional relationships, echoing the techniques of patrons such as Luman Reed a century before. Her efforts heralded not only the decline of a separate "women's culture" but also the fact that "the world sustaining a separate men's culture had faded"—and no one did more to hasten this transition within the artistic arena than Whitney.[1]

She was an interesting, talented woman, the disaffected child of luxury and wealth. Born into one of America's richest families, she was the great-granddaughter of the legendary Commodore Vanderbilt, an uncouth but intensely gifted businessman who parlayed a small ferrying company into a railroad empire. The commodore died in 1877, the year of the great railroad strike, when Gertrude was two years old. Her father, Cornelius Vanderbilt, expanded the family's railroad holdings and dabbled in a growing array of philanthropic ventures, including service on the board of the Metropolitan Museum of Art for almost twenty years. He had also served on the exhibition committee of Candace Wheeler's New York Society of Decorative Art. One of his more notable contributions to the Metropolitan was Rosa Bonheur's *Horse Fair,* one of the most celebrated paintings of the mid-nineteenth century. Gertrude was reared in an atmosphere infused with the artistic gleanings of the Gilded Age, from her father's collection of Barbizon paintings to the Fifth Avenue mansion in which they were hung. Crafted by such fashionable architects and designers as George B. Post, Richard Morris Hunt, Augustus St.-Gaudens and John La Farge, Cornelius Vanderbilt's houses were among the leading exemplars of the Victorian craftsmanship, aesthetic ideals, and materialistic display embodied in the decorative arts movement.

Gertrude's parents also owned what was perhaps the country's most extravagant mansion, the Breakers at Newport. Their decision to build their Newport palace stemmed, in part, from her mother's social ambitions and her rivalry with her sister-in-law, Mrs. William Kissam Vanderbilt, another reigning society queen. Alice Vanderbilt was a Cincinnati belle, a distant relative of Washington Allston, and an extremely competitive woman who managed to marry Gertrude's sister, Gladys, to Count Laszlo Szechenyi of Hungary in one of the more celebrated international matches of the time.

Gertrude was brought up within the cloistered environment of the

very rich. Educated first by tutors, then at the exclusive Brearly School for girls, she was cosseted, protected, and ultimately isolated by her family's wealth. Even as a child, Gertrude chafed at the constraints that her position and her gender imposed, later recalling how she longed more than ever "to be a boy." As she explained, "There were lots of things I could not do simply because I was Miss Vanderbilt. . . . I longed to be someone else, to be liked only for myself, [and] to live quietly and happily" in more modest settings. She was also "frightfully shy," and years later still winced at the memory that "no matter how well I knew my lessons when it came to being called on to answer questions, every thought went out of my head."[2]

Her parents were perhaps overly protective, which heightened Gertrude's ambivalence about her wealth. As she later admitted, "It seems almost inconceivable to have been brought up as I was—never allowed out of the house alone, never [to] read a book uncensored by my mother. Oh, that older generation never had any contact with the experiences of life." Nor was she particularly taken with her mother's social pursuits. By the time Gertrude was in her teens, she had come to the conclusion that "the only way to enjoy [life] most is to have other interests besides the social ones."[3]

Her marriage to Harry Payne Whitney in 1896 shifted her from one gilded setting to another. The son of the former secretary of the navy, and one of the Vanderbilts' wealthiest neighbors in New York, Whitney was an amiable dilettante, who was educated at Yale University, but who was best known as an avid sportsman who raced his own ponies and hunted tigers in India. As such, Harry was almost the perfect embodiment of the masculine virtues of "the strenuous life" and the vigorous cult of male sports and outdoorsmanship that emerged at the end of the nineteenth century. The nature/culture split so celebrated in the periodical press came to typify their marriage, as Harry increasingly gravitated toward his sports, and Gertrude toward her art.

In the beginning, they seemed destined to have a comfortable future. Harry's father gave them an elaborate mansion on Fifty-seventh Street, replete with Renaissance tapestries, French furniture, and Italian paintings, as a wedding present. For Gertrude, the gift merely emphasized the static nature of her life. She later remembered it as being "the very same atmosphere in which I had been brought up, the very same surroundings. Just as physically I had moved some fifty feet from my father's house into my husband's, so I had moved some fifty feet in feeling, environment and period." Perhaps to mark a break with her family's tastes, she decided to add some decorative touches of her own, which brought her into contact with the artist John La Farge. "I will never forget the . . . pleasure I experienced,"

she later recalled, "in having had the privilege of meeting so great a man. From then on I took an interest in American art. I began to realize the opportunity I had of acquiring." Like their parents before them, the Whitneys also entertained on a lavish scale. As Gertrude saw herself sliding into the patterns of her parents' lives, she became increasingly discontented: "We lived in the country and were surrounded by the sort of people we had always known. The sons and daughters of our parents and the general run of society folk frequented the house. Every weekend we had big parties and everyone was nice and respectable and conventional."[4]

After a few years, her marriage soured as well. The problems intensified with her third pregnancy in 1902 and her daughter's premature birth, which triggered an extended postpartum depression, despite the fact that the child survived. As she sank into despair, her husband increasingly made it a point to stay away, and Gertrude correctly suspected that he was having an affair, which increased her anguish. Whitney was an avid diarist, recording even her most intimate thoughts with arresting candor. Thus, she wrote, "there was so much to live for and sometimes so little joy in living," describing herself as "a ghost in an unreal world."[5]

Whitney's journals from this period are filled with self-loathing, self-doubt, and lingering insecurities. "I am an idiot," she angrily noted, "I am a fool, and that is all that counts. There are two sorts of people, those who are stupid and whom I get along with, and those who are clever and whom I do not get along with. When I go with the stupid ones I have a fairly nice time . . . when I go with the others I am self-conscious, unhappy, and ill at ease. I continually see my faults and hate myself for being stupid." Nor was she particularly enamored of her friends. "Almost all of the people I am thrown with I do not like and am not interested in," she complained, adding that "most of the things I do are not congenial to me." However, much of her anger was directed at herself. "You have no friends, no—— nothing left," she bitterly noted. "You have controlled yourself for so long and held check on yourself to such an extent that you can no longer express any feelings or be sympathetic to anyone."[6]

As Gertrude's suspicions about her husband's infidelities mounted, so did her ire. "Men are tyrants," she declared. "They wish to become possessors of the soul of woman as well as her body. . . . If she would live and enjoy again . . . she should escape from the tyranny of one man. While she belongs to him she is a poor thing indeed, with no object to fulfill but the physical one, with no place in life but the lower one, with no dreams or thoughts to express but the baser ones. . . . She must be untrammeled and free before all her faculties can work. . . . How is that possible while the heavy hand of man rests upon her."[7]

Gradually, her depression began to give way to a new desire to do something meaningful with her life, in order to mitigate the agony of a disintegrating marriage. "You must make some part of your life congenial to yourself," she wrote, "so that at least for a few hours you can be yourself and let out your feelings, your thoughts and emotions." "We all long for completeness in life," she philosophically admitted as she began to recover, ". . . to play on the instrument that is ourself on every note, in every key, every interest developed, one's nature the medium that receives experience."[8]

Like generations of women before her, Whitney initially sought solace in her family and through charitable work. By 1904 she had begun to record lists of possible activities, from spending more time with her children "to begin to interest their minds," to keeping abreast of current topics, to working at Greenwich House. In one particularly poignant entry, Whitney admonished herself to find "some charity" to fill her time, since "these things will elevate me in the eyes of H. P. W. That is my chief reason for wanting to do them."[9]

As she began regularly visiting Mary Simkhovitch's settlement, Greenwich House, her spirits rose. "I took hold of one of my charities," she recorded. "Gave the entertainment . . . largely ran it, and we made a great success, including $7,000." Spearheaded by the pioneering activities of a new generation of college-educated female reformers, settlement work became an increasingly common and appealing outlet for the energies of women at all levels of society by the turn of the century. Greenwich House was founded in 1901 to serve a diverse constituency of Irish, Italians, and blacks in New York's Greenwich Village. Whitney was elected to the board in 1902, drawn there by the interest of her friend and fellow trustee Meredith ("Bunny") Hare. Whitney quickly took a leading role in bolstering the settlement's artistic offerings, funding art classes that she also helped to oversee.[10]

She turned increasingly to art during these troubled years. It was a natural interest for her, following on the flanks of her father's enthusiasms. On an early trip to Europe in 1890, Gertrude devoted part of the time to visiting the exhibition at the Paris Salon, dutifully making notes on each of the paintings, and made the requisite tour of the Louvre. She began to dabble in sculpture four years after her marriage, studying privately with the Scandinavian sculptor Hendrik Christian Andersen. Initially, it was little more than a pleasant pastime. As she later recalled, "While I worked he read Ibsen to me and I began to see how many things in life I knew nothing about." During her depression, however, sculpting took on new importance. Thus, she noted in one entry, "your object in life now is modelling

[sculpting], and it has made life far happier." In another, she toyed with the notion that "perhaps the only way to do it is to have a Studio. Anyway if you don't work hard it will be a place where the atmosphere is congenial and where you can live."[11]

This in turn strengthened her interest in art and the notion that cultural philanthropy might provide a means of personal salvation, ideas codified in the "plan of action" she mapped out in 1904. First, she reminded herself, it was necessary to "decide what you could be permanently interested in," adding an admonition to "be sure that it is something in which all of your advantages count. Let it also be something which you yourself start. Be sure your position as well as money helps, also any special gifts you yourself have." Whitney advised herself to canvass as many people as possible first and to "use your position to influence men who in turn have the influence you desire. It is the only road to happiness and it must be done." Harry was also to be conscripted into the plan, since although "he is uninterested in your present life and aims [it] does not mean that he will be of these." Her real power, she reminded herself, was her "money and position. . . . Why do what is fitting for Jane Smith when you are not Jane Smith?" Unlike women in earlier generations, Whitney was keenly aware of the power her wealth bestowed, as well as the opportunities that it provided for the creation of new philanthropic initiatives.[12]

Although the outlines were still unclear, she suggested "vaguely an idea—to found a Beaux Arts—with painting and modeling in connection. Tuition low. Scholarships. Exhibition rooms in connection . . . $1,000,000 . . . Best teachers. . . . Lectures from prominent artists." Casting aside the narrow emphasis on female education in the arts of design, Whitney envisioned an institution to serve the artistic community as a whole, grounded in the fine arts and purely aesthetic ends—all of which marked a sharp break with the separatist initiatives of Candace Wheeler's generation. She also pragmatically noted that "the artists who influence things in this country should be gotten on my side. That might be hard." Once again, the emphasis was on professional, rather than gender, considerations. Like Isabella Stewart Gardner and Gertrude Stein, Whitney had already begun to consider ways in which to recast the contours of female cultural philanthropy at the cusp of the century, transcending the bounds of earlier constraints. To accomplish her ends, she plotted a concrete campaign, including plans to conscript men like Charles McKim with carefully orchestrated invitations and conversations. "He is in himself a prize," she noted, "try to win him to your side." Augustus St.-Gauden was subsequently invited to tea, and the painter John Alexander was offered a portrait commis-

sion as bait. Despite her prominence and her wealth, Whitney began her artistic and philanthropic career at the edges of male cultural elite networks, scheming to draw prominent men into her plans in order to legitimize her designs.[13]

She also began to hone her own artistic skills. As Whitney explained, she had initially taken up sculpting because she "wanted to work. I was not very happy or satisfied in my life. The more I tried to forget myself in my life the less I succeeded in doing so. . . . I had always drawn and painted a little, now I wanted to try modeling." After studying with Andersen, she briefly enrolled in James Earle Fraser's class at the Art Students League, where sculptors Anna Vaughn Hyatt and Malvina Hoffman were among her classmates. Later, she continued her studies with Andrew O'Connor in Paris, where her work was encouraged by the famed French sculptor Auguste Rodin. And she began to exhibit, submitting her statute *Aspiration* to the Buffalo exposition under a pseudonym in 1901.[14]

Although Whitney's family and friends had humored her when they thought that her sculpting was only an avocation, as it became clear that she intended to pursue a serious career, they began to balk. Part of their reaction stemmed from the startling notion that an upper-class matron and mother of three would actively pursue a serious professional career, and part of it stemmed from the changing nature of female art education. Although the preceding generation of female art students had won the right to study in life classes, many upper-class women artists—women like Mary Cassatt and William Morris Hunt's protégés—pursued their craft without the benefit of this training. By 1900 the democratizing impact of the country's growing array of professional art schools erased earlier gender differences, as both men and women were expected to work with nude models as an essential part of their training. Whitney's mother was particularly shocked by the prospect of her work with nude models. According to one source, the "unprudish attitude and the manual labor involved in shaping plaster and clay represented for Gertrude an explosive defiance of the entirely ladylike existence she had known." When Alice Vanderbilt saw a photograph of one of her daughter's early nudes, she hastily admonished her to hide it from her granddaughter, exclaiming: "The fig leaf is so little!"[15]

Harry apparently tried to dissuade her with ridicule, rather than guilt, which only strengthened her resolve. "Never expect Harry to take your work seriously," she advised. "It never has made any difference to him that I feel as I do about art and it never will (except as a source of annoyance)." Her friends "took the attitude of a group of people watching . . . a difficult parlor trick. . . . Few of them took the thing seriously." Whitney con-

tended that if a man of her station had decided to pursue an artistic career, it would not have elicited much comment. But when a woman tried it, her efforts were invariably "greeted by a chorus of horror-stricken voices."[16]

Whitney's situation was complicated by her wealth, since she did not have to work for a living. As she explained, if a wealthy artist insists on commissions, "he is regarded as taking the bread out of the mouth of some struggling artist. If he does something for nothing he is accused of helping in the disastrous work of reducing prices which, if not high treason, is at least sedition in the arts, as business." This, unfortunately, was a taint that never left her. Even after she was well established as both an artist and a patron, reporters continued to describe her efforts as "Poor Little Rich Girl and Her Art: Mrs. Harry Payne Whitney's Struggles to Be Taken Seriously as a Sculptor without Having Starved in a Garret." Even strangers were condescending. "The public at large refused to believe that I was doing anything serious. The people I met were all very nice about it. Very. In the manner that a fond parent pats a wayward child on the head."[17]

Whitney was subjected to the same dilemma faced by many middle- and upper-class women who sought to pursue serious careers. The Nobel laureate and founder of Hull-House, Jane Addams, suffered through a similar nervous breakdown before finally settling on her metier. Addams described her decision in terms of a "subjective necessity": the need and the desire to put her college training to good use. She also bitterly noted that although parents schooled their daughters to care for the poor, they protested when their children sought to develop meaningful careers in reform. They encouraged them to study, then waited for them to fail. Thus, although a growing array of career opportunities began to open for women after the Civil War, the decision to exercise these options continued to be hemmed in by a variety of subtle personal and familial constraints. Like Addams, Gertrude Vanderbilt Whitney developed her career against considerable odds, not the least of which was the opposition of her family and friends. And like Addams, she was more determined to succeed when they protested.

"I had to fight, fight all the time, to break down the walls of half-sympathetic, and half-scornful criticism," Whitney later recalled. One of the most appealing things about her was her candor about the limits of her own creative abilities, particularly in the early years of her career. In one of her journal entries she underscored the fact that "until you have succeeded you are nothing, and what is more you have no right to your views, your tastes, etc. But you have won battles already and you will win more." As for her family's dismay that she was "doing an unprecedented and rather horrid thing," she claimed in retrospect that "it never even worried me." In a

passage that would have sent chills down the spines of antebellum domestic publicists such as Catharine Beecher, she proclaimed, "To the selfish all things are possible. . . . How many forceful natures have been ruined by being unselfish. How many lives wasted through unnecessary sacrifice." Instead, Whitney vowed to embrace "the doctrine of Individuality." As she told a reporter at the height of her career, "I should not . . . be doing the work that I am doing today if it were not for the battle I had to fight to show that I was not merely amusing myself." By the turn of the century, female individualism was beginning to come of age.[18]

Like Addams, Whitney found her solace and her salvation in her work. In explaining the reasons surrounding her own "subjective necessity," Addams commented on the plight of women who were immobilized by "the shock of inaction," whose "uselessness hangs about them heavily." In Addams's opinion, there was "nothing after disease, indigence and a sense of guilt so fatal to health and to life itself as the want of a proper outlet for active faculties." Whitney unabashedly concurred. "I pity, I pity above all that class of people who have no necessity to work," she wrote. "They have fallen from the world of action and feeling into a state of immobility and unrest." When people tactlessly asked her why she worked when she did not have to, her reply was short and to the point: "I work for the joy of working, the pure selfish joy of it."[19]

By 1905 Whitney had begun to pull out of her depression by focusing on sculpting. Whereas before she had begged for Harry's attention, using this as her rationale for good works, art now became a solace in and of itself. Thus, when he abandoned her yet again for another junket with his mistress, she exclaimed, "Two weeks of absolute freedom . . . wonderful! It is glorious. No one to wear you out, no one to discourage you, and no one to keep up for. Oh God, it is almost too good to be true." Whitney had finally begun to come into her own.[20]

By 1910 she began to exhibit works under her own name and to achieve a modicum of success. During that year her marble group *Paganisme Immortel* was shown at the National Academy of Design, the following year her *Spanish Peasant* was accepted for showing at the Paris Salon, and her *Aztec Fountain* won a bronze medal at the San Francisco Exhibition of 1915. Although art historians such as Avis Berman have found Whitney's work to be clichéd and mediocre, by the time that her *Fountain of El Dorado* was shown at the Panama-Pacific Exposition, she was being hailed by some as the country's "most gifted woman sculptor." Even the conservative art critic Royal Cortissoz applauded her skill in the "handling of realistic forms: she aims at the truth and gets it." Commissioned by the Spanish government in 1917, her 114-foot statue of Columbus in the

harbor at Palos, Spain, added to Whitney's growing list of commissions and to public recognition for her work. After the First World War, her name began to appear on rosters of the era's most outstanding women, in a public tribute to her sculpting career.[21]

Initially, she developed a studio on her estate in Old Westbury, Long Island. But by 1903 she had acquired quarters in Manhattan as well, first on Fortieth Street, then at 19 MacDougal Alley in Greenwich Village. When Whitney moved to the Village in 1907, she joined a thriving colony of artists, including some of her colleagues from the Art Students League. Malvina Hoffman already had a studio in the alley, as did their former instructor, James Earle Fraser. This must have struck many of Whitney's acquaintances as a bold and bohemian move. As she later pointed out, "One of the strongest prejudices against which a woman in my position has to fight is working in a studio. . . . Let a woman who does not have to work for her livelihood take a studio to do the work in which she is most intensely interested and she is greeted by a chorus of horror-stricken voices, a knowing lifting of the eyebrows, or a twist of the mouth that is equally expressive. And much more condemnatory."[22]

Nonetheless, she was enamored of her new quarters, which she described in terms of "suggestion and inspiration. The ceiling is high and one's ideas soar upward. I felt at once that I must do something large in it. . . . Great vistas of possibility open out before one. Life is lived in such a place." The transition had a remarkable effect. The year before, Whitney had complained that she longed "with an intensity that frightens me for the impossible. . . . Just for a little space to let all go, all the control of my fenced in life, all the conventionality." After moving her work to Greenwich Village, she began to note that her "shyness has become much less embarrassing" and that she was suddenly "happy in meeting people with big personalities, especially in my own sphere. . . . I felt as if I had been let into a Secret Society." Where once she had complained that "it is my doom only to *see* the possibilities, and never really realize them," she now demanded "adventures . . . and feelings without end."[23]

And adventures she had. One of her more memorable evenings in the Village was marked by an "Oriental Feast," staged in her honor by Edward Knobloch in 1913. Only four guests were invited, and instructed to come in oriental garb. Whitney arrived in a creation by the famed costumer of the Ballet Russe, Léon Bakst. Dinner was served in a tent, accompanied by the strains of a five-man orchestra of Indian musicians. This was a time of social, as well as artistic, ferment, and Greenwich Village served as the crucible of new norms. In the words of one contemporary, "Unconventionality, especially the matter of sex, was taken for granted." And in this case, her

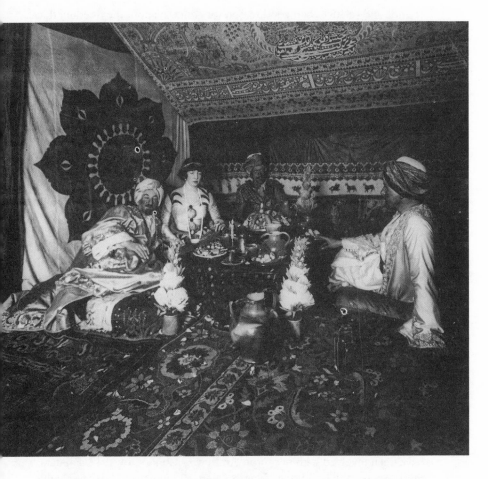

GERTRUDE VANDERBILT WHITNEY AT "ORIENTAL FEAST"

GREENWICH VILLAGE, 1913

friends and relatives had good reason for concern about the freedom that her studio life allowed.[24]

Ironically, Whitney managed to do the things that earlier artists such as Vinnie Ream had only been accused of, and not only kept her respectability but was hailed as a modern heroine. Unfettered by the entourage of family members and chaperones with which artists such as Mary Cassatt had surrounded themselves in order to protect their reputations, Whitney discreetly jettisoned the moral sanctions of her mother's generation. Although women's reputations were still vulnerable to innuendo if they relied too heavily on male mentors for professional advice, after the turn of the century increasingly liberal moral standards finally diminished the emphasis on feminine morality as an index to professional standing. Nor did discreet sexual liaisons necessarily ban women of Whitney's stature from the social networks they needed to build their institutional designs. While antebellum women had been shuttled to the periphery of the artistic arena, in part because of popular misgivings about the sensuality of paintings and statuary, many of these concerns had dissipated by century's end. From the sensuality of her statues to her bohemian lifestyle in her Greenwich Village sanctuary, Whitney both revelled in and exemplified the spirit of her time. Her new freedom must have provided an exhilarating sense of revenge, compensating in part for the humiliation and sexual neglect she had suffered because of Harry's unfaithfulness. A "lonely woman" with "a pronounced streak of eroticism," she found her studio a perfect setting for satisfying her sexual fantasies, as well as a welcome anodyne to the sting of marital indifference.[25]

Whitney engaged in a number of affairs. By 1906 she was involved in an intense flirtation with the aristocratic painter Robert Chanler and may have been involved with her tutor, Andrew O'Connor, by 1912. Painters, models, and childhood acquaintances were all fair game. Harry was quite civilized when he came across a nest of incriminating letters from another paramour in 1919, although he proved unable to resist the comment that "I believed in you and trusted you." Nonetheless, from the time that she signed the lease of her MacDougal Alley studio, the Whitneys led increasingly separate lives.[26]

As Harry drifted off to his racing ponies and polo clubs, Gertrude turned to art and art patronage. Part of her interest was rooted in gratitude. As she explained, "It was the kindness of the men and women who were doing things in the work of art that helped me through the dark ages." Part, however, was the product of experience. As her fellow artist John W. Alexander pointed out in the *Nation,* "In no other country do we find such self-satisfaction and complacency in regard to art as we do over here, and

nowhere else such a lack of . . . intelligent appreciation." The French cubist Marcel Duchamp stated the problem still more succinctly, chiding Americans to "realize that the art of Europe is finished—dead—and that America is the country of the art of the future."[27]

Few Americans heeded Duchamp's advice. The fortunes of American art had steadily declined since the Philadelphia Centennial Exposition, eclipsed by the country's growing appetite for more cosmopolitan fare. Moreover, the bonds that initially linked prominent male patrons and painters steadily eroded after the Civil War, undermined by the growing ranks of dealers, museums, and art schools that assumed many of the symbiotic functions that once united these two groups. As the fortunes of living American artists changed, women assumed new importance in the mentoring practices that had once been the province of men. By the twentieth century, the efforts of prescient connoisseurs such as Katherine Dreier and Gertrude Vanderbilt Whitney had begun to lend new stature to female patrons by virtue of their support of living artists and neglected genres that fell beyond the pale of museum support.

Innovative painters who defied convention—painters like the men of the much maligned Ashcan school—were in a particularly anomalous position. As William Glackens's son recalled, "The exhibition situation was serious." Dealers who were willing to handle American art were in the minority, and "these few usually were not interested in showing the works of rising painters." As a result, artists were forced to "go begging for patrons, and are turned to the wall in sheer desperation." Nor were museums of much assistance. By the 1920s many critics began to attack "the museum habit of mind." Far from pacing contemporary trends, museums were castigated as "graveyards of dead art." Thus, "an artist must die to have his work shown, or else be a foreigner and have his work hall-marked by dealers." "Art doesn't enter into our lives," Whitney complained, "that is the trouble."[28]

Whitney initially addressed the problem on an individual basis, commissioning paintings and signing checks for painters who caught her eye. Cecilia Beaux painted Whitney's daughter Flora's portrait, Maxfield Parrish received $4,000 for a mural to grace the walls of her Westbury studio, and Fraser received the stunning sum of $25,000 for a six-foot pewter bas relief of the Whitney children in 1914. Robert Henri was also commissioned for a portrait of Whitney. She became an enthusiastic and extremely loyal patron of Henri and his fellow urban realists of the Ashcan School. When they staged their famous show at the Macbeth Gallery in 1908, she purchased four of the seven canvases that were sold. Although she passed over his paintings, John Sloan was clearly impressed by the gesture. As he

explained, "At that time, to buy such unfashionable pictures was almost as revolutionary as painting them."[29]

In addition to buying their works, Whitney began to exhibit with Henri's circle at the Independent Artists Exhibition of 1910. Staged in rented galleries at Thirty-fifth Street and Fifth Avenue, the show included the works of many of the realists who had been shunned by the increasingly conservative National Academy of Design. Exhibition space was provided for any qualified artist in return for a modest fee, and the show featured neither juries nor awards. Several of the Ashcan realists also participated on the planning committee for the Armory Show in 1913, including George Bellows and John Sloan, and Whitney supplied $1,000 for decorations for the milestone exhibition, as did her sister-in-law, Dorothy Straight.

Four years later, when the Society of Independent Artists staged its first show, she became one of the organization's major backers, supplying funds for artists too poor to pay the $10 exhibitor's fee. She also made up the deficit for this and several subsequent shows, and by 1918 was a member of the board. Following in the venerable tradition of Luman Reed, she helped to broker commissions among her wealthy friends for her growing coterie of protégés. In 1907 she helped to coordinate an exhibition of works by such artists as Arthur Davies, Ernest Lawson, and Jerome Meyers at the Colony, one of the city's most fashionable women's clubs. She also worked to broker one-man shows for Davies, Lawson, Glackens, Bellows, and Fraser (among others) through the Newport Art Association, thereby broadening the audiences for their works. In 1923 the *Arts* was added to her list of pensioners, ensuring that the nation's leading progressive arts magazine would continue to appear through most of the Twenties. Under the editorship of Forbes Watson, the journal became an important champion of modern art, featuring articles by writers as diverse as Edward Hopper, John Dos Passos, Mabel Dodge Luhan, Virginia Woolf, Igor Stravinsky, Pablo Picasso, and Diego Rivera.

She was also keenly aware of the need for exhibition space. Her fellow sculptor Daniel Chester French complained in 1907 that his Sculpture Society had "not given up all hope of finding something, and we are still searching but I fear it is a forlorn hope." As Ira Glackens explained, "The only way for an artist to have his work displayed at all was in the large annual and semiannual exhibitions held by the National Academy, the Society of American Artists, and similar organizations in a few other cities. The alternative was oblivion." Henri's group was particularly aware of this problem, since more conservative institutions such as the National Academy of Design refused to show their works. Thus, John Sloan re-

called, "we talked a great deal of renting some store or loft building where many artists could exhibit all year round."[30]

Whitney provided one answer to the problem by hosting impromptu exhibitions in her studio. In 1908 she opened two galleries next door as a permanent gallery, and six years later she expanded into the adjacent building at 8 West Eighth Street, which was refitted with additional gallery and office space. This in turn led to a more regular, and increasingly ambitious, schedule of exhibitions. One of the first to be held in the Whitney Studio, as her growing empire was officially dubbed, was the "50-50 Art Sale" held in December 1914. As was the case with most of the exhibitions she sponsored, her maiden venture had an unusual twist. In this case, the title indicated that 50 percent of the proceeds were earmarked for the wartime ministrations of the American Hospital in Paris, and 50 percent for the artists, such as Cecilia Beaux, Arthur B. Davies, and Malvina Hoffman, who exhibited their works.

Many of these early shows were staged as charity benefits, with a strong emphasis on causes connected to the European war, providing a new slant on the role of the domestic impresario. Thus, A. E. Gallatin's collection of modernist paintings was shown in February 1915 as a benefit for the Fraternité des Artistes in France, highlighting the works of (among others) James McNeill Whistler, Everett Shinn, George Luks, Honoré Daumier, Auguste Rodin, Edouard Manet, and Mary Cassatt. The Committee of Mercy and the American Ambulance Hospital in Paris received the proceeds from other shows. Aided by her secretary, Juliana Force (who came to play an important role in these activities), Whitney made an excellent broker, drawing contributions from a wide range of artists. She also used her social connections and her name to lure some of the city's leading patrons to view the works. Noted collectors such as Lillie Bliss and Mrs. E. H. Harriman were among the buyers at these early shows, as was Whitney herself.

Both Whitney's early interest in individual artists and her benefits echoed earlier precedents, blending art and charitable concerns in newer, more individualistic ways. According to historian Avis Berman, "She wanted to defend art that was not yet accredited," both as a means of helping struggling artists and as "a statement of class rebellion." Her efforts also echoed older forms of nonprofit entrepreneurship, turning thousands of dollars in profits to be equally divided between the relief efforts and the artists themselves. In all of Whitney's ventures, "the aim was to be pro-artist," casting the net as widely as possible to help the greatest number in need.[31]

These early exhibitions reflected not only her interest in artists and

their art, but also her involvement in the war effort. Like the Sanitarians who preceded her, Whitney enlisted art in the cause of charity to raise money for wartime relief. By the end of 1914, Whitney was already planning to establish a field hospital in France, stocked with doctors, medical supplies, and a small fleet of ambulances at her own expense. Her resolve was strengthened when her younger brother, Alfred, perished in the sinking of the *Lusitania* the following year. The war was doubly tragic in that her daughter's fiancé, Quinten Roosevelt (the son of the former president), was killed in one of the final skirmishes of 1918. Whitney established her hospital at Juilly, France, in 1915 and travelled to the front several times to personally oversee its work. By the war's end, she had invested nearly $700,000 in its operations and was duly decorated by the French government for her efforts.

Between trips to France, Whitney continued to host exhibitions at her studio in New York, where she increasingly relied on Juliana Force's lively insights and managerial skills. With Force's help, she held the first of several loan exhibitions, featuring modern canvases from six nations, including the work of Cecilia Beaux, George Bellows, Robert Henri, and John La Farge. Interestingly, most of the paintings were lent by women, including her cousin, Mrs. W. K. Vanderbilt, Jr. John Sloan received his first one-man show at the Whitney studio in 1916, to atone for the fact that he had been inadvertently deleted from the mailing list for the earlier, multinational group show. Reviewed widely and well, Sloan's exhibition was hailed as the work of an "American Hogarth" by the *New York Times*. The artist later recalled enjoying "the most successful winter of [his] career" as a result of the show. The gallery also hosted the first of two interesting exhibits entitled "To Whom Shall I Go for My Portrait," which collectively included the works of such diverse stylists as Cecilia Beaux, Malvina Hoffman, Everett Shinn, Alfred Stieglitz, Edward Steichen, and Childe Hassam.[32]

Including the photographs of Stieglitz and Steichen was one way of broadening the definition of "fine art"; exhibiting the work of school children was another. In 1918 the exhibition schedule included the show "Art by Children of the Greenwich House School," as well as "Photographs of American Indians by E. S. Curtis." The same year witnessed a showing of works by Chinese modernists, to be followed two years later by an exhibit of Russian posters, daringly staged at the height of the Red Scare. The "Immigrant in America" show offered a $500 prize for the best work of sculpture on the theme of "the meaning of America to the immigrant, and of America in the fusion of races, traditions and forces." Robert Henri, John Sloan, and Charles Dana Gibson were persuaded to serve on the jury for the event, with Whitney providing the purse. Like all of the studio's ex-

hibits, it was open to the public, with admission fees ranging from $1 on the first day to 25 cents each day thereafter, the proceeds of which were donated to various Americanization campaigns. Roosevelt was persuaded to visit the exhibit, bringing the press in his wake, thus ensuring extensive coverage.[33]

Like earlier decorative art societies, Whitney sponsored and financed several travelling exhibitions. One of the most ambitious was the "Overseas Exhibition," which showcased the works of thirty-two living American artists in galleries in London, Paris, Venice, and Sheffield, England. The show had a preliminary run in the galleries of the prestigious Colony Club, augmented by Impressionist and Postimpressionist works borrowed from local collectors such as Lillie Bliss.

This in turn was followed by a number of innovative exhibits in New York in the 1920s. Stieglitz's former colleague and the erstwhile co-owner of the Modern Gallery, Marius de Zayas, staged the exhibition "Negro Sculpture" in 1923, replicating an earlier show that he had coordinated with Agnes Meyer's backing at 291 Fifth Avenue. The Whitney show added a new twist, coupling the sculptures with twenty Picasso paintings, to underscore the links between modernism and African art.

Perhaps the most original exhibits were the "indigenous" shows held in 1918. Two were held, featuring the works of painters and sculptors in turn. The format was a recipe for chaos. Approximately twenty artists participated in the painters' show. Each received a blank canvas, drawn by lot from a selection of radically varying sizes. Paints, brushes, food, whiskey, and cigars were also supplied. In return, the artists agreed to present a finished painting in three days (the sculptors were allotted one week's time). The method of distributing the canvases produced some "disconcerting results." Thus, a muralist was handed a tiny twelve-by-sixteen-inch canvas, while others stared with exasperation at canvases that far exceeded their usual scope, adding to the difficulty and to the fun. William Glackens, Luks, Sloan, du Bois, Gifford Beal, and Luis Mora were among the artists who picked up the gauntlet and participated in the show. George Luks was particularly inspired by the "prospect of an all-day audience and limitless drink." Tossing all reticence aside, he enlivened the proceedings with an impromptu one-man musical, "with music and lyrics by Luks, all parts played by Luks, and scenery impersonated by Luks." Echoing the high-jinks of the Tile Club and the Sketch, the indigenous shows exemplified and celebrated the integration of women like Whitney and Force into the once resoundingly masculine terrain of the studio, the gallery, and the club.[34]

The year after the Whitney Studio opened its doors, Whitney founded

the Friends of Young Artists. Backed by a group of prominent artists and patrons, it hosted a number of exhibitions and competitions for fledgling American painters and sculptors. In one instance, a prize was offered for the best mausoleum design; in another, they were invited to submit designs for theater decorations. In the process, the artists who participated gained an unprecedented amount of visibility and some modest prize monies as well.

Initially, the association sponsored juried competitions. By 1917, however, Whitney and Force had begun to heed Robert Henri's injunctions against the use of prizes, shifting to nonjuried exhibitions instead. Henri was adamant on this point. As he explained, the practice of awarding prizes constituted "an attempt to control the course of another man's work. It is a bid to have him do what *you* will approve," and as such implied "an effort to stop evolution, to hold things back to the plane of your judgment." Instead, he urged potential patrons to "realize that artists *are not in competition with each other.*" In Henri's opinion, "the pernicious influence of prize and medal giving in art" was "so great that it should be stopped," particularly since "with few exceptions, the greatest artists have been repudiated by the art juries in all countries and at all times." Thus, he recommended that "if you want to be an encouragement to the deserving young artist, don't try to pick him or judge him, but become interested in his *effort* with keen willingness to accept the surprises of its outcome."[35]

By 1918 the Friends of Young Artists had matured into the Whitney Studio Club, giving substance and form to Henri's advice. Many of the artists in Whitney's entourage had had a particularly difficult time in finding places to exhibit their works during the war. To remedy this problem, the club provided "a gallery devoted to the free expression of non-partisan American artists," as well as a clubhouse where members could gather. Opened in a renovated house at 147 West Fourth Street in the Village, it featured an art library, a billiard room, two exhibition galleries, studio space, and even a squash court. A few particularly favored artists, such as Blendon Campbell, were also given living space on the second floor. In addition to exhibitions teas, parties, lectures, sketch classes, and musical evenings filled the club's calendar of events. Enrollment requirements were extremely casual. Initially, an introduction by another member to Juliana Force would suffice. Later, prospective members were asked to submit a painting to an informal jury before being allowed to join, but the evidence suggests that few serious professionals were turned away.[36]

Whitney later claimed that the idea was an outgrowth of her discussions with students and artists, since she generally made it a point to ask her

acquaintances where they went when not working. "The answers opened up a vista of dreariness which appalled me," she later recalled, "revealing a terrible lack in our city's capacities." In addition to providing a convenient meeting place, the club regularly hosted exhibitions of members' works and helped them to broker sales as well, allowing members to set their own prices and to sell their works without having to turn over commissions. Every exhibition was marked by purchases for Whitney's collection as well, guaranteeing additional sales.[37]

Membership was admirably broad, open to painters from almost every school. Bellows, Sloan, William Glackens, and Henri were charter members, as were Nan Watson, William and Marguerite Zorach, Peggy Bacon, and du Bois. Men and women were welcomed on equal terms. By the time the club was phased out in 1928, it boasted over four hundred members, with another four hundred artists on the waiting list. It also went through a series of progressively larger houses as it grew, moving first to 14 West Eighth Street, and then to 10 West Eighth, near Whitney's studio.

Juliana Force officially presided over this growing empire. Force had briefly taught at a business school before taking a position as a social secretary for Whitney's sister-in-law, Helen Hay Whitney. She joined Gertrude's employ in 1907, serving not only as her secretary, but as an informal literary critic for her voluminous writings. After the Whitney Studio formally opened, Force began to help with the exhibitions as well, and when the Whitney Studio Club was founded in 1918, Whitney tapped her to head the new venture.[38]

Although separated by a single year, the two women differed markedly in temperament. Whitney was described as being "tall and slender, with an innate reserve and dignity, and a genuine modesty that made it . . . painful [for her] to engage in the hurly-burly of art politics." Force was by far the more outgoing of the two. The art critic Forbes Watson described her in terms of her "quickness, wit, courage, great powers of improvisation, [and] a genius for transforming an idea into an act before the idea could be dropped," as well as her "active hatred of boring or being bored." As he explained, she had "such a gusto for life that wherever she was there was always something doing." Many people commented on Force's "striking auburn hair and compelling green eyes," as well as her "personal magnetism that struck one instantly on meeting her, like a physical sensation." Others noted her "terrifying wit" and her love of a good fight. To quote Force's biographer, "The heat from her tongue could barbecue anyone." Others described her as "a brilliant talker, vital, witty, sometimes devastatingly frank, with a humor edged with malice, but irre-

sistible. She loathed bores, pretence or pomposity, and punctured them without mercy. . . . The social temperature rose when she entered a room."[39]

Yet, despite their stylistic differences, both women shared "a liking for people, intuitive knowledge of human nature, generosity, a sense of humor, and . . . a deep attraction towards artistic creativity, a respect for its importance, and an understanding of the artist's temperament and problems." Although they occasionally clashed over details, marking their anger with "politely veiled furies," the two women got along extremely well, with a working relationship grounded in mutual respect. Their personalities also complemented each other quite nicely. "If Juliana Force had bored Gertrude Whitney, there would be no Whitney Museum," Watson asserted. "Both ladies abhorred boredom, especially the boredom generated by . . . dull earnestness. . . . There was nothing good-goody about either of them."[40]

In addition to her administrative skills, Juliana Force was a gifted hostess, famed for her parties. Under her stewardship, the club was infused with a "democratic atmosphere" and a lively sense of fun. Exhibitions were inevitably followed by parties, and Force delighted in staying up all night, enveloped in conversation. In one instance, she spent the night drinking champagne in the bathtub with one of the artists. At another party, the Ashcan painter George Luks caused a scene by following Whitney "so closely that his toes touched her heels. She turned around and said, 'George, why are you following me around in this ridiculous fashion?'" To which he replied, "Because you are so damned rich." One of Force's associates, Lloyd Goodrich, later recalled that "many a project for the benefit of American art was settled over coffee and Scotch in her Victorian drawing room." There were also luncheons and formal dinners with celebrities from all walks of life. One such dinner brought together Force, Whitney, John Sloan, and the notorious anarchist Emma Goldman. Ira Glackens later recounted that, "as soon as she was served, Emma Goldman started to eat." When "she noticed that everyone else was waiting until all were served," she apologized by noting, "I learned my manners in jail."[41]

Although Force had no formal artistic training, she was blessed with "an unerring sense of quality" and an ability to listen and to learn. She served as Whitney's talent scout, echoing the brokering roles of Mary Cassatt and Edith Halpert by bringing new artists to Whitney's attention. If Whitney was suitably impressed, "the artist's work was bought or his studio rent paid or he was given a trip to Paris with an allowance." Sloan considered Force "a wonderfully wise and witty manager," in part because "people interested her, especially artists."[42]

The standard view of Greenwich Village in the 1920s depicts it as little more than a haven for pseudo-intellectuals and sightseers, the "Coney Island of the soul," a pale imitation of the intellectual mecca that it had been in the decade before the war. This was certainly the view of Mary Simkhovitch and of the Village's chronicler Carolyn Ware. Malcolm Cowley also painted the 1920s as an era of cultural aridity. "Alas!" cried a former resident, Floyd Dell, "Greenwich Village that was, is no more." And yet, although these gloomy assessments may have accurately marked the passing of the area's literary intelligentsia, they overlooked the vibrant artistic activity that swirled around Whitney, Force, their studio gallery, and their club. Far from an era of stagnation, the Village became a primary focus for American artistic productivity, experimentation, and reform during the 1920s.[43]

During the eleven years of its existence, the Whitney Studio Club hosted eighty-six exhibits, including twenty-eight one-artist shows. It also sponsored annual exhibitions and loan collections noted for their breadth and catholicity of taste. In some instances, members were tapped to coordinate special exhibitions. Five such shows were convened in 1923, including one of the earliest exhibitions of American folk art, backed by contributions from Force's own collection of American artifacts.

Aggressive efforts were also made to help the members sell their works. The club's loan exhibitions were circulated to places as diverse as the Denver Art Museum, the Arts and Crafts Club in New Orleans, and the Fogg Museum at Harvard University, garnering new audiences and helping to sell American paintings and sculpture en route. Whitney and Force had a genius for attracting reporters to their exhibitions, which further highlighted the artists' works. The club's 1921 annual exhibition, for example, netted reviews in most of the city's major newspapers, including the *New York Times*. Many were highly favorable, describing the exhibitions as "an embarrassment of riches" and "the most important American show of the year." In addition to encouraging others to buy members' works, Whitney regularly made acquisitions of her own, often presenting these canvases to museums. Thus, John Sloan's *Hay Market* was donated to the Brooklyn Museum in 1923, and paintings by Max Kuehne and Guy Pène du Bois made their way into the collections of the Detroit Institute of Arts and the Metropolitan Museum.[44]

In addition to marketing members' works, the club developed an enviable record of one-artist shows, promoting the works not only of established artists such as John Sloan and William Glackens, but also of newcomers such as Edward Hopper and Reginald Marsh, who were given their first individual exhibitions under the club's auspices. Women also fig-

ured prominently in these exhibitions. Perhaps because she had had to struggle so hard to be taken seriously herself, Whitney was always sensitive to the plight of other women artists. Louise Nevelson later recalled that, even after the turn of the century, a woman artist was still considered to be something of a "freak." But not within the precincts of the Whitney Studio Club. Katherine Schmidt, Dorothy Varian, Molly Luce, Nan Watson, Isabel Whitney, and Peggy Bacon were among the many women whose works were regularly and prominently displayed in the club's galleries. They also made up a significant percentage of the members. Rather than being segregated in special "women's exhibitions," the works of these and other women were shown in concert with those of men, or given individual shows. The sculptor Malvina Hoffman received a one-woman show, as did Edith Dimock Glackens. Some, like Glackens, also exhibited strong suffragist leanings, marching with the artists' contingent in New York's massive 1913 suffrage parade.[45]

The club was disbanded in 1928. As Juliana Force explained, it had "not only fulfilled its purpose, but has outgrown itself, defeating its own objectives." American art was finally beginning to come of age. In its stead, the women began another lively venture, the Whitney Studio Galleries. To quote Force, the new venture was "an exhibiting gallery for contemporary art, rather than an organization of artists, philanthropically inspired." Instead of advancing the works of a single nationality or school, the new gallery was designed to highlight "the work of artists whom Mrs. Whitney and I believe in." Forty of the forty-four exhibitions hosted during its three-year span were one-artist shows, including the first exhibition devoted to the American regionalist John Steuart Curry. The works of women artists continued to be prominently featured as well, as were those of the realists of the Ashcan school. Many of the works were modestly priced to encourage popular consumption, including lithographs by Reginald Marsh, Peggy Bacon, and Yasuo Kuniyoshi.[46]

Perhaps the galleries' most memorable exhibition was "The Circus in Paint." Staged in 1929, this show featured paintings of circus themes, complete with sawdust on the floor, an organ-grinder and monkey selling peanuts at the door, and balloons suspended from the ceiling. The critics were delighted, commenting on "the freshness of the idea" and the exhibit's "joie de vivre."[47]

After nearly two decades of innovation, Whitney created her final and most enduring institution in 1929. By the end of the Jazz Age, opportunities for American artists had considerably expanded. Many of the functions that Whitney initially sought to fulfill were now carried on by a growing number of galleries and art journals, all of which were helping to

build audiences for American art in new ways. Whitney's own acquisitions had continued to expand as well. By 1929, her collection was becoming increasingly unwieldy, forcing her to decide whether to once again enlarge her gallery space or to enlist other institutions to continue her work. Whitney decided to phase her projects out by donating her collection of over six hundred works (which may have constituted the country's largest assemblage of contemporary American art) to the Metropolitan Museum of Art. Despite its long-standing aversion to the acquisition of non-academic contemporary American artworks, the Metropolitan seemed a likely resting place for Whitney's collection, particularly since her father had served prominently on the museum's board.

Force was duly appointed as her emissary to make the offer to the museum, along with a pledge for an additional $5 million to build and endow a new wing to house the collection. However, Force's visit was cut short when the director curtly dismissed the offer with the comment that "we don't want any more Americans. We have a cellar full of that kind of painting." When Force indignantly reported his comment, Whitney decided to create her own repository instead, one that would be "unhampered by official restrictions, but with the prestige which a museum invariably carries." Like Isabella Stewart Gardner before her, she adopted a less bureaucratic tack.[48]

Forbes Watson, editor of the *Arts* (and Force's paramour), was also present at the proceedings and later recalled that Whitney made her decision "swiftly and gaily." "Before lunch was over Mrs. Force was made director," marking, according to Watson, "perhaps the happiest second in Mrs. Force's life." The museum's primary mandate would be to amass and display "a collection of the finest American paintings obtainable." Beyond this, the two women decided that the new museum should focus on American art, particularly the work of living artists, and that it would welcome the work of any school, provided the level of quality was sufficiently high. Hermon More, a painter who had previously served as the director of a museum in Iowa, was appointed curator, and two other artists were appointed to assistant curatorial posts.[49]

The Whitney Museum of American Art formally opened in mid-November 1931, barely a year after Harry's death from pneumonia at the age of fifty-eight. An estimated four thousand invited guests attended the opening ceremonies on November 17, including artists, critics, museum directors, patrons, dealers, and a large contingent of newspaper reporters. President Hoover provided one of the highlights of the opening ceremonies by sending a congratulatory letter that lauded the new museum for its efforts to "quicken our national sense of beauty, and increase America's

pride in her own culture." As always, Whitney's own prominence served to bolster the visibility accorded her designs.[50]

Press coverage of the museum's debut was extensive and lively. The *New York Times* hailed the creation of the new museum as a "far reaching event" that would leave "behind the old sense of inferiority, the old dependence upon foreign fashion and foreign leadership." Other reporters approvingly noted the stylistic diversity of the collections, the museum's emphasis on living artists, and the novelty of Force's decorating scheme, which featured canvases displayed against bright walls of blue and vivid yellow. Royal Cortissoz described the setting as "something like that of a private house, [with] an air of beguiling intimacy," adding, "There is nothing derivative about the Whitney Museum." The *Outlook* called it "an event of first importance," and the reporter for the *Brooklyn Eagle* concluded that "the result is distinguished, elegant, modern, and above all, American."[51]

Other commentaries were more reserved. Several reviewers questioned the quality of the collection. Matthew Josephson complained that, despite the museum's catholicity of taste, abstractionist painters had been given short shrift. Paul Rosenfeld's essay in the *Nation* was particularly strident, calling the collection "puny and gray." He was especially critical of the Ashcan school paintings, which he deemed "least deserving of a place in a museum of art." Thus, Rosenfeld concluded, the Whitney Museum confirmed the very notion that it sought to dispel, by offering "conclusive proof that American painting is a second-rate affair." Spokesmen for other museums also adopted a condescending view. Hermon More later noted that the Whitney was initially "looked upon with indulgent amusement by older, traditional institutions." According to Forbes Watson, it was "considered intransigent and the human interest of our two ladies in the welfare of the unarrived was looked down upon by the arrived as romantic." Some of the more academic painters also dismissed the collection as "amateurish," covering the museum's early years with "clouds of chilly criticism."[52]

Commentaries such as these underscored the risks entailed in promoting new and neglected fields. While acquisitions of Old Masters were inevitably hailed as a national boon, the pursuit of fields that had yet to win the blessing of museum certification often yielded mixed reviews. Like Gertrude Stein and Katherine Dreier before them, Whitney and Force acted on the courage of their convictions, exposing their tastes, talents, and beliefs to occasionally hostile, sometimes dismissive, reviews.

Nevertheless, their museum ultimately emerged as one of the nation's leading repositories. One of the most noticeable changes in its format as it

matured was the increasingly limited role accorded to women. Although the works of Cecilia Beaux, Georgia O'Keeffe, Nan Watson, Anne Goldthwaite, and several other women were included in the permanent collection, they were accorded secondary status in the museum's more specialized exhibitions (although this may have been partly a result of the museum's policy of hosting only memorial exhibitions). The first retrospective for a woman artist was held in 1943, with the memorial exhibition of Whitney's works. Moreover, when the museum's publications program was launched with a series of twenty-one biographies of leading artists, only one dealt with a woman, Mary Cassatt, along with those of several fairly minor male artists of the caliber of Henry Schnackenberg.[53]

The shift in policy may have stemmed from the fact that Whitney ultimately stepped aside after the museum opened, and the authority for running its activities increasingly fell to Juliana Force and her staff. Although Force's biographer states that she "believed unshakably in the equality of women," the museum's record suggests another interpretation. Whitney seemed more attuned to the needs of women artists than most patrons of her time, with the possible exception of Edith Halpert, perhaps because, like Halpert, she was an artist herself and had felt the sting of discrimination. She also provided the opportunities that undergirded Force's artistic career. Juliana assumed a different pattern, hiring men as her aides and favoring the works of her male colleagues.[54]

Another theme centered on the museum's finances. Unlike the women of Sarah Worthington King Peter's generation, Whitney and her contemporaries often controlled substantial funds, at least on paper. In Whitney's case, she inherited one fortune and married another, and even though her personal holdings represented only a fraction of her husband's resources, they were sufficient to allow her to create her own institutions. Whitney's biographer estimates that by 1932 she was receiving an annual income of approximately $800,000 from her various trusts, a figure that must have been augmented by Harry's death. Her annual contributions for the museum's upkeep and expenses was running at about $160,000, which was bolstered by the donation of her collection (valued at $510,000) in 1935, and subsequent gifts of $100,000 in 1935 and $790,000 worth of stocks in 1937. Whitney's final gift of $2.5 million was bequeathed in 1942. Yet although substantial, these sums were still significantly smaller than the outlays presented by John D. Rockefeller, Jr., to create the Cloisters, or Frank Munsey's $10 million bequest to the Metropolitan Museum of Art, or the sums that Henry Clay Frick lavished on his house museum.[55]

Backed by relatively modest revenues, Whitney and Force set their sights on nothing less than "breaking down the wall of indifference" that

had surrounded American art since 1876. As Force resolutely noted, "This museum will be devoted to the difficult but important task of gaining for the art of this country the prestige which heretofore the public has devoted too exclusively to the art of foreign countries and of the past." It was a formidable challenge, and they handled it with grace and skill. Even the very fact of the museum's creation had an impact. Afterwards, Ira Glackens pointed out, "American art no longer needed to come in the back door."[56]

The museum's impact was enhanced because both Whitney and Force were gifted entrepreneurs. Whitney had a genius for attracting the press and for using her social position to draw prominent artists and potential patrons into the sphere of her activities. She and Force were impresarios on a grand scale. In one instance, Whitney hosted a party for almost five hundred people at her Long Island estate, mixing scores of painters, sculptors, and illustrators with the publishers and patrons she numbered among her friends, thereby playing a subtle but important brokering role. Whitney also had a "theatrical sense of public relations" and a gift for staging exhibitions around newsworthy themes, talents that were more than matched by Force's skills. And she did take a strong role in staging the exhibitions, in tandem with Force, particularly before 1918. As Whitney's biographer explains, she was, "in effect, *the director* of the exhibition program of the Studio. . . . Nothing [was] done there which [was] not connected with her interests, her life." Whitney skillfully blended the traditional prerogatives of the domestic impresario with the insights and concerns of the professional artist in all of her institutional designs.[57]

In many respects, her career exemplified the changing fortunes of the "new woman." While the nineteenth century was the heyday of male individualism, by the 1920s female individualism was ascendant and increasingly accepted. It marked a striking reversal. During the Gilded Age, laissez-faire governmental policies and unrestrained economic competition served as the rallying cry for the individualistic tenets of the Social Darwinist credo. The reigning ethos for middle-class women, on the other hand, stressed collectivism, cooperation, self-sacrifice, and the constraining dictates of ladylike behavior inherent in the cult of domesticity.

By the 1920s, the Social Darwinist buccaneer was well on his way to becoming the "organization man." As male individualism began to be tempered and subsumed in the emerging bureaucratic state, the constraints on women's behavior began to crumble. The splintering of the woman movement, the decline of a separate "women's culture," slackening moral codes, and increased educational and employment opportunities all contributed to the appeal of the "new woman." Bolstered by a growing spirit of social laissez-faire, female individualism became one of the leitmotivs of the Jazz

Age. Gardner's unapologetic quest for public recognition had garnered public censure, as well as public praise. By the 1920s, popular tolerance for female bravado had mellowed into a celebration of a new set of heroines that included women like Whitney, Mary Pickford, and Amelia Earhart, who had prospered in unconventional careers. Once faulted, female independence was now hailed as a model of success, and female individualism celebrated as one of the hallmarks of the age.[58]

The women of Whitney's generation also enjoyed more freedom in choosing their pursuits. The decline of a separate "women's culture" after the turn of the century and loosening sexual mores meant that women such as Whitney and Force had a far greater range of alternatives in choosing their associates, their causes, and the nature of the institutions that they ultimately controlled. Although women's organizations continued to flourish in the 1920s, passage of the Nineteenth Amendment fragmented the woman movement, diminishing much of the appeal of separatist organizations. In the eyes of many scholars, these events heralded the demise of feminist sentiments as well, as "women gave up many of the strengths of the female sphere without gaining equally from the man's world they entered."[59]

However, analyses such as these are more relevant to the careers of assimilationists such as Louisine Havemeyer than to individualists such as Whitney. By sidestepping the separatist strategies of their mother's generation, Whitney and Edith Halpert provided a new twist to female mentoring as well, promoting the careers of women artists in ways matched by few earlier patrons. Rather than segregating their works in specialized exhibits, Whitney treated them as artists first and women second, presenting their works on a par with those of men, as well as buying them for her public and private collections. In effect, she used her money—and the authority it commanded—to accord women artists professional parity with men.

Moreover, the opportunities that women like Whitney, Force, and Halpert helped to create may have indirectly served to mitigate some of the tensions that traditionally resonated through women artists' personal and professional lives. In Candace Wheeler's generation, when women artists married it usually marked the end of their careers, even if their mate was another artist. By the 1920s a number of husband/wife teams were exhibiting together in Whitney's and Halpert's galleries. Organizations such as the Whitney Studio Club and the Downtown Gallery may have provided the incentive, as well as the financial resources, to continue women's careers. In effect, individualistic solutions had the potential to devise models for achieving professional credibility that went well beyond the scope of separatist designs.

The problem, then, was not that feminist sentiments were necessarily incompatible with female individualism. The problem stemmed from the difficulties inherent in institutionalizing highly individualistic campaigns. Despite Whitney's important cultural legacy, her concern for women artists was not fully incorporated in the subsequent policies of her museum. Individually inspired, these programs depended on the commitment of one or two individuals to survive. When they passed from the scene, their feminist agendas could be easily scrapped. Nonetheless, by the early twentieth century female philanthropists were suddenly in a position to experiment with new institutional designs that had at least the potential to offer fresh points of leverage within traditionally male-dominated fields.

Certainly, not every women who took an interest in art, or even artists, was necessarily moved by feminist sentiments. Gertrude Stein did little to promote the weal of the female artists who graced her salons, and by the 1940s Agnes Meyer had soured into a glowering antifeminist who deemed the "feminist cry of equal rights . . . pernicious," the movement's goals " a false lead," and its emphasis on competition with men "disastrous." Even now, observers complain that influential female art dealers and critics have been reluctant to "champion women artists." Ironically, by the time that women finally controlled sufficient funds to forward significant artistic ventures on their own, the imperatives that automatically linked female philanthropy to female career opportunities was in decline. Within this milieu, feminist sentiments were reduced to a matter of personal commitment, with uneven results.[60]

In many respects, Whitney's career was exceptional, an isolated example. Yet purely quantitative analyses of women's changing professional fortunes in the 1920s tend to obscure the very real achievements inherent in careers such as hers. Within the scant space of fifty years, women had moved from being champions of the "minor" arts to an enviable position of cultural leadership, and individualistic philanthropists such as Whitney played an instrumental role in that transition.[61]

There were continuities as well. Like Isabella Stewart Gardner, Whitney cast her efforts in a highly personal form. Some of the commentaries about Whitney and Force capture the strikingly individualistic nature of their work. Thus, noted one of Force's obituaries, "almost nothing at all in her procedure was done as a man would have done it." Both created their programs on the basis of firsthand experience, rather than relying on cadres of certified professionals. As Forbes Watson pointed out, "It was the constant solving of artists' troubles which was the basis of their training for the direction of a museum." When they created their museum, they did it on their own, eschewing the advice of the seasoned officers and trustees of

other museums. As a result, notes Watson, "when the museum was born it was not the ward of committees." Instead, it was "an informal establishment based on personal contacts." In much the same manner as Fenway Court, "theirs was not a trustee-guided museum. . . . All the prerogatives belonged to them."[62]

Even when a formal board was added in 1935, the two women kept control by filling it with Whitney's family members and trusted friends. As a result, noted one commentator, "throughout the museum reflects the personal taste of Mrs. Whitney. In each case the final choice of a work of art has depended on her, since there is no board of trustees." Like Gardner, Whitney and Force made the impact they did, the way they did, because they retained complete control. Rather than running their institution by the book or by the dictates of an increasingly professionalized curatorial community, they forged it from the artists' perspectives and on the basis of their personal perceptions. Rather than creating new bureaucracies, they kept the venture to a comfortably manageable scale, replicating more traditional, preindustrial institutional forms.[63]

The advent of Gertrude Vanderbilt Whitney, Juliana Force, Abby Aldrich Rockefeller, Edith Halpert, Katherine Dreier, and Isabella Stewart Gardner heralded women's arrival as a major presence on the American artistic scene. Like Luman Reed and Robert Gilmor, Whitney forwarded the cause of American art and living artists. She opened her studio and galleries to aspiring artists, supporting some, occasionally paying for their study overseas. She was also deeply immersed in networks of friendship and symbiotic returns. While men like Gilmor and Reed may have netted business gains in return for their support, Whitney's "subjective necessity" formed the basis of her involvement. In a bleak period of her life, when neither friends nor family members seemed capable of aiding her, she found the strength she needed in her work, and in the friendships and professional relationships that it opened to her. In return, she and Force helped to open a new chapter in the history of American art, ultimately giving tangible substance and form to Luman Reed's aspirations by creating a permanent gallery for the works of living American artists. In the process, they translated the patron's role into their own idiom by creating a museum that countered the bureaucratic ethos of male-dominated repositories such as the Metropolitan Museum of Art in highly personal, highly effective ways.

Rather than supporting accepted canons of art, institutional development, or women's appropriate roles, the individualistic female patrons of Whitney's generation sought to challenge, to test the boundaries, and to legitimize new areas of artistic endeavor. They left an extraordinary legacy,

promoting the art and artists of their own time in new and ingenious ways. By the 1940s, their efforts and the institutions they created helped to shift the acknowledged capital of international art from Paris to New York. Other women would leave a lasting impression on the avant-garde as well. Hilla Rebay, another professional artist, helped to spark the creation of the Guggenheim Museum in her capacity as Solomon Guggenheim's art advisor in the 1930s. Gallery owners such as Betty Parsons also parlayed their artistic training into institutional resources for the promotion of the avant-garde. One of the most influential figures of the 1940s was Peggy Guggenheim. Founded in 1942, her gallery, Art of This Century, became a leading center for abstract art. Since "there was virtually no one else with prestige or money enough to support such an undertaking during the war," Guggenheim was able to force "the market to pay attention" to the work of emerging abstractionists such as Jackson Pollock "for the first time."[64]

As Whitney candidly admitted, "It took a long time and a great deal of thought to build the Gallery from what was considered the whim of a woman who could spend money, or a charity organization, into a serious undertaking." The history of women's cultural philanthropy in the United States was marked by a slow evolution from charity to cultural authority. While earlier museums "sacralized" the artistic legacies of Europe and Asia, Whitney and her contemporaries placed their bets on living artists and won extraordinary gains. Rather than heralding the treasures of the past, they made their presence felt by celebrating "the future of American culture." By 1930 the old constraints began to crumble, and women finally took the lead.[65]

Would others follow? The question is raised to avoid concluding with the impression that women's cultural efforts constituted a story of uninterrupted progress. Although the advances made by women like Whitney were undeniable, one hesitates to draw sweeping generalizations from single instances. Indeed, the history of American philanthropy and art suggests that most women fell far short of enjoying the influence and status that their wealth and talent might have commanded, belying the contentions of classical political philosophers that power follows property. Why this lingering disparity between wealth, power, and authority? This question remains to be explored by those who would seek to know the past in order to better overcome it.

Notes

Preface

1. Margaret Mead, "One Aspect of Male and Female," in Johnson E. Fairchild, ed., *Women, Society, and Sex* (New York: Sheridan House, 1952), 23; George Santayana, "The Genteel Tradition in American Philosophy" (1911), in Douglas L. Wilson, ed., *The Genteel Tradition: Nine Essays by George Santayana* (Cambridge: Harvard University Press, 1967), 40; Ann Douglas, *The Feminization of American Culture* (New York: Alfred A. Knopf, 1977). Douglas examines the literary scene, rather than the visual arts. Richard Hofstadter notes that Gilded Age politicians emphasized that "culture is impractical and men of culture are ineffectual, that culture is feminine and cultivated men tend to be effeminate." Thus, "culture suggested femininity." *Anti-Intellectualism in American Life* (New York: Vintage Books, 1962), 186, 189. For additional examples of this idea, see (among others) Henry James, *The American Scene* (New York: Harper and Bros., 1907), passim; Margaret Mead, *Male and Female* (New York: Morrow Quill, 1949), 330; Peter G. Filene, *Him Her/Self: Sex Roles in Modern America* (Baltimore: Johns Hopkins University Press, 1974), 8, 70; Annette K. Baxter, preface to Karen Blair, *The Clubwoman as Feminist: True Womanhood Redefined, 1868–1914* (New York: Holmes and Meier, 1980), xiv; Charles C. Alexander, *Here the Country Lies: Nationalism and the Arts in Twentieth-Century America* (Bloomington: Indiana University Press, 1980), 26; Charlotte Streifer Rubenstein, *American Women Artists* (New York: Avon Books, 1982), ix, 150; Joe L. Dubbert, "Progressivism and the Masculine Crisis," in Elizabeth H. Pleck and Joseph H. Pleck, eds., *The American Man* (Englewood Cliffs, New Jersey: Prentice Hall, 1980), 307.

2. The history of women's efforts in the development of art institutions has not previously been examined in a sustained or systematic way. Most of the standard institutional histories either mention women in passing or provide only scattered references to their donations. See, for example, Daniel M. Fox, *Engines of Culture: Philanthropy and Art Museums* (Madison: State Historical Society of Wisconsin, 1963); Neil Harris, *The Artist in American Society: The Formative Years, 1790–1860* (New York: Simon and Schuster, 1966); Neil Harris, "The Gilded Age Revisited: Boston and the Museum Movement," *American Quarterly* 14 (Winter 1964), 545–66; Paul DiMaggio, "Cultural Entrepreneurship in Nineteenth-Century Boston: The Creation of an Organizational Base for High Culture in America," *Media, Culture, and Society* 4 (1982): 33–50; Nathaniel Burt, *Palaces for the People: A Social History of the American Art Museum* (Boston: Little, Brown and Co., 1977); Carol Troyen, *The Boston Tradition: American Paintings from the*

Museum of Fine Arts, Boston (New York: American Federation of Arts, 1980); Carol Troyen and Pamela S. Tabbaa, *The Great Boston Collectors: Paintings from the Museum of Fine Arts* (Boston: Museum of Fine Arts, 1984); Lillian B. Miller, *Patrons and Patriotism: The Encouragement of the Fine Arts in the United States, 1790–1860* (Chicago: University of Chicago Press, 1966); Helen Lefkowitz Horowitz, *Culture and the City: Cultural Philanthropy in Chicago from the 1880s to 1917* (Lexington: University Press of Kentucky, 1976); H. Wayne Morgan, *New Muses: Art in American Culture, 1865–1920* (Norman: University of Oklahoma Press, 1978); Walter M. Whitehill, *Museum of Fine Arts, Boston: A Centennial History* (Cambridge: Harvard University Press, 1970); Winifred E. Howe, *A History of the Metropolitan Museum of Art* (New York: Metropolitan Museum of Art, 1913; Columbia University Press, 1946).

3. Linda Nochlin, "Why Have There Been No Great Women Artists?" in Thomas B. Hess and Elizabeth C. Baker, eds., *Art and Sexual Politics* (New York: Collier Macmillan Publishers, 1971), 37. Although some biographies do provide information on women artists and their patrons, most of these works have not systematically addressed the ways in which their efforts fit within the context of larger institutional developments. See, for example, Rubenstein, *American Women Artists;* Ann Sutherland Harris and Linda Nochlin, *Women Artists 1550–1950* (New York: Alfred A. Knopf, 1976); Eleanor Tufts, ed., *American Women Artists, 1830–1930* (Washington: National Museum of Women in the Arts, 1987); Linda Nochlin, *Women, Art, Power, and Other Essays* (New York: Harper and Row, 1988); William H. Gerdts, *The White Marmorean Flock: Nineteenth-Century Women Neoclassical Sculptors* (Poughkeepsie, New York: Vassar College Art Gallery, 1972); Germaine Greer, *The Obstacle Race: The Fortunes of Women Painters and Their Work* (New York: Farrar, Straus and Giroux,1979); Rozsika Parker and Griselda Pollock, *Old Mistresses: Women, Art, and Ideology* (New York: Pantheon Books, 1981): Adelyn D. Breeskin, *Mary Cassatt: A Catalogue Raisonné of the Oils, Water-Colors, and Drawings* (Washington: Smithsonian Institution Press, 1970); Natalie Spassky, *Mary Cassatt* (New York: Metropolitan Museum of Art, 1984); Frederick A. Sweet, *Miss Mary Cassatt, Impressionist from Pennsylvania* (Norman: University of Oklahoma Press, 1966); Laurie Lisle, *Portrait of an Artist: A Biography of Georgia O'Keeffe* (New York: Simon and Schuster, 1980); Robin Bolton-Smith and William H. Truettner, *Lilly Martin Spencer, 1822–1902: The Joys of Sentiment* (Washington: Smithsonian Institution Press, 1973); Kathleen Adler and Tamar Garb, *Berthe Marisot* (Ithaca: Cornell University Press, 1987); Aline B. Saarinen, *The Proud Possessors: The Lives, Times, and Tastes of Some Adventurous American Art Collectors* (New York: Random House, 1958); Frances Weitzenhoffer, *The Havemeyers: Impressionism Comes to America* (New York: Harry N. Abrams, 1986); Ruth L. Bohan, *The Société Anonyme's Brooklyn Exhibition: Katherine Dreier and Modernism in America* (Ann Arbor: UMI Research Press, 1982). One significant exception is Avis Berman, *Rebels on Eighth Street: Juliana Force and the Whitney Museum of American Art* (New York: Atheneum, 1990).

4. Gerda Lerner, "Placing Women in History: Definitions and Challenges" *Feminist Studies* 3 (Fall 1975): 5–41; Joan Scott, "Gender: A Useful Category of

Historical Analysis," *American Historical Review* 91 (December 1986): 1053–75. Excellent discussions of the notion of "women's culture" can be found in Carroll Smith-Rosenberg, "The Female World of Love and Ritual: Relations between Women in Nineteenth-Century America," in *Disorderly conduct: Visions of Gender in Victorian America* (New York: Oxford University Press, 1985), 53–76; and Suzanne Lebsock, *The Free Women of Petersburg: Status and Culture in a Southern Town, 1784–1860* (New York: W. W. Norton and Co., 1985).

5. The term "nonprofit corporation" is used here to denote nonprofit organizations that reflected the hierarchical, bureaucratic structure of the modern corporation, rather than entities that were simply incorporated as nonprofit corporations.

6. For a fuller discussion of the concept of "parallel power structures," see Kathleen D. McCarthy, "Parallel Power Structures: Women and the Voluntary Sphere," in Kathleen D. McCarthy, ed., *Lady Bountiful Revisited: Women, Philanthropy, and Power* (New Brunswick, New Jersey: Rutgers University Press, 1990), 1–31.

7. A sampling of some of the works on separatist organizations includes Estelle Freedman, "Separatism as Strategy: Female Institution Building in American Feminism, 1870–1930," *Feminist Studies* 5 (1979): 512–29, reprinted in Mary Beth Norton, ed., *Major Problems in American Women's History* (Toronto: D. C. Heath and Co., 1989); Nancy A. Hewitt, *Women's Activism and Social Change: Rochester, New York, 1822–1872* (Ithaca: Cornell University Press, 1984); Mary P. Ryan, "The Power of Women's Networks," in Judith L. Newton, Mary P. Ryan, and Judith R. Walkowitz, eds., *Sex and Class in Women's History* (London: Routledge, Kegan and Paul, 1983), 167–86; Kathleen D. McCarthy, *Noblesse Oblige: Charity and Cultural Philanthropy in Chicago, 1849–1929* (Chicago: University of Chicago Press, 1982); Nancy F. Scott, *The Bonds of Womanhood: "Woman's Sphere" in New England, 1780–1835* (New Haven: Yale University Press, 1977); Carroll Smith-Rosenberg, "Beauty, the Beast, and the Militant Woman: A Case Study in Sex Roles and Social Stress in Jacksonian America," in *Disorderly Conduct*, 109–28; Sara M. Evans, *Born for Liberty: A History of Women in America* (New York: Free Press, 1989); Lebsock, *Free Women of Petersburg;* Paula Baker, "The Domestication of Politics: Women and American Political Society, 1780–1920," *American Historical Review* 89 (June 1984): 647; Barbara J. Berg, *The Remembered Gate: Origins of American Feminism: The Woman and the City, 1800–1860* (New York: Oxford University Press, 1978); Gerda Lerner, "The Political Activities of Antislavery Women," in *The Majority Finds Its Past: Placing Women in History* (New York: Oxford University Press, 1979), 112–28; Nancy F. Cott, *The Grounding of Modern Feminism* (New Haven: Yale University Press, 1987).

8. For discussions of the relative valuation of the decorative arts as "minor" arts see Parker and Pollock, *Old Mistresses,* chapter 2, "Crafty Women and the Hierarchy of the Arts"; Anthea Callen, *Women Artists of the Arts and Crafts Movement, 1870–1914* (New York: Pantheon Books, 1979); Eileen Boris, *Art and Labor: Ruskin, Morris, and the Craftsman Ideal in America* (Philadelphia: Temple University Press, 1986); and Isabelle Anscombe, *A Woman's Touch: Women in Design from 1860 to the Present Day* (New York: Viking Press, 1984).

9. Assimilationist activities have attracted far less scholarly attention than separatist initiatives, although developments in the fields of medicine, education, and science have been fairly thoroughly surveyed. See, for example, Margaret W. Rossiter, *Women Scientists in America: Struggles and Strategies to 1940* (Baltimore: Johns Hopkins University Press, 1982); Rosalind Rosenberg, *Beyond Separate Spheres: Intellectual Roots of Modern Feminism* (New Haven: Yale University Press, 1982); and Regina Markell Morantz-Sanchez, *Sympathy and Science: Women Physicians in American Medicine* (New York: Oxford University Press, 1985).

10. Carroll Smith-Rosenberg, "The New Woman as Androgyne: Social Disorder and Gender Crisis, 1870–1936," in *Disorderly Conduct*, 296. The "new woman" is also discussed in Cott, *Grounding of Modern Feminism*.

Chapter 1

1. Alexis de Tocqueville, *Democracy in America* (1835–40; New York: Modern Library, 1981), 403, 405. See also Arthur M. Schlesinger, "Biography of a Nation of Joiners," *American Historical Review* 50 (October 1944): 1–25. E. P. Thompson's *The Making of the English Working Class* (New York: Vintage Books, 1966) played an influential role in drawing historians' attention to the role of voluntary associations in shaping working-class consciousness. Influential recent works include Christine Stansell, *City of Women: Sex and Class in New York, 1789–1860* (New York: Alfred A Knopf, 1986); Susan E. Hirsch, *The Roots of the American Working Class* (Philadelphia: University of Pennsylvania Press, 1978); Mary P. Ryan, *Cradle of the Middle Class: Family in Oneida County, New York, 1790–1865* (New York: Cambridge University Press, 1981); Paul Johnson, *A Shopkeeper's Millennium: Society and Revivals in Rochester, New York, 1815–1837* (New York: Hill and Wang, 1978); and Roy Rosenzweig, *Eight Hours for What We Will: Workers and Leisure in an Industrial City, 1870–1920* (New York: Cambridge University Press, 1983).

2. Although equity settlements provided one means of sidestepping common law prescriptions, they were not uniformly used. For a fuller discussion of equity settlements, see Suzanne Lebsock, *The Free Women of Petersburg: Status and Culture in a Southern Town, 1784–1860* (New York: W. W. Norton and Co., 1985), chapter 2.

3. The best discussion of the efforts of the domestic publicists remains Kathryn Kish Sklar, *Catharine Beecher: A Study in American Domesticity* (New Haven: Yale University Press, 1973). For a thoughtful treatment of the career of Sarah Josepha Hale, see William R. Taylor, *Cavalier and Yankee: The Old South and American National Character* (New York: George Braziller, 1961). Other accounts of Hale's life include Isabelle Webb Entriken, *Sarah Josepha Hale and Godey's Lady's Book* (Philadelphia: J. B. Lippincott Co., 1931).

4. Nancy F. Cott, *The Bonds of Womanhood: "Woman's Sphere" in New England, 1780–1835* (New Haven: Yale University Press, 1977), 141.

5. Sarah Josepha Hale, "The Fine Arts at Home," *Godey's Lady's Book* 62 (March 1861): 270.

6. *Cosmopolitan Art Journal* (November 1856): 29.

7. James Jackson Jarves, *Art Hints* (London: Sampson, Law, Son and Co., 1855).

8. "Editor's Table," *Godey's Lady's Book* 22 (April 1841): 189.

9. "Editor's Table," *Godey's Lady's Book* 29 (October 1844): 192, quoting Miss H. T. Bull; Park Benjamin, "The True Rights of Women," *Godey's Lady's Book* 28 (June 1844): 271; Emily Thornwell, *The Lady's Guide to Perfect Gentility* (New York: Derby and Jackson, 1858), 148–49.

10. Benjamin, "The True Rights of Women," 274; Louis Fitzgerald Tasistro, "Modern Female Education," *Godey's Lady's Book* 24 (April 1842): 191; T. S. Arthur, *Advice to Young Ladies on Their Duties and Conduct in Life* (Boston: G. W. Cottrell and Co., 1851).

11. Harriet Beecher Stowe, "Art and Nature," *Godey's Lady's Book* 19 (December 1839): 241, 244; "Editor's Table," *Godey's Lady's Book* 22 (April 1841): 189.

12. Tasistro, "Modern Female Education," 190.

13. The subject of male bonding has received surprisingly little scholarly attention, particularly for the antebellum period. For a fuller discussion of the friendships between painters and writers, see James T. Callow, *Kindred Spirits: Knickerbocker Writers and American Artists, 1807–1855* (Chapel Hill: University of North Carolina Press, 1967). In many respects, these alliances constituted a male counterpart to "the female world of love and ritual" described in Carroll Smith-Rosenberg, *Disorderly Conduct: Visions of Gender in Victorian America* (New York: Oxford University Press, 1985), 53–76.

14. James Thomas Flexner, *History of American Painting*, volume 3, *That Wilder Image (the Native School from Thomas Cole to Winslow Homer)* 1962; New York: Dover Publications, 1970), 91, 90.

15. John Durand, *The Life and Times of A. B. Durand* (New York: Charles Scribner's Sons, 1894; Kennedy Graphics, 1970), 185.

16. Quoted in Paul Zweig, *Walt Whitman: The Making of the Poet* (New York: Basic Books, 1984), 127.

17. Harriet Martineau, *Retrospect of Western Travel* (1838), 1;146, quoted in E. Maurice Bloch, *George Caleb Bingham: The Evolution of an Artist* (Berkeley: University of California Press, 1967), 56.

18. Alan R. Pred, *Urban Growth and the Circulation of Information: The United States System of Cities, 1790–1840* (Cambridge: Harvard University Press, 1973).

19. John Durand, *A. B. Durand*, 47.

20. Quoted in William G. Constable, *Art Collecting in the United States of America* (London: Thomas Nelson and Sons, 1964), 21.

21. quoted in John Durand, *A. B. Durand*, 116.

22. Luman Reed to William Sidney Mount, November 11, 1835, William Sidney Mount Journals and Notebooks, reel SM4, frame 253, Archives of American Art, New York (hereafter cited as AAA); John Durand, *A. B. Durand*, 120.

23. Asher B. Durand to Luman Reed, March 8, 1835, and June 15, 1835, Luman Reed MSS, New-York Historical Society (hereafter cited as NYHS).

24. George W. Flagg to Asher B. Durand, June 12, 1836, Asher B. Durand MSS, New York Public Library, quoted in Russell Bastado, "Luman Reed (1786–1836), New York City Merchant and Patron of American Artists," n.d., 41, Reed MSS, NYHS.

25. Anne Marie Dolan, "The Literary Salon in New York, 1830–1860" (Ph.D. dissertation, Columbia University, 1957), 140.

26. Friendships between artists and writers are described in Callow, *Kindred Spirits.* For a fuller discussion of intellectual and cultural trends in this period, see Thomas Bender, *New York Intellect: A History of Intellectual Life in New York City from 1750 to the Beginning of Our Own Time* (New York: Alfred A. Knopf, 1987).

27. Although one contemporary source suggested that the Sketch may have included women members, the nature of their proceedings makes this somewhat unlikely. "Art Intelligence," American Art-Union Scrapbook, 2:12, American Art-Union Manuscripts (hereafter cited as AAU MSS), NYHS.

28. Benjamin, "True Rights of Women," 272; Mrs. Ellis, *The Family Monitor and Domestic Guide* (New York, 1844), 35, quoted in Linda Nochlin, "Why Have There Been No Great Women Artists?" in Thomas B. Hess and Elizabeth C. Baker, eds., *Art and Sexual Politics* (New York: Collier Macmillan Publishers, 1971), 28.

29. Scholars have just begun to examine the significance of quilts and needlework as women's art. One of the most suggestive treatments in Patricia Mainardi, "Quilts: The Great American Art," in Norma Broude and Mary D. Garrard, eds., *Feminism and Art History: Questioning the Litany* (New York: Harper and Row, 1982), 331–46. For an example of the links between women's art and fund-raising fairs, see Nancy A. Hewitt, "The Social Origins of Women's Antislavery Politics in Western New York," in Alan M. Kraut, ed., *Crusaders and Compromisers: Essays on the Relationship of the Antislavery Struggle to the Antebellum Party System* (Westport, CT: Greenwood Press, 1983), 205–34. Interestingly, Hale advertised for subscribers for the Ladies' New England Art-Union of Needlework in 1852. Much like the Philadelphia School of Design for Women, the Ladies' Art-Union straddled the line between charity and art. The primary aim was to improve the lot of women who made their living via skilled embroidery. For a $5 subscription, members were promised a book entitled *Beauties of Sacred Literature,* as well as a chance to win an elaborate piece of embroidery illustrating the theme of "Mary Queen of Scots resigning the crown at Locklevin Castle."

30. Flexner, *History of American Painting* 3:149.

31. Ralph Waldo Emerson, *Journals,* 6:370–71, quoted in Charles R. Metzger, *Emerson and Greenough: Transcendental Pioneers of an American Aesthetic* (Berkeley: University of California Press, 1954), 63. For a fuller discussion of Rousseauian ideas about female intellectual capacities, see Linda Kerber, *Women of the Republic: Intellect and Ideology in Revolutionary America* (Chapel Hill: University of North Carolina Press, 1980).

32. Dinah M. Craik, *Olive* (1850), quoted in Rozsika Parker and Griselda Pol-

lock, *Old Mistresses: Women, Art, and Ideology* (New York: Pantheon Books, 1981), 83.

33. Jarves, *Art Hints,* 13.

34. Ibid., 314–15.

35. As in the case of quilts, scholars have just begun to examine the careers and capacities of women artists. See, for example, Nochlin, "Why Have There Been No Great Women Artists?"; Germaine Greer, *The Obstacle Race: The Fortunes of Women Painters and Their Work* (New York: Farrar, Straus and Giroux, 1979); Charlotte Streifer Rubenstein, *American Women Artists* (New York: Avon Books, 1982); Jean Gordon, "Early American Women Artists and the Social Context in Which They Worked," *American Quarterly* 30 (Spring 1978): 54–69; Parker and Pollock, *Old Mistresses.*

36. Lilly Martin Spencer to Mrs. I. P. Martin, September 10, 1856, p. 2, Lilly Martin Spencer MSS, reel 131, AAA. For biographical information on Spencer, see Rubenstein, *American Women Artists,* 50–53; Robin Bolton-Smith and William H. Truettner, *Lilly Martin Spencer, 1822–1902: The Joys of Sentiment* (Washington: Smithsonian Institution Press, 1973); Elsie F. Freivogel, "Lilly Martin Spencer: Feminist without Politics," *Archives of American Art Journal* 12 (1972): 9–14.

37. Lilly Martin Spencer to Mrs. I. P. Martin, October 11, 1850, p. 1, and September 10, 1856, p. 1, Spencer MSS, reel 131.

38. Spencer to Martin, September 10, 1856, p. 1; Lilly Martin Spencer to Mr. and Mrs. Martin, October 14, 1860, typescript, p. 1, Spencer MSS, reel 131.

39. William Sidney Mount, Journal, 1843–48, p. 27, Mount MSS, reel SM2.

40. Joseph Hopkinson, "Annual Discourse Delivered before the Pennsylvania Academy of the Fine Arts" (Philadelphia: Bradford and Inskeep, 1810), 35. Ironically, even paintings on velvet came to be prized as American folk art in the 1920s and 1930s through the influence of entrepreneurial connoisseurs such as Edith Halpert of New York's Downtown Gallery.

41, For exhibition patterns in Boston, see Carol Troyen's excellent catalogue raisonné, *The Boston Tradition: American Paintings from the Museum of Fine Arts, Boston* (New York: American Federation of Arts, 1980).

42. Account Books, passim, John F. Kensett MSS, AAA.

43. Thomas Sully MSS, passim, AAA; Anna Cabot Lowell, quoted in William H. Gerdts and Theodore E. Stebbins, Jr., *"A Man of Genius": The Art of Washington Allston (1779–1843)* (Boston: Museum of Fine Arts, 1979), 61; Marie de Mare, *GPA Healy, American Artist* (New York, 1954), 52, quoted in Troyen, *Boston Tradition,* 132.

44. New York Gallery of Fine Arts, *Catalogue* (New York, 1844).

45. Quoted in Flexner, *History of American Painting* 3:96.

46. American Art-Union, *Transactions* (New York:, 1844), 10.

47. They also accounted for a minority of the lottery winners. In 1841 the six winners selected to receive paintings were all men. In 1842 one of the thirty-four canvases was sent to a woman, in 1843 one in fifty, and in 1844 three in ninety-two. Minutes, Annual Meeting, passim, AAU MSS.

48. John Sartain MSS, reel P-28, p. 663, AAA; [Sarah Josepha Hale], "The Bazaar Post-Office," *Godey's Lady's Book* 31 (December 1845): 268.

49. John Sartain to Miss Wagner, December 11, 1875, Sartain MSS, reel P-20, p. 177.

50. For a description of Botta's salon, see *Memoirs of Anne Lynch Botta, Written by Her Friends* (New York: J. Selwin Tait and Sons, 1894).

51. Quoted in "Proceedings Relative to the Establishment of a School of Design for Women," p. 3, Franklin Institute MSS, reel P-39, AAA; Alice B. Neal, "Employment of Women in Cities," *Godey's Lady's Book* 45 (September 1852): 275. For details of Peter's life see Margaret R. King, *Memoirs of the Life of Mrs. Sarah Peter,* 2 vols. (Cincinnati: Robert R. Clarke and Co., 1889); and Anna Shannon McAlister, *In Winter We Flourish: Life and Letters of Sarah Worthington King Peter, 1800– 1877* (New York: Longmans, Green and Co., 1939).

52. Bruce Sinclair, *Philadelphia's Philosopher' Mechanics: A History of the Franklin Institute, 1824–1865* (Baltimore: Johns Hopkins University Press, 1974), 263.

53. Sarah Worthington King Peter, letter from Edinburgh, July 30, 1851, and letter from Florence, December 1851, quoted in King, *Memoirs* 1:95, 155.

54. Ladies Academy of Fine Art, "Catalogue of Pictures at the Ladies' Gallery: First Exhibition, Independence Hall" (Cincinnati: LAFA, 1854), 3. For additional information on the academy, see Ladies Academy of Fine Art MSS (hereafter cited as LAFA MSS), Cincinnati Historical Society; Annual Reports, LAFA MSS; *Women's Art Museum Association of Cincinnati, 1877–1886* (Cincinnati: Robert R. Clarke and Co., 1886); and Lea J. Brinker, "Women's Role in the Development of Art as an Institution in Nineteenth-Century Cincinnati" (master's thesis, University of Cincinnati, 1968).

55. Sarah B. Carlisle to Sarah Worthington King Peter, November 11, 1854, LAFA MSS; Annual Report, 1854–5, "Treasuresses Report," 28, LAFA MSS; Sarah Worthington King Peter, quoted in King, *Memoirs* 1:259; Rufus King to Sarah Worthington King Peter, quoted in McAlister, *In Winter We Flourish,* 217; Rufus King to Sarah Worthington King Peter, February 15, 1855, quoted in Brinker, "Women's Role," 17.

56. Brinker, "Women's Role," 17; Sarah Worthington King Peter to Mrs. H. F. Jones, July 26, 1854, LAFA MSS; Sarah Worthington King Peter to Managers of the Ladies Academy of Fine Art, March 14, 1855, quoted in Brinker, "Women's Roles," 19.

57. Sarah B. Carlisle to Sarah Worthington King Peter, November 11, 1854, quoted in Brinker, "Women's Role," 18–19; Annual Report, 1855, p. 30, LAFA MSS.

58. For the development of comparable men's groups in other levels of society, see (among others) Anthony F. C. Wallace, *Rockdale: The Growth of an American Village in the Early Industrial Revolution* (New York: W. W. Norton and Co., 1971); Hirsch, *Roots of the American Working Class;* and Steven J. Ross, *Workers on the Edge: Work, Leisure, and Politics in Industrializing Cincinnati, 1788–1890* (New York: Columbia University Press, 1985).

Chapter 2

1. Candace Wheeler, *Yesterdays in a Busy Life* (New York: Harper and Bros., 1918), 35.

2. Ibid., 46, 49, 98, 47–48.

3. Ibid., 66, 65, 70.

4. Ibid., 89, 93–94.

5. Ibid., 159. Lori D. Ginzberg, *Women and the Work of Benevolence: Morality, Politics, and Class in the Nineteenth-Century United States* (New Haven: Yale University Press, 1990), 152, 155.

6. For a fuller discussion of the Sanitary Commission, see Ginzberg, *Women and the Work of Benevolence;* George M. Fredrickson, *The Inner Civil War: Northern Intellectuals and the Crisis of the Union* (New York: Harper and Row, 1965); and Robert H. Bremner, *The Public Good: Philanthropy and Welfare in the Civil War Era* (New York: Alfred A. Knopf, 1980).

7. For an excellent discussion of the relationship of the Centennial Exposition to the rise of Gilded Age aestheticism, see Doreen Bolger Burke et al., *In Pursuit of Beauty: Americans and the Aesthetic Movement* (New York: Rizzoli, 1987).

8. Walter Smith, "Industrial Art Education," address delivered at the Philadelphia Concert Hall, April 23, 1875, p. 2, pamphlet in Pennsylvania Museum and School of Industrial Art scrapbook, reel P 14, frames 560–62, AAA.

9. "The Royal School of Art Needlework," *Magazine of Art* (1882): 219, quoted in Anthea Callen, *Women Artists of the Arts and Crafts Movement, 1870–1914* (New York: Pantheon Books, 1979), 99; Amelia Gere Mason, *Memories of a Friend* (Chicago: Laurence C. Woodworth, 1918), 66; "Art Needlework," newsclipping, April 12, 1876, in Mrs. E. E. Atwater, compiler, *Scrapbook of Clippings from the Centennial* (n.p.), Library, Chicago Historical Society.

10. John Ruskin, *Sesame and Lilies* (New York: John Wiley and Sons, 1866). See also John Ruskin, *The Seven Lamps of Architecture* (1849; New York: Farrar, Straus and Giroux, 1986); John Ruskin, *The Two Paths: Being Lectures on Art and Its Application to Decoration and Manufacture* (New York: John Wiley, 1859); and Peter Stansky, *Redesigning the World: William Morris, the 1880s, and the Arts and Crafts* (Princeton: Princeton University Press, 1985). For the impact of the ideas of Ruskin and Morris in the United States, see Eileen Boris, *Art and Labor: Ruskin, Morris, and the Craftsman Ideal in America* (Philadelphia: Temple University Press, 1986). For a general discussion of the Royal School of Art Needlework and the decorative arts movement, see Isabelle Anscombe, *A Woman's Touch: Women in Design from 1860 to the Present Day* (New York: Viking, 1984); and Callen, *Women Artists of the Arts and Crafts Movement.*

11. Wheeler, *Yesterdays in a Busy Life,* 209, 212, 213.

12. Ibid., 212.

13. Mrs. J. C. Croly, *The History of the Woman's Club Movement in America* (New York: Henry G. Allen and Co., 1898), 16; Harriette Greenbaum Frank and Amalie Hofer Jerome, *Annals of the Chicago Woman's Club, 1876–1916* (Chicago:

Chicago Woman's Club, 1971), 89. For a fuller treatment of the history of the women's club movement, see Karen Blair, *The Clubwoman as Feminist: True Womanhood Redefined, 1868–1914* (New York: Holmes and Meier, 1980).

14. Mrs. John Sherwood, *An Epistle to Posterity* (New York: Harper and Bros., 1897), 184–85, 186. One of Sherwood's most popular books was her etiquette manual, *Manners and Social Usages* (New York: Harper and Bros., 1884).

15. By the end of the century, these bourgeois palaces would bring storms of public criticism raining down on the heads of their possessors, but in the 1870s and 1880s their presence was still regarded by many observers as a positive gesture. Thus, art critic Mary Gay Humphreys hailed the lavish Cornelius Vanderbilt mansion as "the most important example of decorative work yet attempted in this country." Mary Gay Humphreys, "The Cornelius Vanderbilt House," *Art Amateur* 8 (May 1883): 135, quoted in Dianne H. Pilgrim, "Decorative Art: The Domestic Environment," in Brooklyn Museum, *The American Renaissance, 1876–1917* (New York: Pantheon Books, 1979), 120. Others deemed it an "educational force, [and] a college for the development of the higher crafts." Earl Shinn [Edward Strahan], *Mr. Vanderbilt's House and Collection,* 10 vols. (New York: privately printed, 1883–84), quoted in ibid., 123. Even John Ruskin condoned lavish display when pursued in the name of art. In an essay entitled, ironically, "The Lamp of Sacrifice," Ruskin argued that every family, especially those of great wealth, should invest in beautiful houses to educate their fellow citizens in the rudiments of sound design. As such, even the most elaborate mansion could potentially legitimize its presence, and its owner's extravagance, when viewed as a laboratory for the development of American craftsmanship, notions promulgated and legitimized by the decorative arts movement. The design elements of the decorative arts movement are also detailed in Burke et al., *In Pursuit of Beauty,* especially in Roger Stein's insightful essay, "Artifact as Ideology: The Aesthetic Movement in Its American Cultural Context," 22–51; and Wendy Kaplan, ed., *"The Art That Is Life": The Arts and Crafts Movement in America, 1875–1920* (Boston: Little, Brown and Co., 1987).

16. Wheeler, *Yesterdays in a Busy Life,* 211; Candace Wheeler, *The Development of Embroidery in America* (New York: Harper and Bros., 1921), 4.

17. New York Society of Decorative Art (NYSDA), *Annual Report* (1885), 7; Wheeler, *Development of Embroidery,* 102, 108.

18. Candace Wheeler, ed., *Household Art* (New York: Harper and Bros., 1893), 195–96; Wheeler, *Yesterday in a Busy Life,* 212.

19. Anscombe, *Woman's Touch,* 28.

20. NYSDA, *Annual Report* (1879), p. 27. Both Callen (*Women Artists of the Arts and Crafts Movement*) and Anscombe (*Woman's Touch*) emphasize this point as well.

21. Wheeler, *Yesterdays in a Busy Life,* 219.

22. Ibid., 210.

23. NYSDA, *Annual Report,* (1885), 10.

24. Chicago Society of Decorative Art, "Constitution and By-Laws," (1886), 17.

25. Wheeler, *Yesterdays in a Busy Life,* 226.

26. An overview of the lives of working women can be gleaned from Christine Stansell, *City of Women: Sex and Class in New York, 1789–1860* (New York: Alfred A. Knopf, 1986); Thomas Dublin, *Women at Work: The Transformation of Work and Community in Lowell, Massachusetts, 1826–1860* (New York: Columbia University Press, 1979); Alice Kessler-Harris, *Out to Work: A History of Wage-Earning Women in the United States* (New York: Oxford University Press, 1982); Ruth Rosen, *The Lost Sisterhood: Prostitution in America, 1900–1918* (Baltimore: Johns Hopkins University Press, 1982); Susan Porter Benson, *Counter Cultures: Saleswomen, Managers, and Customers in American Department Stores, 1890–1940* (Urbana: University of Illinois Press, 1986); Kathy Peiss, *Cheap Amusements: Working Women and Leisure in Turn-of-the-Century New York* (Philadelphia: Temple University Press, 1986); Susan M. Reverby, *Ordered to Care: The Dilemma of American Nursing, 1850–1945* (New York: Cambridge University Press, 1987); and Faye E. Dudden, *Serving Women: Household Service in Nineteenth-Century America* (Middletown, Connecticut: Wesleyan University Press, 1983).

27. *New York Times*(June 16, 1877): 4; address by Maria Scammon, 1888, Chicago Society of Decorative Art MSS, Chicago Historical Society.

28. *New York Times* (June 16, 1877): 4.

29. Patricia R. Hill, *The World Their Household: The American Woman's Foreign Mission Movement and Cultural Transformation, 1870–1920* (Ann Arbor: University of Michigan Press, 1985), 87, 96.

30. NYSDA *Annual Report* (1879), 21, and (1877), 43–44; Chicago Society of Decorative Art, *Circular #3,* n.p., n.d.; Wheeler, *Yesterdays in a Busy Life,* 214.

31. Boston Society of Decorative Art, *Annual Report* (1880), 6.

32. Wheeler, *Household Art,* 14. For an excellent discussion of Victorian ideas about the relation of domestic design to broader social ideals, see Gwendolyn Wright, *Moralism and the Model Home: Domestic Architecture and Cultural Conflict in Chicago, 1873–1913* (Chicago: University of Chicago Press, 1980). See also Barbara Stein Frankel, "The Genteel Family: High Victorian Conceptions of Domesticity and Good Behavior" (Ph.D. dissertation, University of Wisconsin, Madison, 1969); Clifford Edward Clark, Jr., *The American Family Home, 1800–1960* (Chapel Hill: University of North Carolina Press, 1986); and David P. Handlin, *The American Home: Architecture and Society, 1815–1915* (Boston: Little, Brown and Co., 1979).

33. Charles L. Eastlake, *Hints on Household Taste* (Boston: James R. Osgood and Co., 1876), 136–37.

34. William Leach, *True Love and Perfect Union: The Feminist Reform of Sex and Society* (New York: Basic Books, 1980), 234.

35. For a discussion of the decontextualization of art, see Remy G. Saisselin, *The Bourgeois and the Bibelot* (New Brunswick, New Jersey: Rutgers University Press, 1984).

36. Boston Society of Decorative Art, *Annual Report* (1879), 12–13.

37. Wheeler, *Yesterdays in a Busy Life,* 215.

38. Dinah M. Craik, "A Woman's Thoughts about Women" 1859), quoted in C. Kurt Dewhurst, Betty MacDowell, and Marsha MacDowell, *Artists in Aprons: Folk Art by American Women* (New York: E. P. Dutton, 1979), 41.

39. NYSDA, *Annual Report* (1885), p. 7.

40. Wheeler, *Yesterdays in a Busy Life,* 223–24, 231.

41. Wheeler, *Development of Embroidery,* 112.

Chapter 3

1. Kate Gannett Wells, "Women in Organizations," *Atlantic Monthly* 46 (September 1880): 864; Regina Markell Morantz-Sanchez, *Sympathy and Science: Women Physicians in American Medicine* (New York: Oxford University Press, 1985), 73, 82. See also Mary Roth Walsh, *"Doctors Wanted: No Women Need Apply": Sexual Barriers in the Medical Profession, 1835–1975* (New Haven: Yale University Press, 1977).

2. Wells, "Women in Organizations," 863; Patricia R. Hill, *The World Their Household: The American Woman's Foreign Mission Movement and Cultural Transformation, 1870–1920* (Ann Arbor: University of Michigan Press, 1985), 61. See also Kathryn Kish Sklar, "Hull-House in the 1890s: A Community of Women Reformers," *Signs* 10 (1985): 657–77.

3. For a fuller discussion of women's roles in these fields, see Anthea Callen, *Women Artists of the Arts and Crafts Movement, 1870–1914* (New York: Pantheon Books, 1979), chapters 2–6.

4. Frances Anne Wister, *Twenty-five Years of the Philadelphia Orchestra* (Philadelphia: Women's Committee of the Philadelphia Orchestra, 1925), 47; Paul DiMaggio, *Organizing Culture* (New York: Basic Books, forthcoming), chapter 2, p. 79. For women's communities see, for example, Sklar, "Hull-House in the 1890s"; and Martha Vicinus, *Independent Women: Work and Community for Single Women, 1850–1920* (Chicago: University of Chicago Press, 1985). For a discussion of women's roles in antebellum nonprofit entrepreneurship, see Lori D. Ginzberg, *Women and the Work of Benevolence: Morality, Politics, and Class in the Nineteenth-Century United States* (New Haven: Yale University Press, 1990), chapter 2. I am indebted to Nancy Hewitt for bringing Ginzberg's book to my attention shortly before this volume went to press.

5. Gertrude Barnum, "The Chicago Woman and Her Clubs," *Graphic* (March 27, 1893): 344, in Clipping Files, Chicago Historical Society; Lucy M. Salmon, "The Women's Exchange: Charity or Business?" *Forum* 13 (May 1892): 402, 395.

6. Max West, "Revival of Handicrafts," *Bulletin of the Bureau of Labor* (1904): 1605, 1607; Salmon, "Woman's Exchange," 396.

7. Salmon. "Woman's Exchange," 397.

8. Ibid.

9. Ibid., 398.

10. Ibid., 401, 398, 399.

11. quoted in Alice Severance, article on Hopkins in *Godey's Lady's Book,*

quoted in New York School of Design for Women Brochure (New York, 1896), 52 (hereafter cited as NYSDW Brochure).

12. "Art as Applied to Design," *Morning Leader* (February 15, 1894), in "London Scrapbook, 1894," 2, Mrs. Dunlop Hopkins MSS, NYHS; NYSDW brochure, 13, Hopkins MSS.

13. NYSDW brochure, quoting article from *Hearth and Home* (February 22, 1894): 62-63.

14. Doreen Bolger Burke et al., *In Pursuit of Beauty: Americans and the Aesthetic Movement* (New York: Rizzoli, 1987), 453.

15. John Robinson Frazier, "History of the Rhode Island School of Design Museum," n.d., John Robinson Frazier MSS, reel 2804, frame 400, AAA.

16. F. Hopkinson Smith, "Around Their Wood Fire," in *A Book of the Tile Club* (New York: Houghton Mifflin and Co., 1886), 59; William H. Shelton, "Soldier, Artist, Writer: Typescript of His Unpublished Autobiography, 1840–1890," chapter 18, p. 12, NYHS.

17. Ronald G. Pisano, *William Merritt Chase* (New York: Watson-Guptill, 1986), 16.

18. Edward Strahan, "Their Habitat," in *A Book of the Tile Club*, 5–6.

19. Ibid., 6; F. Hopkinson Smith, "Shop Talk," in *A Book of the Tile Club*, 53; Louis Comfort Tiffany quoted in Robert Koch, *Louis C. Tiffany: Rebel in Glass* (New York: Crown Publishers, 1964), 66.

20. Candace Wheeler, "Home Industries and Domestic Manufactures," *Outlook* 63 (October 14, 1899): 405–6.

21. Ibid., 403–4; "Home Industries and Domestic Manufactures from the Standpoint of a Farmer's Wife," *Outlook* 63 (December 12, 1899): 985.

22. Quoted in Frances Weitzenhoffer, *The Havemeyers: Impressionism comes to America* (New York: Harry N. Abrams, 1986), 214. For a fuller discussion of the careers of Edith Halpert and Abby Aldrich Rockefeller, see chapter 7.

23. Quoted in Cincinnati Art Museum, *"The Ladies, God Bless 'Em: The Women's Art Movement in the Nineteenth Century* (Cincinnati: Cincinnati Art Museum, 1976), 10. See also Lea J. Brinker, "Women's Role in the Development of Art as an Institution in Nineteenth-Century Cincinnati" (master's thesis, University of Cincinnati, 1968); and Robert C. Vitz, "Cincinnati Art and Artists, 1870–1920" (master's thesis, Miami University, 1967). For additional information on women's potteries, see Eileen Boris, *Art and Labor: Ruskin, Morris, and the Craftsman Ideal in America* (Philadelphia: Temple University Press, 1986).

24. *Women's Art Museum Association of Cincinnati: 1877–1886* (Cincinnati: Robert R. Clarke and Co., 1886), 3, 84–86.

25. Ibid., 56.

26. Women's Art Museum Association, circular (Cincinnati: WAMA, March 12, 1877).

28. Ibid., 38.

29. Quoted in Brinker, "Women's role," 50–51. Nor was this an isolated inci-

dent. Although Theodore Thomas recalled that a woman (Maria Longworth Nichols) had originated the idea for the Cincinnati Music Festival at which he conducted, the organization's early public reports contain no reference to her role. True to her word, Nichols found "the men to take care of the business details." Although she originated the idea, the resulting organization was run entirely by men (including *both* of her husbands!). The Philadelphia Orchestra also began with a fund-raising campaign by women, only to be incorporated by a board composed almost entirely of men. Theodore Thomas, *A Musical Autobiography* (1905; New York: Da Capo Press, 1964), 79. For the history of the Philadelphia Orchestra, see Wister, *Twenty-five Years.*

30. *Women's Art Museum Association,* 51, 91.

31. *Detroit Art Loan Record* (September 3, 1883): 15, in Detroit Art Loan MSS, reel D10A, AAA. The Indianapolis Art Association also originated with the efforts of a group of local women. Initially, they sponsored lectures on ceramics and other crafts, but by 1882 they turned their attention to the more ambitious task of staging exhibitions. The goals espoused at the time of its incorporation in 1883 were simple and direct: "to provide opportunities for the public to look at pictures" and "to provide opportunities for the public to learn to produce pictures." Although their plans for an art school were scrapped two years later, a sizable bequest from a local farmer ensured the institution's survival and continued growth after 1895.

32. Russell Lynes, *More Than Meets the Eye: The History and Collections of Cooper-Hewitt Museum* (Washington: Smithsonian Institution, 1981), 19, 27.

33. Suzanne Lebsock, *The Free Women of Petersburg: Status and Culture in a Southern Town, 1784–1860* (New York: W. W. Norton and Co., 1985), xvii.

34. Margaret W. Rossiter, *Women Scientists in America: Struggles and Strategies to 1940* (Baltimore: Johns Hopkins University Press, 1982), 30, 23. See also Kathryn Kish Sklar, "Who Funded Hull House?" in Kathleen D. McCarthy, ed., *Lady Bountiful Revisited: Women, Philanthropy, and Power* (New Brunswick, New Jersey: Rutgers University Press, 1990).

Chapter 4

1. Candace Wheeler, "Art Education for Women," *Outlook* 55 (January 2, 1897): 81, 86.

2. E. A. Randall, "The Artistic Impulse in Man and Woman," *Arena* 24 (October 1900): 420.

3. Margaret W. Rossiter, *Women Scientists in America: Struggles and Strategies to 1940* (Baltimore: Johns Hopkins University Press, 1982), 53.

4. For an interesting discussion of some of the tensions surrounding the professional lives of women painters, see Kathleen Adler and Tamar Garb, *Berthe Morisot* (Ithaca: Cornell University Press, 1987).

5. Helen M. Knowlton, *Art-Life of William Morris Hunt* (1899; New York: Benjamin Blom, 1971), 31; H. Winthrop Pierce, "Early Days of the Copley Society" (Boston: Rockwell and Churchill Press, 1903), 7.

6. Theodore E. Stebbins, Jr., introduction to Trevor J. Fairbrother, *The Bostonians: Painters of an Elegant Age, 1870–1930* (Boston: Museum of Fine Arts, 1986), 6; Pierce, "Early Days of the Copley Society," 10.

7. Martha J. Hoppin, "Women Artists in Boston, 1870–1900: The Pupils of William Morris Hunt," *American Art Journal* 13 (Winter 1981): 18; *New York Daily Tribune* (September 10, 1879), 4; Henry C. Angell, *Records of William M. Hunt* (Boston: privately printed, n.d.), 72, 59.

8. Hoppin, "Women Artists in Boston," 19; Knowlton, *Art-Life of William Morris Hunt,* 85, 84.

9. Knowlton, *Art-Life of William Morris Hunt,* 99, and quoting Kate Field (1866 MS), 42–43.

10. For a fuller discussion of the history of art colonies see Michael Jacobs, *The Good and Simple Life: Artist Colonies in Europe and America* (Oxford: Phaidon Press, 1985).

11. Quoted in Charlotte Streifer Rubenstein, *American Women Artists* (New York: Avon Books, 1982), 79. Much of the biographical information in this section is drawn from Rubenstein's work.

12. William H. Gerdts, *The White Marmorean Flock: Nineteenth-Century American Women Neoclassical Sculptors* (Poughkeepsie, New York: Vassar College Art Gallery, 1972), 1; Harriet Hosmer quoted in Margaret Wendell LaBarre, "Harriet Hosmer: Her Era and Art" (master's thesis, University of Illinois, Champaign-Urbana, 1966), 104; Harriet Hosmer to Wayman Crow, August 1854, quoted in Rubenstein, *American Women Artists,* 79.

13. Lydia Maria Child, quoted in LaBarre, "Harriet Hosmer," 60; Lydia Maria Child, "Miss Harriet Hosmer," *Littel's Living Age* 20 (March 13, 1858): 697.

14. William Wetmore Story to James Russell Lowell, quoted in Rubenstein, *American Women Artists,* 75; William Wetmore Story to James Russell Lowell, February 11, 1853, quoted in LaBarre, "Harriet Hosmer," 56.

15. Quoted in LaBarre, "Harriet Hosmer," 98, 100.

16. Quoted in Harold E. Miner, "Vinnie and Her Friends: Unpublished Biography of Vinnie Ream Hoxie" c.1972, p. 74, reel 297, AAA.

17. Ibid., 205, 132.

18. Ibid., 312, 198–99.

19. Ibid., 199, 132–33. Although Ream's statue was criticized, it was also praised. According to Rubenstein, "Lorado Taft objected to the absence of 'body within the garments,' [a somewhat unfair comment in an era when women were still denied access to life classes!] but many critics have found the work honest and realistic and compared it favorably with other, more pretentious statues of Lincoln that were being erected all over the nation at the time." *American Women Artists,* 84. Similarly, William Gerdts notes that her work was favorably "compared to Horatio Greenough's *Washington,*" with "prevailing sentiments that unlike Greenough Vinnie Ream had not made use of absurd classic costume, and that she did not attempt to create a Jupiter, but rather an exact and faithful likeness." Moreover, as he points out, "Vinnie Ream's *Lincoln* was, in fact, so successful that she received a

second Congressional commission, that of the statue of Admiral Farragut for Washington, D.C." *White Marmorean Flock,* 14. Art historian Whitney Chadwick also describes her statue as "a moving depiction." *Women, Art, and Society* (London: Thames and Hudson, 1990), 208.

20. Quoted in Christine Jones Huber, *The Pennsylvania Academy and Its Women* (Philadelphia: Pennsylvania Academy of the Fine Arts, 1974), 21.

21. Thomas Eakins to Emily Sartain, quoted in Theodore Siegl, *The Thomas Eakins Collection* (Philadelphia: Philadelphia Museum of Art, 1978), 32.

22. Wheeler, "Art Education for Women," 82.

23. Rosalind Rosenberg, *Beyond Separate Spheres: Intellectual Roots of Modern Feminism* (New Haven: Yale University Press, 1982), 8; "Some Lady Artists of New York," *Art Amateur* 3 (July 1880): 27.

24. Quoted in Jean Strouse, *Alice James: A Biography* (Boston: Houghton Mifflin, 1980), 88; Mrs. Jameson, "Sketches in Art," quoted in *Detroit Art Loan Record* (September 3, 1883): 15, in Detroit Art Loan MSS, reel D10A, AAA.

25. Elizabeth H. Pleck and Joseph H. Pleck, introduction to *The American Man* (Englewood Cliffs, New Jersey: Prentice Hall, 1980), 22.

26. Lizzie W. Champney (1885), quoted in Doreen Bolger Burke, "Painters and Sculptors in the Decorative Age," in Doreen Bolger Burke et al., *In Pursuit of Beauty: Americans and the Aesthetic Movement* (New York: Rizzoli, 1987), 322. The use of studios as informal showrooms also limited women's roles, since middle-class women living alone and opening their apartments to the public would have suffered a loss of status and credibility.

27. Hunt's studio and those of some of his colleagues are described in Paul R. Baker, *Richard Morris Hunt* (Cambridge: MIT Press, 1980), passim. The change in studio decoration was brilliantly captured in William Merrit Chase's 1880 painting *In the Studio.*

28. Ibid., 97.

29. Ann Douglas, *The Feminization of American Culture* (New York: Alfred A. Knopf, 1977), 327.

30. Quoted in Remy G. Saisselin, *The Bourgeois and the Bibelot* (New Brunswick, New Jersey: Rutgers University Press, 1984), 67.

31. Art Students League, "First Report" (New York), 35; Ira Glackens, *William Glackens and the Ashcan Group: The Emergence of Realism in American Art* (New York: Crown Publishers, 1957), 36.

32. Quoted in Carol Troyen, *The Boston Tradition: American Paintings from the Museum of Fine Arts, Boston* (New York: American Federation of Arts, 1980), 36.

33. St. Botolph Club, Notice, November 22, 1892, p. 182, St. Botolph Club MSS, AAA.

34. Elizabeth H. Ellett to Lilly Martin Spencer, October 6, 1859, Lilly Martin Spencer MSS, reel 131, AAA.

35. "Women's National Art Association," *New York Times* (November 12, 1866): 4.

36. "Ladies Art Association," *New York Times* (February 28, 1877): 5; (March 24, 1877): 2.

37. Wanda Corn, "Women Building History," in Eleanor Tufts, ed., *American Women Artists, 1830–1930* (Washington: National Museum of Women in the Arts, 1987), 27–28.

38. Circular, quoted in Jeanne Madeline Weimann, *The Fair Women: The Story of the Woman's Building, World's Columbian Exposition, Chicago, 1893* (Chicago: Academy Chicago, 1981), 131.

39. Quoted in Nancy Hale, *Mary Cassatt: A Biography of the Great American Painter* (Garden City, New York: Doubleday and Co., 1975), 163–64.

40. Bertha Palmer to Chauncey De Pew, quoted in Weimann, *Fair Women,* 185; Sara Hallowell to Bertha Palmer, quoted in ibid., 187; ibid.,188.

41. Corn, "Women Building History," 31–32; Bertha Palmer to Candace Wheeler, February 1893, quoted in Weimann, *Fair Women,* 298; Sara Hallowell quoted in ibid., 281.

42. Bertha Palmer to Sara Hallowell, quoted in Weimann, *Fair Women,* 191.

43. Ibid., 285, 320.

44. Quoted in Julie Graham, "American Women Artists' Groups, 1867–1930," *Feminist Art Journal* 1 (Spring–Summer 1980): 12.

45. Truman Bartlett, introduction to *Exhibition Catalogue of the Paintings and Charcoal Drawings of the Late William Morris Hunt* (Boston, 1880), 4, quoted in Hoppin, "Women Artists in Boston," 19.

46. Stephanie M. Buck, "Sarah Choate Sears: Artist, Photographer, and Art Patron" (master's thesis, Syracuse University, 1985), 19.

47. Quoted in Natalie Spassky, *Mary Cassatt* (New York: Metropolitan Museum of Art, 1984), 6.

48. For a fuller discussion of these trends, see Adler and Garb, *Berthe Morisot.*

49. Quoted in Rubenstein, *American Women Artists,* 132.

50. Frances Weitzenhoffer, *The Havemeyers: Impressionism Comes to America* (New York: Harry N. Abrams, 1986), 28.

51. Their biographer suggests that part of his initial reticence may have stemmed from pecuniary, rather than aesthetic, reservations. As she explains, Henry resisted the modernists' work "while he was convinced he would be throwing his money away," remaining aloof "until events in America and abroad indicated that these artists had carved out a relatively respectable place for themselves." Once Henry O. Havemeyer was finally convinced that they represented a sound investment, he began to share his wife's enthusiasm for impressionist works. Ibid., 99.

52. Quoted in Spassky, *Mary Cassatt,* 27.

53. Weitzenhoffer, *Havemeyers,* 116.

54. The Metropolitan Museum of Art, *The H. O. Havemeyer Collection* (New York: Metropolitan Museum of Art, 1958).

Chapter 5

1. Lawrence W. Levine, *Highbrow/Lowbrow: The Emergence of Cultural Hierarchy in America* (Cambridge: Harvard University Press, 1988); Paul DiMaggio, "Cultural Entrepreneurship in Nineteenth-Century Boston: The Creation of an Organizational Base for High Culture in America," *Media, Culture, and Society* 4 (1982): 33–50; Paul DiMaggio, *Organizing Culture* (New York: Basic Books, forthcoming).

2. DiMaggio, *Organizing Culture*, chapter 2.

3. Burton J. Bledstein, *The Culture of Professionalism: The Middle Class and the Development of Higher Education in America* (New York: W. W. Norton and Co., 1976), 126. For the role of foundations in training managerial elites, see Barry D. Karl and Stanley N. Katz, "The American Philanthropic Foundation and the Public Sphere, 1890–1930," *Minerva* 19 (Summer 1981): 236–70. The rise of for-profit corporations is detailed in Alfred D. Chandler, Jr., *The Visible Hand: The Managerial Revolution in American Business* (Cambridge: Harvard University Press, 1977).

4. C. Wright Mills, *The Power Elite* (New York: Oxford University Press, 1956), 10. See also Leonard Silk and Mark Silk, *The American Establishment* (New York: Basic Books, 1980).

5. Andrew Carnegie, "The Gospel of Wealth," in *The Gospel of Wealth and Other Timely Essays by Andrew Carnegie,* ed. Edward C. Kirkland (Cambridge: Harvard University Press, 1962), 14, 25.

6. Robert Wiebe, *The Search for Order* (New York: Hill and Wang, 1967), 12.

7. Ibid., 41; E. Digby Baltzell, *Puritan Boston and Quaker Philadelphia: Two Protestant Ethics and the Spirit of Class Authority and Leadership* (Boston: Beacon Press, 1979), 21.

8. Metropolitan Museum of Art, *Annual Report* (1905), 11; Levine, *Highbrow/Lowbrow,* 139; Museum of Fine Arts, Boston, *Annual Report* (1919), 85.

9. Nancy F. Cott, *The Grounding of Modern Feminism* (New Haven: Yale University Press, 1987), 277. Despite a strong presence within the philanthropic sector as a whole, women seem to have rarely created major "nonprofit corporations" of their own before 1930. In terms of foundations, Harkness and Sage were exceptions, rather than the rule. Harkness quickly turned the Commonwealth Fund over to her son and a board of prominent male trustees. Sage, on the other hand, did take a role in the management of her foundation and ensured that other women figured prominently among both its staff and trustees. After she passed from the scene, however, the organization's tenor gradually changed. By the late 1930s, the board was entirely male, and women's interests were increasingly shuttled to the bottom of the foundation's priorities. Like multipurpose museums, the majority of the country's first big foundations—Kellogg, Kettering, Kresge, Mott, Duke, Carnegie, Surdna, and Hartford—were founded and managed by men. For a general overview of their early history, see Waldemar Nielsen, *The Big Foundations* (New York: Columbia University Press, 1972).

Although Lori Ginzberg suggests in *Women and the Work of Benevolence:*

Morality, Politics, and Class in the Nineteenth-Century United States (New Haven: Yale University Press, 1990) that Charity Organization Societies also followed a corporate format, this interpretation confuses COS rhetoric with the realities that surrounded the societies' efforts. Despite their emphasis on efficiency and coordination, these organizations remained essentially volunteer groups until the turn of the century, and even afterward the pace of professionalization was extremely slow. As historian Roy Lubove explains, "There was a wide disparity between the professed standards and goals of social work theorists and the day-to-day work in agencies. By the criterion of objective achievement, 'scientific' social work remained an elusive ideal rather remote from reality." Nor were COSs capitalized on the same level as museums, major foundations, or universities. Roy Lubove, *The Professional Altruist: The Emergence of Social Work as a Career, 1880–1930* (New York: Atheneum, 1965), 20.

10. The role of men's clubs in promoting American art after the Civil War is discussed in Linda H. Skalet, "The Market for American Painting in New York, 1870–1915" (Ph.D. dissertation, Johns Hopkins University, 1980).

11. For a fuller discussion of the early history of the Metropolitan, see Winifred E. Howe, *A History of the Metropolitan Museum of Art*, 2 vols. (New York: Metropolitan Museum of Art, 1913; Columbia University Press, 1946); and Calvin Tomkins, *Merchants and Masterpieces: The Story of the Metropolitan Museum of Art* (New York: E. P. Dutton and Co., 1973).

12. Metropolitan Museum of Art, *Annual Report* (1910), 40. However, not all museums received municipal appropriations. For example, Boston's museum remained privately funded during these years. For the role of women's groups in gleaning municipal appropriations, see Ginzberg, *Women and the Work of Benevolence.*

13. *Paterson Guardian,* quoted in Tomkins, *Merchants and Masterpieces,* 88.

14. Winifred E. Howe, *History of the Metropolitan* 2:84; "The Metropolitan Museum's Amazing Windfall," *Literary Digest* 88 (January 23, 1926): 27.

15. Miriam Langsam, "Anna M. Richards Harkness," in Edward T. James, Janet Wilson James, and Paul S. Boyer, eds., *Notable American Women* (Cambridge: Harvard University Press, 1971), 2:134.

16. Metropolitan Museum of Art, *Annual Report* (1921), 19; Metropolitan Museum of Art, Archives, correspondence files.

17. Emily de Forest to Henry Kent, December 13, 1909; Henry Kent to Emily de Forest, December 14, 1909; Emily de Forest to Henry Kent, July 14, 1927; all in Emily de Forest file, "Personal, 1895–1936," D 3623, Metropolitan Museum of Art MSS (hereafter cited as MMA MSS).

18. Although Elizabeth Stillinger's book *The Antiquers* (New York: Alfred A. Knopf, 1980) suggests that men may have been the primary collectors of decorative artifacts, collecting habits varied considerably by field. Continuing the patterns of the decorative arts movement, women were particularly active in the collection of such things as laces, embroidery, other textiles, costumes, ceramics, musical instruments, jewelry, and to lesser extent, household furnishings from various periods.

19. Henry Kent to Howard Mansfield, September 1, 1914, memo; Robert W.

de Forest to Mr. Friedley, July 11, 1914; both in "Gifts (Misc.) 1913–1917," Sa 179, MMA MSS.

20. Quoted in Winifred E. Howe, *History of the Metropolitan* 2:77.

21. Ibid. 2:75; "The Greatest Art Collection Ever Given to the American Public," *Current Opinion* 58 (January 1915): 50.

22. Metropolitan Museum of Art, *The H. O. Havemeyer Collection* (New York: Metropolitan Museum of Art, 1958), introduction, unpaginated.

23. Mrs. J. Crosby Brown to Metropolitan Museum of Art, February 16, 1889, "Collected Correspondence, 1889–1894," B8175, MMA MSS.

24. Ibid.

25. Mrs. J. Crosby Brown to General diCesnola, December 16, 1893, MMA MSS, "Collected Correspondence, 1889–1894," B8175.

26. Quoted in Frederick Baekeland, "Collectors of American Painting, 1813–1913," *American Art Review* 3 (1976): 152–53.

27. Margaret W. Rossiter, *Women Scientists in America: Struggles and Strategies to 1940* (Baltimore: Johns Hopkins University Press, 1982), chapter 2.

28. Richter was hired at the suggestion of Harriet Boyd, an anthropologist who was a professional acquaintance of the museum's director, Edward Robinson. The Cambridge-educated daughter of a noted art historian who had served as one of Bernard Berenson's mentors, Richter worked with Boyd on an archaeological excavation in Crete before going to the Metropolitan in 1905. During the course of her tenure, she became a leading expert on Hellenic art and Greek sculpture, publishing 20 books and almost 150 articles by the end of her career. Women curators are discussed in Claire Richter Sherman and Adele M. Holcomb, eds., *Women as Interpreters of the Visual Arts, 1820–1979* (Westport, Connecticut: Greenwood Press, 1981).

29. Howe, *History of the Metropolitan* 2:787.

30. Ibid., 201; Mrs. J. Crosby Brown to Henry Kent, June 8, 1912, "General Correspondence, 1885–1918," B817, MMA MSS.

31. Tomkins, *Merchants and Masterpieces*, 285.

32. These figures do not include the Wilstach bequest, which was left to the city, rather than to the museum.

33. Elizabeth D. Gillespie, *A Book of Remembrance* (Philadelphia: J. B. Lippincott and Co., 1901), 371–72.

34. Ibid., 372.

35. Pennsylvania Museum and School of Industrial Art, scrapbook, reel P14, frame 687, AAA.

36. "Art Treasures," *Philadelphia Inquirer* (May 16, 1882), in ibid., frame 719.

37. Pennsylvania Museum and School of Industrial Art, *Annual Report* (1899), 54.

38. W. T. Baker, quoted in undated newsclipping, Art Institute scrapbook 1;4, Ryerson Library, Art Institute of Chicago; Charles L. Hutchinson, undated newsclipping, ibid., 3. For a fuller discussion of the history of the Art Institute, see

Kathleen D. McCarthy, *Noblesse Oblige: Charity and Cultural Philanthropy in Chicago, 1849–1929* (Chicago: University of Chicago Press, 1982); and Helen Lefkowitz Horowitz, *Culture and the City: Cultural Philanthropy in Chicago from the 1880s to 1917* (Lexington: University Press of Kentucky, 1976).

39. A. T. Andreas, *History of Chicago* (Chicago: A. T. Andreas Co., 1885), 3:421; Ezra B. McCagg to Charles L. Hutchinson, March 17, 1885, p. 2, Charles L. Hutchinson MSS, box 2, Newberry Library, Chicago.

40. A significant number of the Art Institute's women donors were alumnae of the Antiquarian Society, CSDA,or both. For example, Mrs. A. H. M. Ellis donated funds for a collection of plaster casts in the 1880s as a memorial to her late husband. Several Antiquarians amassed substantial collections of Old Master and impressionist paintings by themselves or with their husbands, which eventually made their way to the museum's walls as well. Bertha and Potter Palmer were one such collecting team; Carrie and Martin Ryerson were another.

41. Art Institute of Chicago, Trustees' Minutes, July 25, 1889, p. 143, Archives, Art Institute of Chicago (hereafter cited as AI).

42. While Kimball amassed one of the city's most important impressionist collections, others adopted more modest goals. For example, Mrs. Marshall Field was an avid collector of old laces. Frances Glessner, the guiding spirit behind the reorganization, was a former school teacher who married well. As the wife of a local manufacturer of farm implements, she became one of the city's leading society matrons. A talented pianist, Glessner helped to raise funds for the Chicago Symphony Orchestra (her husband was on the board), and counted Theodore Thomas and Ignacy Paderewski among her friends. She was also an avid craftswoman, skilled at needlework, wood carving, and silversmithing, talents that may have attracted her to CSDA.

43. Ibid., October 29, 1896, pp. 151–52; Charles L. Hutchinson to Mrs. Jewett, November 7, 1896, Antiquarian Society Minutes, vol. 1, AI.

44. Antiquarian Society of Minutes, December 13, 1910, vol. 1, AI.

45. Friends of American Art, Minutes, passim, AI.

46. In addition to the $25,000 gift from Mrs. T. Bigelow Lawrence that helped to spark the museum's creation, eight women were listed among the first seventy-one donors of $1,000 and $2,000, as well as two women in the $5,000 range. For a fuller discussion of the relationships of class and cultural institutions in Boston, see Ronald Story, *Harvard and the Boston Upper Class: The Forging of an Aristocracy, 1800–1870* (Middletown, Connecticut: Wesleyan University Press, 1980). The history of the museum is detailed in Walter M. Whitehill, *Museum of Fine Arts, Boston: A Centennial History,* 2 vols. (Cambridge: Harvard University Press, 1970); Neil Harris, "The Gilded Age Revisited: Boston and the Museum Movement," *American Quarterly* 14 (Winter 1964): 545–66; and DiMaggio, "Cultural Entrepreneurship in Nineteenth-Century Boston."

47. Memorandum, August 10, 1881, p. 30, Museum of Fine Arts, Boston (hereafter cited as BMFA), in Minutes, reel 536, frames 0238–39, AAA.

48. Ibid., frame 0239.

49. Whitehill, *Museum of Fine Arts* 1:51.

50. Susan Warren to General Loring, January 12, 1895, BMFA, Director's Correspondence, reel 559, frame 0008, AAA.

51. Museum of Fine Arts, Boston, *Annual Report* (1906), 10–11.

52. Charles G. Loring to Isabella Stewart Gardner, April 20, 1890, BMFA, Director's Correspondence, reel 2455, folder 86.

553. Isabella Stewart Gardner to Charles G. Loring, c. 1900, BMFA, Director's Correspondence, reel 2455, frame 99.

54. M. S. Prichard to Denman Ross, November 15, 1903, BMFA, reel 2455, frames 105–6, AAA; Internal Memos, BMFA, Director's Correspondence, reel 2455, frame 107.

55. Arthur Fairbanks to Maria Antoinette Evans, December 9, 1913, BMFA, Director's Correspondence, reel 2453, frame 291.

56. Louisine Havemeyer, "The Suffrage Torch: Memories of a Militant," *Scribner's Monthly* 71 (May 1922): 529. The director's correspondence from Boston's Museum of Fine Arts also reveals that women were extremely reticent to hazard opinions about the quality of the gifts they gave or lent.

57. For other examples of these tactics see Rossiter, *Women Scientists in America,* chapter 2.

58. Robert Moses, quoted in Avis Berman, *Rebels on Eighth Street: Juliana Force and the Whitney Museum of American Art* (New York: Atheneum, 1990), 440.

59. Cott, *Grounding of Modern Feminism,* 217.

60. Mary Beard quoted in ibid., 280.

Chapter 6

1. For a fuller description of these trends see John Higham, "The Reorientation of American Culture in the 1890s," in John Higham, ed., *Writing American History: Essays on Modern Scholarship* (Bloomington: Indiana University Press, 1970), 71–102; and Joe L. Dubbert, "Progressivism and the Masculine Crisis," in Elizabeth H. Pleck and Joseph H. Pleck, eds., *The American Man* (Englewood Cliffs, New Jersey: Prentice Hall, 1980), 303–20.

2. Earl Barnes, "The Feminizing of Culture," *Atlantic Monthly* 109 (June 1912): 770, 772; Hugo Munsterberg, quoted in Anna A. Rogers, "Some Faults of American Men," *Atlantic Monthly* 103 (June 1909): 735, his emphasis.

3. Ramsey Traquair, "Women and Civilization," *Atlantic Monthly* 132 (September 1923): 290.

4. "The Uncultured Sex," *Independent* 67 (November 11, 1909): 1100.

5. Eliott J. Gorn, *The Manly Art: Bare-Knuckle Prize Fighting in America* (Ithaca: Cornell University Press, 1986), 187, 189.

6. "Uncultured Sex," 1100; Barnes, "Feminizing of Culture," 773; "Culture under Fire," *Nation* 91 (September 22, 1910): 258.

7. Henry Childs Merwyn, "On Being Civilized Too Much," *Atlantic Monthly* 79 (June 1897): 838, 839, 846.

8. W. J. Stillman, "The Revival of Art," *Atlantic Monthly* 70 (August 1892): 249; Merwyn, "On Being Civilized Too Much," 844; "Uncultured Sex," 1100; Rogers, "Some Faults of American Men," 737; Henry W. Lanier, "What's the Good of Art?" *World's Work* 28 (July 1914): 339; Barnes, "Feminizing of Culture," 776.

9. Quoted in Frances Weitzenhoffer, *The Havemeyers: Impressionism Comes to America* (New York: Harry N. Abrams, 1986), 111.

10. Remy G. Saisselin, *The Bourgeois and the Bibelot* (New Brunswick, New Jersey: Rutgers University Press, 1984), 30.

11. Frank Jewett Mather, Jr., "The Drift of the World's Art toward America," *World's Work* 45 (December 1922): 201, 198, 200–201.

12. Ramsey Traquair, "Man's Share in Civilization," *Atlantic Monthly* 134 (October 1924): 503; "The President Talks on Art," *Literary Digest* 95 (November 5, 1927): 31.

13. Frank Jewett Mather, Jr., "The Art Collector: His Fortes and Foibles," *Nation* 88 (May 13, 1909): 495; Frank Jewett Mather, Jr., "Great Masters in American Galleries," *World's Work* 20 (May 1910): 12937; Mather, "Drift of the World's Art," 200; "Our Art Market," *Nation* 86 (May 14, 1908): 439.

14. Mather, "Art Collector," 496; Mather, "Great Masters in American Galleries," 12934; Mather, "Art Collector," 494; "Mobilizing Our Millionaires in the Cause of Art," *Current Opinion* 62 (January 1917): 54.

15. Nathaniel Burt, *Palaces for the People: A Social History of the American Art Museum* (Boston: Little, Brown and Co., 1977), 238.

16. "Mr. Morgan as a Collector," *Literary Digest* 46 (May 10, 1913): 1062, quoting London's *Morning Post;* Francis Henry Taylor, *Pierpont Morgan as Collector and Patron, 1837–1913* (New York: Pierpont Morgan Library, 1957), 27, 33; Aline B. Saarinen, *The Proud Possessors: The Lives, Times, and Tastes of Some Adventurous American Art Collectors* (New York: Random House, 195), 64, 56.

17. Francis Henry Taylor, *Pierpont Morgan,* 35. See also William G. Constable, *Art Collecting in the United States of America* (London: Thomas Nelson and Sons, 1964).

18. The value of Morgan's collection is cited in Francis Henry Taylor, *Pierpont Morgan,* 36.

19. Raymond B. Fosdick, *John D. Rockefeller, Jr.: A Portrait* (New York: Harper and Bros., 1956), 346. For a discussion of the bequest, see "Mr. Frick's Royal Gift," *Literary Digest* 111 (October 31, 1931): 20–21.

20. "The Nation's Benefactor in Art," *Literary Digest* 63 (October 18, 1919): 29.

21. Harrison S. Morris, "The Art Collection of John G. Johnson," *Scribner's* 68 (September 1920): 380.

22. Caroline Ticknor, "The Steel Engraving Lady and the Gibson Girl," *Atlantic Monthly* 88 (July 1901): 106, 107.

23. Ibid., 107–8.

24. Victor Turner, *The Ritual Process: Structure and Anti-structure* (Ithaca: Cornell University Press, 1969), 94.

25. Arnold Van Gennep, *The Rites of Passage* (1909; Chicago: University of Chicago Press, 1960), 18, 114; Carroll Smith-Rosenberg, "The New Woman as Androgyne: Social Disorder and Gender Crisis, 1870–1936," in *Disorderly Conduct: Visions of Gender in Victorian America* (New York: Oxford University Press, 1985), 245–96.

26. Rollin Van N. Hadley, ed., *The Letters of Bernard Berenson and Isabella Stewart Gardner, 1887–1924* (Boston: Northeastern University Press, 1987), xviii.

27. Henry James, quoted in Leon Edel, *Henry James: The Middle Years, 1882–1895* (1962; New York: Avon Books, 1978), 325; Edward Hooper, quoted in Ernest Samuels, *Bernard Berenson: The Making of a Connoisseur* (Cambridge: Harvard University Press, 1979), 249; "Mrs. Gardner's Fame as New York Sees It," undated newsclipping in Additional Newsclippings Scrapbook, Isabella Stewart Gardner MSS, Isabella Stewart Gardner Museum, Boston (hereafter cited as ISG MSS).

28. Mary Berenson to Isabella Stewart Gardner (hereafter cited as ISG), November 1903; Mary Cassatt to Louisine Havemeyer, February 2, 1903; both quoted in Weitzenhoffer, *Havemeyers,* 145.

29. Samuels, *Connoisseur,* 208; Morris Carter, *Isabella Stewart Gardner and Fenway Court* (Boston: Isabella Stewart Gardner Museum, 1925), 157, 158. Although Morris Carter and Aline Saarinen both placed the figure of Gardner's inheritance at $2.75 million, Hadley sets it $1 million lower. Ibid., 121; Saarinen, *Proud Possessors,* 38; Hadley, *Letters,* xix.

30. ISG to Bernard Berenson (hereafter cited as BB), quoted in Samuels, *Connoisseur,* 247.

31. Newspaper article, quoted in Carter, *Gardner,* 143; Samuels, *Connoisseur,* 188.

32. Samuels, *Connoisseur,* 239.

33. Ibid., 240; Louis A. Holman, "America's Rembrandts," *Century* 80 (October 1910): 881–87. Three of the six Rembrandts that Havemeyer donated to the Metropolitan Museum were later deemed incorrect attributions, as were two of Altman's.

34. ISG to BB, September 25, 1898, in Hadley, *Letters,* 154; Samuels, *Connoisseur,* 301.

35. ISG to BB, September 11, October 21, and September 19, 1896, quoted in Hadley, *Letters,* 65, 68–69, 65, 66.

36. ISG to BB, February 2, 1896, in Hadley, *Letters,* 48; Samuels, *Connoisseur,* 245; ISG to BB, November 27, 1896, August 18, 1896, August 30, 1898, and February 8, 1897, in Hadley, *Letters,* 71, 63, 150, 76.

37. "Prices Paid for Paintings," ISG MSS, reel 632, frames 341–63, from Isabella Stewart Gardner Museum, Boston, AAA; Samuels, *Connoisseur,* 303. According to Aline Saarinen, the Fra Lippo Lippi *Madonna and Child* and the Cranach *Adam and Eve* later turned out to be faulty attributions. Saarinen, *Proud Possessors,* 38.

38. ISG to BB, April 27, 1900, in Hadley *Letters,* 213; Carter, *Gardner,* 173;

ISG to BB, February 11, February 22, August 11, and September 7, 1899, in Hadley, *Letters,* 168, 186, 188.

39. Samuels, *Connoisseur,* 412–13; BB to ISG, June 10, 1900, in Hadley, *Letters,* 219.

40. Ida Higginson to ISG, March 8, 1923, ISG MSS.

41. Carter, *Gardner,* 190.

42. Ibid., 184–85; *Guide to the Collection: Isabella Stewart Gardner Museum* (Boston: Trustees of the Isabella Stewart Gardner Museum, 1976), 5; Hadley, *Letters,* xx.

43. William James, quoted in Carter, *Gardner,* 201; Henry Adams to ISG, quoted in ibid., 204; "Boston Public Marvels at the Beauties of the Gardner Museum," newsclipping, February 23, 1903, ISG Scrapbook, 1903–14, ISG MSS; Mary Augusta Milliken, "The Art Treasures of Fenway Court," *New England Magazine,* n.s. 33 (November 1905): 249; "Mrs. Gardner's Museum Open," newsclipping, c. 1903, ISG Scrapbook, 1903–14, ISG MSS; Mather, "Drift of the World's Art," 199.

44. Carter, *Gardner,* 207; Samuels, *Connoisseur,* 299.

45. ISG to BB, April 27, 1900, in Hadley, *Letters,* Charles Eliot Norton to ISG, April 3, 1905, quoted in Carter, *Gardner,* 208; Henry Lee Higginson to ISG, June 1, 1905, in ibid.; Kenyon Cox, quoted in ibid., 207.

46. Carter, *Gardner,* 230.

47. "Estate Tax Form—Schedule K," ISG MSS.

48. ISG to BB, May 1899, cited in Samuels, *Connoisseur,* 303.

49. Louise Hall Tharp, *Mrs. Jack: A Biography of Isabella Stewart Gardner* (Boston: Little, Brown and Co., 1965), 216; Ernest Samuels, *Bernard Berenson: The Making of a Legend* (Cambridge: Harvard University Press, 1987), 20; Carter, *Gardner,* 175–76. For a discussion of Fenway Court as a unified work of art and an alternative museum, see Anne Higonnet, "Where There's a Will . . ." *Art in America* 79 (May 1989): 65–75.

50. Samuels, *Legend,* 2.

51. For Sophia Smith, see Barbara Miller Solomon, *In the Company of Educated Women: A History of Women and Higher Education in America* (New Haven: Yale University Press, 1985), 47.

52. BB quoted in Hadley, *Letters,* xxii; Constable, *Art Collecting,* 49.

53. Henry James quoted in Samuels, *Connoisseur,* 356.

54. "Mrs. Gardner's Fame as New York Press Sees It," undated newsclipping from the *New York Herald Tribune,* Additional Clippings Scrapbook, ISG MSS.

Chapter 7

1. Janet Hobhouse, *Everybody Who Was Anybody: A Biography of Gertrude Stein* (New York: Doubleday, 1975), 43.

2. Madel Dodge Luhan, *European Experiences* (New York: Harcourt, Brace and Co., 1935), 323, 322; Hobhouse, *Everybody Who Was Anybody,* 61.

3. Hobhouse, *Everybody Who Was Anybody,* 22. Stein did buy two works by Laurencin: one in 1908, which she later sold to the Cone sisters, and one in the 1940s. Agnes Meyer, who was no feminist, later confessed her preference for Leo. "I have always distrusted masculine women," she wrote, "and found their self-assertion distasteful." She also found Gertrude Stein aesthetically distasteful, ungenerously dismissing her as a "heavy woman who seemed to squat rather than sit." Agnes Ernst Meyer, *Out of These Roots: The Autobiography of an American Woman* (Boston: Little, Brown and Co., 1953), 80–81.

4. The Cone sisters and their collection are described in Brenda Richardson, *Dr. Claribel and Miss Etta* (Baltimore: Baltimore Museum of Art, n.d.).

5. Quoted in William Innes Homer, *Alfred Stieglitz and the American Avant-Garde* (Boston: New York Graphic Society, 1977), 67.

6. Milton W. Brown, *The Story of the Armory Show* (New York: Abbeville Press, 1988), 131.

7. Justin Kaplan, *Lincoln Steffens: A Biography* (New York: Simon and Schuster, 1974), 199; Milton W. Brown, *Story of the Armory Show,* 138, 179; *Chicago Record Herald* (April 7, 1913); *Chicago Evening Post* (March 19, 1913).

8. Trevor J. Fairbrother, *The Bostonians: Painters of an Elegant Age, 1870–1930* (Boston: Museum of Fine Arts, 1986), 86; Milton W. Brown, *Story of the Armory Show,* 206.

9. Luhan, *European Experiences, 322–23.*

10. Henry F. May, *The End of American Innocence: A Study of the First Years of Our Own Time, 1912–1917* (Chicago: Quadrangle Books, 1959), 393.

11. Avis Berman, *Rebels on Eighth Street: Juliana Force and the Whitney Museum of American Art* (New York: Atheneum, 1990), 172, 440.

12. "Near 'Crime Wave' in Art," *Literary Digest* 76 (February 10, 1923): 29; Berman, *Rebels,* 243.

13. Mrs. John O'Connor, President, Chicago Woman's Club, quoted in Eileen Boris, *Art and Labor: Ruskin, Morris, and the Craftsman Ideal in America* (Philadelphia: Temple University Press, 1986), 80.

14. Adelaide S. Hall, "Practical Work among Club-Women," *Chatauquan* 31 (September 1900): 624, 621; Sarah W. Whitman, "Art in the Public Schools," *Atlantic Monthly* 79 (May 1897): 620.

15. General Federation of Women's Clubs, "Study Outline and a Bibliography of American Art" (1922), 1–5. However, in 1934 the women's clubs joined forces with the Museum of Modern Art in a series of radio broadcasts and publications on art that did go up to the present. See Holger Cahill and Alfred H. Barr, Jr., eds., *Art in America in Modern Times* (New York: Reynal and Hitchcock, 1934).

16. Edith Halpert, "Folk Art Collecting in America," Downtown Gallery/Edith Halpert MSS, reel 1883, frame 282, AAA.

17. Dreier, quoted in Ruth L. Bohan, *The Société Anonyme's Brooklyn Exhibi-*

tion: Katherine Dreier and Modernism in America (Ann Arbor: UMI Research Press, 1982), 6.

18. Katherine Dreier to Marcel Duchamp, April 13, 1917, and April 23, 1925, "Duchamp, 1917–1927" folder, box 14, Société Anonyme MSS (hereafter cited as SA MSS), Beinicke Library, Yale University.

19. Katherine Dreier to Man Ray, April 26, 1921, "Man Ray" folder, SA MSS.

20. Katherine Dreier to Mrs. Louise Arensberg, February 5, 1923, "Arensberg" folder; Dreier to Marcel Duchamp, March 8, 1928, "Duchamp, 1928–29" folder; Dreier to Charles Worcester, February 1, 1923, "Art Institute" folder; all in SA MSS.

21. Katherine Dreier to Walter Arensberg, June 23, 1925, "Arensberg" folder, SA MSS.

22. Katherine Dreier to Arthur Aldis, June 14, 1921, "Aldis" folder, SA MSS.

23. Arthur Aldis to Katherine Dreier, January 22, 1923, "Aldis" folder; Alice Roullier to Katherine Dreier, February 22, 1921, "Arts Club" folder, both in SA MSS.

24. Katherine Dreier to Alice Roullier, March 9, 1921, "Arts Club" folder, SA MSS.

25. Bohan, *Brooklyn Exhibition,* 68, 88, 85.

26. Royal Cortissoz, quoted in ibid., 106; "Near Crime Wave in Art," 29.

27. Katherine Dreier to Marcel Duchamp, March 7, 1926, "Duchamp, 1926–27" folder; William Henry Fox to Katherine Dreier, July 29, 1926, "Brooklyn Museum" file; both in SA MSS.

28. Katherine Dreier to William Henry Fox, March 25, 1977; William Henry Fox to Katherine Dreier, March 12, 1927; both in "Brooklyn Museum" file, SA MSS.

29. *Collection of the Société Anonyme: Museum of Modern Art, 1920* (New Haven: Yale University Art Gallery, 1950), xv; Katherine Dreier to Louise Arensberg, February 5, 1923, "Arensberg" file, SA MSS: Katherine Dreier to Marcel Duchamp, January 10, 1926, "Duchamp, 1926–27" folder, SA MSS.

30. The collection is described in *Collection of the Société Anonyme.*

31. "She Fought the Battle for Modern Art," *Literary Digest* 109 (June 6, 1931): 17.

32. Ibid. According to Dore Ashton, "The museum was essentially the dream of an artist, Arthur B. Davies." *The New York School: A Cultural Reckoning* (New York: Penguin Books, 1979), 100. However, years later Rockefeller admitted to being puzzled about people's notions about Davies's connection with the museum's inception. As she explained, although she had purchased some of his watercolors in the late 1920s, "I do not remember meeting him until after [the museum] was well under way." Letter to A. Conger Goodyear, March 23, 1936, p. 2, Museum of Modern Art Archives, Alfred H. Barr, Jr., MSS, reel 3264, frame 1130, AAA, (hereafter cited as Barr MSS).

33. Mary Ellen Chase, *Abby Aldrich Rockefeller* (New York: Avon Books, 1950), 125.

34. Abby Aldrich Rockefeller to A. Conger Goodyear, March 23, 1936, p. 1, Barr MSS, reel 3264, frame 1130.

35. Edith Halpert, "The Village/Past," Downtown Gallery/Edith Halpert MSS, reel 1883, frame 24; Edith Halpert, "Talk at Detroit Institute of Art, September 18, 1963," Downtown Gallery/Edith Halpert MSS, reel 1883, frame 915.

36. Halpert, "Talk at Detroit Institute of Art"; Edith Halpert, "Chicago, November 9, 1948," typescript speech, Downtown Gallery/Edith Halpert MSS, reel 1883, frames 454, 455.

37. The price on the Zorach tapestry is cited in Aline B. Saarinen, *The Proud Possessors: The Lives, Times, and Tastes of Some Adventurous American Art Collectors* (New York: Random House, 1958), 361. The Rockefeller/Halpert alliance spread into other areas as well, particularly folk art. While Candace Wheeler attempted to raise women's traditional household crafts to the level of fine art as a route to female self-support, women like Rockefeller, Halpert, and another of Halpert's clients, Electra Havemeyer Webb, set aside charitable considerations to win these humble artifacts a place in the nation's artistic canon on the basis of their inherent aesthetic merits alone. Halpert was initially attracted to the field for financial reasons. As she later explained with great candor and not a little relish, since contemporary art was not widely appreciated, "dead men" (i.e., folk artists) supported her gallery and paid the deficits. Even when contemporary American art did not sell, folk art did, helping to subsidize the gallery's efforts on behalf of living artists. A few others had already preceded her in the celebration of folk art. For example, the painter and editor Hamilton Easter Field set up a collection at his artists' colony at Ogunquit, Maine, where the Halperts also summered. Another of the Halperts' haunts, the Whitney Studio Club, held the first exhibition of folk art in America in 1924, at about the time that one of her protégés, Elie Nadelman, opened an impromptu folk art museum in Riverdale, New York. Halpert helped to increase the popularity of these art forms, as well as their commercial value. She began collecting old pictures, samplers, and weather vanes at rummage sales on her trips through New England. In 1929 she launched the American Folk Art Gallery as part of her commercial operations. The first of its kind, the gallery pioneered in staging exhibitions at its New York headquarters and in museums throughout the country. In Halpert's opinion, folk art reflected the same reverence for design that distinguished contemporary art. Men also collected these homely artifacts and staged early exhibitions such as the on coordinated at the Newark Museum by Halpert's colleague and Rockefeller's advisor, Holger Cahill. But women took an early lead in institutionalizing folk art within specialized museums. Rockefeller began collecting in this area when Halpert's gallery opened; her acquisitions were later transferred to the Abby Aldrich Rockefeller Museum of Folk Art in Williamsburg, Virginia.

38. Halpert, "Chicago, November 9, 1948," frame 455.

39. Raymond B. Fosdick, *John D. Rockefeller, Jr.: A Portrait* (New York: Harper and Bros., 1956), 328.

40. Mary Ellen Chase, *Abby Aldrich Rockefeller,* 118, 119.

41. Fosdick, *Rockefeller,* 334, 335.

42. Ibid., 333.

43. Russell Lynes, *Good Old Modern: An Intimate Portrait of the Museum of Modern Art* (New York: Atheneum, 1973), 345; John Ensor Harr and Peter J. Johnson, *The Rockefeller Century: Three Generations of America's Greatest Family* (New York: Scribner's Sons, 1988), 218; Fosdick, *Rockefeller*, quoting Frank Crowninshield, 329.

44. "Fifty-third Street Patron," *Time* 27 (January 27, 1936): 28; Abby Aldrich Rockefeller MSS (hereafter cited as AAR MSS), box 34, Rockefeller Archive Center, Pocantico Hills, New York: "Abby Aldrich Rockefeller Art Account, 1933," Abby Aldrich Rockefeller Personal Correspondence, "Personal General 1909–1937," AAR MSS; Russell Lynes, *Good Old Modern*, 345.

45. Alice Goldfarb Marquis, *Alfred H. Barr, Jr.: Missionary for the Modern* (Chicago: Contemporary Books, 1989), 89, 90; Fosdick, *Rockefeller*, 328; Abby Aldrich Rockefeller (hereafter cited as AAR) to A. Conger Goodyear, March 23, 1936, p. 4, Barr, MSS, reel 3264, frame 1133. For a different interpretation of the museum's genesis, see Russell Lynes, *Good Old Modern*, and Saarinen, *Proud Possessors*, 363–64.

46. AAR to A. Conger Goodyear, March 23, 1926, pp. 2–3, Barr MSS, reel 3264, frames 1130–33.

47. AAR to A. Conger Goodyear, July 26, 1929, Box 25, folder 1, AAR MSS; Russell Lynes, quoted in Harr and Johnson, *Rockefeller Century*, 219.

48. As Mrs. Rockefeller later explained to Goodyear, they settled on his appointment because "we had been told of your efforts in the cause of modern art in Buffalo, and that you had resigned the presidency of that museum because the trustees would not go along with you in your desire to show the best things in modern art." AAR to Goodyear, March 23, 1926, p. 2, Barr MSS, Reel 3264, frame 1130.

49. AAR to A. Conger Goodyear, July 31, 1929; A. Conger Goodyear to AAR, August 7, 1929; both in box 25, folder 1, AAR MSS.

50. Quoted in Marquis, *Alfred H. Barr, Jr.,* 62.

51. A. Conger Goodyear cable, September 4, 1929; AAR to Alfred Barr, Jr., August 23, 1929; both in box 25, folder 1, AAR MSS. As Rockefeller explained to Barr in a missive of August 20, 1929, "Miss Bliss and I feel great hesitation about making the first exhibition only American." I would like to thank Darwin Stapleton for this citation.

52. Lloyd Goodrich, "A Museum of Modern Art, *Nation* (December 4, 1929): 664; "Meeting a Need," *Outlook* 53 (September 18, 1929): 98; "Modern Museum Makes Its Bow," *Literary Digest* 103 (November 23, 1929): 19.

53. "Modernism at Home," *Outlook* 53 (November 20, 1929): 455; A. Conger Goodyear to AAR, October 29, 1929, box 25, folder 1, AAR MSS; "Gifts Made by Abby Aldrich Rockefeller," accounting prepared by Lybrand, Ross for the estate of Abby Aldrich Rockefeller, 1949, Rockefeller Family and Associates MSS. I would like to thank Peter Johnson for sharing this material on Mrs. Rockefeller's estate with me, as well as the estimates on JDR Jr.'s total gifts to the Cloisters.

54. AAR to Alfred H. Barr, Jr., March 14, 1931, Barr MSS, reel 2164, frame 55.

55. The mechanics of the trusts are detailed in Harr and Johnson, *Rockefeller Century,* 358–59.

56. A. Conger Goodyear to AAR, September 5, 1930, p. 2, box 25, folder 1, AAR MSS.

57. Fosdick, *Rockefeller,* 330.

58. Alfred H. Barr, Jr., to Nelson Rockefeller, April 17, 1948, p. 1, Barr MSS, reel 3264, frame 1000. For a fuller account of the association of modern art with radicalism, see Serge Guilbaut, *How New York Stole the Idea of Modern Art: Abstract Expressionism, Freedom, and the Cold War* (Chicago: University of Chicago Press, 1983); and Dore Ashton, *New York School.*

59. Milton W. Brown, *American Painting from the Armory Show to the Depression* (Princeton: Princeton University Press, 1955), 95.

60. Ashton, *New York School,* 99–100; press release, October 21, 1927, scrapbook, Albert Eugene Gallatin MSS, reel 1293, frame 560, AAA.

61. Milton W. Brown, *American Painting,* 98, 97.

Chapter 8

1. Elizabeth H. Pleck and Joseph H. Pleck, eds., introduction to *The American Man* (Englewood Cliffs, New Jersey: Prentice Hall, 1980), 35.

2. Quoted in B. H. Friedman, *Gertrude Vanderbilt Whitney* (Garden City, New York: Doubleday and Co., 1978), 4, 5; Gertrude Vanderbilt Whitney, "Beginning of an Autobiography," in Typescript Journals, Gertrude Vanderbilt Whitney MSS (hereafter cited as GVW MSS), reel 1903, frame 1240, AAA, Gift of Flora Miller Irving.

3. Whitney, "Beginning of an Autobiography," frames 1236–37; Friedman, *Whitney,* 71.

4. Whitney, "Beginning of an Autobiography," frames 1250, 1239; Friedman, *Whitney,* 160.

5. Whitney, "Beginning of an Autobiography," frame 1250.

6. Gertrude Vanderbilt Whitney, Journals, December 31, 1905, and October 31, 1904, reel 1903, frames 1144, 1189, GVW MSS.

7. Ibid., August 24, 1906, frame 1280.

8. Ibid., October 31, 1903, and c. 1908, frames 1189, 1304.

9. Ibid., September 24, and December 6, 1904, frames 1163, 1193.

10. Ibid., December 5, 1904, frame 1192.

11. Friedman, *Whitney,* 168; Whitney, Journals, n.d. and October 21, 1904, frames 1206, 1189.

12. Whitney, Journals, June 27, 1904, frames 1157–58.

13. Ibid., frames 1159–61, 1163; January 15, 1905, frames 1192–93.

14. Friedman, *Whitney,* 162.

15. Avis Berman, *Rebels on Eighth Street: Juliana Force and the Whitney Museum of American Art* (New York: Atheneum, 1990), 55, 60.

16. Whitney, Journals, July 2, 1905, frame 1113; *New York Times Magazine* (November 9, 1919): 7.

17. Frederick James Gregg, "Gertrude Whitney, Sculptor and Personage," GVBW scrapbook, GVW MSS, reel 2374, frame 19; *New York Times* article, 1919, quoted in Friedman, *Whitney,* 415.

18. Friedman, *Whitney,* 415, 416; Whitney, Journals, July 2, 1905, frame 1113; Whitney, "Beginning of an Autobiography," frame 1241; Whitney, Journals, c. 1911, frames 1341–42.

19. Jane Addams, *Twenty Years at Hull-House* (1910; New York: New American Library, 1960), 94, 93; Friedman, *Whitney,* 181; Whitney, Journals, n.d., frame 1234.

20. Whitney, Journals, July 2, 1905, frame 1113.

21. *Tatler,* March 17, 1915, Newsclips, Whitney Museum of American Art MSS (hereafter cited as WM MSS), Records, 1914–45, reel NWH4, frame 66, AAA; Royal Cortissoz, "Mrs. H. P. Whitney Shows Own Work," *New York Tribune* (February 19, 1916); "The Twelve Greatest Women in America," *Literary Digest* 74 (July 8, 1922): 42. Avis Berman's biography of Juliana Force raises some troubling issues about Whitney's artistic ethics and capacities. In her opinion, "Gertrude never really studied long and effortfully enough in those early stages to master the plastic understanding necessary to achieve the highest technical proficiency." Moreover, her "powers of invention" were "weak," her work "clichéd" her statues marred by a "predictable sameness" that indicated a lack of "any outright skill or manifest talent." There were other problems as well. Like Vinnie Ream before her, the "degree of assistance she received over the years became a subject of some rumor in less friendly corners of the art world." In particular, it was alleged in some quarters that "her neighbor and teacher, Andrew O'Connor—helped her beyond legitimate bounds in the fine points of design, shape, and detail that Gertrude was unable to resolve." She even suggests that Whitney never attained full membership in the National Sculpture Society "because the majority were convinced that O'Connor was doing the work that counted." (Whitney was proposed for full membership in the National Academy of Design shortly before her death but failed to be elected on a technicality.) *Rebels,* 54, 55, 77, 79, 80. Here, once again, was the dilemma that haunted Harriet Hosmer and Vinnie Ream. Women artists who relied too heavily on their male mentors risked subjecting themselves to charges of copying, lack of originality, or in some cases outright plagiarism. Sculptors seem to have been particularly vulnerable to this sort of innuendo, since much of the actual production process was turned over to male artisans, in accordance with the artist's designs. Thus, although women were increasingly celebrated for their social and professional gains, their creative talents remained suspect when they worked in close association with men.

22. *New York Times,* 1919, quoted in Friedman, *Whitney,* 416.

23. Whitney, Journals, November 17, 1907, n.d., April 5, 1906, and c. 1908, frames 1268–69, 1234–35, 1266, 1306.

24. Carolyn Ware, *Greenwich Village, 1920–1930: A Comment on American Civilization in the Post-war Years* (1935; New York: Octagon Books, 1977), 236, and passim.

25. Berman, *Rebels*, 55.

26. Friedman, *Whitney*, 411.

27. Ibid., 417; John W. Alexander, letter to the editor, "The American Attitude toward Art," *Nation* 97 (July 31, 1913): 98; "The Iconoclastic Opinions of M. Marcel Duchamp concerning Art and America," *Current Opinion* 59 (November 1915): 346.

28. Ira Glackens, *William Glackens and the Ashcan Group: The Emergence of Realism in American Art* (New York: Crown Publishers, 1957), 76; Arthur Haeber, "A Plea for the American Artist," *North American* 189 (February 1909): 221; Rollo Walter Brown, "The Creative Spirit and Art," *Harper's* 150 (February 1925): 344; Joseph Pennell, "Can Art Be Made to Pay?" *Forum* 66 (December 1921): 523; Friedman, *Whitney*, 423.

29. John Sloan in Whitney Museum of American Art, *Juliana Force and American Art: A Memorial Exhibition* (New York: Whitney Museum of American Art, 1949), 34.

30. Daniel Chester French to Gertrude Vanderbilt Whitney, April 19, 1907, Typescript MSS, reel 1904, frame 427, GVW MSS; Glackens, *William Glackens*, 76; Whitney Museum, *Juliana Force*, 34–35.

31. Berman, *Rebels*, 92, 224.

32. *New York Times* (January 30, 1916); John Sloan to Gertrude Vanderbilt Whitney, quoted in Friedman, *Whitney*, 376.

33. "Offers $1,100 in Prizes for Immigrant in Art," undated newsclipping, Gertrude Vanderbilt Whitney Personal Newsclippings, c. 1915, WM MSS, reel NWH4, frame 79.

34. Guy Pène du Bois, in Whitney Museum, *Juliana Force*, 45; Berman, *Rebels*, 151.

35. Robert Henri, *The Art Spirit* (1923; New York: Harper and Row, 1984), 139, 140, 214, 215.

36. "Announcement," Gertrude Vanderbilt Whitney, Scrapbooks, GVW MSS, reel 2374, p. 473.

37. Friedman, *Whitney*, 403.

38. For an excellent discussion of Juliana Force's career, see Berman, *Rebels*.

39. Hermon More and Lloyd Goodrich, in Whitney Museum, *Juliana Force*, 12, 31–32; Forbes Watson, in ibid., 54; Berman, *Rebels*, 211; Glackens, *William Glackens*, 233.

40. More and Goodrich, in Whitney Museum, *Juliana Force*, 13; Watson, in ibid., 58, 55.

41. John Sloan, in ibid., 35; Louis Bouche, "Autobiographical Notes," n.d.,

Bouche MSS, reel 688, frame 867, AAA; Lloyd Goodrich, "Juliana Force," in Edward T. James, Janet Wilson James, Paul S. Boyer, eds., *Notable American Women* (Cambridge: Harvard University Press, 1971), 1:646; Glackens, *William Glackens,* 136.

42. More and Goodrich, in Whitney Museum, *Juliana Force,* 15; Watson, in ibid., 61; Sloan, in ibid., 35.

43. "Art Threatens to Abandon Greenwich Village," *Literary Digest* 75 (October 21, 1922): 30. See also Mary K. Simkhovitch, *Neighborhood: My Story of Greenwich House* (New York: W. W. Norton and Co., 1938); and Ware, *Greenwich Village.*

44. *New York Post,* April 7, 1923, Whitney Studio Club and Whitney Studio Galleries Papers, 1916–1930, reel NWH5, frame 232, AAA (hereafter cited as WS Papers); *New Yorker,* May 30, 1925, WS Papers, reel NWH5, frame 148.

45. Laurie Lisle, *Portrait of an Artist: A Biography of Georgia O'Keeffe* (New York: Simon and Schuster, 1980), 52.

46. *New York Post,* April 7, 1923, WS Papers, reel NWH5, frame 232; *New Yorker,* May 30, 1925, WS Papers, reel NWH5, frame 148; "The Whitney Studio Club," typescript, WS Papers, reel NWH5, frames 142–43; "Mrs. Whitney Replaces Club with Galleries," *New York Herald* December 7, 1928, WS Papers, reel NWH5, frame 369.

47. Friedman, *Whitney,* 520.

48. Charlotte Streifer Rubenstein, *American Women Artists* (New York: Avon Books, 1982), 188; More and Goodrich, in Whitney Museum, *Juliana Force,* 24. The Metropolitan Museum did not create its own department of American painting until 1949.

49. Watson, in Whitney Museum, *Juliana Force,* 56; Daty Healy, "A History of the Whitney Museum of American Art, 1930–1954" (Ph.D. dissertation, New York University, 1960), 96.

50. "Hoover Lauds Aims of Whitney Museum," *New York Times,* n.d., WS Papers, reel NWH5, frame 402. Governor Al Smith also gave a speech, in which he noted that "a civilization entirely devoted to material things will inevitably become mechanical and uninspired." Off the record, he also confided that he had his own collection, consisting primarily of amateur portraits of him, which had been "painted, burned or engraved on canvas, wood, leather, glass and almost every sort of material you can imagine. I even saw a photograph of myself carefully executed on the face of an egg, and it was not a bad piece of work." Ibid.

51. *New York Times,* November 18, 1931, WS Papers, reel N593, frame 2; Royal Cortissoz, "Mrs. Whitney's Gift to American Art," November 22, 1931, reel NWH5, frame 23; "Museum of American Art," *Outlook* 159 (December 3, 1931), reel NWH5, frame 422; Helen Appleton Read, "The Whitney Museum," *Brooklyn Eagle,* November 22, 1931, Scrapbooks, WM MSS, reel NWH5, frame 17.

52. Paul Rosenfeld, "The Whitney Museum," *Nation* 133 (December 30, 1931): 731–32; More and Goodrich, in Whitney Museum, *Juliana Force,* 27; Watson, in ibid., 59. Rosenfeld's extreme negativism may have been spurred by his

friendship with Alfred Stieglitz, who took a particularly dim view of the Whitney's inclusive style.

53. *Whitney Museum of American Art: History, Purpose, and Activities* (New York: Whitney Museum of American Art, 1935).

54. According to her biographer, "Juliana was not a thoroughgoing feminist. . . . But she believed unshakably in the equality of women, especially in the workplace and in the struggle for creative recognition." Her nephew later recalled that, as a museum director, "she refused to hold special exhibits for women artists on the grounds that this was condescending to women." Berman, *Rebels,* 134.

55. Friedman, *Whitney,* 569; F. L. Crocker to Mrs. G. McCollogh Mills, February 3, 1937, WM MSS, reel 2374, frame 563; List of Contributions, GVW MSS, reel 1903, frames 213–15; Healy, "Whitney Museum," 221; *New York Herald Tribune,* May 5, 1942, in Scrapbook, GVW MSS, reel 2374, frame 158.

56. Healy, "Whitney Museum," 100, quoting Hermon More in the museum's first catalogue; Juliana Force, quoted in *New York Times,* November 18, 1931, WS Papers, reel NWH5, frame 402; Glackens, *William Glackens,* 233.

57. Friedman, *Whitney,* 419, 375. Conversely, Berman asserts that "Juliana had absolute" hold of the reins of the Whitney enterprises after 1917. *Rebels,* 142, and passim.

58. For a discussion of the rise of bureaucratic culture, see Robert Wiebe, *The Search for Order* (New York: Hill and Wang, 1967); William H. Whyte, *The Organization Man* (New York: Simon and Schuster, 1956); William E. Leuchtenburg, *The Perils of Prosperity, 1914–1932* (Chicago: University of Chicago Press, 1958); Malcolm Cowley, *Exile's Return: A Literary Odyssey of the 1920s* (New York: Viking Press, 1934).

59. Estelle Freedman, "Separatism as Strategy: Female Institution Building in American Feminism, 1870–1930," *Feminist Studies* 5 (1979), reprinted in Mary Beth Norton, ed., *Major Problems in American Women's History* (Toronto: D. C. Heath and Co., 1989), 332.

60. Agnes Ernst Meyer, *Out of These Roots: The Autobiography of an American Woman* (Boston: Little, Brown and Co., 1953) 348, 342, 343; Elizabeth C. Baker, "Sexual Art-Politics," in Thomas B. Hess and Elizabeth C. Baker, eds., *Art and Sexual Politics* (New York: Macmillan Publishing Co., 1971), 112.

61. See, for example, Alice Kessler-Harris, *Out to Work: A History of Wage-Earning Women in the United States* (New York: Oxford University Press, 1982), 249; and Cott, *Grounding of Modern Feminism,* chapter 7.

62. "General Director's Newsletter, American Association of University Women," February 1949, Juliana Force MSS, reel N614, frame 733, AAA; Watson, in ibid., 61, 57.

63. Watson, in Whitney Museum, *Juliana Force,* 61; Rubenstein, *American Women Artists,* 188; "Whitney Museum to Be Opened Today," *New York Times,* n.d., WS Papers, reel NWH5, frame 400.

64. Serge Guilbaut, *How New York Stole the Idea of Modern Art: Abstract Expressionism, Freedom, and the Cold War* (Chicago: University of Chicago Press,

1983), 68. Peggy Guggenheim's career is detailed in her autobiography, *Out of This Century: Confessions of an Art Addict* (1946; Garden City, New York: Anchor Books, Doubleday and Co., 1980).

65. Berman, *Rebels,* 291; Guilbaut, *How New York Stole the Idea of Modern Art,* 77.

Bibliography

Primary and Unpublished Sources

Addams, Jane. *Twenty Years at Hull-House.* 1910. New York: New American Library, 1960.

Albany Gallery of the Fine Arts. "Catalogue of Second Exhibition." Albany, New York: Albany Gallery of the Fine Arts, 1847.

Alexander, John W. "The American Attitude toward Art." *Nation* 97 (July 31, 1913): 98.

American Academy of Fine Arts. Minutes, 1802–1839. New-York Historical Society.

American Art-Union. *Bulletin.* New York, 1850–51.

———. "Circular of the American Art Union and Catalogue of Paintings." New York, 1847.

———. Manuscripts. New-York Historical Society.

———. Newspaper Cuttings and Scrapbooks. New-York Historical Society.

———. *Transactions.* New York, 1844.

"The American Woman." *Independent* 53 (June 6, 1901): 1334–36.

Andreas, A. T. *History of Chicago.* 3 volumes. Chicago: A. T. Andreas Co., 1885.

Angell, Henry C. *Records of William M. Hunt.* Privately printed, n.d.

Antiquarian Society. Manuscripts. Archives, Art Institute of Chicago.

Apollo Association. Bylaws. New York.

———. Constitution. New York.

———. Transactions. New York.

Apollo Gallery. "Catalogue of the Eighth Exhibition." New York, 1841.

———. "Catalogue of the Paintings and Sculpture . . . at the Apollo Gallery." New York, 1839.

Art Amateur, 1879–1900.

"The Art Academy and Its Influence." Cincinnati Art Museum Library, Cincinnati.

"Art and the People." *Outlook* 102 (October 19, 1912): 336–37.

Arthur, T. S. *Advice to Young Ladies on Their Duties and Conduct in Life.* Boston: G. W. Cottrell and Co., 1851.

Art Institute of Chicago. Annual Reports.

———. Bulletins.

———. "Catalogue of an Exhibition of Works by Chicago Artists."

———. Scrapbooks. Ryerson Library, Art Institute of Chicago.

———. Trustees' Minutes. Archives, Art Institute of Chicago.

Artistic Houses. New York: Appleton, 1883.

Artist's Fund Society. "Catalogue of First Exhibition." Philadelphia, 1835.

———. Minute Books. John Sartain Manuscripts, Archives of American Art, New York.

Art Students League. Annual Reports. New York.

"Art Threatens to Abandon Greenwich Village." *Literary Digest* 75 (October 21, 1922): 30–31.

Athenaeum Gallery. "Catalogue of the Thirteenth Exhibition of Paintings in the Athenaeum Gallery." Boston, 1834.

Atwater, Mrs. E. E., compiler. *Scrapbook of Clippings from the Centennial.* Library, Chicago Historical Society.

Banks, Talcott Miner, Jr. "St. Botolph Club: Highlights from the First Forty Years, 1880, circa 1920." St. Botolph Club Manuscripts, Archives of American Art, New York.

Barker, George. "Reminiscences of Luman Reed." 1894. Luman Reed Manuscripts, New-York Historical Society.

Barnes, Earl. "The Feminizing of Culture." *Atlantic Monthly* 109 (June 1912): 770–76.

Barnum, Gertrude. "The Chicago Woman and Her Clubs." *Graphic* (March 27, 1893): 343–44. Clipping Files, Chicago Historical Society.

Bartlett, Mary K. "The Philanthropic Work of the Chicago Woman's Club." *Outlook* 49 (May 12, 1894): 827–28.

Bastado, Russell. "Luman Reed &1786–1836), New York City Merchant and Patron of American Artists." N.d. Luman Reed Manuscripts, New-York Historical Society.

Beaux, Cecilia. *Background with Figures.* Boston: Houghton Mifflin Co., 1930.

———. Manuscripts. Archives of American Art, New York.

Beecher, Catharine. *A Treatise on Domestic Economy.* New York: Marsh, Capen, Lyon and Webb, 1841.

Bisland, Elizabeth. "Plan for the Proposed Cooper Union Museum for the Arts of Decoration." 1896. Archives of American Art, New York.

A Book of the Tile Club. New York: Houghton Mifflin and Co., 1886.

Boston Athenaeum. "Catalogue of the Exhibition of the Boston Athenaeum." Boston, 1850.

Boston Society of Arts and Crafts. Manuscripts. Archives of American Art, New York.

Boston Society of Decorative Art. Annual Reports.

————. "Loan Exhibition of the Boston Society of Decorative Art." Boston, 1879.

Bouche, Louis. "Autobiographical Notes." N.d. Bouche Manuscripts, Archives of American Art, New York.

Boynton, Charles Brandon, compiler. *History of the Great Western Sanitary Fair.* Cincinnati: C. F. Vent and Co., 1864.

Brinker, Lea J. "Women's Role in the Development of Art as an Institution in Nineteenth-Century Cincinnati." Master's thesis, University of Cincinnati, 1968.

Brooklyn Institute. "Third Annual Exhibition: Catalogue." Brooklyn, 1844.

Brooklyn Museum. Miscellaneous. Exhibition Catalogues, 1809–1945. Archives of American Art, New York.

Brooklyn Woman's Club. "Paintings and Other Works of Art by Women Artists of New York and Brooklyn." Brooklyn, 1891.

Brown, Rollo Walter. "The Creative Spirit and Art." *Harper's* 150 (February 1925): 343–50.

Bryant, William Cullen. "Bryant: The Middle Years: A Study in Cultural Fellowship." Ph.D. dissertation, Columbia University, 1954.

Buck, Stephanie M. "Sarah Choate Sears: Artist, Photographer, and Art Patron." Master's thesis, Syracuse University, 1985.

Bushnell, Horace. *Christian Nurture.* 1842. Delmore, New York: Scholar's Facsimiles and Reprints, 1975.

Cahill, Holger, and Alfred H. Barr, Jr., eds. *Art in America in Modern Times.* New York: Reynal and Hitchcock, 1934.

Carey, Mabelle Gilman. "Art and American Society." *Cosmopolitan* 46 (March 1909): 432–38.

Carnahan, Paul. "The Book in the Domestic Environment: The Glessner Family Library, 1886–1893." Master's thesis, Library School, University of Chicago, 1986.

Carnegie, Andrew. *The Gospel of Wealth and Other Timely Essays.* Ed. Edward C. Kirkland. Cambridge: Harvard University Press, 1962.

Carnes, Mark. "A Pilgrimage for Legitimacy: Fraternal Ritualism in America." Ph.D. dissertation, Columbia University, 1982.

Carr, Cornelia, ed. *Harriet Hosmer: Letters and Memories.* New York: Moffat, Yard and Co., 1912.

"Catalogue of Paintings by Daniel Huntington: Exhibiting at the Art-Union Building." New York: American Art-Union, 1849.

"Catalogue of Paintings, Statuary, etc., in the Art Department of the Great Northwestern Sanitary Fair." Chicago: Northwestern Sanitary Fair, 1865.

"Catalogue of the Art Exhibition of the Metropolitan Fair in Aid of the U.S. Sanitary Commission." New York: n.p., 1864.

"Catalogue of the Collection of the Late Mrs. S. D. Warren of Boston, Mass." Boston: Frank A. Leonard, 1902.

Century Association. Manuscripts. Archives of American Art, New York.

Champney, Benjamin. *Sixty Years' Memories of Art and Artists.* Woburn, Massachusetts: Wallace and Andrews, 1899.

"Characteristics of the International Fair." *Atlantic Monthly* 38 (July 1876): 85–91.

Chase, William Merritt. "The Impact of Art: An Interview with Walter Pach." *Outlook* 95 (January 25, 1910): 441–45.

Chicago Exhibition of the Fine Arts. Catalogue. Chicago: Press and Tribune Company, 1859.

Chicago Society of Decorative Art. Annual Reports. Chicago Historical Society.

_____. Manuscripts. Chicago Historical Society.

_____. Miscellaneous Pamphlets. Chicago Historical Society.

_____. Scrapbook. Chicago Historical Society.

Chicago Women's Club. *Annals.* Chicago: Chicago Woman's Club, 1916.

_____. Annual Announcements.

_____. Board Minutes. Chicago Historical Society.

_____. *Columbian Souvenir Edition, 1893.* Chicago: Chicago Woman's Club, 1893.

Child, Lydia Maria. "Miss Harriet Hosmer." *Littel's Living Age* 20 (March 13, 1858): 697.

Cincinnati Museum Association. "Woman's Art Club Exhibition." Cincinnati, 1902.

Cincinnati Music Festival. *Reports.*

Cincinnati Woman's Club. Annual Reports.

_____. Club Calendars.

Cleveland Institute of the Arts. Scrapbook. Archives of American Art, New York.

Clymer, George. "The Fine Arts." *Port Folio* 3 (May 2, 1807): 278–82.

Coburn, Frederick D. "Worcester's Great Opportunity." *New England Magazine,* n.s. 34 (March 1906): 35–42.

Cole, Thomas. Manuscripts. Archives of American Art, New York.

Collection of the Société Anonyme: Museum of Modern Art, 1920. New Haven: Yale University Art Gallery, 1950.

Colman, Samuel. Manuscripts. Archives of American Art, New York.

Cooke, Abigail Whipple. "Providence Art Club." *New England Magazine,* n.s. 43 (January 1911), 492–96.

Cooper Union for the Advancement of Science and Art. Annual Reports.

Cosmopolitan Art Journal, 1854.

Croly, Mrs. J. C. [Jenny June]. *The History of the Woman's Club Movement in America.* New York: Henry G. Allen and Co., 1898.

"Culture and Democracy." *Nation* 90 (April 28, 1910): 421–22.

"Culture under Fire." *Nation* 91 (September 22, 1910): 258–59.

Davis, Katherine Landon. *In Memoriam*. Cincinnati, privately printed, 1900.

Detroit Art Loan. Manuscripts. Archives of American Art, New York.

Detroit Museum of Art. Annual Reports.

Dickerson, James Spencer. "The Art Movement in Chicago." *World To-Day* 14 (April 1908): 73–80.

Dodd, Jane Porter Hart. Scrapbook. Cincinnati Art Museum Library.

"Does Masculine Predominence Injure Our Fine Arts?" *Current Literature* 50 (May 1911): 548–50.

Dolan, Anne Marie. "The Literary Salon in New York, 1830–1860." Ph.D. dissertation, Columbia University, 1957.

Douglas, Paul H. *American Apprenticeship and Industrial Education*. New York: Columbia University Press, 1921.

Downes, William H. "Boston as an Art Centre." *New England Magazine,* n.s. 30 (April 1904): 155–66.

Downtown Gallery/Edith Halpert. Manuscripts. Archives of American Art, New York.

Dreier, Katherine. Manuscripts. Beinicke Library, Yale University.

Dunlap, William. "Address to the Students of the National Academy of Design." New York: n.p., 1831.

———. *History of the Rise and Progress of the Arts of Design in the United States*. 2 volumes. New York: George P. Scott and Co., 1834.

Durand, Asher B. Manuscripts. Mary Bartlett Cowdry Papers, Archives of American Art, New York.

———. Manuscripts. New York Public Library, New York.

Durand, John. *The Life and Times of A. B. Durand*. New York: Charles Scribner's Sons, 1894: Kennedy Graphics, 1970.

———. "Prehistoric Notes of the Century Club." New York: Century Club, 1882.

Duveen, Albert. Manuscripts. Archives of American Art, New York.

Dwyer, Doris D. "A Century of City-Building: Three Generations of the Kilgour Family in Cincinnati, 1798–1914." Ph.D. dissertation, Miami University, 1979.

Eastlake, Charles L. *Hints on Household Taste*. Boston: James R. Osgood and Co., 1876.

Elliott, Maude Howe, ed. *Art and Handicraft in the Woman's Building of the World's Columbian Exposition*. Chicago: Rand McNally and Co., 1894.

Elwell, F. Edwin. "New York as an Art Center." *Arena* 22 (September 1904): 258–65.

"The Endowments of Culture in Chicago." *Dial* 15 (November 16, 1893): 285–87.

"The Field of Art." *Scribner's Magazine* 20 (November 1896): 649–52.

Fields, Annie. *Authors and Friends.* New York: Houghton Mifflin and Co., 1896.

"Fifty-third Street Patron." *Time* 27 January 27, 1936): 28–29.

Flexner, James Thomas. "Paintings on the Century's Walls." Address delivered at the Century Association, March 7, 1963. New-York Historical Society.

Force, Juliana. Manuscripts. Archives of American Art, New York.

Ford. Sheridan. "Art: A Commodity." New York: n.p., 1888.

Frank, Harriette Greenbaum, and Amalie Hofer Jerome. *Annals of the Chicago Woman's Club, 1876–1916.* Chicago: Chicago Woman's Club, 1971.

Frankel, Barbara Stein. "The Genteel Family: High Victorian Conceptions of Domesticity and Good Behavior." Ph.D. dissertation, University of Wisconsin, Madison, 1969.

Franklin Institute. "Proceedings Relative to the Establishment of a School of Design for women." Franklin Institute Manuscripts, Archives of American Art, New York.

Frazier, John Robinson. "History of the Rhode Island School of Design Museum." N.d. John Frazier Manuscripts, Archives of American Art, New York.

"The Frick Collection of Art Becomes the Public's Property." *Current Opinion* 68 (January 1920): 100–102.

Friends of American Art. Manuscripts. Archives, Art Institute of Chicago.

Gallatin, Albert Eugene. Manuscripts. Archives of American Art, New York.

———. Scrapbooks. Archives of American Art, New York.

Gardner, Inez. "Boston and the Woman's Club." *New England Magazine,* n.s. 34 (July 1906): 597–615.

Gardner, Isabella Stewart. Manuscripts. Archives of American Art. From Isabella Stewart Gardner Museum, Boston.

———. Manuscripts and Scrapbooks. From Isabella Stewart Gardner Museum, Boston.

General Federation of Women's Clubs. "Study Outline and a Bibliography of American Art." 1922. Archives of American Art, New York.

Gillespie, Elizabeth D. *A Book of Remembrance.* Philadelphia: J. B. Lippincott and Co., 1901.

Glackens, Ira. *William Glackens and the Ashcan Group: The Emergence of Realism in American Art.* New York: Crown Publishers, 1957.

Godey's Lady's Book.

Goodrich, Lloyd. "A Museum of Modern Art." *Nation* (December 4, 1929): 664–65.

Gourlie, John H. *The Origin and History of the Century.* New York: William C. Bryant and Co., 1856.

"The Greatest Art Collection Ever Given to the American Public." *Current Opinion* 58 (January 1915): 50–51.

Guggenheim, Peggy. *Out of This Century: Confessions of an Art Addict.* 1946. Garden City, New York: Anchor Books, Doubleday and Co., 1980.

Hadley, Rollin Van N., ed. *The Letters of Bernard Berenson and Isabella Stewart Gardner, 1887–1924.* Boston: Northeastern University Press, 1987.

Haeber, Arthur. "A Plea for the American Artist." *North American* 189 (February 1909): 213–22.

Hall, Adelaide S. "Practical Work among Club Women." *Chatauquan* 31 (September 1900): 621–24.

"Handbook of the Art Collections of Smith College." Northampton, Massachusetts: Smith College, 1925.

Harrison, Constance Cary. *Woman's Handiwork in Modern Homes.* New York: Charles Scribner's Sons, 1881.

Havemeyer, Louisine. "The Suffrage Torch: Memories of a Militant." *Scribner's Monthly* 71 (May 1922): 528–39, (June 1922): 661–76.

Healy, Daty. "A History of the Whitney Museum of American Art, 1930–1954." Ph.D. dissertation, New York University, 1960.

Henderson, Helen. W. *The Pennsylvania Academy of the Fine Arts and Other Collections of Philadelphia.* Boston: L. C. Page and Co., 1911.

Henri, Robert. *The Art Spirit.* 1923. New York: Harper and Row, 1984.

Hewitt, Eleanor G. *The Making of a Modern Museum.* New York: Cooper Union Museum for the Arts of Decoration, 1941.

Hills, Patricia. "The Genre Painting of Eastman Johnson: The Source and Development of His Style and Times." Ph.D. dissertation, New York University, 1973.

Hispanic Society of America. "Catalogue of Mexican Majolica Belonging to Mrs. Robert W. de Forest." New York, 1911.

Holman, Louis A. "America's Rembrandts." *Century* 80 (October 1910): 881–87.

"Home Industries and Domestic Manufactures from the Standpoint of a Farmer's Wife." *Outlook* 63 (December 12, 1899): 985.

Hone, Philip. *The Diary of Philip Hone, 1828–1851.* 2 volumes. Ed. Bayard Tuckerman. New York: Dodd, Mead and Co., 1889.

Hopkins, Mrs. Dunlop. Manuscripts. New-York Historical Society.

Hopkinson, Joseph. "Annual Discourse Delivered before the Pennsylvania Academy of the Fine Arts." Philadelphia: Bradford and Inskeep, 1819.

———. "Annual Discourse Delivered before the Pennsylvania Academy of the Fine Arts." Philadelphia: Bradford and Inskeep, 1810.

Howe, Barbara Jeanette. "Clubs, Culture, and Charity: Anglo-American Upper Class Activities in the Late Nineteenth Century." Ph.D. dissertation, Temple University, 1976.

Howe, Julia Ward. "A Chronicle of Boston Clubs." *New England Magazine,* n.s. 34 (July 1906): 610–15.

———. *Reminiscences, 1819–1899.* Boston: Houghton Mifflin and Co., 1899.

Hughes, Adella Prentiss. *Music Is My Life*. New York: World Publishing Co., 1947.

Huntington, Arabella. Manuscripts. George Arents Research Library, Syracuse University, Syracuse, New York.

Huntington, William Henry. "Catalogue of His Gift to the Metropolitan Museum of Art, 1883." Archives, New-York Historical Society.

Hutchinson, Charles L. Manuscripts. Newberry Library, Chicago.

"The Iconoclastic Opinions of M. Marcel Duchamp concerning Art and America." *Current Opinion* 59 (November 1915): 346–47.

"In Memoriam: Elizabeth Johnston Jones." Cincinnati: n.p., n.d.

"In Memoriam: Katharine Landon Davis." Cincinnati: n.p., 1900.

Inness, George, Jr. *Life, Art, and Letters of George Inness*. 1917. New York: Da Capo Press, 1969.

"Is the Progress in Art an Illusion?" *Current Opinion* 57 (November 1914): 352.

"Is Woman Making a Man of Herself?" *Current Literature* 52 (June 1912): 682–84.

James, Henry. *The American Scene*. New York: Harper and Bros., 1907.

Jarves, James Jackson. *Art Hints*. London: Sampson, Law, Son and Co., 1855.

Johnson, Henry. "Descriptive Catalogue of the Art Collections of Bowdoin College." Brunswick, Maine: Bowdoin College, 1906.

Jones, Mary Cadwalader. *Lantern Slides*. Privately printed, 1937.

Kensett, John F. Manuscripts. Archives of American Art, New York.

Keyes, Donald D. "Aspects of the Development of Genre Painting in the Hudson River Area before 1852." Ph.D. dissertation, New York University, 1973.

King, Margaret R. *Memoirs of the Life of Mrs. Sarah Peter*. 2 volumes. Cincinnati: Robert R. Clarke and Co., 1889.

Knowlton, Helen M. *Art-Life of William Morris Hunt*. 1899. New York: Benjamin Blom, 1971.

LaBarre, Margaret Wendell. "Harriet Hosmer: Her Era and Art." Master's thesis, University of Illinois, Champaign-Urbana, 1966.

LaBudde, Kenneth James. "The Mind of Thomas Cole." Ph.D. dissertation, University of Minnesota, 1954.

Ladies Academy of Fine Arts (Cincinnati). Annual Reports.

————. "Catalogue of Pictures at the Ladies' Gallery: First Exhibition, Independence Hall." Cincinnati, 1854.

————. Manuscripts. Cincinnati Historical society.

Ladies' Art Association. Report. 1884.

Ladies' Centennial Committee, Salem, Massachusetts. "Catalogue of Antique Articles on Exhibition at Plummer Hall, Salem, December, 1875."

Ladies' Sewing Society, St. Paul's Church. "Catalogue of the Loan Exhibition." Norwalk, Connecticut, 1879.

Lanier, Henry W. "What's the Good of Art?" *World's Work* 28 (July 1914): 339–44.

Lathrop, George Parsons. "The Progress of Art in New York." *Harper's Monthly* 86 (April 1893): 740–52.

Layton Art Gallery. Catalogue. Milwaukee, 1921.

Leslie, Charles R. *Autobiographical Recollections.* Boston: Ticknor and Fields, 1860.

Lossing, Benson J. "Some Notes on the History of the Fine Arts in New York City during the Past Fifty Years." New York: Pierce Engraving and Publishing Co., c. 1885.

Louisville Museum and Gallery of the Fine Arts. "Catalogue of the First Annual Exhibition of Paintings at the Louisville Museum and Gallery of the Fine Arts." Louisville, 1834.

Luhan, Mabel Dodge. *European Experiences.* New York: Harcourt, Brace and Co., 1935.

———. *Movers and Shakers.* New York: Harcourt, Brace and Co., 1936.

McEntee, Jervis. Diary, 1872–1890. Archives of American Art, New York.

Maryland Historical Society. "Catalogue of Paintings, Engravings, etc., in the Picture Gallery of the Maryland Historical Society." Baltimore, 1848.

Mason, Amelia Gere. *Memories of a Friend.* Chicago: Laurence C. Woodworth, 1918.

Mather, Frank Jewett, Jr., "The Art Collector: His Fortes and Foibles." *Nation* 88 (May 13, 1909): 494–97.

———. "The Drift of the World's Art toward America." *World's Work* 45 (December 1922): 198–205.

———. "Great Masters in American Galleries." *World's Work* 20 (May 1910): 12933–50.

"Meeting a Need." *Outlook* 53 (September 18, 1929): 98.

Memoirs of Anne Lynch Botta, Written by Her Friends. New York: J. Selwyn Tait and Sons, 1894.

Merwyn, Henry Childs. "On Being Civilized Too Much." *Atlantic Monthly* 79 (June 1897): 838–46.

Metropolitan Fair of the United States Sanitary Commission. Manuscripts and Miscellaneous Publications. New-York Historical Society.

Metropolitan Museum of Art. Annual Reports.

———. *The H. O. Havemeyer Collection.* New York: Metropolitan Museum of Art, 1958.

———. Manuscripts. Archives, Metropolitan Museum of Art, New York.

"The Metropolitan Museum's Amazing Windfall." *Literary Digest* 88 (January 23, 1926): 27–28.

Meyer, Agnes Ernst. Manuscripts. Library of Congress, Washington, D.C.

————. *Out of These Roots: The Autobiography of an American Woman.* Boston: Little, Brown and Co., 1953.

Milliken, Mary Augusta. "The Art Treasures of Fenway Court." *New England Magazine,* n.s. 33 (November 1905): 241–50.

Miner, Harold E. "Vinnie and Her Friends: Unpublished Biography of Vinnie Ream Hoxie." C. 1972. Archives of American Art, New York.

"Mobilizing Our Millionaires in the Cause of Art." *Current Opinion* 62 (January 1917): 52–54.

"Modernism at Home." *Outlook* 53 (November 20, 1929): 455.

"Modern Museum Makes Its Bow." *Literary Digest* 103 (November 23, 1929): 19–20.

Moore, Charles H. "The Fogg Art Museum of Harvard University." *New England Magazine,* n.s. 32 (August 1905): 699–709.

Morris, Harrison S. "The Art Collection of John G. Johnson." *Scribner's* 68 (September 1920): 379–84.

"The Most Extraordinary Bostonian of Her Day." *Literary Digest* 82 (August 9, 1924): 26–27.

Mount, William Sidney. Journals and Notebooks. Archives of American Art, New York.

————. Manuscripts, 1833–1868. New-York Historical Society.

"Mr. Frick as a Patron of Culture." *Literary Digest* 63 (December 20, 1919): 29–30.

"Mr. Frick's Royal Gift." *Literary Digest* 111 (October 31, 1931): 20–21.

"Mrs. Jack Gardner." *Outlook* 137 (July 30, 1924): 495.

"Mr. Morgan as a Collector." *Literary Digest* 46 (May 10, 1913): 1062–63.

Museum of Fine Arts, Boston. Annual Reports.

————. "Catalogue of the Fourth Annual Exhibition of Contemporary American Art." Boston, 1883.

————. Director's Correspondence. Archives of American Art, New York.

————. "Exhibition of Works by Living American Artists." Boston, 1880.

————. Manuscripts. Archives of American Art, New York.

Museum of Modern Art. *The Lillie P. Bliss Collection.* New York: Museum of Modern Art, 1934.

Museum of Modern Art Archives, Alfred H. Barr, Jr., Ms., Archives of American Art, New York City.

National Academy of Design. Catalogues of Annual Exhibitions, 1833–60. New York.

National Association of Women Artists. Exhibition Catalogues.

"The Nation's Benefactor in Art." *Literary Digest* 63 (October 18, 1919): 28–29.

"The Near 'Crime Wave' in Art." *Literary Digest* 76 (February 10, 1923): 29–31.

New England Woman's Club. "Report of the Annual Meeting." Boston, 1873.

"New York Acquires a Bit of Southern France." *Literary Digest* 86 (July 25, 1925): 26–27.

New York Gallery of Fine Arts. *Catalogue.* New York, 1844.

New York School of Design for Women. Brochure. New York, 1896.

New York Society of Decorative Art. Annual Reports.

"Our Art Market," *Nation* 86 (May 14, 1908): 439.

"Our Daily Fair." Philadelphia: Sanitary Fair, 1864.

Page, Walter H. "The Cultivated Man in an Industrial Era." *World's Work* 8 (July 1904): 4980–85.

Partridge, William O. "Manhood in Art." *New England Magazine,* n.s. 9 (November 1893): 281–88.

Peale, Rembrandt. Manuscripts. Archives of American Art, New York.

Pennell, Elizabeth Robins. "Art and Women." *Nation* 106 (June 1, 1918): 663–64.

Pennell, Joseph. "Can Art Be Made to Pay?" *Forum* 66 (December 1921): 522–29.

Pennsylvania Academy of the Fine Arts. Act of Incorporation. Philadelphia, 1831.

———. Charter and Bylaws. Philadelphia, 1813.

———. Manuscripts. Archives of American Art.

Pennsylvania Museum and School of Industrial Art. Annual Reports.

———. "A Living Museum." Philadelphia, 1928.

———. Scrapbooks. Archives of American Art, New York.

Philadelphia Art Union. *Reporter.*

Philadelphia Sanitary Fair. "Catalogue of Paintings, Drawings, Statuary, etc., of the Art Department in the Great Central Fair." Philadelphia, 1864.

Philadelphia School of Design for Women. Annual Reports.

———. Manuscripts. Archives of American Art, New York.

Phillips, Marjorie. *Duncan Phillips and His Collection.* Boston: Little, Brown and Co., 1970.

Pierce, H. Winthrop. "Early Days of the Copley Society." Boston: Rockwell and Churchill Press, 1903.

"The President Talks on Art." *Literary Digest* 95 (November 5, 1927): 31.

Pullman, Mrs. George. Scrapbook. Chicago Historical Society.

Randall, E. A. "The Artistic Impulse in Man and Woman." *Arena* 24 (October 1900): 415–20.

Read, Helen Appleton. "Modern Art in the Collection of Mrs. John D. Rockefeller, Jr." *Vogue* (April 1, 1931): 79–81.

"Recollections of the Art Exhibition: Metropolitan Fair, New York." New York: Metropolitan Fair of the United States Sanitary Commission, 1864.

Reed, Luman. Manuscripts. New-York Historical Society.

"Renaissance Sculpture in New York." *Literary Digest* 89 (May 22, 1926): 24–25.

Richards, Laura E., and Maude Howe Elliott. *Julia Ward Howe, 1819–1910.* Volume 1. Boston: Houghton Mifflin Co., 1915.

Rockefeller, Abby Aldrich. Manuscripts. Rockefeller Archive Center, Pocantico Hills, New York.

Rogers, Anna A. "Some Faults of American Men." *Atlantic Monthly* 103 (June 1909): 732–38.

Rosenfeld, Paul. "A Memorial to Miss Bliss." *Nation* 133 (November 4, 1931): 493–95.

———. "The Whitney Museum." *Nation* 133 (December 30, 1931): 731–33.

Ruskin, John. *Sesame and Lilies.* New York: John Wiley and Sons, 1866.

———. *The Seven Lamps of Architecture.* 1849. New York: Farrar, Straus and Giroux, 1986.

———. *The Two Paths: Being Lectures in Art and Its Application to Decoration and Manufacture.* New York: John Wiley, 1859.

Rutledge, Anna Wells, compiler. *Cumulative Record of Exhibition Catalogues: The Pennsylvania Academy of the Fine Arts, 1807–1870; The Society of Artists, 1800–1814; The Artists' Fund Society, 1835–1845.* Philadelphia: American Philosophical Society, 1955.

Sage, Olivia. Manuscripts. Rockefeller Archive Center, Pocantico Hills, New York.

St. Botolph Club. Manuscripts. Archives of American Art, New York.

Salmon, Lucy M. "The Woman's Exchange: Charity or Business?" *Forum* 13 (May 1892): 394–406.

Santayana, George. "The Genteel Tradition in American Philosophy." In Douglas L. Wilson, ed., *The Genteel Tradition: Nine Essays by George Santayana,* 37–64. 1911. Cambridge: Harvard University Press, 1967.

Sartrain, John. Manuscripts. Archives of American Art, New York.

School of Industrial Design and Technical Education for Women. Annual Reports.

Seiss, J. A. "The Arts of Design: Especially as Related to Female Education." Baltimore: n.p., 1856.

Severance, Caroline M. *The Mother of Clubs.* Los Angeles: Baumgardt Publishing Co., 1906.

Sharf, Frederic Alan. "Art and Life in Boston, 1837–1850: A Study of the Painter and Sculptor in American Society." Typescript, n.d. Archives of American Art, New York.

"She Fought the Battle for Modern Art." *Literary Digest* 109 (June 6, 1931): 17–18.

Shelton, William H. "Soldier, Artist, Writer: Typescript of His Unpublished Autobiography, 1840–1890." New-York Historical Society.

Sherwood, Mrs. John. *An Epistle to Posterity.* New York: Harper and Bros., 1897.

———. *Manners and Social Usages.* New York: Harper and Bros., 1884.

———. "New York in the 'Seventies'." *Lippincott's Magazine* 62 (September 1898): 393–400.

Simkhovitch, Mary K. *Neighborhood: My Story of Greenwich House.* New York: W. W. Norton and Co., 1938.

Skalet, Linda H. "The Market for American Painting in New York, 1870–1915." Ph.D. dissertation, Johns Hopkins University, 1980.

Sketch Club. Manuscripts. Century Association Manuscripts, Archives of American Art, New York.

Smith, Helen Everston. "Women Art Patrons." In Lydia Hayes Farmer, ed., *What America Owes to Women,* 463–70. Chicago: Charles Wells Moulton, 1893.

Smith, Walter. "Industrial Art Education." Philadelphia: n.p., 1875.

Société Anonyme. Manuscripts. Beinecke Library, Yale University.

Society for the Promotion of Painting in Water Colors, New York City. "Constitution and Minutes." New York, 1850–55.

Society of Artists. Constitution. Philadelphia: 1810.

"Some Lady Artists of New York." *Art Amateur* 3 (July 1880): 27–29.

"Some Modern Paintings Shown at the Union League Club." New York: Union League Club, 1895.

Spencer, Lilly Martin. Manuscripts. Archives of American Art, New York.

Sprague, Julia A., compiler. *History of the New England Women's Club from 1868 to 1893.* Boston: Lee and Shepard, 1894.

Springfield Art Association. *A History and Prospectus.* Springfield, Mass. 1937.

Stevens, Kate. "The New England Woman." *Atlantic Monthly* 88 (July 1901): 60–66.

Stillman, W. J. "The Revival of Art." *Atlantic Monthly* 70 (August 1892): 248–61.

Strahan, Edward, ed. *Art Treasures of America.* Philadelphia: George Barrie, 1880.

Strong, George Templeton. *The Diary of George Templeton Strong.* Ed. Allan Nevins Milton Halsey Thomas. New York: Macmillan Co., 1952.

Stuyvesant Institute. Catalogue. New York, 1838.

"The Successor of Morgan as Art Patron." *Literary Digest* 50 (March 27, 1915): 688–89.

Sully, Thomas. Manuscripts. Archives of American Art, New York.

Teall, Gardner. "A Gift of National Importance." *Independent* 109 (December 9, 1922): 337.

Thayer, Mary P., compiler. *The Purpose of the Museum.* Worcester, Massachusetts: Worcester Museum of Art, 1926.

Thomas, Theodore. *A Musical Autobiography.* 1905. New York: Da Capo Press, 1964.

Thornwell, Emily. *The Lady's Guide to Perfect Gentility.* New York: Derby and Jackson, 1858.

Ticknor, Caroline. "The Steel Engraving Lady and the Gibson Girl." *Atlantic Monthly* 88 (July 1901): 105–8.

Tiffany, W. L. "Art and Its Future Prospects in the United States." *Godey's Lady's Book* 46 (March 1826): 217–21.

Tocqueville, Alexis de. *Democracy in America.* 1835–40. New York: Modern Library, 1981.

Traquair, Ramsey. "Man's Share in Civilization." *Atlantic Monthly* 134 (October 1924): 502–8.

————. "Women and Civilization." *Atlantic Monthly* 132 (September 1923): 289–96.

Triggs, Oscar Lovell. *Chapters in the History of the Arts and Crafts Movement.* Chicago: Bohemia Guild of the Industrial Art League, 1902.

Tuckerman, Henry T. *Book of the Artists.* 1867. New York: James F. Carr, 1967.

"The Twelve Greatest Women in America." *Literary Digest* 74 (July 8, 1922): 36–45.

Twombly, Mary. "The Art Students' League of New York." *Bookman* 12 (November 1900): 248–55.

"The Uncultured Sex." *Independent* 67 (November 11, 1909): 1099–1100.

Union League Club. Annual Reports. New York.

————. "Art Exhibition." New York, 1884.

Uzanne, Octave. "The Arts relating to Women and Their Exhibition in Paris." *Scribner's Magazine* 13 (April 1893): 503–9.

Valentiner, William H. Manuscripts. Archives of American Art, New York.

Van Dycke, John C. *American Painting and Its Tradition.* New York: Charles Scribner's Sons, 1919.

————. "The Art Student's League of New York." *Harper's Monthly* 83 (October 1891): 688–700.

Vassar College. "Art Gallery Catalogue." Poughkeepsie, New York: 1939.

Verplanck, Gulian C. "An Address Delivered at the Opening of the Tenth Exhibition of the American Academy of the Fine Arts." New York: G. C. Carwell, 1825.

Vitz, Robert C. "Cincinnati Art and Artists, 1870–1920." Master's thesis, Miami University, 1967.

Waller, Frank. "Report on Art Schools." New York: Art Students League, 1879.

Ware, Carolyn. *Greenwich Village, 1920–1930: A Comment on American Civilization in the Post-war Years.* 1935. New York: Octagon Books, 1977.

Washington Art Association. "Catalogue of the Works of Art Comprising the First Annual Exhibition." Washington, 1857.

————. Constitution and Bylaws. Washington, 1856.

Wells, Kate Gannett. "Women in Organizations." *Atlantic Monthly* 46 (September 1880): 860–67.

West, Max. "Revival of Handicrafts." *Bulletin of the Bureau of Labor* (1904): 1573–1622.

Wheeler, Candace. "Art Education for Women." *Outlook* 55 (January 2, 1897): 81–89.

———. *The Development of Embroidery in America*. New York: Harper and Bros., 1921.

———. "Home Industries and Domestic Manufactures." *Outlook* 63 (October 14, 1899): 402–6.

———. *How to Make Rugs*. New York: Doubleday, Page and Co., 1919.

———. *Principles of Home Decoration*. New York: Doubleday, Page and Co., 1903.

———. *Yesterdays in a Busy Life*. New York: Harper and Bros., 1918.

———. ed. *Household Art*. New York: Harper and Bros., 1893.

White, Richard Grant. *Companion to the Bryan Gallery of Christian Art*. New York: Baker, Godwin and Co., 1853.

Whitman, Sarah W. "Art in the Public Schools." *Atlantic Monthly* 79 (May 1897): 617–23.

Whitney, Gertrude Vanderbilt. Manuscripts. Gift of Flora Miller Irving. Archives of American Art, New York.

Whitney Museum of American Art. *Juliana Force and American Art: A Memorial Exhibition*. New York: Whitney Museum of American Art, 1949.

———. Manuscripts. Archives of American Art, New York.

Whitney Museum of American Art: History, Purpose, and Activities. New York: Whitney Museum of American Art, 1935.

Whitney Studio Club and Whitney Studio Galleries. Papers. Archives of American Art, New York.

Wilson, James Grant. *Bryant and His Friends: Some Reminiscences of the Knickerbocker Writers*. New York: Fords, Harvard and Hulbert, 1886.

Winslow, Helen M. "The Story of the Woman's Club Movement." *New England Magazine,* n.s. 38 (June 1908): 543–47; n.s. 39 (October 1908): 214–22; n.s. 39 (November 1908): 300–310.

Wister, Frances Anne. *Twenty-five Years of the Philadelphia Orchestra*. Philadelphia: Women's Committee of the Philadelphia Orchestra, 1925.

"Women Artists." *Living Age* 220 (March 18, 1899): 730–32.

Women's Art Museum Association. Circular. Cincinnati: Women's Art Museum Association, March 12, 1877.

Women's Art Museum Association of Cincinnati, 1877–1886. Cincinnati: Robert R. Clarke and Co., 1886.

Women's Educational and Industrial Union. *Annual Report*. Boston, 1886.

Zueblin, Rho Fisk. "Patronage of the Arts and Crafts." *Chatuaquan* 37 (June 1903): 266–72.

Secondary Sources

Adler, Kathleen, and Tamar Garb. *Berthe Morisot*. Ithaca: Cornell University Press, 1987.

Alexander, Charles C. *Here the Country Lies: Nationalism and the Arts in Twentieth-Century America*. Bloomington: Indiana University Press, 1980.

Anscombe, Isabelle. *A Woman's Touch: Women in Design from 1860 to the Present Day*. New York: Viking, 1984.

Ashton, Dore. *The New York School: A Cultural Reckoning*. New York: Penguin Books, 1979.

Baekeland, Frederick. "Collectors of American Painting, 1813–1913." *American Art Review* 3 (1976): 120–57.

Baker, Elizabeth C. "Sexual Art-Politics." In Thomas B. Hess and Elizabeth C. Baker, eds., *Art and Sexual Politics*, 108–19. New York: Collier Macmillan Publishers, 1971.

Baker, Paul, R. *Richard Morris Hunt*. Cambridge: MIT Press, 1980.

Baker, Paula. "The Domestication of Politics: Women and American Political Society, 1780–1920." *American Historical Review* 89 (June 1984): 620–47.

Baltzell, E. Digby. *Puritan Boston and Quaker Philadelphia: Two Protestant Ethics and the Spirit of Class Authority and Leadership*. Boston: Beacon Press, 1979.

Bank, Mirra. *Anonymous Was a Woman*. New York: St. Martin's Press, 1979.

Bender, Thomas. *New York Intellect: A History of Intellectual Life in New York City from 1750 to the Beginning of Our Own Time*. New York: Alfred A. Knopf, 1987.

Benson, Susan Porter. *Counter Cultures: Saleswomen, Managers, and Customers in American Department Stores, 1890–1940*. Urbana: University of Illinois Press, 1986.

Berg, Barbara J. *The Remembered Gate: Origins of American Feminism: The Woman and the City, 1800–1860*. New York: Oxford University Press, 1978.

Berman, Avis. *Rebels on Eighth Street: Juliana Force and the Whitney Museum of American Art*. New York: Atheneum, 1990.

Bishop, Robert, and Patricia Coblentz. *American Decorative Arts: Three Hundred and Sixty Years of Creative Design*. New York: Harry N. Abrams, 1982.

Blair, Karen. *The Clubwoman as Feminist: True Womanhood Redefined, 1868–1914*. New York: Holmes and Meier, 1980.

Bledstein, Burton J. *The Culture of Professionalism: The Middle Class and the Development of Higher Education in America*. New York: W. W. Norton and Co., 1976.

Bloch, E. Maurice. *George Caleb Bingham: The Evolution of an Artist*. Berkeley: University of California Press, 1967.

Bode, Carl. *Antebellum Culture*. Carbondale: Southern Illinois University Press, 1959.

Bohan, Ruth L. *The Société Anonyme's Brooklyn Exhibition: Katherine Dreier and Modernism in America.* Ann Arbor: UMI Research Press, 1982.

Bolton-Smith, Robin, and William H. Truettner. *Lilly Martin Spencer, 1822–1902: The Joys of Sentiment.* Washington: Smithsonian Institution Press, 1973.

Boris, Eileen. *Art and Labor: Ruskin, Morris, and the Craftsman Ideal in America.* Philadelphia: Temple University Press, 1986.

Branch, Douglas E. *The Sentimental Years, 1836–1860: A Social History.* 1934. New York: Hill and Wang, 1962.

Breeskin, Adelyn D. *Mary Cassatt: A Catalogue Raisonné of the Oils, Water-Colors, and Drawings.* Washington: Smithsonian Institution Press, 1970.

Bremner, Robert H. *The Public Good: Philanthropy and Welfare in the Civil War Era.* New York: Alfred A. Knopf, 1980.

Brinnin, John Malcolm. *The Third Rose: Gertrude Stein and Her World.* New York: Addison-Wesley Publishing Co., 1959.

Brooklyn Museum. *The American Renaissance, 1876–1917.* New York: Pantheon Books, 1979.

Brown, Carol. "Sexism and the Russell Sage Foundation." *Signs* 1 (1972): 25–44.

Brown, Milton W. *American Painting from the Armory Show to the Depression.* Princeton: Princeton University Press, 1955.

————. *The Story of the Armory Show.* New York: Abbeville Press, 1988.

Brown, Milton W., Sam Hunter, John Jacobs, Naomi Rosenblum, and David M. Sokol. *American Art.* New York: Harry N. Abrams, 1979.

Bullard, E. John. *Mary Cassatt: Oils and Pastels.* New York: Watson-Guptill, 1976.

Burke, Doreen Bolger, Jonathan Freedman, Alice Cooley Freylinghuysen, David A. Hanks, Marilynn Johnson, James D. Kornwolf, Catherine Lynn, Roger B. Stein, Jennifer Toher, and Catherine Hoover Voorsanger. *In Pursuit of Beauty: Americans and the Aesthetic Movement.* New York: Rizzoli, 1987.

Burt, Nathaniel. *Palaces for the People: A Social History of the American Art Museum.* Boston: Little, Brown and Co., 1977.

Callen, Anthea. *Women Artists of the Arts and Crafts Movement, 1870–1914.* New York: Pantheon Books, 1979.

Callow, James T. *Kindred Spirits: Knickerbocker Writers and American Artists, 1807–1855.* Chapel Hill: University of North Carolina Press, 1967.

Carter, Morris. *Isabella Stewart Gardner and Fenway Court.* Boston: Isabella Stewart Gardner Museum, 1925.

Chadwick, Whitney. *Women, Art, and Society.* London: Thames and Hudson, 1990.

Chandler, Alfred D., Jr. *The Visible Hand: The Managerial Revolution in American Business.* Cambridge: Harvard University Press, 1977.

Chase, Mary Ellen. *Abby Aldrich Rockefeller.* New York: Avon Books, 1950.

Cikovsky, Nicolai, Jr., and Michael Quick. *George Inness.* New York: Harper and Row, 1985.

Cincinnati Art Museum. *The Ladies, God Bless 'Em: The Women's Art Movement in the Nineteenth Century.* Cincinnati: Cincinnati Art Museum, 1976.

Clark, H. Nichols B. *Francis W. Edmonds: American Master in the Dutch Tradition.* Washington: Smithsonian Institution Press, 1988.

Clark, Clifford Edward, Jr. *The American Family Home, 1800–1960.* Chapel Hill: University of North Carolina Press, 1986.

Clark, Eliot. *History of the National Academy of Design, 1825–1953.* New York: Columbia University Press, 1954.

Conrad, Susan Phinney. *Perish the Thought: Intellectual Women in Romantic America, 1830–1860.* New York: Oxford University Press, 1976.

Constable, William G. *Art Collecting in the United States of America.* London: Thomas Nelson and Sons, 1964.

Cott, Nancy F. *The Bonds of Womanhood: "Woman's Sphere" in New England, 1780–1835.* New Haven: Yale University Press, 1977.

———. *The Grounding of Modern Feminism.* New Haven: Yale University Press, 1987.

Cowdrey, Mary Bartlett. *The American Academy of Fine Arts and American Art-Union, 1816–1851.* New York: New-York Historical Society, 1953.

Cowley, Malcolm. *Exile's Return: A Literary Odyssey of the 1920s.* New York: Viking Press, 1934.

Dewhurst, C. Kurt, Betty MacDowell, and Marsha MacDowell. *Artists in Aprons: Folk Art by American Women.* New York: E. P. Dutton, 1979.

DiMaggio, Paul. "Cultural Entrepreneurship in Nineteenth-Century Boston: The Creation of an Organizational Base for High Culture in America." *Media, Culture, and Society* 4 (1982): 33–50.

———. *Organizing Culture.* New York: Basic Books, forthcoming.

Doeringer, David B. "Asher B. Durand and Henry Kirke Brown: An Artistic Friendship." *American Art Journal* 20 (1988): 74–83.

Douglas, Ann. *The Feminization of American Culture.* New York: Alfred A. Knopf, 1977.

Downs, Joseph. "A Handbook of the Pennsylvania German Galleries in the American Wing." New York: Metropolitan Museum of Art, 1934.

Dublin, Thomas. *Women at Work: The Transformation of Work and Community in Lowell, Massachusetts, 1826–1860.* New York: Columbia University Press, 1979.

Dudden, Faye E. *Serving Women: Household Service in Nineteenth-Century America.* Middletown, Connecticut: Wesleyan University Press, 1983.

Edel, Leon. *Henry James: The Middle Years, 1882–1895.* 1962. New York: Avon Books, 1978.

Entriken, Isabelle Webb. *Sarah Josepha Hale and Godey's Lady's Book.* Philadelphia: privately printed, 1946.

Epstein, Barbara Lee. *The Politics of Domesticity: Women, Evangelicalism, and Temperance in Nineteenth-Century America*. Middletown, Connecticut: Wesleyan University Press, 1981.

Evans, Sara M. *Born for Liberty: A History of Women in America*. New York: Free Press, 1989.

Fairbrother, Trevor J. *The Bostonians: Painters of an Elegant Age, 1870–1930*. Boston: Museum of Fine Arts, 1986.

Faxon, Alicia. "Painter and Patron: Collaboration of Mary Cassatt and Louisine Havemeyer." *Feminist Art Journal* (Fall 1982/Winter 1983): 15–20.

Filene, Peter, G. *Him/Her/Self: Sex Roles in Modern America*. Baltimore: Johns Hopkins University Press, 1974.

Finley, Ruth E. *The Lady of Godey's*. Philadelphia: J. B. Lippincott Co., 1931.

Flexner, James Thomas. *History of American Painting*. 3 volumes. Boston: Little, Brown and Co., 1962. Reprinted New York: Dover Publications, 1970.

Fosdick, Raymond B. *John D. Rockefeller, Jr.: A Portrait*. New York: Harper and Bros., 1956.

Four Americans in Paris: The Collections of Gertrude Stein and Her Family. New York: Museum of Modern Art, 1970.

Fox, Daniel M. *Engines of Culture: Philanthropy and Art Museums*. Madison: State Historical Society of Wisconsin, 1963.

Frankenstein, Alfred. *Painter of Rural America: William Sidney Mount, 1807–1868*. Stony Brook, New York: Suffolk Museum, 1968.

Fredrickson, George M. *The Inner Civil War: Northern Intellectuals and the Crisis of the Union*. New York: Harper and Row, 1965.

Freedman, Estelle. "Separatism as Strategy: Female Institution Building in American Feminism, 1870–1930." *Feminist Studies* 5 (1979): 512–29. Reprinted in Mary Beth Norton, ed., *Major Problems in American Women's History*. Toronto: D. C. Heath and Co., 1989.

Freivogel, Elsie F. "Lilly Martin Spencer: Feminist without Politics." *Archives of American Art Journal* 12 (1972): 9–14.

Friedman, B. H. *Gertrude Vanderbilt Whitney*. Garden City, New York: Doubleday and Co., 1978.

Gardner, Albert Ten Eyck. *Winslow Homer, American Artist: His World and His Work*. New York: Bramball House, 1961.

Gerdts, William H. *American Impressionism*. New York: Abbeville Press, 1984.

————. *The White Marmorean Flock: Nineteenth-Century American Women Neoclassical Sculptors*. Poughkeepsie, New York: Vassar College Art Gallery, 1972.

Gerdts, William H., and Theodore E. Stebbins, Jr. *"A Man of Genius": The Art of Washington Allston (1779–1843)*. Boston: Museum of Fine Arts, 1979.

Ginzberg, Lori D. *Women and the Work of Benevolence: Morality, Politics, and Class in the Nineteenth-Century United States*. New Haven: Yale University Press, 1990.

Goodrich, Lloyd. *Edward Hopper.* New York: Whitney Museum of American Art, 1964.

Gordon, Jean. "Early American Women Artists and the Social Context in Which They Worked." *American Quarterly* 30 (Spring 1978): 54–69.

Gorn, Elliott J. *The Manly Art: Bare-Knuckle Prize Fighting in America.* Ithaca: Cornell University Press, 1986.

Graham, Julie. "American Women Artists' Groups, 1867–1930." *Feminist Art Journal* 1 (Spring–Summer 1980): 7–12.

Greer, Germaine. *The Obstacle Race: The Fortunes of Women Painters and Their Work.* New York: Farrar, Straus and Giroux, 1979.

Guide to the Collection: Isabella Stewart Gardner Museum. Boston: Trustees of the Isabella Stewart Gardner Museum, 1976.

Guilbaut, Serge. *How New York Stole the Idea of Modern Art: Abstract Expressionism, Freedom, and the Cold War.* Chicago: University of Chicago Press, 1983.

Hale, Nancy. *Mary Cassatt: A Biography of the Great American Painter.* Garden City, New York: Doubleday and Co., 1975.

Handlin, David P. *The American Home: Architecture and Society, 1815–1915.* Boston: Little, Brown and Co., 1979.

Harr, John Ensor, and Peter J. Johnson. *The Rockefeller Century: Three Generations of America's Greatest Family.* New York: Scribner's Sons, 1988.

Harris, Ann Sutherland, and Linda Nochlin. *Women Artists, 1550–1950.* New York: Alfred A. Knopf, 1976.

Harris, Neil. *The Artist in American Society: The Formative Years, 1790–1860.* New York: Simon and Schuster, 1966.

———. "The Gilded Age Revisited: Boston and the Museum Movement." *American Quarterly* 14 (Winter 1964): 545–66.

Hayes, Bartlett. *Art in Transition: A Century of the Museum School.* Boston: Museum of Fine Arts, 1977.

Hendricks, Gordon. *The Life and Work of Winslow Homer.* New York: Harry N. Abrams, 1979.

Hewitt, Nancy A. "The Social Origins of Women's Antislavery Politics in Western New York." In Alan M. Kraut, ed., *Crusaders and Compromisers: Essays on the Relationship of the Antislavery Struggle to the Antebellum Party System,* 205–34. Westport, Connecticut: Greenwood Press, 1983.

———. *Women's Activism and Social Change: Rochester, New York, 1822–1872.* Ithaca: Cornell University Press, 1984.

Higham, John. "The Reorientation of American Culture in the 1890s." In John Higham, ed., *Writing American History: Essays on Modern Scholarship,* 71–102. Bloomington: Indiana University Press, 1970.

Higonnet, Anne. "Where There's a Will . . ." *Art in America* 79 (May 1989): 65–75.

Hill, Patricia R. *The World Their Household: The American Woman's Foreign*

Mission Movement and Cultural Transformation, 1870–1920. Ann Arbor: University of Michigan Press, 1985.

Hirsch, Susan E. *The Roots of the American Working Class.* Philadelphia: University of Pennsylvania Press, 1978.

Hobhouse, Janet. *Everybody Who Was Anybody: A Biography of Gertrude Stein.* New York: Doubleday, 1975.

Hofstadter, Richard. *Anti-intellectualism in American Life.* New York: Vintage Books, 1962.

———. *Social Darwinism in American Thought.* Boston: Beacon Press, 1955.

Holt, Elizabeth Gilmor, ed. *The Triumph of Art for the Public.* Garden City, New York: Anchor Press, Doubleday, 1979.

Homer, William Inness. *Alfred Stieglitz and the American Avant-Garde.* Boston: New York Graphic Society, 1977.

Hoopes, Donelson. *Childe Hassam.* New York: Watson-Guptill, 1979.

Hoppin, Martha J. "Women Artists in Boston, 1870–1900: The Pupils of William Morris Hunt." *American Art Journal* 13 (Winter 1981): 17–46.

Horowitz, Helen Lefkowitz. *Alma Mater: Design and Experience in the Women's Colleges from their Nineteenth-Century Beginnings to the 1930s.* Boston: Beacon Press, 1986.

———. *Culture and the City: Cultural Philanthropy in Chicago from the 1880s to 1917.* Lexington: University of Kentucky Press, 1976.

Howat, John K. *The Hudson River and Its Painters.* New York: American Legacy Press, 1983.

———. *John Frederick Kensett, 1816–1872.* New York: American Federation of Arts, 1968.

Howe, Winifred E. *A History of the Metropolitan Museum of Art.* 2 volumes. New York: Metropolitan Museum of Art, 1913; Columbia University Press, 1946.

Huber, Christine Jones. *The Pennsylvania Academy and Its Women.* Philadelphia: Pennsylvania Academy of the Fine Arts, 1974.

Huntington, David C. *The Quest for Unity: American Art between World's Fairs, 1876–1893.* Detroit: Detroit Institute of Arts, 1983.

Hyland, Douglas K. S. "Agnes Ernst Meyer: Patron of American Modernism." *American Art Journal* 12 (Winter 1980): 64–81.

Jacobs, Michael. *The Good and Simple Life: Artist Colonies in Europe and America.* Oxford: Phaidon Press, 1985.

James, Edward T., Janet Wilson James, and Paul S. Boyer, eds. *Notable American Women.* 3 volumes. Cambridge: Harvard University Press, 1971.

Johnson, Paul. *A Shopkeeper's Millennium: Society and Revivals in Rochester, New York, 1815–1837.* New York: Hill and Wang, 1978.

Jones, Caroline A. *Modern Art at Harvard: The Formation of the Nineteenth- and Twentieth-Century Collections of the Harvard University Art Museums.* New York: Abbeville Press, 1985.

Kaplan, Justin. *Lincoln Steffens: A Biography.* New York: Simon and Schuster, 1974.

Kaplan, Wendy, ed. *"The Art That Is Life": The Arts and Crafts Movement in America, 1875–1920.* Boston: Little, Brown and Co., 1987.

Karl, Barry D., and Stanley N. Katz. "The American Philanthropic Foundation and the Public Sphere, 1890–1930." *Minerva* 19 (Summer 1981): 236–70.

Kerber, Linda. *Women of the Republic: Intellect and Ideology in Revolutionary America.* Chapel Hill: University of North Carolina Press, 1980.

Kessler-Harris, Alice. *Out to Work: A History of Wage-Earning Women in the United States.* New York: Oxford University Press, 1982.

Kimball, LeRoy E. "The Old University Building and the Society's Years on Washington Square." *New-York Historical Society Quarterly* 32 (July 1948): 149–219.

Koch, Robert. *Louis C. Tiffany: Rebel in Glass.* New York: Crown Publishers, 1964.

Korzenik, Diana. "Feminist Art Educator: Henry Walker Herrick." *Women Artists News* 12 (February to March 1987): 8–9.

Larkin, Oliver W. *Samuel F. B. Morse and American Democratic Art.* Boston: Little, Brown and Co., 1954.

Lawall, David. *Asher B. Durand: A Documentary Catalogue of the Narrative and Landscape Paintings.* New York: Garland Publishers, 1978.

———. *Asher Brown Durand: His Art and Art Theory in Relation to His Times.* New York: Garland Publishers, 1977.

Leach, William. *True Love and Perfect Union: The Feminist Reform of Sex and Society.* New York: Basic Books, 1980.

Lears, T. Jackson. *No Place of Grace: Antimodernism and the Transformation of American Culture, 1880–1920.* New York: Pantheon Books, 1981.

Lebsock, Suzanne. *The Free Women of Petersburg: Status and Culture in a Southern Town, 1784–1860.* New York: W. W. Norton and Co., 1985.

Lerner, Gerda. "Placing Women in History: Definitions and Challenges." *Feminist Studies* 3 (Fall 1975): 5–14.

———. ed. *The Majority Finds Its Past: Placing Women in History.* New York: Oxford University Press, 1979.

Leuchtenburg, William E. *The Perils of Prosperity, 1914–1932.* Chicago: University of Chicago Press, 1958.

Levine, Lawrence W. *Highbrow/Lowbrow: The Emergence of Cultural Hierarchy in America.* Cambridge: Harvard University Press, 1988.

"Lilly Martin Spencer." *Archives of American Art Journal* 12 (1972): 9–14.

Lisle, Laurie. *Portrait of an Artist: A Biography of Georgia O'Keeffe.* New York: Simon and Schuster, 1980.

Livermore, Mary. *My Story of the War.* Hartford: A. D. Worthington and Co., 1889.

Lubove, Roy. *The Professional Altruist: The Emergence of Social Work as a Career, 1880–1930.* New York: Atheneum, 1965.

Lynch, Michael. "Here Is Adhesiveness: From Friendship to Homosexuality." *Victorian Studies* 29 (Autumn 1985): 67–96.

Lynes, Barbara Buhler. *O'Keeffe, Stieglitz, and the Critics, 1916–1929.* Ann Arbor: UMI Research Press, 1989.

Lynes, Russell. *Good Old Modern: An Intimate Portrait of the Museum of Modern Art.* New York: Atheneum, 1973.

_____. *More Than Meets the Eye: The History and Collections of Cooper-Hewitt Museum.* Washington: Smithsonian Institution, 1981.

_____. *The Tastemakers: The Shaping of American Popular Taste.* New York: Harper and Bros., 1955.

Mabee, Carleton. *The American Leonardo: A Life of Samuel F. B. Morse.* New York: Alfred A. Knopf, 1943.

McAlister, Anna Shannon. *In Winter We Flourish: Life and Letters of Sarah Worthington King Peter, 1800–1877.* New York: Longmans, Green and Co., 1939.

McCarthy, Kathleen D. *Noblesse Oblige: Charity and Cultural Philanthropy in Chicago, 1849–1929.* Chicago: University of Chicago Press, 1982.

_____, ed. *Lady Bountiful Revisited: Women, Philanthropy, and Power.* New Brunswick, New Jersey: Rutgers University Press, 1990.

McClaugherty, Martha Crabill. "Household Art: Creating the Artistic Home, 1868–1893." *Winterthur Portfolio* 18 (Spring 1983): 1–26.

Mainardi, Patricia. "Quilts: The Great American Art." In Norma Broude and Mary D. Garrard, eds., *Feminism and Art History: Questioning the Litany,* 331–46. New York: Harper and Row, 1982.

Mann, Maybelle. *The American Art-Union.* Washington: Collage, 1977.

Marquis, Alice Goldfarb. *Alfred H. Barr, Jr.: Missionary for the Modern.* Chicago: Contemporary Books, 1989.

May, Henry F. *The End of American Innocence: A Study of the First Years of Our Own Time, 1912–1917.* Chicago: Quadrangle Books, 1959.

Mead, Margaret. *Male and Female.* New York: Morrow Quill, 1949.

_____. "One Aspect of Male and Female." In Johnson E. Fairchild, ed., *Women, Society, and Sex.* New York: Sheridan House, 1952

Merritt, Howard S. *Thomas Cole.* Rochester: Memorial Art Gallery of the University of Rochester, 1969.

Metzger, Charles R. *Emerson and Greenough: Transcendental Pioneers of an American Aesthetic.* Berkeley: University of California Press, 1954.

Miller, Lillian B. *Patrons and Patriotism: The Encouragement of the Fine Arts in the United States, 1790–1860.* Chicago: University of Chicago Press, 1966.

Mills, C. Wright. *The Power Elite.* New York: Oxford University Press, 1956.

Morantz-Sanchez, Regina Markell. *Sympathy and Science: Women Physicians in American Medicine.* New York: Oxford University Press, 1985.

Morgan, H. Wayne. *New Muses: Art in American Culture, 1865–1920.* Norman: University of Oklahoma Press, 1978.

Museum of Modern Art, New York. New York: Harry N. Abrams, 1984.

Nielsen, Waldemar. *The Big Foundations.* New York: Columbia University Press, 1972.

Noble, Louis L. *The Life and Works of Thomas Cole.* New York: Sheldon, Blakeman and Co., 1856.

Nochlin, Linda. "Why Have There Been No Great Women Artists?" In Thomas B. Hess and Elizabeth C. Baker, eds., *Art and Sexual Politics,* 1–43. New York: Collier Macmillan Publishers, 1971.

———. *Women, Art, Power, and Other Essays.* New York: Harper and Row, 1988.

Novak, Barbara. *American Painting of the Nineteenth Century: Realism, Idealism, and the American Experience.* New York: Harper and Row, 1969.

Orosz, Joel. *Curators and Culture: The Museum Movement in America, 1740–1870.* Tuscaloosa: University of Alabama Press, 1990.

Paine, Judith. "The Woman's Pavilion of 1876." *Feminist Art Journal* 4 (Winter 1975–76): 5–12.

Parker, Rozsika, and Griselda Pollock. *Old Mistresses: Women, Art, and Ideology.* New York: Pantheon Books, 1981.

Pauline Palmer: American Impressionist. Peoria: Lakeview Museum of Arts and Sciences, 1984.

Peiss, Kathy. *Cheap Amusements: Working Women and Leisure in Turn-of-the-Century New York.* Philadelphia: Temple University Press, 1986.

Perlman, Bernard B. *Painters of the Ashcan School: The Immortal Eight.* New York: Dover Publications, 1979.

Pisano, Ronald G. *The Students of William Merritt Chase.* Huntington, New York: Heckscher Museum, 1973.

———. *William Merritt Chase.* New York: Watson-Guptill, 1986.

Pleck, Elizabeth H., and Joseph H. Pleck, eds. *The American Man.* Englewood Cliffs, New Jersey: Prentice Hall, 1980.

Pollock, Griselda. "Women, Art, and Ideology: Questions for Feminist Art Historians." *Woman's Art Journal* 1 (Spring/Summer 1983): 39–46.

Pred, Alan R. *Urban Growth and the Circulation of Information: The United States System of Cities, 1790–1840.* Cambridge: Harvard University Press, 1973.

Prown, Jules David. *American Painting from Its Beginnings to the Armory Show.* New York: Rizzoli, 1980.

Reverby, Susan W. *Ordered to Care: The Dilemma of American Nursing, 1850–1945.* New York: Cambridge University Press, 1987.

Richardson, Brenda. *Dr. Claribel and Miss Etta.* Baltimore: Baltimore Museum of Art, n.d.

Richardson, Edgar Preston. *Washington Allston: A Study of the Romantic Artist in America*. Chicago: University of Chicago Press, 1948.

Rogers, Millard F., Jr. "Mary M. Emery: Development of an American Collector." *Cincinnati Art Museum Bulletin* 13 (December 1986): 5–19.

Rosen, Ruth. *The Lost Sisterhood: Prostitution in America, 1900–1918*. Baltimore: Johns Hopkins University Press, 1982.

Rosenberg, Rosalind. *Beyond Separate Spheres: Intellectual Roots of Modern Feminism*. New Haven: Yale University Press, 1982.

Rosenzweig, Roy. *Eight Hours for What We Will: Workers and Leisure in an Industrial City, 1870–1920*. New York: Cambridge University Press, 1983.

Ross, Steven J. *Workers on the Edge: Work, Leisure, and Politics in Industrializing Cincinnati, 1788–1890*. New York: Columbia University Press, 1985.

Rossiter, Margaret W. *Women Scientists in America: Struggles and Strategies to 1940*. Baltimore: Johns Hopkins University Press, 1982.

Rubenstein, Charlotte Streifer. *American Women Artists*. New York: Avon Books, 1982.

Ryan, Mary P. *Cradle of the Middle Class: Family in Oneida County, New York, 1790–1865*. New York: Cambridge University Press, 1981.

———. "The Power of Women's Networks." In Judith L. Newton, Mary P. Ryan, and Judith R. Walkowitz, eds., *Sex and Class in Women's History*, 167–86. London: Routledge, Kegan and Paul, 1983.

Rydell, Robert W. *All the World's a Fair: Visions of Empire at American International Expositions, 1876–1916*. Chicago: University of Chicago Press, 1984.

Saarinen, Aline B. *The Proud Possessors: The Lives, Times, and Tastes of some Adventurous American Art Collectors*. New York: Random House, 1958.

Saisselin, Remy G. *The Bourgeois and the Bibelot*. New Brunswick, New Jersey: Rutgers University Press, 1984.

Samuels, Ernest. *Bernard Berenson: The Making of a Connoisseur*. Cambridge: Harvard University Press, 1979.

———. *Bernard Berenson: The Making of a Legend*. Cambridge: Harvard University Press, 1987.

Schlesinger, Arthur M., Sr. "Biography of a Nation of Joiners." *American Historical Review* 50 (October 1944): 1–25.

Schmeckebier, Laurence E. *John Steuart Curry's Pageant of America*. New York: American Artist Group, 1943.

Scott, Joan. "Gender: A Useful Category of Historical Analysis." *American Historical Review* 91 (December 1986): 1053–75.

Sherman, Claire Richter, and Adele M. Holcomb, eds. *Women as Interpreters of the Visual Arts, 1820–1979*. Westport, Connecticut: Greenwood Press, 1981.

Sicherman, Barbara, and Carol Hurd Green. *Notable American Women: The Modern Period*. Cambridge: Harvard University Press, 1980.

Siegl, Theodore. *The Thomas Eakins Collection*. Philadelphia: Philadelphia Museum of Art, 1978.

Silk, Leonard, and Mark Silk. *The American Establishment*. New York: Basic Books, 1980.

Sinclair, Bruce. *Philadelphia's Philosopher Mechanics: A History of the Franklin Institute, 1824–1865*. Baltimore: Johns Hopkins University Press, 1974.

Sklar, Kathryn Kish. *Catharine Beecher: A Study in American Domesticity.* New Haven: Yale University Press, 1973.

————. "Hull-House in the 1890s: A Community of Women Reformers." *Signs* 10 (1985): 657–77.

————. "Who Funded Hull House?" In Kathleen D. McCarthy, ed., *Lady Bountiful Revisited: Women, Philanthropy, and Power*, 94–115. New Brunswick, New Jersey: Rutgers University Press, 1990.

Smith-Rosenberg, Carroll. *Disorderly Conduct: Visions of Gender in Victorian America*. New York: Oxford University Press, 1985.

Solomon, Barbara Miller. *In the Company of Educated Women: A History of Women and Higher Education in America*. New Haven: Yale University Press, 1985.

Spassky, Natalie. *Mary Cassatt*. New York: Metropolitan Museum of Art, 1984.

Stansell, Christine. *City of Women: Sex and Class in New York, 1789–1860*. New York: Alfred A. Knopf, 1986.

Stansky, Peter. *Redesigning the World: William Morris, the 1880s, and the Arts and Crafts*. Princeton: Princeton University Press, 1985.

Stebbins, Theodore E., Jr., Carol Troyan, and Trevor J. Fairbrother. *A New World: Masterpieces of American Painting, 1760–1910*. Boston: Museum of Fine Arts, 1983.

Stillinger, Elizabeth. *The Antiquers*. New York: Alfred A. Knopf, 1980.

Story, Ronald. *Harvard and the Boston Upper Class: The Forging of an Aristocracy, 1800–1870*. Middletown, Connecticut: Wesleyan University Press, 1980.

Strouse, Jean. *Alice James: A Biography*. Boston: Houghton Mifflin, 1980.

Swan, Susan Burrows. *Plain and Fancy: American Women and Their Needlework, 1700–1850*. New York: Holt, Rinehart and Winston, 1977.

Sweet, Frederick A. *Miss Mary Cassatt, Impressionist from Pennsylvania*. Norman: University of Oklahoma Press, 1966.

Taylor, Francis Henry. *Pierpont Morgan as Collector and Patron, 1837–1913*. New York: Pierpont Morgan Library, 1957.

Taylor, Joshua C. *America as Art*. New York: Harper and Row, 1976.

————. *The Fine Arts in America*. Chicago: University of Chicago Press, 1979.

Taylor, William R. *Cavalier and Yankee: The Old South and American National Character*. New York: George Braziller, 1961.

Tharp, Louise Hall. *Mrs. Jack: A Biography of Isabella Stewart Gardner*. Boston: Little, Brown and Co., 1965.

Thompson, E. P. *The Making of the English Working Class*. New York: Vintage Books, 1966.

_____. *William Morris: Romantic to Revolutionary*. New York: Pantheon Books, 1977.

Tomkins, Calvin. *Merchants and Masterpieces: The Story of the Metropolitan Museum of Art*. New York: E. P. Dutton and Co., 1973.

Troyen, Carol. *The Boston Tradition: American Paintings from the Museum of Fine Arts, Boston*. New York: American Federation of Arts, 1980.

Troyen, Carol, and Pamela S. Tabbaa. *The Great Boston Collectors: Paintings from the Museum of Fine Arts*. Boston: Museum of Fine Arts, 1984.

Tufts, Eleanor, ed. *American Women Artists, 1830–1930*. Washington: National Museum of Women in the Arts, 1987.

Turner, Victor. *The Ritual Process: Structure and Anti-structure*. Ithaca: Cornell University Press, 1969.

Van Gennep, Arnold. *The Rites of Passage*. 1908. Chicago: University of Chicago Press, 1960.

Vicinus, Martha. *Independent Women: Work and Community for Single Women, 1850–1920*. Chicago: University of Chicago Press, 1985.

Wallace, Anthony F. C. *Rockdale: The Growth of an American Village in the Early Industrial Revolution*. New York: W. W. Norton and Co., 1971.

Walsh, Mary Roth. *"Doctors Wanted: No Women Need Apply": Sexual Barriers in the Medical Profession, 1835–1975*. New Haven: Yale University Press, 1977.

Weimann, Jeanne Madeline. *The Fair Women: The Story of the Woman's Building, World's Columbian Exposition, Chicago, 1893*. Chicago: Academy Chicago, 1981.

Weitzenhoffer, Frances. *The Havemeyers: Impressionism Comes to America*. New York: Harry N. Abrams, 1986.

Whitehill, Walter M. *Museum of Fine Arts, Boston: A Centennial History*. 2 volumes. Cambridge: Harvard University Press, 1970.

Whyte, William H. *The Organization Man*. New York: Simon and Schuster, 1956.

Wichmann, Siegfried. *Japonisme: The Japanese Influence on Western Art in the Nineteenth and Twentieth Centuries*. New York: Harmony Books, 1980.

Wiebe, Robert. *The Search for Order*. New York: Hill and Wang, 1967.

Williams, Herman Warner, Jr. *Mirror to the American Past: A Survey of American Genre Painting, 1750–1900*. Greenwich, Connecticut: New York Graphic Society, 1973.

Winant, Marguerite Dawson. *A Century of Sorosis, 1868–1968*. New York: Sorosis, 1968.

Wittke, Carl. *The First Fifty Years: The Cleveland Museum of Art, 1916–1966*. Cleveland: Museum of Art, 1966.

Wright, Gwendolyn. *Moralism and the Model Home: Domestic Architecture and Cultural Conflict in Chicago, 1873–1913*. Chicago: University of Chicago Press, 1980.

Yale University Art Gallery. *Pictures for a Picture: Gertrude Stein as a Collector and Writer on Art and Artists.* New Haven: Yale University Press, 1951.

Zilcar, Judith. "Alfred Stieglitz and John Quinn: Allies in the American Avant-Garde." *American Journal* 17 (Summer 1985): 18–33.

Zweig, Paul. *Walt Whitman: The Making of the Poet.* New York: Basic Books, 1984.

Index

Abolitionism, 4, 38, 40
Académie Colarossi, 94, 105
Académi des Beaux Arts, 94
Académie Julian, 89, 94, 105
Adams, Henry, 163, 171
Adams, John Quincy, 12, 28
Addams, Jane, 67, 77, 187, 222, 223
Agassiz, Ida. *See* Higinson, Ida
 Agassiz
Ahmedabad Wood Carving Com-
 pany, 67
Albright, Gallery, 204
Alcott, Bronson, 28
Alcott, May, 107
Aldis, Arthur, 191
Aldrich, Lucy, 200
Alexander, John W., 77, 220–21,
 226–27
Allston, Washington, 12, 22–23, 28,
 216
Altman, Benjamin, 121–22, 167
Alvord, Lady Marion, 90
American Academy of Fine Arts, 23
American art: and antebellum-era
 collectors, 11, 32; at Art Institute,
 134; Ashcan school, 187, 227–28,
 234, 238; Hudson River school,
 22, 121; loss of interest in, 95,
 98–99, 112–13; at Metropolitan
 Museum, 124; and Whitney, 215,
 227–44
American Art-Union (AAU), 17, 25–
 27, 32, 34
American Federation of the Arts,
 187
American Folk Art Gallery, 272n.37
Amherst College, 175

Anatomy, study of, 85, 87, 89, 93
Andersen, Hendrik Christian, 219,
 221
Anscombe, Isabelle, 46–47
Anti-intellectualism, 98, 151–52
Antiquarian Society, 132–34
Apollinaire, Guillaume, 183
Apollo Association, 25
Appleton, Mrs. Samuel, 90
Arensberg, Walter, 189, 193, 195,
 210
Armory show: and Bliss, 196–97;
 history of, 184–88; mentioned,
 190, 198, 206, 228
Armour, P. D., 130
Art Amateur, 103
"Art and Nature" (Stowe), 7
Arthur, T. S., 7
Art Institute of Chicago: and avant-
 garde, 184–86, 192; women's role
 in, 125, 130–35, 143, 144; men-
 tioned, ix, 105, 187
Art Interchange (journal), 51
"Artistic Impulse in Man and
 Woman, The" (Randall), 84
Artist's Fund Society, 10, 20, 32
Art of This Century (gallery), 244
Arts (journal), 228
Arts and Crafts Club (New Orleans),
 235
Arts and crafts movement, 60, 67–71
Arts Club, 192–93
Art Students League, 88, 99–100,
 105, 221, 224
Ashburton, Lady Louisa, 90
Ashcan school, 187, 227–28, 234,
 238

Asheville Exchange for Women's
 Work, 70
Aspinwall, William, 45
Assimilationism: rejection of, 150,
 166; strategy of, xv, 81–145, 210,
 241
Associate Committee of Women
 (ACW), 127–30
Associated Artists, 67
Association in Aid of the Museum of
 Fine Arts, 136, 137
Astor, Augusta, 45
Astor, Mrs. John Jacob, 45, 56, 119
Astor, Mrs. William, 45
Avant-garde, 179–212, 244
Avery, Samuel, 116

Bacon, Peggy, 199, 233, 236
Baker, George F., 118
Baker, Julia, 99
Bakst, Léon, 224
Ball, Thomas, 99
Baltimore, 10
Baltimore Historical Society, 20
Barnard, George Grey, 201
Barnes, Alfred, 210–11
Barnes Foundation, 158
Barr, Alfred H., Jr., 205, 206, 209
Bartlett, Helen Birch, 186
Barton, Susan, 128
Bauhaus, 193
Beal, Gifford, 88, 231
Beard, Mary, 144
Beaux, Cecilia: career of, 106; and
 Friends of American Art, 135;
 and Gardner, 163, 165; at Penn-
 sylvania Academy, 99; and
 Whitney, 227, 229, 230, 239
Beecher, Catharine, 4–6, 223
Bellows, George, 85, 228, 230, 233
Bellows, Henry W., 116
Belmont, August, 50
Belmont, Mrs. August, 20, 89
Bennett, Bessie, 125
Berenson, Bernard, 138, 166–69,
 172–75

Berenson, Mary, 163
Berger, Florence Paull, 125
Berman, Avis, 223, 229, 275n.21
Bierstadt, Albert, 39, 97, 98
Bingham, George Caleb, 10
Bird in Space (Brancusi), 186
Blackstone, Isabella, 133, 134
Blaine, Anita McCormick, 134
Bliss, Cornelius, 208
Bliss, Lillie: and Museum of Modern
 Art, 196–97, 202–4, 206–9, 212;
 mentioned, 186, 229, 231
Blodgett, Henry, 116
Blodgett, Mrs. William Tilden, 77
Bloomfield-Moore, Clara, 128
Blue Boy (Gainsborough), 168
Blumenthal, Florence, 118, 185
Blumenthal, George, 118
Bolles furniture collection, 120–21
Bonheur, Rosa, 102, 216
Boott, Elizabeth. See Duveneck, Eliz-
 abeth Boott
Boston: art and class in, 86; museum
 development in, 141; women's
 design schools in, 63; women's
 exchanges in, 62; mentioned, 27.
 See also Fenway Court; Museum
 of Fine Arts (Boston)
Boston Art Committee, 99
Boston Art Students Association,
 100
Boston Athenaeum, 12, 17, 24, 26,
 27, 135–36
Boston Herald, 184
Boston Museum of Fine Arts, 100,
 125
Boston Society of Decorative Art,
 49, 52, 61–62, 137
Botta, Anne Lynch, 28, 163
Botticelli, Sandro, 165
Bouguereau, William, 88, 89
Bourgeois and the Bibelot, The
 (Saisselin), 153–54
Bowen, Louise De Koven, 77
Boxing, 151, 161
Boyd, Harriet, 264n.28

Brancusi, Constantin, 183, 186, 190
Braque, Georges, 192
Bread and Cheese Club, 13
Brearley, W. H., 75
Brewster, Anna Richards, 105
Brimmer, Martin, 136
Brimmer, Mrs. Martin, 52, 136
Brooklyn Art Union, 9–10
Brooklyn Eagle, 238
Brooklyn Museum, 193–94, 235
Brooklyn Woman's Club, 104
Brown, Henry Kirke, 9, 85
Brown, J. Crosby, 143
Brown, Mary Ellen, 122–26
Bryan, Thomas Jefferson, 24, 113, 158
Bryan Gallery of Christian Art, 24
Bryant, William Cullen, 12–13, 25, 26, 50
Bryn Mawr College, 78, 124
Buckingham, Kate, 133
Bureaucracy, 114
Burne-Jones, Edward, 43
Burroughs, Bryson, 186

Campbell, Blendon, 232
Capitalism, 153–56
Carey, Thomas, 11–12
Carnegie, Andrew, 98, 106, 114, 156, 157
Carnegie Institute, 99, 154, 185
Carpenter, Mrs. John A., 192
Carter, Morris, 169, 171, 174
Carter, Susan, 32
Cassatt, Mary: career of, 84–85, 106–9; and Gardner, 163; and Havemeyer, 111, 122, 142; illustration, 82; *Modern Woman,* 102–3; Whitney compared with, 226; mentioned, xiii, 100, 135, 185, 198, 221, 229, 234, 239
Century association, 13, 25, 27, 100, 117
Cesnola, General di, 50, 123, 126
Cézanne, Paul, 106, 180, 182, 185, 186, 206

Chadbourne, Emily Crane, 133, 172–73, 185
Champney, Benjamin, 8
Chanler, Robert, 226
Charity. *See* Philanthropy
Charity Organization Societies, 263n.9
Chase, William Merritt: illustration, 96; as mentor to women painters, 85, 87–88, 105; studio of, 95, 97; and Tile Club, 65, 66; mentioned, 98
Cheney, Ednah Dow, 32
Chicago: arts and crafts movement in, 67–69; Arts Club of, 192–93; Columbian Exposition, 102, 104, 129, 144, 154; fire of 1871, 130, 131, 141; museum development in, 141; mentioned, 27, 49. *See also* Art Institute of Chicago
Chicago Academy of Design, 130–31
Chicago Examiner, 185
Chicago Inter-Ocean, 103
Chicago Society of Arts and Crafts, 67
Chicago Society of Decorative Art (CSDA), 50, 131–32, 133
Chicago Symphony Orchestra, 61
Chicago Woman's Club, 187
Child, Lydia Maria, 90
Choate, Joseph H., 117
Christian, Princess, of Schleswig-Holstein, 41, 64
Church, Frederic, 39, 97
Cincinnati: art institution development in, 27, 28, 30–32, 71–75, 77; decorative arts movement in, 50; women's design schools in, 63; women's exchange in, 62
Cincinnati Commercial, 74
Cincinnati Music Festival, 258n.29
Cincinnati Orphan Asylum, 28, 29
"Circus in Paint, The" (exhibition), 236
Civil War, U.S.: art careers for women after, 95, 109; and decorative arts movement, 48, 52; and Sanitary Commission, 39;

Civil War, U.S. (*continued*)
mentioned, 89, 98, 112, 131, 141, 151
Clark, Stephen, 206–7
Clarkson, Ralph, 134
Clay, Henry, 28
Clemens, Samuel, 67
Cloisters, 201, 202, 212, 239
Clubs. *See* Men's clubs; Women's clubs
Coburn, Mrs. L. L., 122
Cole, Thomas: career of, 23; friend-ship circle of, 11–13; mentioned, 16, 25, 37, 86, 88, 98
Colleges: medical, for women, 59–60; women's, finances of, 77–78. *See also* Universities
Colman, Samuel, 47, 67, 108
Columbian Exposition, 102, 104, 129, 144, 154
Columbia University, 70
Committee of Fifty, 117
Cone, Claribel, 183
Cone, Etta, 183
Cook, Clarence, 86
Cooke, Jay, 92, 98
Coolidge, Calvin, 154
Cooper, James Fenimore, 12–13
Cooper, Peter, 76, 174
Cooperative Mural Workshops, 190
Cooper-Hewitt Museum, 75–77, 204
Cooper Union, 32, 76, 94, 101, 174
Copley Society, 100
Corcoran Gallery, 158
Cortissoz, Royal, 194, 223, 238
Cosmopolitan, 104
Cosmopolitan Art Association, 17–18
Cott, Nancy F., 5, 144, 241
Courbet, Gustave, 107
Couture, Thomas, 95
Cowley, Malcolm, 235
Cox, Kenyon, 99–100
Crafts. *See* Decorative arts
Crane, Mrs. W. Murray, 205, 207
Crane, Walter, 43

Croly, Jenny June, 44
Crow, Dr. Wayman, 89–91
Crowninshield, Frank, 205
Crystal Palace Exhibition, 41
Cubism, 182, 184–85
Curry, John Steuart, 236
Curtis, E. L., 230
Cushman, Charlotte, 89, 90

Dadaism, 190–91
Damrosch, Walter, 106, 162
Dana, Richard Henry, 12
Darwin, Charles, 94
Daumier, Honoré, 229
Davidge, Clara, 185, 198
Davies, Arthur B., 106, 184–86, 188, 196–97, 202, 228, 229, 271n.32
Dean, Bashford, 123–24
Decorative arts: antebellum, 5–6, 14–15; and arts and crafts move-ment, 67–71; and avant-garde, 179–80; at design schools for women, 63–65; and men, 46–47, 56, 65–67; at museums, 71–77, 119, 125, 128–32, 136–37, 139, 144–45; and women's exchanges, 60–63. *See also* Decorative arts movement; Needlework
Decorative arts movement: arts and crafts movement, link with, 70; decline of, 56, 78; history of, 37–56; museums contrasted with, 112, 113; organizations modeled on, 59–61; and prejudice against female artists, 55–56, 83–84, 109
de Forest, Emily, 120–21, 125
de Forest, Lockwood, 47, 67
de Forest, Robert, 120–21
Degas, Edgar, 102, 106–8, 122, 142, 186, 197
Dell, Floyd, 235
Demuth, Charles, 88
Denver Art Museum, 105, 235
Department stores, 53, 54
Depression, Great, 133, 208

Design schools for women, 60, 63–65, 78, 113
Detroit, museum movement in, 75, 77
Detroit Art Loan, 75
Detroit Art Loan Record, 75
Detroit Institute of Arts, 235
Dewey, John, 183
Dewing, Thomas Wilmer, 88
Dick, Harvey Brisbane, 118
Dickens, Charles, 44
DiMaggio, Paul, 112
Dodge, Mabel. *See* Luhan, Mabel Dodge
Doherty, Knucksey, 161
Dole, James H., 130
Domesticity, cult of, 4–8, 15, 38
Dos Passos, John, 228
Douglas, Ann, xi
Downtown Gallery, 198–99, 241
Dreier, Dorothea, 188
Dreier, Katherine: and Armory Show, 185; and avant-garde, 210–11; Société Anonyme of, 187–96; mentioned, xv, 183, 198, 204, 209, 227, 238, 243
Dreier, Mary, 195
Du Bois, Guy Pène, 231, 233, 235
Duchamp, Marcel, 184–85, 190–91, 193–95, 227
Dudley, Katherine, 134–35
Duncan, Isadora, 180, 183
Durand, Asher: career of, 11–13; journeys of, 9; mentioned, 24, 25, 37, 86, 88, 98
Duveen, Henry, 157
Duveen, Sir Joseph, 157, 200, 206
Duveneck, Elizabeth Boott, 87, 88, 96
Duveneck, Frank, 88
Duyckinck, Evert, 12
Duyckinck, George, 12

Eakins, Thomas, 85, 88, 93–94, 105, 109, 206
Earhart, Amelia, 241

Earl, Ralph, 135
Eddy, Arthur Jerome, 210
Edmonds, Francis, 25
Edwards, Julia Cheney, 122
Ellett, Elizabeth, 100–101
Elliott, Maude Howe, 163
Ellis, Mrs., 14
Ellis, Mrs. A. H. M., 265n.40
Embroidery. *See* Needlework
Emerson, Ralph Waldo, 15, 28, 89
England, and decorative arts, 41
Engraving, 5–6, 23–24
Enlightenment, 15, 94, 152
Entrepreneurship, 59–79
Europe: art of, and American collectors, 95, 98–99, 112–13, 153–55; as art world center, 227, 244; women artists in, 89–90
Evans, Anne, 105
Evans, Maria Antoinette, 140, 174
Evans, Robert Dawson, 140

Family Monitor and Domestic Guide, The (Ellis), 14
Fancy work, 47
Farm wives, 69
Fauvism, 182, 184
Feminization myth, ix, 85, 94, 149–53, 155, 176
"Feminizing of Culture, The" (article), 150
Femme couverte, 4
Fenollosa, Ernest, 158
Fenway Court: history of, 169–76; illustration, 164; mentioned, 149–50, 153, 243
Ffoulke, Charles, 139–40, 172–73
Field, Hamilton Easter, 272n.37
Field, Marshall, 130
Field, Mrs. Marshall, 265n.42
Fields, Annie, 163
"50-50 Art Sale," 229
Fish, Hamilton, 50
Fitzgerald, F. Scott, 182
Flagg, George W., 11, 12
Fletcher, Isaac D., 118

Fogg Art Museum, 205, 207, 235
Folk art, 70, 179, 180, 235, 272n.37
"Fontaine" (Duchamp), 190–91
Force, Juliana, 229–43
Fosdick, Raymond, 200–202
Foundations: and sacralization, 113–14; women's role in, 143, 144, 176, 262n.9
Fox, Henry, 193
Fragonard, Jean-Honoré, 157, 174
Franklin Institute, 29
Fraser, James Earle, 221, 224, 227, 228
Freer, Charles Lang, 158
French, Daniel Chester, 77, 100, 228
French, William M. R., 132, 173
Frick, Henry Clay, 153, 157–58, 173–75, 239
Frick Museum, 153, 157–58, 239
Friends of American Art (FAA), 134–35, 144, 199
Friends of Young Artists, 231–32
Frishmuth, Mrs. W. D., 129
Fry, Roger, 124, 157
Fuller, Margaret, 28

Gainsborough, Thomas, 156, 168
Gallatin, A. E., 195, 210–12, 229
Galleries: and American art, 236–37; antebellum, 113; and avant-garde, 188; early, 4; feminization of, 150
Gallery of Living Art, 211
Gardner, Elizabeth Jane, 88–89
Gardner, George, 169
Gardner, Isabella Stewart: career of, 149–76; illustration, 148; and Museum of Fine Arts, 138–40, 150, 161, 168, 171, 175–76; Whitney contrasted with, 220, 237, 242, 243; mentioned, xv, 52, 100, 106, 179, 204, 210
Gardner, John Lowell, 139, 160–61, 165–70, 172, 174
Gardner, Julia, 160
Garrett, Mary, 124, 143
Gauguin, Paul, 182, 186, 190, 206

General Federation of Women's Clubs, 187
Gennep, Arnold van, 159–60
Gerdts, William, 259n.19
Gibson, Charles Dana, 230
Gibson, John, 90, 91
Gilder, Helena de Kay, 99, 106
Gillespie, Mrs. E. D., 127
Gilmor, Robert: career of, 10–11; mentioned, 20, 22, 24, 33, 106, 158, 211, 243
Girard College, 174
Glackens, Edith Dimock, 236
Glackens, Ira, 228, 234, 240
Glackens, William, 227, 231, 233, 235
Glessner, Frances, 265n.42
Godey's Lady's Book, 4, 6–7, 27, 28, 47
Gogh, Vincent van, 186, 190, 206
Goldman, Ira, 234
Goldthwaite, Anne, 195, 199, 239
Goodrich, Lloyd, 206, 234
Goodyear, A. Conger, 204–7, 215
Greco, El, 182
Greene, Bella da Costa, 157
Greenough, Horatio, 12–13, 89, 259n.19
Greenwich House, 219
Greenwich Village, 70, 198–99, 224–26, 230, 235
Gregory, Lady, 162
Gris, Juan, 191
Guggenheim, Peggy, 244
Guggenheim, Solomon, 244
Guggenheim Museum, 244

Hale, Sarah Josepha, 4–6, 27, 28, 250n.29
Hall, Ann, 20
Hallowell, Sara, 103, 122
Halpert, Edith Gregory: on connoisseurship of modern art, 189; and folk art, 272n.37; and Rockefeller, 196–99, 204; Whitney compared with, 239; mentioned, 70, 159, 209, 210, 234, 241, 243, 251n.40

Halpert, Samuel, 198
Hare, Meredith ("Bunny"), 219
Harkness, Anna M., 118–20, 141, 174, 262n.9
Harkness, Edward, 119, 202, 204, 206
Harriman, Mrs. E. H., 229
Harrington, Tim, 161
Harrison, Mrs. John, 129
Harshe, Robert, 192, 193
Hart, "Pop," 199–200
Harvard Society for Contemporary Art, Inc., 205
Harvard University: Fogg Art Museum, 205, 207, 235; and museum development, 136, 141; mentioned, 143, 172, 175
Hassam, Childe, 134, 199, 230
Havemeyer, Henry O., 108, 197
Havemeyer, Louisine Elder: career of, 107–8; and Gardner, 163, 167, 175, 176; illustration, 110; and Metropolitan Museum of Art, 111–12, 122; Rockefeller compared with, 197, 198; as suffragist, 142; mentioned, xv, 71, 102, 121, 141, 144, 241
Hawthorne, Nathaniel, 89
Healy, G. P. A., 23, 91
Hearn, George A., 77, 124
Hemingway, Ernest, 182
Henri, Robert: and Whitney, 227–28, 230, 232, 238; mentioned, 134, 187, 209
Henrotin, Ellen, 104
Herring, James, 25
Hewitt, Abram, 76
Hewitt, Amelia, 76–77
Hewitt, Eleanor, 76–77
Hewitt, Frederick C., 118
Higginson, Henry Lee, 100, 172
Higginson, Ida Agassiz, 160, 163, 170
Hoffman, Malvina, 221, 224, 229, 230, 236
Holmes, Mrs. Oliver Wendell, 52, 55
Holmes, Oliver Wendell, 163
Homer, Winslow, 65, 206

Hone, Philip, 9, 12, 13, 45
Hoover, Herbert, 237–38
Hopkins, Ellen Dunlop, 63–64
Hopkinson, Joseph, 20
Hopper, Edward, 228, 235
Hosack, David, 12
Hosmer, Harriet, 89–93, 101, 104, 275n.21
House Palatial, 53
Howe, Julia Ward, 163, 165
Howe, Winifred, 121–22, 126
Howells, William Dean, 97
Hoyt, Mrs. William, 88
Hudson River school, 22, 121
Hull-House, 67–68, 70, 77, 222
Humphreys, Mary Gay, 254n.15
Hunt, Catherine, 45
Hunt, Richard Morris, 45, 47, 97, 216
Hunt, William Morris: as mentor to women painters, 85–87, 88, 93, 104–5, 109; studio of, 95; mentioned, 8, 51, 100, 138, 221
Huntington, Daniel, 9, 13, 22
Hutchinson, Charles, 130–32
Hutchinson, Mrs. Charles, 132
Hyatt, Anna Vaughn, 221

Ibsen, Henrik, 219
"Immigrant in America" (exhibition), 230–31
Impressionism, 95, 106–8, 122, 196, 231
Independent Artists Exhibition, 228
Indianapolis Art Association, 258n.31
Individualism: of "new woman," 240–41; strategy of, xv, 147–244; of Whitney, 223, 241–42
Industrial design, 41, 63–64, 67, 73. See also Design schools for women
Industrialization, 52
Inman, John, 13
Inness, George, 98, 199
Irving, Washington, 11, 12
It Club, 163
Ives, Halsey, 103

Jackson, Andrew, 12
James, Alice, 95
James, Henry, 105, 162, 163, 175
James, William, 163, 171
Jameson, Mrs. 95
Janvier, Mrs. C. A., 128
Jarves, James Jackson, 6, 15–16, 24, 158
Jay, John, 116–17
Jesup, Mrs. Morris K., 121
Jewitt, Sarah Orne, 163
Johns Hopkins University, 124, 180
Johnson, John G., 158, 167, 173
Johnston, John Taylor, 50, 116, 120
Joint stock companies, 23
Jones, Elizabeth Sparhawk, 134
Jones, Mary Cadwalader, 45
Josephson, Matthew, 238

Kahn, Otto, 155
Kandinsky, Wassily, 190, 193
Kann, Rodolph, 156
Kauffmann, Angelica, 102
Kemble, Fanny, 89, 90
Kennedy, John Stewart, 118
Kensett, John, 8, 9, 22–25, 116
Kent, Henry, 120, 121, 126
Kent, Rockwell, 192
Keppel, Frederick, 102
Kimball, Evaline, 122, 132, 133
Kimball, Fiske, 126
King, Edward, 28
King, Rufus (father), 28
King, Rufus (son), 30, 31, 72
Kirstein, Lincoln, 205
Klee, Paul, 190
Knobloch, Edward, 224
Knowlton, Helen, 87, 109
Koussevitsky, Serge, 106
Kreisler, Fritz, 106, 162
Kuehne, Max, 235
Kuniyoshi, Yasuo, 236

Ladies Academy of Fine Art (LAFA), 30–33, 71, 160
Ladies' Art Association, 101–2

Ladies Lunch Club, 126
Ladies' New England Art-Union of Needlework, 250n.29
La Farge, John: character of, 98; and Fenway Court, 165; and Wheeler, 39, 47, 56; and Whitney, 216–18, 230; mentioned, 105
Laurencin, Marie, 106, 183, 185
Lawrence, Mrs. T. Bigelow, 135
Lawson, Ernest, 228
Lebsock, Suzanne, 77
Lee, Vernon, 163
Léger, Fernand, 190
Leland, Francis I., 118
Lending libraries, 51
Lenox, James, 98
Lerner, Gerda, xiii
Leslie, Ann, 16
Leslie, Charles, 8
Leupp, Charles M., 9, 13, 25, 26
Leutze, Emanuel, 85
Levine, Lawrence, 112, 115
Lewis, Edmonia, 89, 102
Libraries, 51, 114
Liminality, 159–60
Lincoln, Abraham, 91–92
Lincoln, Mary Todd, 91
Liszt, Franz, 91
Literary Digest, 119, 206
Livermore, Mary, 40
L'Oeuvre (Zola), 153
Log Cabin Settlement, 70
London Daily Mail, 156–57
Longfellow, Henry Wadsworth, 12, 28
Longworth, Joseph, 73, 74
Longworth, Nicholas, 17, 71
Lord, Samuel, 53
Loring, Charles G., 138, 139
Louvre, 106, 116, 153, 219
Lowden, Florence, 134
Lowell, Abbott, 151
Lowell, Anna Cabot, 23
Lowell, James Russell, 91
Lowell Institute, 86
Lowell School of Design, 101
Lubove, Roy, 263n.9

Luce, Molly, 236
Luhan, Mabel Dodge, 180–85, 189, 228
Luks, George, 229, 231, 234
Lunch Club, 13, 27
Lusitania (ship), 230
Lyman, Susan Chester, 70
Lynes, Russell, 76

McAlister, Ward, 45
Macbeth Gallery, 227
McCagg, Ezra B., 131
McCormick, Edith Rockefeller, 134
MacDowell, Susan, 88
McGuffey, Alexander, 72
McKim, Charles, 220
McLaughlin, Louise, 71, 72
Madison, James, 12
Manet, Edouard, 106–9, 122, 182, 229
Marin, John, 199, 202
Marquand, Henry, 121, 122, 154–55
Marriage: and artistic careers of women, 17, 88–89, 95, 107, 241; Hosmer on, 90; property laws, 4, 22, 112, 141; Wheeler on, 39; Whitney on, 218
Marsh, Reginald, 235, 236
Martineau, Harriet, 10, 17
Masses (journal), 209
Mather, Frank, 154–55, 171
Matisse, Henri: Dreier's reaction to, 189; and Rockefeller, 200–202, and Stein, 180, 182, 183; mentioned, 185, 186, 211
Maverick, Peter, 24
May, Henry, 185
Mead, Margaret, xi
Medical colleges for women, 59–60. *See also* Nursing
Melba, Nellie, 106, 162
Melville, Herman, 12–13
Men: denigration of women's art by, 15–16, 99–100; and domesticity cult, 4–8; feminization fears of, 149–53, 176

—, as artists: antebellum era, 8–13, 18–20, 22–23, 33; and decorative arts, 46–47, 56, 65–67; and Gardner, 163–65; mentoring relationships with women artists, 83–109, 275n.21; and Stein, 182–83; and Whitney, 221–22, 235–36, 241
—, as art patrons and philanthropists: acquisitiveness of, 153–58; antebellum era, 8–13; of avant-garde, 180, 185, 187–88, 205; control of art institutions by, ix–xiv, 23–27, 33, 152–53, 176, 243–44; female patrons and philanthropists contrasted with, 73, 173–75, 239; and museum development, 71–77, 111–45
Men's clubs: antebellum, 8, 13, 15; decorative arts, 65–66; and museum development, 116–17
Merriman, Helen Bigelow, 105
Merritt, Anna Lea, 134, 102–4
Metcalf, Helen, 64–65, 76
Metropolitan Museum of Art: and avant-garde, 185–86, 191, 202, 206; Fenway Court compared with, 171; Havemeyer collection at, 108, 111–12, 122; history of, 116–26, 141, 143–44; and Morgan, 157; Whitney offer to, 237; mentioned, ix, 201, 216, 229, 243
Meyer, Agnes Ernst: antifeminism of, 242; career of, 183–84, 188; on Stein, 270n.3; mentioned, 186, 195, 231
Meyer, Eugene, Jr., 183
Meyers, Jerome, 228
Mills, C. Wright, 114
Miró, Joan, 190
Modern Gallery, 183
Modernism. *See* Avant-garde
Modern Woman (Cassatt), 102–3
Mondrian, Piet, 192
Monet, Claude, 105, 108, 122, 165, 186

Mora, Luis, 231
Moran, Thomas, 88
More, Hermon, 237, 238
Morgan, J. Pierpont: career of, 153, 155–58; and decorative arts, 50, 76; Gardner compared with, 173–75; mentioned, 25, 166, 168, 180, 200
Morgan, Junius, 157
Morgan, Junius Spencer, 155–56
Morgan, Mrs. J. Pierpont, 119
Morgan Library, 153, 157
Morisot, Berthe, 106–8
Morris, Frances, 124–26
Morris, William, 43, 46
Morse, Samuel F. B., 8, 9, 13, 15
Moses, Robert, 143
Mount, William Sidney, 11, 13, 18–20, 95, 98
Munsey, Frank, 118–19, 239
Museum of Fine Arts (Boston): and Gardner, 138–40, 150, 161, 168, 171, 175–76; history of, 135–40
Museum of Folk Art, 70–71
Museum of Modern Art, 180, 196–209, 211, 212
Museums: decorative arts movement contrasted with, 37–38; development of, xi, 41, 60, 71–77, 111–45; and modernism, 179–80, 185–86, 190–191, 227; and sacralization of art, 112–15, 244; mentioned, 152–53, 176
Music, 38
Musical instruments, Brown collection of, 123, 125, 126

Nation, 155, 192, 206, 226–27, 238
National Academy of Design (NAD): and American Art-Union, 26; member characteristics, 23–24; role of women in, 20, 27; and Whitney, 223, 228, 231; women in life classes at, 93; mentioned, 10, 11, 13, 17, 25, 29, 32, 34, 184
National Arts Club, 70, 100

National Gallery (England), 25
Nature, and culture, 151, 152
Needle and Bobbin Club, 125
Needlework, 101, 106; antebellum, 14–15; and decorative arts movement, 38, 43–47, 50, 55, 60; in museums, 128, 137; and women's exchanges, 61. See also Decorative arts
"Negro Sculpture" (exhibition), 231
Nevelson, Louise, 236
Newark, N.J., 27
Newbold, Catherine, 125
Newcomb Pottery, 71
New England Female Medical College, 60
New Republic, 192
"New woman," 149, 158–60, 240–41
New York City: art institution development in, 23–27, 141; artists' circles in, 12–13; as art world capital, 244; Spencer on conditions in, 18. See also Metropolitan Museum of Art; Museum of Modern Art
New York Design School for Women (NYDSW), 63–64
New Yorker, 193
New York Exchange for Woman's Work, 62
New York Gallery of Fine Arts (NYGFA), 24–27
New-York Historical Society, 24, 25
New York Society of Decorative Art (NYSDA): and Cooper-Hewitt Museum, 76–77; and decorative arts movement, 44–51, 55–56; revenues at turn of century, 62; Tiffany in, 67; mentioned, 73, 88, 216
New York Times, 50–51, 101, 104, 230, 235, 238
New York Tribune, 92
New York University, 9, 211
Nichols, George, 73
Nichols, Maria Longworth, 71–72, 258n.29

Nimmo, Mary, 89
Nineteenth Amendment, 241
Nochlin, Linda, xiii
Nonprofit corporations, xiii, 113, 115, 143, 144, 204, 262n.9
Norris, Frank, 97–98
Norton, Charles Eliot: and decorative arts, 69, 72; and Gardner, 162, 165, 166, 172; mentioned, 24
Nude Descending a Staircase (Duchamp), 184–85, 193
Nursing, 60, 61, 78, 84, 144

Oakey, Maria, 87, 88
O'Connor, Andrew, 211, 226, 275n.21
Okakura-Kakuzo, 165
O'Keeffe, Georgia: and Museum of Modern Art, 199, 202, 208; and Société Anonyme, 193, 195; mentioned, 88, 239
Olmsted, Frederick Law, 170
Otis, Mrs. Harrison Gray, 23
Outlook, 206, 238
Out of Money Club, 8

Paderewski, Ignacy, 106, 162
Palmer, Bertha Honoré: and Art Institute, 132–34, 144; and Columbian Exposition, 102–4, 144; Gardner compared with, 175; mentioned, 67, 90, 107, 121, 141, 142, 165, 265n.40
Palmer, Pauline, 134
Palmer, Potter, 103, 265n.40
Paris, 89, 106, 107, 183, 244; Salon of, 89, 95, 105, 118, 219, 223
Parrish, Maxfield, 227
Parrish, Samuel, 88
Parsons, Betty, 244
Parsons, Mary, 125
Paul Revere Pottery, 71
Pavlova, Anna, 162
Peabody, George, 155–56
Peale, Anna Claypoole, 16, 20
Peale, Mary Jane, 17
Peale, Miriam, 88

Peale, Sarah, 20
Pennsylvania Academy of Fine Arts: avant-garde at, 185; origin of, 23; role of women at, 20, 27–28, 99, 141; women in life classes at, 93; mentioned, 29, 32, 106
Pennsylvania Museum of Art, 126–30, 141
Pepper, William Platt, 127
Perkins, Charles, 136
Perkins, Louisa, 85
Perry, Lilla Cabot, 100, 105, 109, 122, 165
Perry, Mrs., 73–74
Perry, Thomas, 105
Peter, Sarah Worthington King: career of, 28–32; Gardner compared with, 160, 163; illustration, 2; Rockefeller compared with, 209; Wheeler compared with, 37, 38, 46; Whitney compared with, 239; mentioned, 34, 43, 55, 63, 72, 77, 189, 212
Peter, William, 28–29
Philadelphia: art institution development in, 27–28, 141; women's design schools in, 63. *See also* Pennsylvania Academy of Fine Arts
Philadelphia Artist's Fund Society, 20
Philadelphia Centennial Exposition: and Boston Museum of Fine Arts, 135, 138; and capitalistic ethos, 153; and decorative arts movement, 40–43; and Pennsylvania Museum of Art, 126–27, 141; and Rhode Island School of Design, 64; women's art exhibitions at, 27–28, 101–2; and Women's Art Museum Association, 71, 72; mentioned, 64, 227
Philadelphia Museum of Art, 158, 211
Philadelphia Orchestra, 61, 258n.29
Philadelphia School of Design for Women, 28–29, 32, 34, 38
Philanthropy: and arts and crafts

Philanthropy (*continued*)
 movement, 67; and capitalism,
 154; Carnegie on, 114; and decora-
 tive arts movement, 47–48, 55, 56,
 59; and design schools for women,
 63, 78; and domesticity, 5, 32, 33,
 84; and entrepreneurship, 59–61;
 of Gardner, 162; limitations of, for
 women artists, 84, 109; men and
 women contrasted in approach to,
 73, 174–75; of Peter, 28, 29, 34; of
 Sanitary Commission, 39–40; of
 Whitney, 219–21, 229–30; and
 women's exchanges, 62–63. *See
 also* Men, as art patrons and phil-
 anthropists; Women, as art patrons
 and philanthropists
Phillips, Duncan, 205
Phillips, Marjorie Acker, 105
Phillips Gallery, 105, 211
Photography, 22. *See also* Steichen,
 Edward; Stieglitz, Alfred
Photo-Secession gallery, 106
Picasso, Pablo, 180–82, 185, 204, 211,
 228, 231
Pickford, Mary, 241
Pit, The (Norris), 97–98
Pitman, Benn, 71, 72, 101
Pleck, Elizabeth, 95
Pleck, Joseph, 95
Pollock, Jackson, 244
Popular Science Monthly, 151
Post, George B., 216
Pottery clubs, 71
Power Elite, The (Mills), 114
Powers, Hiram, 24, 92
Pratt Institute, 196
Pred, Alan, 10
Prendergast, Maurice, 106, 202
Professionalization, 115, 143
Pullman, George, 130
Pullman, Harriet, 134

Quilts. *See* Needlework
Quinn, John, 186, 210–11

Radcliffe College, 143, 180
Radeke, Eliza, 64
Randall, E. A., 84
Rape of Europa, The (Titian), 165–69,
 173
Ravlin, Grace, 134–35
Ray, Man, 190, 191
Ream, Vinnie: career of, 89, 91–94;
 mentioned, 102, 104, 109, 226,
 275n.21
Rebay, Hilla, 244
Redon, Odilon, 202
Red Scare, 186, 209, 230
Reed, Luman: art collection of, 24–
 25; career of, 11; Whitney com-
 pared with, 216, 243; mentioned,
 9, 20, 22, 33, 37, 106, 113, 158,
 163, 182, 211, 228
Reid, Whitelaw, 92
Religion, 5
Rembrandt paintings, in American
 collections, 31, 121, 122, 138, 154,
 155, 157, 163–70 passim
Renoir, Pierre-Auguste, 122, 182, 186
Rhode Island Art Association, 64
Rhode Island School of Design Edu-
 cation (RISDE), 64–65
Richardson, H. H., 100
Richter, Gisela, 125
Riggs, William, 156
Rimmer, William, 86–87
Rivera, Diego, 202, 209, 228
Robbins, Margaret Dreier, 189
Roberts, Marshall, 98
Rockefeller, Abby Aldrich: and folk
 art, 272n.37; illustrations, 178,
 197, 203; and Museum of Modern
 Art, 196–212; Whitney contrasted
 with, 215–16; mentioned, 70–71,
 243
Rockefeller, John D., 156, 158, 174,
 197
Rockefeller, John D., Jr., 118, 197,
 200–204, 207–9, 239
Rockefeller, Nelson Aldrich, 205, 208

Rodin, Auguste, 183, 221, 229
Rogers, Jacob S., 118
Rome, 89, 91
Rookwood Pottery, 71
Roosevelt, Mrs. Theodore, 106
Roosevelt, Quinten, 230
Roosevelt, Theodore, 151, 184, 231
Rosenberg, Rosalind, 94
Rosenfeld, Paul, 238
Rossetti, Dante Gabriel, 91
Rossiter, Margaret W., 78, 84, 124
Rousseau, Jean-Jacques, 15, 95
Royal School of Art Needlework, 41–43, 64
Rubens, Peter Paul, 165, 166
Rug-making, 69, 70
Ruskin, John, 43, 254n.15
Russell Sage Foundation, 120
Ryder, Albert, 206
Ryerson, Martin, 122, 130, 132, 202, 204, 265n.40
Ryerson, Mrs. Martin, 132–33, 265n.40

Sachs, Paul J., 205, 206
Sacralization of art, 112–15, 143, 160, 244
Sage, Olivia, 118, 120, 141, 174–75, 262n.9
Sage, Russell, 120
St. Botolph Club, 100
St. Denis, Ruth, 162
St.-Gaudens, Augustus, 65, 89, 216, 220
St. Louis, 27, 49
Saisselin, Remy, 153–54
Salmon, Lucy, 62–63
Salons, 12–13, 28, 105–6
Samuels, Ernest, 166, 168, 174
Sand, George, 90
San Francisco, 62, 182
Sanitary Commission, 39–41, 44, 78, 116, 128, 230
Santayana, George, xi
Sargent, John Singer, 100, 106, 135, 163

Sartain, Emily, 16
Sartain, John, 27–28, 128
Scammon, Maria, 50, 133
Schille, Alice, 105
Schmidt, Katherine, 236
Schnackenberg, Henry, 239
Schuyler, Georgina, 119
Science, women in, 84, 124
Scott, Joan, xiii
Scott, Mrs. Thomas, 128
Scudder, Janet, 134
Sculpture, 89–93, 219–26
Sears, Joshua Montgomery, 105–6
Sears, Sarah Choate, 105–7, 109, 185
Sedgwick, Catharine, 12
Separatism: rejection of, 84, 150, 163, 166; strategy of, xii, 1–79, 145, 241
Sesame and Lillies (Ruskin), 43
Seurat, Georges, 186, 206
Shaw, Mrs. G. Howland, 136
Sherwood, Mrs. John, 45
Shinn, Everett, 229, 230
Shinnecock art colony, 88
Sibyl Carter Indian Lace Association, 70
Simkhovitch, Mary, 219, 235
Sketch Club, 13, 25, 27, 47, 231
Sloan, John, 209, 227–31, 233–35
Smith, Al, 277n.50
Smith, F. Hopkinson, 66
Smith, Mary, 99
Smith, Mary Rozet, 77
Smith, Sophia, 175
Smithsonian Institution, 158
Social class, 49, 86
Social Darwinism, 94, 97, 240
Société Anonyme, 187–95, 201, 204, 211
Societies of decorative art. *See* Decorative arts movement
Society of American Art, 99
Society of Independent Artists, 228
Society of Lady Artists, 100–101
Sorosis, 44

South Kensington Museum, 41–44, 64, 72, 76
Spaulding, John, 207
Spencer, Benjamin Rush, 17
Spencer, Lilly Martin, 17–20, 99–102
Sports, 97, 151
Springer, Reuben, 74
Starr, Ellen Gates, 67
Stebbins, Emma, 89
Stebbins, Theodore, 86
"Steel Engraving Lady and the Gibson Girl, The" (Ticknor), 158–59
Steichen, Edward, 183, 186, 230
Stein, Gertrude: career of, 180–83; mentioned, 176, 189, 190, 197, 209, 210, 220, 238, 242
Stein, Leo, 180–82
Stein, Michael, 180
Stein, Sally, 180, 182, 185
Stella, Joseph, 199
Sterner, Marie, 198
Stettheimer, Florine, 208
Stevens, Thaddeus, 91
Stevenson, Sara Yorke, 129
Stewart, A. T., 53, 90
Stewart, David, 160, 174
Stickney, Mrs. E. S., 133
Stieglitz, Alfred: impact of, 210–11; and Meyer, 183–84; mentioned, 106, 187, 193, 198, 230, 231
Stimpson, Mrs. Henry, 43
Stokes, Mrs. Phelps, 20
Storrow, Mrs. James G., 71–72
Story, Ronald, 136
Story, William Wetmore, 89–91
Stowe, Harriet Beecher, 7
Strahan, Edward, 66
Straight, Dorothy, 228
Stravinsky, Igor, 228
Stuart, Gilbert, 12, 16, 17, 22
Stuart, Jane, 16, 17
Studios, artists', 9–10, 39, 95, 97
Sturges, Jonathan, 9, 13, 24–27, 33, 156
Suffrage movement, 129, 142
Sullivan, Cornelius, 196

Sullivan, Mary Quinn, 196–98, 202–4, 209, 212
Sully, Jane, 20, 88
Sully, Thomas, 22–23
Swisshelm, Jane Grey Cannon, 91–92
Szechenyi, Count Laszlo, 216

Taft, Lorado, 134, 259n.19
Taylor, Bayard, 28
Taylor, George, 53
Tenth Street Studio, 97, 98
Thomas, M. Carey, 124
Thomas, Theodore, 258n.29
Ticknor, Caroline, 158–59
Tiffany, Louis Comfort, 47, 56, 66–67, 77
Tile Club, 65–66, 100, 231
Titian, 165–69, 173
Tocqueville, Alexis de, 3
Toulouse-Lautrec, Henri de, 85, 191
Townsend, Gertrude, 125
Transactions, 26
Triggs, Oscar Lovell, 69
Tuckerman, Henry, 9, 13
Twain, Mark, 67
Tweed, William Marcy, 76, 117
291 (journal), 183

Union League Club, 116, 117
Universities: and sacralization, 113–14; women's role in, 143, 144, 152–53, 176. See also Colleges
University of Chicago, 174, 201, 204

Valentiner, William, 202, 204
Vanderbilt, Alice, 216, 221
Vanderbilt, Cornelius, 50, 67, 216
Vanderbilt, Cornelius ("Commodore"), 216
Vanderbilt, Gladys, 216
Vanderbilt, Mrs. W. K., Jr., 230
Vanderbilt, William H., 50
Vanderlyn, John, 13
Varian, Dorothy, 236
Vassar College, 78
Vedder, Elihu, 65, 89

Velázquez, Diego, 154, 166
Venetian Painters, The (Berenson), 166
Vermeer, Jan, 157, 165
Verplanck, Gulian, 9, 13
Victoria, Queen, 64, 104
Voluntary associations: antebellum, 3–4, 20; women's, xii, 61, 78–79. *See also* Philanthropy

Wadsworth Atheneum, 125, 157
Wagner, Maria Louisa, 17
Waldo, Samuel, 135
Wallace, Sir Richard, 157
Warburg, Edward M. M., 205
Ward, Samuel, 9, 12
Ware, Carolyn, 235
Warren, Edward, 138
Warren, Samuel, 139
Warren, Susan, 52, 138, 167
Waters Gallery, 158
Watson, Forbes, 228, 233, 237, 238, 242–43
Watson, Nan, 233, 236, 239
Webb, Electra Havemeyer, 71, 272n.37
Weber, Max, 199
Wellesley College, 205
West, Charles, 74
Wheeler, Candace Thurber: and arts and crafts movement, 67, 69–70; and Associated Artists, 67; career of, xiii–xiv, 37–56; and Columbian Exposition, 102; Dreier compared with, 194; Gardner compared with, 160, 163; Rockefeller compared with, 209, 210; Whitney compared with, 220; on women in art careers, 83, 95; mentioned, 59, 72, 79, 88, 97, 112, 119, 141, 216, 241, 272n.37
Wheeler, Dora, 55
Wheeler, Thomas, 39
Whistler, James McNeill, 98, 158, 163, 229
White, Stanford, 65, 88

Whitman, Sarah W., 87, 100, 165, 166
Whitman, Walt, 9–10
Whitney, Anne, 99, 102, 104
Whitney, Flora, 221, 227
Whitney, Gertrude Vanderbilt: and Armory Show, 185, 186; career of, xv, 215–44; illustrations, 214, 225; mentioned, 159, 195, 210, 212
Whitney, Harry Payne, 217–23, 226, 237, 239
Whitney, Helen Hay, 233
Whitney, Isabel, 236
Whitney Museum of American Art, 234, 237–43
Whitney Studio, 229–31, 240
Whitney Studio Club, 198, 232–33, 236, 241, 272n.37
Whitney Studio Galleries, 236
Whittredge, Worthington, 116
Widener, P. A. B., 167
Wiebe, Robert, 114–15
Wier, J. Alden, 65
Wilde, Oscar, 98
Williams College, 175
Wister, Mrs. Jones, 129
Wolfe, Catharine Lorillard, 117–18, 174
Wolfe, John, 118
Woman and Child (Beaux), 135
Woman's Exchange, 56
Women: class distinctions between, and work, 49; consumption and culture of, 53–54; Darwinian ideas on mentality of, 94; and domesticity cult, 4–8; and feminization myth, 149–52; "new woman," 158–60, 240–41; and suffrage movement, 142
—, as artists: antebellum era, 8, 14–22; and arts and crafts movement, 67–71; attacks on works by, 15–16, 91–95, 99–100; and decorative arts movement, 37–56, 59–60; design schools for, 63–65, 78; and Halpert, 199; mentoring relationship with men, 83–109, 275n.21;

Women (*continued*)
 and Stein, 182–83, 242; and
 Whitney, 235–36, 238–39, 241–
 42; and women's exchanges, 60–
 63, 78
—, as art patrons and philanthropists:
 antebellum era, 22–23, 27–34; of
 avant-garde, 179–212, 244; change
 in role of, ix–xiv, 243–44; Dreier,
 career of, 187–96; Gardner, career
 of, 158–76; Havemeyer, career of,
 107–8; male art patrons and phil-
 anthropists contrasted with, 73,
 173–75, 239; and museum devel-
 opment, 71–77, 111–45; Wheeler
 and decorative arts movement, 37–
 56; Whitney, career of, 215–16,
 226–44
Women's Art Museum Association
 (WAMA), 71–75, 132
Women's auxiliaries, 61
Women's Centennial Committee, 64,
 72
Women's Christian Temperance
 Union (WCTU), xiv, 50, 78
Women's clubs: aid to women artists

by, 61, 99, 104, 105, 109; and
 avant-garde, 186–87, 210; and de-
 corative arts movement, 44–45;
 and museum development, 125–
 26; pottery, 71; mentioned, 70, 78
Women's Educational Association
 (Boston), 60
Women's exchanges, 56, 60–63, 78
Women's National Art Association,
 101
Woolf, Virginia, 228
Worcester Museum of Art, 105, 192
World War I, 70, 125, 141, 182, 210
Wrightsman, Mrs. William, Jr., 128–
 29
Writers, and artists, 12–13

Yale University, 175, 195, 211

Zayas, Marius de, 183, 231
Zola, Emile, 153
Zorach, Marguerite, 185, 195, 199,
 208, 233
Zorach, William, 199, 233
Zorn, Anders, 148, 163–65
Zurbarán, Francisco de, 165, 166

West, Max. "Revival of Handicrafts." *Bulletin of the Bureau of Labor* (1904): 1573–1622.

Wheeler, Candace. "Art Education for Women." *Outlook* 55 (January 2, 1897): 81–89.

———. *The Development of Embroidery in America.* New York: Harper and Bros., 1921.

———. "Home Industries and Domestic Manufactures." *Outlook* 63 (October 14, 1899): 402–6.

———. *How to Make Rugs.* New York: Doubleday, Page and Co., 1919.

———. *Principles of Home Decoration.* New York: Doubleday, Page and Co., 1903.

———. *Yesterdays in a Busy Life.* New York: Harper and Bros., 1918.

———. ed. *Household Art.* New York: Harper and Bros., 1893.

White, Richard Grant. *Companion to the Bryan Gallery of Christian Art.* New York: Baker, Godwin and Co., 1853.

Whitman, Sarah W. "Art in the Public Schools." *Atlantic Monthly* 79 (May 1897): 617–23.

Whitney, Gertrude Vanderbilt. Manuscripts. Gift of Flora Miller Irving. Archives of American Art, New York.

Whitney Museum of American Art. *Juliana Force and American Art: A Memorial Exhibition.* New York: Whitney Museum of American Art, 1949.

———. Manuscripts. Archives of American Art, New York.

Whitney Museum of American Art: History, Purpose, and Activities. New York: Whitney Museum of American Art, 1935.

Whitney Studio Club and Whitney Studio Galleries. Papers. Archives of American Art, New York.

Wilson, James Grant. *Bryant and His Friends: Some Reminiscences of the Knickerbocker Writers.* New York: Fords, Harvard and Hulbert, 1886.

Winslow, Helen M. "The Story of the Woman's Club Movement." *New England Magazine,* n.s. 38 (June 1908): 543–47; n.s. 39 (October 1908): 214–22; n.s. 39 (November 1908): 300–310.

Wister, Frances Anne. *Twenty-five Years of the Philadelphia Orchestra.* Philadelphia: Women's Committee of the Philadelphia Orchestra, 1925.

"Women Artists." *Living Age* 220 (March 18, 1899): 730–32.

Women's Art Museum Association. Circular. Cincinnati: Women's Art Museum Association, March 12, 1877.

Women's Art Museum Association of Cincinnati, 1877–1886. Cincinnati: Robert R. Clarke and Co., 1886.

Women's Educational and Industrial Union. *Annual Report.* Boston, 1886.

Zueblin, Rho Fisk. "Patronage of the Arts and Crafts." *Chatuaquan* 37 (June 1903): 266–72.

Secondary Sources

Adler, Kathleen, and Tamar Garb. *Berthe Morisot.* Ithaca: Cornell University Press, 1987.

Alexander, Charles C. *Here the Country Lies: Nationalism and the Arts in Twentieth-Century America.* Bloomington: Indiana University Press, 1980.

Anscombe, Isabelle. *A Woman's Touch: Women in Design from 1860 to the Present Day.* New York: Viking, 1984.

Ashton, Dore. *The New York School: A Cultural Reckoning.* New York: Penguin Books, 1979.

Baekeland, Frederick. "Collectors of American Painting, 1813–1913." *American Art Review* 3 (1976): 120–57.

Baker, Elizabeth C. "Sexual Art-Politics." In Thomas B. Hess and Elizabeth C. Baker, eds., *Art and Sexual Politics,* 108–19. New York: Collier Macmillan Publishers, 1971.

Baker, Paul, R. *Richard Morris Hunt.* Cambridge: MIT Press, 1980.

Baker, Paula. "The Domestication of Politics: Women and American Political Society, 1780–1920." *American Historical Review* 89 (June 1984): 620–47.

Baltzell, E. Digby. *Puritan Boston and Quaker Philadelphia: Two Protestant Ethics and the Spirit of Class Authority and Leadership.* Boston: Beacon Press, 1979.

Bank, Mirra. *Anonymous Was a Woman.* New York: St. Martin's Press, 1979.

Bender, Thomas. *New York Intellect: A History of Intellectual Life in New York City from 1750 to the Beginning of Our Own Time.* New York: Alfred A. Knopf, 1987.

Benson, Susan Porter. *Counter Cultures: Saleswomen, Managers, and Customers in American Department Stores, 1890–1940.* Urbana: University of Illinois Press, 1986.

Berg, Barbara J. *The Remembered Gate: Origins of American Feminism: The Woman and the City, 1800–1860.* New York: Oxford University Press, 1978.

Berman, Avis. *Rebels on Eighth Street: Juliana Force and the Whitney Museum of American Art.* New York: Atheneum, 1990.

Bishop, Robert, and Patricia Coblentz. *American Decorative Arts: Three Hundred and Sixty Years of Creative Design.* New York: Harry N. Abrams, 1982.

Blair, Karen. *The Clubwoman as Feminist: True Womanhood Redefined, 1868–1914.* New York: Holmes and Meier, 1980.

Bledstein, Burton J. *The Culture of Professionalism: The Middle Class and the Development of Higher Education in America.* New York: W. W. Norton and Co., 1976.

Bloch, E. Maurice. *George Caleb Bingham: The Evolution of an Artist.* Berkeley: University of California Press, 1967.

Bode, Carl. *Antebellum Culture.* Carbondale: Southern Illinois University Press, 1959.

Bohan, Ruth L. *The Société Anonyme's Brooklyn Exhibition: Katherine Dreier and Modernism in America.* Ann Arbor: UMI Research Press, 1982.

Bolton-Smith, Robin, and William H. Truettner. *Lilly Martin Spencer, 1822– 1902: The Joys of Sentiment.* Washington: Smithsonian Institution Press, 1973.

Boris, Eileen. *Art and Labor: Ruskin, Morris, and the Craftsman Ideal in America.* Philadelphia: Temple University Press, 1986.

Branch, Douglas E. *The Sentimental Years, 1836–1860: A Social History.* 1934. New York: Hill and Wang, 1962.

Breeskin, Adelyn D. *Mary Cassatt: A Catalogue Raisonné of the Oils, Water-Colors, and Drawings.* Washington: Smithsonian Institution Press, 1970.

Bremner, Robert H. *The Public Good: Philanthropy and Welfare in the Civil War Era.* New York: Alfred A. Knopf, 1980.

Brinnin, John Malcolm. *The Third Rose: Gertrude Stein and Her World.* New York: Addison-Wesley Publishing Co., 1959.

Brooklyn Museum. *The American Renaissance, 1876–1917.* New York: Pantheon Books, 1979.

Brown, Carol. "Sexism and the Russell Sage Foundation." *Signs* 1 (1972): 25–44.

Brown, Milton W. *American Painting from the Armory Show to the Depression.* Princeton: Princeton University Press, 1955.

———. *The Story of the Armory Show.* New York: Abbeville Press, 1988.

Brown, Milton W., Sam Hunter, John Jacobs, Naomi Rosenblum, and David M. Sokol. *American Art.* New York: Harry N. Abrams, 1979.

Bullard, E. John. *Mary Cassatt: Oils and Pastels.* New York: Watson-Guptill, 1976.

Burke, Doreen Bolger, Jonathan Freedman, Alice Cooley Freylinghuysen, David A. Hanks, Marilynn Johnson, James D. Kornwolf, Catherine Lynn, Roger B. Stein, Jennifer Toher, and Catherine Hoover Voorsanger. *In Pursuit of Beauty: Americans and the Aesthetic Movement.* New York: Rizzoli, 1987.

Burt, Nathaniel. *Palaces for the People: A Social History of the American Art Museum.* Boston: Little, Brown and Co., 1977.

Callen, Anthea. *Women Artists of the Arts and Crafts Movement, 1870–1914.* New York: Pantheon Books, 1979.

Callow, James T. *Kindred Spirits: Knickerbocker Writers and American Artists, 1807–1855.* Chapel Hill: University of North Carolina Press, 1967.

Carter, Morris. *Isabella Stewart Gardner and Fenway Court.* Boston: Isabella Stewart Gardner Museum, 1925.

Chadwick, Whitney. *Women, Art, and Society.* London: Thames and Hudson, 1990.

Chandler, Alfred D., Jr. *The Visible Hand: The Managerial Revolution in American Business.* Cambridge: Harvard University Press, 1977.

Chase, Mary Ellen. *Abby Aldrich Rockefeller.* New York: Avon Books, 1950.

Cikovsky, Nicolai, Jr., and Michael Quick. *George Inness.* New York: Harper and Row, 1985.

Cincinnati Art Museum. *The Ladies, God Bless 'Em: The Women's Art Movement in the Nineteenth Century.* Cincinnati: Cincinnati Art Museum, 1976.

Clark, H. Nichols B. *Francis W. Edmonds: American Master in the Dutch Tradition.* Washington: Smithsonian Institution Press, 1988.

Clark, Clifford Edward, Jr. *The American Family Home, 1800–1960.* Chapel Hill: University of North Carolina Press, 1986.

Clark, Eliot. *History of the National Academy of Design, 1825–1953.* New York: Columbia University Press, 1954.

Conrad, Susan Phinney. *Perish the Thought: Intellectual Women in Romantic America, 1830–1860.* New York: Oxford University Press, 1976.

Constable, William G. *Art Collecting in the United States of America.* London: Thomas Nelson and Sons, 1964.

Cott, Nancy F. *The Bonds of Womanhood: "Woman's Sphere" in New England, 1780–1835.* New Haven: Yale University Press, 1977.

———. *The Grounding of Modern Feminism.* New Haven: Yale University Press, 1987.

Cowdrey, Mary Bartlett. *The American Academy of Fine Arts and American Art-Union, 1816–1851.* New York: New-York Historical Society, 1953.

Cowley, Malcolm. *Exile's Return: A Literary Odyssey of the 1920s.* New York: Viking Press, 1934.

Dewhurst, C. Kurt, Betty MacDowell, and Marsha MacDowell. *Artists in Aprons: Folk Art by American Women.* New York: E. P. Dutton, 1979.

DiMaggio, Paul. "Cultural Entrepreneurship in Nineteenth-Century Boston: The Creation of an Organizational Base for High Culture in America." *Media, Culture, and Society* 4 (1982): 33–50.

———. *Organizing Culture.* New York: Basic Books, forthcoming.

Doeringer, David B. "Asher B. Durand and Henry Kirke Brown: An Artistic Friendship." *American Art Journal* 20 (1988): 74–83.

Douglas, Ann. *The Feminization of American Culture.* New York: Alfred A. Knopf, 1977.

Downs, Joseph. "A Handbook of the Pennsylvania German Galleries in the American Wing." New York: Metropolitan Museum of Art, 1934.

Dublin, Thomas. *Women at Work: The Transformation of Work and Community in Lowell, Massachusetts, 1826–1860.* New York: Columbia University Press, 1979.

Dudden, Faye E. *Serving Women: Household Service in Nineteenth-Century America.* Middletown, Connecticut: Wesleyan University Press, 1983.

Edel, Leon. *Henry James: The Middle Years, 1882–1895.* 1962. New York: Avon Books, 1978.

Entriken, Isabelle Webb. *Sarah Josepha Hale and Godey's Lady's Book.* Philadelphia: privately printed, 1946.

Epstein, Barbara Lee. *The Politics of Domesticity: Women, Evangelicalism, and Temperance in Nineteenth-Century America.* Middletown, Connecticut: Wesleyan University Press, 1981.

Evans, Sara M. *Born for Liberty: A History of Women in America.* New York: Free Press, 1989.

Fairbrother, Trevor J. *The Bostonians: Painters of an Elegant Age, 1870–1930.* Boston: Museum of Fine Arts, 1986.

Faxon, Alicia. "Painter and Patron: Collaboration of Mary Cassatt and Louisine Havemeyer." *Feminist Art Journal* (Fall 1982/Winter 1983): 15–20.

Filene, Peter, G. *Him/Her/Self: Sex Roles in Modern America.* Baltimore: Johns Hopkins University Press, 1974.

Finley, Ruth E. *The Lady of Godey's.* Philadelphia: J. B. Lippincott Co., 1931.

Flexner, James Thomas. *History of American Painting.* 3 volumes. Boston: Little, Brown and Co., 1962. Reprinted New York: Dover Publications, 1970.

Fosdick, Raymond B. *John D. Rockefeller, Jr.: A Portrait.* New York: Harper and Bros., 1956.

Four Americans in Paris: The Collections of Gertrude Stein and Her Family. New York: Museum of Modern Art, 1970.

Fox, Daniel M. *Engines of Culture: Philanthropy and Art Museums.* Madison: State Historical Society of Wisconsin, 1963.

Frankenstein, Alfred. *Painter of Rural America: William Sidney Mount, 1807–1868.* Stony Brook, New York: Suffolk Museum, 1968.

Fredrickson, George M. *The Inner Civil War: Northern Intellectuals and the Crisis of the Union.* New York: Harper and Row, 1965.

Freedman, Estelle. "Separatism as Strategy: Female Institution Building in American Feminism, 1870–1930." *Feminist Studies* 5 (1979): 512–29. Reprinted in Mary Beth Norton, ed., *Major Problems in American Women's History.* Toronto: D. C. Heath and Co., 1989.

Freivogel, Elsie F. "Lilly Martin Spencer: Feminist without Politics." *Archives of American Art Journal* 12 (1972): 9–14.

Friedman, B. H. *Gertrude Vanderbilt Whitney.* Garden City, New York: Doubleday and Co., 1978.

Gardner, Albert Ten Eyck. *Winslow Homer, American Artist: His World and His Work.* New York: Bramball House, 1961.

Gerdts, William H. *American Impressionism.* New York: Abbeville Press, 1984.

———. *The White Marmorean Flock: Nineteenth-Century American Women Neoclassical Sculptors.* Poughkeepsie, New York: Vassar College Art Gallery, 1972.

Gerdts, William H., and Theodore E. Stebbins, Jr. *"A Man of Genius": The Art of Washington Allston (1779–1843).* Boston: Museum of Fine Arts, 1979.

Ginzberg, Lori D. *Women and the Work of Benevolence: Morality, Politics, and Class in the Nineteenth-Century United States.* New Haven: Yale University Press, 1990.

Goodrich, Lloyd. *Edward Hopper*. New York: Whitney Museum of American Art, 1964.

Gordon, Jean. "Early American Women Artists and the Social Context in Which They Worked." *American Quarterly* 30 (Spring 1978): 54–69.

Gorn, Elliott J. *The Manly Art: Bare-Knuckle Prize Fighting in America*. Ithaca: Cornell University Press, 1986.

Graham, Julie. "American Women Artists' Groups, 1867–1930." *Feminist Art Journal* 1 (Spring–Summer 1980): 7–12.

Greer, Germaine. *The Obstacle Race: The Fortunes of Women Painters and Their Work*. New York: Farrar, Straus and Giroux, 1979.

Guide to the Collection: Isabella Stewart Gardner Museum. Boston: Trustees of the Isabella Stewart Gardner Museum, 1976.

Guilbaut, Serge. *How New York Stole the Idea of Modern Art: Abstract Expressionism, Freedom, and the Cold War*. Chicago: University of Chicago Press, 1983.

Hale, Nancy. *Mary Cassatt: A Biography of the Great American Painter*. Garden City, New York: Doubleday and Co., 1975.

Handlin, David P. *The American Home: Architecture and Society, 1815–1915*. Boston: Little, Brown and Co., 1979.

Harr, John Ensor, and Peter J. Johnson. *The Rockefeller Century: Three Generations of America's Greatest Family*. New York: Scribner's Sons, 1988.

Harris, Ann Sutherland, and Linda Nochlin. *Women Artists, 1550–1950*. New York: Alfred A. Knopf, 1976.

Harris, Neil. *The Artist in American Society: The Formative Years, 1790–1860*. New York: Simon and Schuster, 1966.

———. "The Gilded Age Revisited: Boston and the Museum Movement." *American Quarterly* 14 (Winter 1964): 545–66.

Hayes, Bartlett. *Art in Transition: A Century of the Museum School*. Boston: Museum of Fine Arts, 1977.

Hendricks, Gordon. *The Life and Work of Winslow Homer*. New York: Harry N. Abrams, 1979.

Hewitt, Nancy A. "The Social Origins of Women's Antislavery Politics in Western New York." In Alan M. Kraut, ed., *Crusaders and Compromisers: Essays on the Relationship of the Antislavery Struggle to the Antebellum Party System*, 205–34. Westport, Connecticut: Greenwood Press, 1983.

———. *Women's Activism and Social Change: Rochester, New York, 1822–1872*. Ithaca: Cornell University Press, 1984.

Higham, John. "The Reorientation of American Culture in the 1890s." In John Higham, ed., *Writing American History: Essays on Modern Scholarship*, 71–102. Bloomington: Indiana University Press, 1970.

Higonnet, Anne. "Where There's a Will . . ." *Art in America* 79 (May 1989): 65–75.

Hill, Patricia R. *The World Their Household: The American Woman's Foreign*

Mission Movement and Cultural Transformation, 1870–1920. Ann Arbor: University of Michigan Press, 1985.

Hirsch, Susan E. *The Roots of the American Working Class.* Philadelphia: University of Pennsylvania Press, 1978.

Hobhouse, Janet. *Everybody Who Was Anybody: A Biography of Gertrude Stein.* New York: Doubleday, 1975.

Hofstadter, Richard. *Anti-intellectualism in American Life.* New York: Vintage Books, 1962.

——. *Social Darwinism in American Thought.* Boston: Beacon Press, 1955.

Holt, Elizabeth Gilmor, ed. *The Triumph of Art for the Public.* Garden City, New York: Anchor Press, Doubleday, 1979.

Homer, William Inness. *Alfred Stieglitz and the American Avant-Garde.* Boston: New York Graphic Society, 1977.

Hoopes, Donelson. *Childe Hassam.* New York: Watson-Guptill, 1979.

Hoppin, Martha J. "Women Artists in Boston, 1870–1900: The Pupils of William Morris Hunt." *American Art Journal* 13 (Winter 1981): 17–46.

Horowitz, Helen Lefkowitz. *Alma Mater: Design and Experience in the Women's Colleges from their Nineteenth-Century Beginnings to the 1930s.* Boston: Beacon Press, 1986.

——. *Culture and the City: Cultural Philanthropy in Chicago from the 1880s to 1917.* Lexington: University of Kentucky Press, 1976.

Howat, John K. *The Hudson River and Its Painters.* New York: American Legacy Press, 1983.

——. *John Frederick Kensett, 1816–1872.* New York: American Federation of Arts, 1968.

Howe, Winifred E. *A History of the Metropolitan Museum of Art.* 2 volumes. New York: Metropolitan Museum of Art, 1913; Columbia University Press, 1946.

Huber, Christine Jones. *The Pennsylvania Academy and Its Women.* Philadelphia: Pennsylvania Academy of the Fine Arts, 1974.

Huntington, David C. *The Quest for Unity: American Art between World's Fairs, 1876–1893.* Detroit: Detroit Institute of Arts, 1983.

Hyland, Douglas K. S. "Agnes Ernst Meyer: Patron of American Modernism." *American Art Journal* 12 (Winter 1980): 64–81.

Jacobs, Michael. *The Good and Simple Life: Artist Colonies in Europe and America.* Oxford: Phaidon Press, 1985.

James, Edward T., Janet Wilson James, and Paul S. Boyer, eds. *Notable American Women.* 3 volumes. Cambridge: Harvard University Press, 1971.

Johnson, Paul. *A Shopkeeper's Millennium: Society and Revivals in Rochester, New York, 1815–1837.* New York: Hill and Wang, 1978.

Jones, Caroline A. *Modern Art at Harvard: The Formation of the Nineteenth- and Twentieth-Century Collections of the Harvard University Art Museums.* New York: Abbeville Press, 1985.

Kaplan, Justin. *Lincoln Steffens: A Biography.* New York: Simon and Schuster, 1974.

Kaplan, Wendy, ed. *"The Art That Is Life": The Arts and Crafts Movement in America, 1875–1920.* Boston: Little, Brown and Co., 1987.

Karl, Barry D., and Stanley N. Katz. "The American Philanthropic Foundation and the Public Sphere, 1890–1930." *Minerva* 19 (Summer 1981): 236–70.

Kerber, Linda. *Women of the Republic: Intellect and Ideology in Revolutionary America.* Chapel Hill: University of North Carolina Press, 1980.

Kessler-Harris, Alice. *Out to Work: A History of Wage-Earning Women in the United States.* New York: Oxford University Press, 1982.

Kimball, LeRoy E. "The Old University Building and the Society's Years on Washington Square." *New-York Historical Society Quarterly* 32 (July 1948): 149–219.

Koch, Robert. *Louis C. Tiffany: Rebel in Glass.* New York: Crown Publishers, 1964.

Korzenik, Diana. "Feminist Art Educator: Henry Walker Herrick." *Women Artists News* 12 (February to March 1987): 8–9.

Larkin, Oliver W. *Samuel F. B. Morse and American Democratic Art.* Boston: Little, Brown and Co., 1954.

Lawall, David. *Asher B. Durand: A Documentary Catalogue of the Narrative and Landscape Paintings.* New York: Garland Publishers, 1978.

———. *Asher Brown Durand: His Art and Art Theory in Relation to His Times.* New York: Garland Publishers, 1977.

Leach, William. *True Love and Perfect Union: The Feminist Reform of Sex and Society.* New York: Basic Books, 1980.

Lears, T. Jackson. *No Place of Grace: Antimodernism and the Transformation of American Culture, 1880–1920.* New York: Pantheon Books, 1981.

Lebsock, Suzanne. *The Free Women of Petersburg: Status and Culture in a Southern Town, 1784–1860.* New York: W. W. Norton and Co., 1985.

Lerner, Gerda. "Placing Women in History: Definitions and Challenges." *Feminist Studies* 3 (Fall 1975): 5–14.

———. ed. *The Majority Finds Its Past: Placing Women in History.* New York: Oxford University Press, 1979.

Leuchtenburg, William E. *The Perils of Prosperity, 1914–1932.* Chicago: University of Chicago Press, 1958.

Levine, Lawrence W. *Highbrow/Lowbrow: The Emergence of Cultural Hierarchy in America.* Cambridge: Harvard University Press, 1988.

"Lilly Martin Spencer." *Archives of American Art Journal* 12 (1972): 9–14.

Lisle, Laurie. *Portrait of an Artist: A Biography of Georgia O'Keeffe.* New York: Simon and Schuster, 1980.

Livermore, Mary. *My Story of the War.* Hartford: A. D. Worthington and Co., 1889.

Lubove, Roy. *The Professional Altruist: The Emergence of Social Work as a Career, 1880–1930*. New York: Atheneum, 1965.

Lynch, Michael. "Here Is Adhesiveness: From Friendship to Homosexuality." *Victorian Studies* 29 (Autumn 1985): 67–96.

Lynes, Barbara Buhler. *O'Keeffe, Stieglitz, and the Critics, 1916–1929*. Ann Arbor: UMI Research Press, 1989.

Lynes, Russell. *Good Old Modern: An Intimate Portrait of the Museum of Modern Art*. New York: Atheneum, 1973.

———. *More Than Meets the Eye: The History and Collections of Cooper-Hewitt Museum*. Washington: Smithsonian Institution, 1981.

———. *The Tastemakers: The Shaping of American Popular Taste*. New York: Harper and Bros., 1955.

Mabee, Carleton. *The American Leonardo: A Life of Samuel F. B. Morse*. New York: Alfred A. Knopf, 1943.

McAlister, Anna Shannon. *In Winter We Flourish: Life and Letters of Sarah Worthington King Peter, 1800–1877*. New York: Longmans, Green and Co., 1939.

McCarthy, Kathleen D. *Noblesse Oblige: Charity and Cultural Philanthropy in Chicago, 1849–1929*. Chicago: University of Chicago Press, 1982.

———, ed. *Lady Bountiful Revisited: Women, Philanthropy, and Power*. New Brunswick, New Jersey: Rutgers University Press, 1990.

McClaugherty, Martha Crabill. "Household Art: Creating the Artistic Home, 1868–1893." *Winterthur Portfolio* 18 (Spring 1983): 1–26.

Mainardi, Patricia. "Quilts: The Great American Art." In Norma Broude and Mary D. Garrard, eds., *Feminism and Art History: Questioning the Litany*, 331–46. New York: Harper and Row, 1982.

Mann, Maybelle. *The American Art-Union*. Washington: Collage, 1977.

Marquis, Alice Goldfarb. *Alfred H. Barr, Jr.: Missionary for the Modern*. Chicago: Contemporary Books, 1989.

May, Henry F. *The End of American Innocence: A Study of the First Years of Our Own Time, 1912–1917*. Chicago: Quadrangle Books, 1959.

Mead, Margaret. *Male and Female*. New York: Morrow Quill, 1949.

———. "One Aspect of Male and Female." In Johnson E. Fairchild, ed., *Women, Society, and Sex*. New York: Sheridan House, 1952

Merritt, Howard S. *Thomas Cole*. Rochester: Memorial Art Gallery of the University of Rochester, 1969.

Metzger, Charles R. *Emerson and Greenough: Transcendental Pioneers of an American Aesthetic*. Berkeley: University of California Press, 1954.

Miller, Lillian B. *Patrons and Patriotism: The Encouragement of the Fine Arts in the United States, 1790–1860*. Chicago: University of Chicago Press, 1966.

Mills, C. Wright. *The Power Elite*. New York: Oxford University Press, 1956.

Morantz-Sanchez, Regina Markell. *Sympathy and Science: Women Physicians in American Medicine.* New York: Oxford University Press, 1985.

Morgan, H. Wayne. *New Muses: Art in American Culture, 1865–1920.* Norman: University of Oklahoma Press, 1978.

Museum of Modern Art, New York. New York: Harry N. Abrams, 1984.

Nielsen, Waldemar. *The Big Foundations.* New York: Columbia University Press, 1972.

Noble, Louis L. *The Life and Works of Thomas Cole.* New York: Sheldon, Blakeman and Co., 1856.

Nochlin, Linda. "Why Have There Been No Great Women Artists?" In Thomas B. Hess and Elizabeth C. Baker, eds., *Art and Sexual Politics,* 1–43. New York: Collier Macmillan Publishers, 1971.

————. *Women, Art, Power, and Other Essays.* New York: Harper and Row, 1988.

Novak, Barbara. *American Painting of the Nineteenth Century: Realism, Idealism, and the American Experience.* New York: Harper and Row, 1969.

Orosz, Joel. *Curators and Culture: The Museum Movement in America, 1740–1870.* Tuscaloosa: University of Alabama Press, 1990.

Paine, Judith. "The Woman's Pavilion of 1876." *Feminist Art Journal* 4 (Winter 1975–76): 5–12.

Parker, Rozsika, and Griselda Pollock. *Old Mistresses: Women, Art, and Ideology.* New York: Pantheon Books, 1981.

Pauline Palmer: American Impressionist. Peoria: Lakeview Museum of Arts and Sciences, 1984.

Peiss, Kathy. *Cheap Amusements: Working Women and Leisure in Turn-of-the-Century New York.* Philadelphia: Temple University Press, 1986.

Perlman, Bernard B. *Painters of the Ashcan School: The Immortal Eight.* New York: Dover Publications, 1979.

Pisano, Ronald G. *The Students of William Merritt Chase.* Huntington, New York: Heckscher Museum, 1973.

————. *William Merritt Chase.* New York: Watson-Guptill, 1986.

Pleck, Elizabeth H., and Joseph H. Pleck, eds. *The American Man.* Englewood Cliffs, New Jersey: Prentice Hall, 1980.

Pollock, Griselda. "Women, Art, and Ideology: Questions for Feminist Art Historians." *Woman's Art Journal* 1 (Spring/Summer 1983): 39–46.

Pred, Alan R. *Urban Growth and the Circulation of Information: The United States System of Cities, 1790–1840.* Cambridge: Harvard University Press, 1973.

Prown, Jules David. *American Painting from Its Beginnings to the Armory Show.* New York: Rizzoli, 1980.

Reverby, Susan W. *Ordered to Care: The Dilemma of American Nursing, 1850–1945.* New York: Cambridge University Press, 1987.

Richardson, Brenda. *Dr. Claribel and Miss Etta.* Baltimore: Baltimore Museum of Art, n.d.

Richardson, Edgar Preston. *Washington Allston: A Study of the Romantic Artist in America.* Chicago: University of Chicago Press, 1948.

Rogers, Millard F., Jr. "Mary M. Emery: Development of an American Collector." *Cincinnati Art Museum Bulletin* 13 (December 1986): 5–19.

Rosen, Ruth. *The Lost Sisterhood: Prostitution in America, 1900–1918.* Baltimore: Johns Hopkins University Press, 1982.

Rosenberg, Rosalind. *Beyond Separate Spheres: Intellectual Roots of Modern Feminism.* New Haven: Yale University Press, 1982.

Rosenzweig, Roy. *Eight Hours for What We Will: Workers and Leisure in an Industrial City, 1870–1920.* New York: Cambridge University Press, 1983.

Ross, Steven J. *Workers on the Edge: Work, Leisure, and Politics in Industrializing Cincinnati, 1788–1890.* New York: Columbia University Press, 1985.

Rossiter, Margaret W. *Women Scientists in America: Struggles and Strategies to 1940.* Baltimore: Johns Hopkins University Press, 1982.

Rubenstein, Charlotte Streifer. *American Women Artists.* New York: Avon Books, 1982.

Ryan, Mary P. *Cradle of the Middle Class: Family in Oneida County, New York, 1790–1865.* New York: Cambridge University Press, 1981.

———. "The Power of Women's Networks." In Judith L. Newton, Mary P. Ryan, and Judith R. Walkowitz, eds., *Sex and Class in Women's History,* 167–86. London: Routledge, Kegan and Paul, 1983.

Rydell, Robert W. *All the World's a Fair: Visions of Empire at American International Expositions, 1876–1916.* Chicago: University of Chicago Press, 1984.

Saarinen, Aline B. *The Proud Possessors: The Lives, Times, and Tastes of some Adventurous American Art Collectors.* New York: Random House, 1958.

Saisselin, Remy G. *The Bourgeois and the Bibelot.* New Brunswick, New Jersey: Rutgers University Press, 1984.

Samuels, Ernest. *Bernard Berenson: The Making of a Connoisseur.* Cambridge: Harvard University Press, 1979.

———. *Bernard Berenson: The Making of a Legend.* Cambridge: Harvard University Press, 1987.

Schlesinger, Arthur M., Sr. "Biography of a Nation of Joiners." *American Historical Review* 50 (October 1944): 1–25.

Schmeckebier, Laurence E. *John Steuart Curry's Pageant of America.* New York: American Artist Group, 1943.

Scott, Joan. "Gender: A Useful Category of Historical Analysis." *American Historical Review* 91 (December 1986): 1053–75.

Sherman, Claire Richter, and Adele M. Holcomb, eds. *Women as Interpreters of the Visual Arts, 1820–1979.* Westport, Connecticut: Greenwood Press, 1981.

Sicherman, Barbara, and Carol Hurd Green. *Notable American Women: The Modern Period.* Cambridge: Harvard University Press, 1980.

Siegl, Theodore. *The Thomas Eakins Collection.* Philadelphia: Philadelphia Museum of Art, 1978.

Silk, Leonard, and Mark Silk. *The American Establishment.* New York: Basic Books, 1980.

Sinclair, Bruce. *Philadelphia's Philosopher Mechanics: A History of the Franklin Institute, 1824–1865.* Baltimore: Johns Hopkins University Press, 1974.

Sklar, Kathryn Kish. *Catharine Beecher: A Study in American Domesticity.* New Haven: Yale University Press, 1973.

———. "Hull-House in the 1890s: A Community of Women Reformers." *Signs* 10 (1985): 657–77.

———. "Who Funded Hull House?" In Kathleen D. McCarthy, ed., *Lady Bountiful Revisited: Women, Philanthropy, and Power,* 94–115. New Brunswick, New Jersey: Rutgers University Press, 1990.

Smith-Rosenberg, Carroll. *Disorderly Conduct: Visions of Gender in Victorian America.* New York: Oxford University Press, 1985.

Solomon, Barbara Miller. *In the Company of Educated Women: A History of Women and Higher Education in America.* New Haven: Yale University Press, 1985.

Spassky, Natalie. *Mary Cassatt.* New York: Metropolitan Museum of Art, 1984.

Stansell, Christine. *City of Women: Sex and Class in New York, 1789–1860.* New York: Alfred A. Knopf, 1986.

Stansky, Peter. *Redesigning the World: William Morris, the 1880s, and the Arts and Crafts.* Princeton: Princeton University Press, 1985.

Stebbins, Theodore E., Jr., Carol Troyan, and Trevor J. Fairbrother. *A New World: Masterpieces of American Painting, 1760–1910.* Boston: Museum of Fine Arts, 1983.

Stillinger, Elizabeth. *The Antiquers.* New York: Alfred A. Knopf, 1980.

Story, Ronald. *Harvard and the Boston Upper Class: The Forging of an Aristocracy, 1800–1870.* Middletown, Connecticut: Wesleyan University Press, 1980.

Strouse, Jean. *Alice James: A Biography.* Boston: Houghton Mifflin, 1980.

Swan, Susan Burrows. *Plain and Fancy: American Women and Their Needlework, 1700–1850.* New York: Holt, Rinehart and Winston, 1977.

Sweet, Frederick A. *Miss Mary Cassatt, Impressionist from Pennsylvania.* Norman: University of Oklahoma Press, 1966.

Taylor, Francis Henry. *Pierpont Morgan as Collector and Patron, 1837–1913.* New York: Pierpont Morgan Library, 1957.

Taylor, Joshua C. *America as Art.* New York: Harper and Row, 1976.

———. *The Fine Arts in America.* Chicago: University of Chicago Press, 1979.

Taylor, William R. *Cavalier and Yankee: The Old South and American National Character.* New York: George Braziller, 1961.

Tharp, Louise Hall. *Mrs. Jack: A Biography of Isabella Stewart Gardner.* Boston: Little, Brown and Co., 1965.

Thompson, E. P. *The Making of the English Working Class*. New York: Vintage Books, 1966.

———. *William Morris: Romantic to Revolutionary*. New York: Pantheon Books, 1977.

Tomkins, Calvin. *Merchants and Masterpieces: The Story of the Metropolitan Museum of Art*. New York: E. P. Dutton and Co., 1973.

Troyen, Carol. *The Boston Tradition: American Paintings from the Museum of Fine Arts, Boston*. New York: American Federation of Arts, 1980.

Troyen, Carol, and Pamela S. Tabbaa. *The Great Boston Collectors: Paintings from the Museum of Fine Arts*. Boston: Museum of Fine Arts, 1984.

Tufts, Eleanor, ed. *American Women Artists, 1830–1930*. Washington: National Museum of Women in the Arts, 1987.

Turner, Victor. *The Ritual Process: Structure and Anti-structure*. Ithaca: Cornell University Press, 1969.

Van Gennep, Arnold. *The Rites of Passage*. 1908. Chicago: University of Chicago Press, 1960.

Vicinus, Martha. *Independent Women: Work and Community for Single Women, 1850–1920*. Chicago: University of Chicago Press, 1985.

Wallace, Anthony F. C. *Rockdale: The Growth of an American Village in the Early Industrial Revolution*. New York: W. W. Norton and Co., 1971.

Walsh, Mary Roth. *"Doctors Wanted: No Women Need Apply": Sexual Barriers in the Medical Profession, 1835–1975*. New Haven: Yale University Press, 1977.

Weimann, Jeanne Madeline. *The Fair Women: The Story of the Woman's Building, World's Columbian Exposition, Chicago, 1893*. Chicago: Academy Chicago, 1981.

Weitzenhoffer, Frances. *The Havemeyers: Impressionism Comes to America*. New York: Harry N. Abrams, 1986.

Whitehill, Walter M. *Museum of Fine Arts, Boston: A Centennial History*. 2 volumes. Cambridge: Harvard University Press, 1970.

Whyte, William H. *The Organization Man*. New York: Simon and Schuster, 1956.

Wichmann, Siegfried. *Japonisme: The Japanese Influence on Western Art in the Nineteenth and Twentieth Centuries*. New York: Harmony Books, 1980.

Wiebe, Robert. *The Search for Order*. New York: Hill and Wang, 1967.

Williams, Herman Warner, Jr. *Mirror to the American Past: A Survey of American Genre Painting, 1750–1900*. Greenwich, Connecticut: New York Graphic Society, 1973.

Winant, Marguerite Dawson. *A Century of Sorosis, 1868–1968*. New York: Sorosis, 1968.

Wittke, Carl. *The First Fifty Years: The Cleveland Museum of Art, 1916–1966*. Cleveland: Museum of Art, 1966.

Wright, Gwendolyn. *Moralism and the Model Home: Domestic Architecture and Cultural Conflict in Chicago, 1873–1913*. Chicago: University of Chicago Press, 1980.

Yale University Art Gallery. *Pictures for a Picture: Gertrude Stein as a Collector and Writer on Art and Artists.* New Haven: Yale University Press, 1951.

Zilcar, Judith. "Alfred Stieglitz and John Quinn: Allies in the American Avant-Garde." *American Journal* 17 (Summer 1985): 18–33.

Zweig, Paul. *Walt Whitman: The Making of the Poet.* New York: Basic Books, 1984.

Index

Abolitionism, 4, 38, 40
Académie Colarossi, 94, 105
Académi des Beaux Arts, 94
Académie Julian, 89, 94, 105
Adams, Henry, 163, 171
Adams, John Quincy, 12, 28
Addams, Jane, 67, 77, 187, 222, 223
Agassiz, Ida. *See* Higinson, Ida
 Agassiz
Ahmedabad Wood Carving Company, 67
Albright, Gallery, 204
Alcott, Bronson, 28
Alcott, May, 107
Aldis, Arthur, 191
Aldrich, Lucy, 200
Alexander, John W., 77, 220–21,
 226–27
Allston, Washington, 12, 22–23, 28,
 216
Altman, Benjamin, 121–22, 167
Alvord, Lady Marion, 90
American Academy of Fine Arts, 23
American art: and antebellum-era
 collectors, 11, 32; at Art Institute,
 134; Ashcan school, 187, 227–28,
 234, 238; Hudson River school,
 22, 121; loss of interest in, 95,
 98–99, 112–13; at Metropolitan
 Museum, 124; and Whitney, 215,
 227–44
American Art-Union (AAU), 17, 25–
 27, 32, 34
American Federation of the Arts,
 187
American Folk Art Gallery, 272n.37
Amherst College, 175

Anatomy, study of, 85, 87, 89, 93
Andersen, Hendrik Christian, 219,
 221
Anscombe, Isabelle, 46–47
Anti-intellectualism, 98, 151–52
Antiquarian Society, 132–34
Apollinaire, Guillaume, 183
Apollo Association, 25
Appleton, Mrs. Samuel, 90
Arensberg, Walter, 189, 193, 195,
 210
Armory show: and Bliss, 196–97;
 history of, 184–88; mentioned,
 190, 198, 206, 228
Armour, P. D., 130
Art Amateur, 103
"Art and Nature" (Stowe), 7
Arthur, T. S., 7
Art Institute of Chicago: and avant-
 garde, 184–86, 192; women's role
 in, 125, 130–35, 143, 144; men-
 tioned, ix, 105, 187
Art Interchange (journal), 51
"Artistic Impulse in Man and
 Woman, The" (Randall), 84
Artist's Fund Society, 10, 20, 32
Art of This Century (gallery), 244
Arts (journal), 228
Arts and Crafts Club (New Orleans),
 235
Arts and crafts movement, 60, 67–71
Arts Club, 192–93
Art Students League, 88, 99–100,
 105, 221, 224
Ashburton, Lady Louisa, 90
Ashcan school, 187, 227–28, 234,
 238

Asheville Exchange for Women's Work, 70
Aspinwall, William, 45
Assimilationism: rejection of, 150, 166; strategy of, xv, 81–145, 210, 241
Associate Committee of Women (ACW), 127–30
Associated Artists, 67
Association in Aid of the Museum of Fine Arts, 136, 137
Astor, Augusta, 45
Astor, Mrs. John Jacob, 45, 56, 119
Astor, Mrs. William, 45
Avant-garde, 179–212, 244
Avery, Samuel, 116

Bacon, Peggy, 199, 233, 236
Baker, George F., 118
Baker, Julia, 99
Bakst, Léon, 224
Ball, Thomas, 99
Baltimore, 10
Baltimore Historical Society, 20
Barnard, George Grey, 201
Barnes, Alfred, 210–11
Barnes Foundation, 158
Barr, Alfred H., Jr., 205, 206, 209
Bartlett, Helen Birch, 186
Barton, Susan, 128
Bauhaus, 193
Beal, Gifford, 88, 231
Beard, Mary, 144
Beaux, Cecilia: career of, 106; and Friends of American Art, 135; and Gardner, 163, 165; at Pennsylvania Academy, 99; and Whitney, 227, 229, 230, 239
Beecher, Catharine, 4–6, 223
Bellows, George, 85, 228, 230, 233
Bellows, Henry W., 116
Belmont, August, 50
Belmont, Mrs. August, 20, 89
Bennett, Bessie, 125
Berenson, Bernard, 138, 166–69, 172–75

Berenson, Mary, 163
Berger, Florence Paull, 125
Berman, Avis, 223, 229, 275n.21
Bierstadt, Albert, 39, 97, 98
Bingham, George Caleb, 10
Bird in Space (Brancusi), 186
Blackstone, Isabella, 133, 134
Blaine, Anita McCormick, 134
Bliss, Cornelius, 208
Bliss, Lillie: and Museum of Modern Art, 196–97, 202–4, 206–9, 212; mentioned, 186, 229, 231
Blodgett, Henry, 116
Blodgett, Mrs. William Tilden, 77
Bloomfield-Moore, Clara, 128
Blue Boy (Gainsborough), 168
Blumenthal, Florence, 118, 185
Blumenthal, George, 118
Bolles furniture collection, 120–21
Bonheur, Rosa, 102, 216
Boott, Elizabeth. See Duveneck, Elizabeth Boott
Boston: art and class in, 86; museum development in, 141; women's design schools in, 63; women's exchanges in, 62; mentioned, 27. See also Fenway Court; Museum of Fine Arts (Boston)
Boston Art Committee, 99
Boston Art Students Association, 100
Boston Athenaeum, 12, 17, 24, 26, 27, 135–36
Boston Herald, 184
Boston Museum of Fine Arts, 100, 125
Boston Society of Decorative Art, 49, 52, 61–62, 137
Botta, Anne Lynch, 28, 163
Botticelli, Sandro, 165
Bouguereau, William, 88, 89
Bourgeois and the Bibelot, The (Saisselin), 153–54
Bowen, Louise De Koven, 77
Boxing, 151, 161
Boyd, Harriet, 264n.28

Brancusi, Constantin, 183, 186, 190
Braque, Georges, 192
Bread and Cheese Club, 13
Brearley, W. H., 75
Brewster, Anna Richards, 105
Brimmer, Martin, 136
Brimmer, Mrs. Martin, 52, 136
Brooklyn Art Union, 9–10
Brooklyn Eagle, 238
Brooklyn Museum, 193–94, 235
Brooklyn Woman's Club, 104
Brown, Henry Kirke, 9, 85
Brown, J. Crosby, 143
Brown, Mary Ellen, 122–26
Bryan, Thomas Jefferson, 24, 113, 158
Bryan Gallery of Christian Art, 24
Bryant, William Cullen, 12–13, 25, 26, 50
Bryn Mawr College, 78, 124
Buckingham, Kate, 133
Bureaucracy, 114
Burne-Jones, Edward, 43
Burroughs, Bryson, 186

Campbell, Blendon, 232
Capitalism, 153–56
Carey, Thomas, 11–12
Carnegie, Andrew, 98, 106, 114, 156, 157
Carnegie Institute, 99, 154, 185
Carpenter, Mrs. John A., 192
Carter, Morris, 169, 171, 174
Carter, Susan, 32
Cassatt, Mary: career of, 84–85, 106–9; and Gardner, 163; and Havemeyer, 111, 122, 142; illustration, 82; *Modern Woman,* 102–3; Whitney compared with, 226; mentioned, xiii, 100, 135, 185, 198, 221, 229, 234, 239
Century association, 13, 25, 27, 100, 117
Cesnola, General di, 50, 123, 126
Cézanne, Paul, 106, 180, 182, 185, 186, 206

Chadbourne, Emily Crane, 133, 172–73, 185
Champney, Benjamin, 8
Chanler, Robert, 226
Charity. *See* Philanthropy
Charity Organization Societies, 263n.9
Chase, William Merritt: illustration, 96; as mentor to women painters, 85, 87–88, 105; studio of, 95, 97; and Tile Club, 65, 66; mentioned, 98
Cheney, Ednah Dow, 32
Chicago: arts and crafts movement in, 67–69; Arts Club of, 192–93; Columbian Exposition, 102, 104, 129, 144, 154; fire of 1871, 130, 131, 141; museum development in, 141; mentioned, 27, 49. *See also* Art Institute of Chicago
Chicago Academy of Design, 130–31
Chicago Examiner, 185
Chicago Inter-Ocean, 103
Chicago Society of Arts and Crafts, 67
Chicago Society of Decorative Art (CSDA), 50, 131–32, 133
Chicago Symphony Orchestra, 61
Chicago Woman's Club, 187
Child, Lydia Maria, 90
Choate, Joseph H., 117
Christian, Princess, of Schleswig-Holstein, 41, 64
Church, Frederic, 39, 97
Cincinnati: art institution development in, 27, 28, 30–32, 71–75, 77; decorative arts movement in, 50; women's design schools in, 63; women's exchange in, 62
Cincinnati Commercial, 74
Cincinnati Music Festival, 258n.29
Cincinnati Orphan Asylum, 28, 29
"Circus in Paint, The" (exhibition), 236
Civil War, U.S.: art careers for women after, 95, 109; and decorative arts movement, 48, 52; and Sanitary Commission, 39;

Civil War, U.S. (*continued*)
 mentioned, 89, 98, 112, 131, 141, 151
Clark, Stephen, 206–7
Clarkson, Ralph, 134
Clay, Henry, 28
Clemens, Samuel, 67
Cloisters, 201, 202, 212, 239
Clubs. *See* Men's clubs; Women's clubs
Coburn, Mrs. L. L., 122
Cole, Thomas: career of, 23; friendship circle of, 11–13; mentioned, 16, 25, 37, 86, 88, 98
Colleges: medical, for women, 59–60; women's, finances of, 77–78. *See also* Universities
Colman, Samuel, 47, 67, 108
Columbian Exposition, 102, 104, 129, 144, 154
Columbia University, 70
Committee of Fifty, 117
Cone, Claribel, 183
Cone, Etta, 183
Cook, Clarence, 86
Cooke, Jay, 92, 98
Coolidge, Calvin, 154
Cooper, James Fenimore, 12–13
Cooper, Peter, 76, 174
Cooperative Mural Workshops, 190
Cooper-Hewitt Museum, 75–77, 204
Cooper Union, 32, 76, 94, 101, 174
Copley Society, 100
Corcoran Gallery, 158
Cortissoz, Royal, 194, 223, 238
Cosmopolitan, 104
Cosmopolitan Art Association, 17–18
Cott, Nancy F., 5, 144, 241
Courbet, Gustave, 107
Couture, Thomas, 95
Cowley, Malcolm, 235
Cox, Kenyon, 99–100
Crafts. *See* Decorative arts
Crane, Mrs. W. Murray, 205, 207
Crane, Walter, 43

Croly, Jenny June, 44
Crow, Dr. Wayman, 89–91
Crowninshield, Frank, 205
Crystal Palace Exhibition, 41
Cubism, 182, 184–85
Curry, John Steuart, 236
Curtis, E. L., 230
Cushman, Charlotte, 89, 90

Dadaism, 190–91
Damrosch, Walter, 106, 162
Dana, Richard Henry, 12
Darwin, Charles, 94
Daumier, Honoré, 229
Davidge, Clara, 185, 198
Davies, Arthur B., 106, 184–86, 188, 196–97, 202, 228, 229, 271n.32
Dean, Bashford, 123–24
Decorative arts: antebellum, 5–6, 14–15; and arts and crafts movement, 67–71; and avant-garde, 179–80; at design schools for women, 63–65; and men, 46–47, 56, 65–67; at museums, 71–77, 119, 125, 128–32, 136–37, 139, 144–45; and women's exchanges, 60–63. *See also* Decorative arts movement; Needlework
Decorative arts movement: arts and crafts movement, link with, 70; decline of, 56, 78; history of, 37–56; museums contrasted with, 112, 113; organizations modeled on, 59–61; and prejudice against female artists, 55–56, 83–84, 109
de Forest, Emily, 120–21, 125
de Forest, Lockwood, 47, 67
de Forest, Robert, 120–21
Degas, Edgar, 102, 106–8, 122, 142, 186, 197
Dell, Floyd, 235
Demuth, Charles, 88
Denver Art Museum, 105, 235
Department stores, 53, 54
Depression, Great, 133, 208

Design schools for women, 60, 63–65, 78, 113
Detroit, museum movement in, 75, 77
Detroit Art Loan, 75
Detroit Art Loan Record, 75
Detroit Institute of Arts, 235
Dewey, John, 183
Dewing, Thomas Wilmer, 88
Dick, Harvey Brisbane, 118
Dickens, Charles, 44
DiMaggio, Paul, 112
Dodge, Mabel. *See* Luhan, Mabel Dodge
Doherty, Knucksey, 161
Dole, James H., 130
Domesticity, cult of, 4–8, 15, 38
Dos Passos, John, 228
Douglas, Ann, xi
Downtown Gallery, 198–99, 241
Dreier, Dorothea, 188
Dreier, Katherine: and Armory Show, 185; and avant-garde, 210–11; Société Anonyme of, 187–96; mentioned, xv, 183, 198, 204, 209, 227, 238, 243
Dreier, Mary, 195
Du Bois, Guy Pène, 231, 233, 235
Duchamp, Marcel, 184–85, 190–91, 193–95, 227
Dudley, Katherine, 134–35
Duncan, Isadora, 180, 183
Durand, Asher: career of, 11–13; journeys of, 9; mentioned, 24, 25, 37, 86, 88, 98
Duveen, Henry, 157
Duveen, Sir Joseph, 157, 200, 206
Duveneck, Elizabeth Boott, 87, 88, 96
Duveneck, Frank, 88
Duyckinck, Evert, 12
Duyckinck, George, 12

Eakins, Thomas, 85, 88, 93–94, 105, 109, 206
Earhart, Amelia, 241

Earl, Ralph, 135
Eddy, Arthur Jerome, 210
Edmonds, Francis, 25
Edwards, Julia Cheney, 122
Ellett, Elizabeth, 100–101
Elliott, Maude Howe, 163
Ellis, Mrs., 14
Ellis, Mrs. A. H. M., 265n.40
Embroidery. *See* Needlework
Emerson, Ralph Waldo, 15, 28, 89
England, and decorative arts, 41
Engraving, 5–6, 23–24
Enlightenment, 15, 94, 152
Entrepreneurship, 59–79
Europe: art of, and American collectors, 95, 98–99, 112–13, 153–55; as art world center, 227, 244; women artists in, 89–90
Evans, Anne, 105
Evans, Maria Antoinette, 140, 174
Evans, Robert Dawson, 140

Family Monitor and Domestic Guide, The (Ellis), 14
Fancy work, 47
Farm wives, 69
Fauvism, 182, 184
Feminization myth, ix, 85, 94, 149–53, 155, 176
"Feminizing of Culture, The" (article), 150
Femme couverte, 4
Fenollosa, Ernest, 158
Fenway Court: history of, 169–76; illustration, 164; mentioned, 149–50, 153, 243
Ffoulke, Charles, 139–40, 172–73
Field, Hamilton Easter, 272n.37
Field, Marshall, 130
Field, Mrs. Marshall, 265n.42
Fields, Annie, 163
"50-50 Art Sale," 229
Fish, Hamilton, 50
Fitzgerald, F. Scott, 182
Flagg, George W., 11, 12
Fletcher, Isaac D., 118

Fogg Art Museum, 205, 207, 235
Folk art, 70, 179, 180, 235, 272n.37
"Fontaine" (Duchamp), 190–91
Force, Juliana, 229–43
Fosdick, Raymond, 200–202
Foundations: and sacralization, 113–
 14; women's role in, 143, 144, 176,
 262n.9
Fox, Henry, 193
Fragonard, Jean-Honoré, 157, 174
Franklin Institute, 29
Fraser, James Earle, 221, 224, 227,
 228
Freer, Charles Lang, 158
French, Daniel Chester, 77, 100, 228
French, William M. R., 132, 173
Frick, Henry Clay, 153, 157–58, 173–
 75, 239
Frick Museum, 153, 157–58, 239
Friends of American Art (FAA), 134–
 35, 144, 199
Friends of Young Artists, 231–32
Frishmuth, Mrs. W. D., 129
Fry, Roger, 124, 157
Fuller, Margaret, 28

Gainsborough, Thomas, 156, 168
Gallatin, A. E., 195, 210–12, 229
Galleries: and American art, 236–37;
 antebellum, 113; and avant-garde,
 188; early, 4; feminization of, 150
Gallery of Living Art, 211
Gardner, Elizabeth Jane, 88–89
Gardner, George, 169
Gardner, Isabella Stewart: career of,
 149–76; illustration, 148; and Mu-
 seum of Fine Arts, 138–40, 150,
 161, 168, 171, 175–76; Whitney
 contrasted with, 220, 237, 242,
 243; mentioned, xv, 52, 100, 106,
 179, 204, 210
Gardner, John Lowell, 139, 160–61,
 165–70, 172, 174
Gardner, Julia, 160
Garrett, Mary, 124, 143
Gauguin, Paul, 182, 186, 190, 206

General Federation of Women's
 Clubs, 187
Gennep, Arnold van, 159–60
Gerdts, William, 259n.19
Gibson, Charles Dana, 230
Gibson, John, 90, 91
Gilder, Helena de Kay, 99, 106
Gillespie, Mrs. E. D., 127
Gilmor, Robert: career of, 10–11;
 mentioned, 20, 22, 24, 33, 106,
 158, 211, 243
Girard College, 174
Glackens, Edith Dimock, 236
Glackens, Ira, 228, 234, 240
Glackens, William, 227, 231, 233, 235
Glessner, Frances, 265n.42
Godey's Lady's Book, 4, 6–7, 27, 28,
 47
Gogh, Vincent van, 186, 190, 206
Goldman, Ira, 234
Goldthwaite, Anne, 195, 199, 239
Goodrich, Lloyd, 206, 234
Goodyear, A. Conger, 204–7, 215
Greco, El, 182
Greene, Bella da Costa, 157
Greenough, Horatio, 12–13, 89,
 259n.19
Greenwich House, 219
Greenwich Village, 70, 198–99, 224–
 26, 230, 235
Gregory, Lady, 162
Gris, Juan, 191
Guggenheim, Peggy, 244
Guggenheim, Solomon, 244
Guggenheim Museum, 244

Hale, Sarah Josepha, 4–6, 27, 28,
 250n.29
Hall, Ann, 20
Hallowell, Sara, 103, 122
Halpert, Edith Gregory: on connois-
 seurship of modern art, 189; and
 folk art, 272n.37; and Rockefeller,
 196–99, 204; Whitney compared
 with, 239; mentioned, 70, 159, 209,
 210, 234, 241, 243, 251n.40

Halpert, Samuel, 198
Hare, Meredith ("Bunny"), 219
Harkness, Anna M., 118–20, 141, 174, 262n.9
Harkness, Edward, 119, 202, 204, 206
Harriman, Mrs. E. H., 229
Harrington, Tim, 161
Harrison, Mrs. John, 129
Harshe, Robert, 192, 193
Hart, "Pop," 199–200
Harvard Society for Contemporary Art, Inc., 205
Harvard University: Fogg Art Museum, 205, 207, 235; and museum development, 136, 141; mentioned, 143, 172, 175
Hassam, Childe, 134, 199, 230
Havemeyer, Henry O., 108, 197
Havemeyer, Louisine Elder: career of, 107–8; and Gardner, 163, 167, 175, 176; illustration, 110; and Metropolitan Museum of Art, 111–12, 122; Rockefeller compared with, 197, 198; as suffragist, 142; mentioned, xv, 71, 102, 121, 141, 144, 241
Hawthorne, Nathaniel, 89
Healy, G. P. A., 23, 91
Hearn, George A., 77, 124
Hemingway, Ernest, 182
Henri, Robert: and Whitney, 227–28, 230, 232, 238; mentioned, 134, 187, 209
Henrotin, Ellen, 104
Herring, James, 25
Hewitt, Abram, 76
Hewitt, Amelia, 76–77
Hewitt, Eleanor, 76–77
Hewitt, Frederick C., 118
Higginson, Henry Lee, 100, 172
Higginson, Ida Agassiz, 160, 163, 170
Hoffman, Malvina, 221, 224, 229, 230, 236
Holmes, Mrs. Oliver Wendell, 52, 55
Holmes, Oliver Wendell, 163
Homer, Winslow, 65, 206

Hone, Philip, 9, 12, 13, 45
Hoover, Herbert, 237–38
Hopkins, Ellen Dunlop, 63–64
Hopkinson, Joseph, 20
Hopper, Edward, 228, 235
Hosack, David, 12
Hosmer, Harriet, 89–93, 101, 104, 275n.21
House Palatial, 53
Howe, Julia Ward, 163, 165
Howe, Winifred, 121–22, 126
Howells, William Dean, 97
Hoyt, Mrs. William, 88
Hudson River school, 22, 121
Hull-House, 67–68, 70, 77, 222
Humphreys, Mary Gay, 254n.15
Hunt, Catherine, 45
Hunt, Richard Morris, 45, 47, 97, 216
Hunt, William Morris: as mentor to women painters, 85–87, 88, 93, 104–5, 109; studio of, 95; mentioned, 8, 51, 100, 138, 221
Huntington, Daniel, 9, 13, 22
Hutchinson, Charles, 130–32
Hutchinson, Mrs. Charles, 132
Hyatt, Anna Vaughn, 221

Ibsen, Henrik, 219
"Immigrant in America" (exhibition), 230–31
Impressionism, 95, 106–8, 122, 196, 231
Independent Artists Exhibition, 228
Indianapolis Art Association, 258n.31
Individualism: of "new woman," 240–41; strategy of, xv, 147–244; of Whitney, 223, 241–42
Industrial design, 41, 63–64, 67, 73. See also Design schools for women
Industrialization, 52
Inman, John, 13
Inness, George, 98, 199
Irving, Washington, 11, 12
It Club, 163
Ives, Halsey, 103

Jackson, Andrew, 12
James, Alice, 95
James, Henry, 105, 162, 163, 175
James, William, 163, 171
Jameson, Mrs. 95
Janvier, Mrs. C. A., 128
Jarves, James Jackson, 6, 15–16, 24, 158
Jay, John, 116–17
Jesup, Mrs. Morris K., 121
Jewitt, Sarah Orne, 163
Johns Hopkins University, 124, 180
Johnson, John G., 158, 167, 173
Johnston, John Taylor, 50, 116, 120
Joint stock companies, 23
Jones, Elizabeth Sparhawk, 134
Jones, Mary Cadwalader, 45
Josephson, Matthew, 238

Kahn, Otto, 155
Kandinsky, Wassily, 190, 193
Kann, Rodolph, 156
Kauffmann, Angelica, 102
Kemble, Fanny, 89, 90
Kennedy, John Stewart, 118
Kensett, John, 8, 9, 22–25, 116
Kent, Henry, 120, 121, 126
Kent, Rockwell, 192
Keppel, Frederick, 102
Kimball, Evaline, 122, 132, 133
Kimball, Fiske, 126
King, Edward, 28
King, Rufus (father), 28
King, Rufus (son), 30, 31, 72
Kirstein, Lincoln, 205
Klee, Paul, 190
Knobloch, Edward, 224
Knowlton, Helen, 87, 109
Koussevitsky, Serge, 106
Kreisler, Fritz, 106, 162
Kuehne, Max, 235
Kuniyoshi, Yasuo, 236

Ladies Academy of Fine Art (LAFA), 30–33, 71, 160
Ladies' Art Association, 101–2

Ladies Lunch Club, 126
Ladies' New England Art-Union of Needlework, 250n.29
La Farge, John: character of, 98; and Fenway Court, 165; and Wheeler, 39, 47, 56; and Whitney, 216–18, 230; mentioned, 105
Laurencin, Marie, 106, 183, 185
Lawrence, Mrs. T. Bigelow, 135
Lawson, Ernest, 228
Lebsock, Suzanne, 77
Lee, Vernon, 163
Léger, Fernand, 190
Leland, Francis I., 118
Lending libraries, 51
Lenox, James, 98
Lerner, Gerda, xiii
Leslie, Ann, 16
Leslie, Charles, 8
Leupp, Charles M., 9, 13, 25, 26
Leutze, Emanuel, 85
Levine, Lawrence, 112, 115
Lewis, Edmonia, 89, 102
Libraries, 51, 114
Liminality, 159–60
Lincoln, Abraham, 91–92
Lincoln, Mary Todd, 91
Liszt, Franz, 91
Literary Digest, 119, 206
Livermore, Mary, 40
L'Oeuvre (Zola), 153
Log Cabin Settlement, 70
London Daily Mail, 156–57
Longfellow, Henry Wadsworth, 12, 28
Longworth, Joseph, 73, 74
Longworth, Nicholas, 17, 71
Lord, Samuel, 53
Loring, Charles G., 138, 139
Louvre, 106, 116, 153, 219
Lowden, Florence, 134
Lowell, Abbott, 151
Lowell, Anna Cabot, 23
Lowell, James Russell, 91
Lowell Institute, 86
Lowell School of Design, 101
Lubove, Roy, 263n.9

Luce, Molly, 236
Luhan, Mabel Dodge, 180–85, 189, 228
Luks, George, 229, 231, 234
Lunch Club, 13, 27
Lusitania (ship), 230
Lyman, Susan Chester, 70
Lynes, Russell, 76

McAlister, Ward, 45
Macbeth Gallery, 227
McCagg, Ezra B., 131
McCormick, Edith Rockefeller, 134
MacDowell, Susan, 88
McGuffey, Alexander, 72
McKim, Charles, 220
McLaughlin, Louise, 71, 72
Madison, James, 12
Manet, Edouard, 106–9, 122, 182, 229
Marin, John, 199, 202
Marquand, Henry, 121, 122, 154–55
Marriage: and artistic careers of women, 17, 88–89, 95, 107, 241; Hosmer on, 90; property laws, 4, 22, 112, 141; Wheeler on, 39; Whitney on, 218
Marsh, Reginald, 235, 236
Martineau, Harriet, 10, 17
Masses (journal), 209
Mather, Frank, 154–55, 171
Matisse, Henri: Dreier's reaction to, 189; and Rockefeller, 200–202, and Stein, 180, 182, 183; mentioned, 185, 186, 211
Maverick, Peter, 24
May, Henry, 185
Mead, Margaret, xi
Medical colleges for women, 59–60. *See also* Nursing
Melba, Nellie, 106, 162
Melville, Herman, 12–13
Men: denigration of women's art by, 15–16, 99–100; and domesticity cult, 4–8; feminization fears of, 149–53, 176

—, as artists: antebellum era, 8–13, 18–20, 22–23, 33; and decorative arts, 46–47, 56, 65–67; and Gardner, 163–65; mentoring relationships with women artists, 83–109, 275n.21; and Stein, 182–83; and Whitney, 221–22, 235–36, 241
—, as art patrons and philanthropists: acquisitiveness of, 153–58; antebellum era, 8–13; of avant-garde, 180, 185, 187–88, 205; control of art institutions by, ix–xiv, 23–27, 33, 152–53, 176, 243–44; female patrons and philanthropists contrasted with, 73, 173–75, 239; and museum development, 71–77, 111–45
Men's clubs: antebellum, 8, 13, 15; decorative arts, 65–66; and museum development, 116–17
Merriman, Helen Bigelow, 105
Merritt, Anna Lea, 134, 102–4
Metcalf, Helen, 64–65, 76
Metropolitan Museum of Art: and avant-garde, 185–86, 191, 202, 206; Fenway Court compared with, 171; Havemeyer collection at, 108, 111–12, 122; history of, 116–26, 141, 143–44; and Morgan, 157; Whitney offer to, 237; mentioned, ix, 201, 216, 229, 243
Meyer, Agnes Ernst: antifeminism of, 242; career of, 183–84, 188; on Stein, 270n.3; mentioned, 186, 195, 231
Meyer, Eugene, Jr., 183
Meyers, Jerome, 228
Mills, C. Wright, 114
Miró, Joan, 190
Modern Gallery, 183
Modernism. *See* Avant-garde
Modern Woman (Cassatt), 102–3
Mondrian, Piet, 192
Monet, Claude, 105, 108, 122, 165, 186

Mora, Luis, 231
Moran, Thomas, 88
More, Hermon, 237, 238
Morgan, J. Pierpont: career of, 153, 155–58; and decorative arts, 50, 76; Gardner compared with, 173–75; mentioned, 25, 166, 168, 180, 200
Morgan, Junius, 157
Morgan, Junius Spencer, 155–56
Morgan, Mrs. J. Pierpont, 119
Morgan Library, 153, 157
Morisot, Berthe, 106–8
Morris, Frances, 124–26
Morris, William, 43, 46
Morse, Samuel F. B., 8, 9, 13, 15
Moses, Robert, 143
Mount, William Sidney, 11, 13, 18–20, 95, 98
Munsey, Frank, 118–19, 239
Museum of Fine Arts (Boston): and Gardner, 138–40, 150, 161, 168, 171, 175–76; history of, 135–40
Museum of Folk Art, 70–71
Museum of Modern Art, 180, 196–209, 211, 212
Museums: decorative arts movement contrasted with, 37–38; development of, xi, 41, 60, 71–77, 111–45; and modernism, 179–80, 185–86, 190–191, 227; and sacralization of art, 112–15, 244; mentioned, 152–53, 176
Music, 38
Musical instruments, Brown collection of, 123, 125, 126

Nation, 155, 192, 206, 226–27, 238
National Academy of Design (NAD): and American Art-Union, 26; member characteristics, 23–24; role of women in, 20, 27; and Whitney, 223, 228, 231; women in life classes at, 93; mentioned, 10, 11, 13, 17, 25, 29, 32, 34, 184
National Arts Club, 70, 100

National Gallery (England), 25
Nature, and culture, 151, 152
Needle and Bobbin Club, 125
Needlework, 101, 106; antebellum, 14–15; and decorative arts movement, 38, 43–47, 50, 55, 60; in museums, 128, 137; and women's exchanges, 61. See also Decorative arts
"Negro Sculpture" (exhibition), 231
Nevelson, Louise, 236
Newark, N.J., 27
Newbold, Catherine, 125
Newcomb Pottery, 71
New England Female Medical College, 60
New Republic, 192
"New woman," 149, 158–60, 240–41
New York City: art institution development in, 23–27, 141; artists' circles in, 12–13; as art world capital, 244; Spencer on conditions in, 18. See also Metropolitan Museum of Art; Museum of Modern Art
New York Design School for Women (NYDSW), 63–64
New Yorker, 193
New York Exchange for Woman's Work, 62
New York Gallery of Fine Arts (NYGFA), 24–27
New-York Historical Society, 24, 25
New York Society of Decorative Art (NYSDA): and Cooper-Hewitt Museum, 76–77; and decorative arts movement, 44–51, 55–56; revenues at turn of century, 62; Tiffany in, 67; mentioned, 73, 88, 216
New York Times, 50–51, 101, 104, 230, 235, 238
New York Tribune, 92
New York University, 9, 211
Nichols, George, 73
Nichols, Maria Longworth, 71–72, 258n.29

Nimmo, Mary, 89
Nineteenth Amendment, 241
Nochlin, Linda, xiii
Nonprofit corporations, xiii, 113, 115, 143, 144, 204, 262n.9
Norris, Frank, 97–98
Norton, Charles Eliot: and decorative arts, 69, 72; and Gardner, 162, 165, 166, 172; mentioned, 24
Nude Descending a Staircase (Duchamp), 184–85, 193
Nursing, 60, 61, 78, 84, 144

Oakey, Maria, 87, 88
O'Connor, Andrew, 211, 226, 275n.21
Okakura-Kakuzo, 165
O'Keeffe, Georgia: and Museum of Modern Art, 199, 202, 208; and Société Anonyme, 193, 195; mentioned, 88, 239
Olmsted, Frederick Law, 170
Otis, Mrs. Harrison Gray, 23
Outlook, 206, 238
Out of Money Club, 8

Paderewski, Ignacy, 106, 162
Palmer, Bertha Honoré: and Art Institute, 132–34, 144; and Columbian Exposition, 102–4, 144; Gardner compared with, 175; mentioned, 67, 90, 107, 121, 141, 142, 165, 265n.40
Palmer, Pauline, 134
Palmer, Potter, 103, 265n.40
Paris, 89, 106, 107, 183, 244; Salon of, 89, 95, 105, 118, 219, 223
Parrish, Maxfield, 227
Parrish, Samuel, 88
Parsons, Betty, 244
Parsons, Mary, 125
Paul Revere Pottery, 71
Pavlova, Anna, 162
Peabody, George, 155–56
Peale, Anna Claypoole, 16, 20
Peale, Mary Jane, 17
Peale, Miriam, 88

Peale, Sarah, 20
Pennsylvania Academy of Fine Arts: avant-garde at, 185; origin of, 23; role of women at, 20, 27–28, 99, 141; women in life classes at, 93; mentioned, 29, 32, 106
Pennsylvania Museum of Art, 126–30, 141
Pepper, William Platt, 127
Perkins, Charles, 136
Perkins, Louisa, 85
Perry, Lilla Cabot, 100, 105, 109, 122, 165
Perry, Mrs., 73–74
Perry, Thomas, 105
Peter, Sarah Worthington King: career of, 28–32; Gardner compared with, 160, 163; illustration, 2; Rockefeller compared with, 209; Wheeler compared with, 37, 38, 46; Whitney compared with, 239; mentioned, 34, 43, 55, 63, 72, 77, 189, 212
Peter, William, 28–29
Philadelphia: art institution development in, 27–28, 141; women's design schools in, 63. *See also* Pennsylvania Academy of Fine Arts
Philadelphia Artist's Fund Society, 20
Philadelphia Centennial Exposition: and Boston Museum of Fine Arts, 135, 138; and capitalistic ethos, 153; and decorative arts movement, 40–43; and Pennsylvania Museum of Art, 126–27, 141; and Rhode Island School of Design, 64; women's art exhibitions at, 27–28, 101–2; and Women's Art Museum Association, 71, 72; mentioned, 64, 227
Philadelphia Museum of Art, 158, 211
Philadelphia Orchestra, 61, 258n.29
Philadelphia School of Design for Women, 28–29, 32, 34, 38
Philanthropy: and arts and crafts

Philanthropy (*continued*)
movement, 67; and capitalism,
154; Carnegie on, 114; and decora-
tive arts movement, 47–48, 55, 56,
59; and design schools for women,
63, 78; and domesticity, 5, 32, 33,
84; and entrepreneurship, 59–61;
of Gardner, 162; limitations of, for
women artists, 84, 109; men and
women contrasted in approach to,
73, 174–75; of Peter, 28, 29, 34; of
Sanitary Commission, 39–40; of
Whitney, 219–21, 229–30; and
women's exchanges, 62–63. *See
also* Men, as art patrons and phil-
anthropists; Women, as art patrons
and philanthropists
Phillips, Duncan, 205
Phillips, Marjorie Acker, 105
Phillips Gallery, 105, 211
Photography, 22. *See also* Steichen,
Edward, Stieglitz, Alfred
Photo-Secession gallery, 106
Picasso, Pablo, 180–82, 185, 204, 211,
228, 231
Pickford, Mary, 241
Pit, The (Norris), 97–98
Pitman, Benn, 71, 72, 101
Pleck, Elizabeth, 95
Pleck, Joseph, 95
Pollock, Jackson, 244
Popular Science Monthly, 151
Post, George B., 216
Pottery clubs, 71
Power Elite, The (Mills), 114
Powers, Hiram, 24, 92
Pratt Institute, 196
Pred, Alan, 10
Prendergast, Maurice, 106, 202
Professionalization, 115, 143
Pullman, George, 130
Pullman, Harriet, 134

Quilts. *See* Needlework
Quinn, John, 186, 210–11

Radcliffe College, 143, 180
Radeke, Eliza, 64
Randall, E. A., 84
Rape of Europa, The (Titian), 165–69,
173
Ravlin, Grace, 134–35
Ray, Man, 190, 191
Ream, Vinnie: career of, 89, 91–94;
mentioned, 102, 104, 109, 226,
275n.21
Rebay, Hilla, 244
Redon, Odilon, 202
Red Scare, 186, 209, 230
Reed, Luman: art collection of, 24–
25; career of, 11; Whitney com-
pared with, 216, 243; mentioned,
9, 20, 22, 33, 37, 106, 113, 158,
163, 182, 211, 228
Reid, Whitelaw, 92
Religion, 5
Rembrandt paintings, in American
collections, 31, 121, 122, 138, 154,
155, 157, 163–70 passim
Renoir, Pierre-Auguste, 122, 182, 186
Rhode Island Art Association, 64
Rhode Island School of Design Edu-
cation (RISDE), 64–65
Richardson, H. H., 100
Richter, Gisela, 125
Riggs, William, 156
Rimmer, William, 86–87
Rivera, Diego, 202, 209, 228
Robbins, Margaret Dreier, 189
Roberts, Marshall, 98
Rockefeller, Abby Aldrich: and folk
art, 272n.37; illustrations, 178,
197, 203; and Museum of Modern
Art, 196–212; Whitney contrasted
with, 215–16; mentioned, 70–71,
243
Rockefeller, John D., 156, 158, 174,
197
Rockefeller, John D., Jr., 118, 197,
200–204, 207–9, 239
Rockefeller, Nelson Aldrich, 205, 208

Rodin, Auguste, 183, 221, 229
Rogers, Jacob S., 118
Rome, 89, 91
Rookwood Pottery, 71
Roosevelt, Mrs. Theodore, 106
Roosevelt, Quinten, 230
Roosevelt, Theodore, 151, 184, 231
Rosenberg, Rosalind, 94
Rosenfeld, Paul, 238
Rossetti, Dante Gabriel, 91
Rossiter, Margaret W., 78, 84, 124
Rousseau, Jean-Jacques, 15, 95
Royal School of Art Needlework, 41–43, 64
Rubens, Peter Paul, 165, 166
Rug-making, 69, 70
Ruskin, John, 43, 254n.15
Russell Sage Foundation, 120
Ryder, Albert, 206
Ryerson, Martin, 122, 130, 132, 202, 204, 265n.40
Ryerson, Mrs. Martin, 132–33, 265n.40

Sachs, Paul J., 205, 206
Sacralization of art, 112–15, 143, 160, 244
Sage, Olivia, 118, 120, 141, 174–75, 262n.9
Sage, Russell, 120
St. Botolph Club, 100
St. Denis, Ruth, 162
St.-Gaudens, Augustus, 65, 89, 216, 220
St. Louis, 27, 49
Saisselin, Remy, 153–54
Salmon, Lucy, 62–63
Salons, 12–13, 28, 105–6
Samuels, Ernest, 166, 168, 174
Sand, George, 90
San Francisco, 62, 182
Sanitary Commission, 39–41, 44, 78, 116, 128, 230
Santayana, George, xi
Sargent, John Singer, 100, 106, 135, 163

Sartain, Emily, 16
Sartain, John, 27–28, 128
Scammon, Maria, 50, 133
Schille, Alice, 105
Schmidt, Katherine, 236
Schnackenberg, Henry, 239
Schuyler, Georgina, 119
Science, women in, 84, 124
Scott, Joan, xiii
Scott, Mrs. Thomas, 128
Scudder, Janet, 134
Sculpture, 89–93, 219–26
Sears, Joshua Montgomery, 105–6
Sears, Sarah Choate, 105–7, 109, 185
Sedgwick, Catharine, 12
Separatism: rejection of, 84, 150, 163, 166; strategy of, xii, 1–79, 145, 241
Sesame and Lillies (Ruskin), 43
Seurat, Georges, 186, 206
Shaw, Mrs. G. Howland, 136
Sherwood, Mrs. John, 45
Shinn, Everett, 229, 230
Shinnecock art colony, 88
Sibyl Carter Indian Lace Association, 70
Simkhovitch, Mary, 219, 235
Sketch Club, 13, 25, 27, 47, 231
Sloan, John, 209, 227–31, 233–35
Smith, Al, 277n.50
Smith, F. Hopkinson, 66
Smith, Mary, 99
Smith, Mary Rozet, 77
Smith, Sophia, 175
Smithsonian Institution, 158
Social class, 49, 86
Social Darwinism, 94, 97, 240
Société Anonyme, 187–95, 201, 204, 211
Societies of decorative art. *See* Decorative arts movement
Society of American Art, 99
Society of Independent Artists, 228
Society of Lady Artists, 100–101
Sorosis, 44

South Kensington Museum, 41–44, 64, 72, 76
Spaulding, John, 207
Spencer, Benjamin Rush, 17
Spencer, Lilly Martin, 17–20, 99–102
Sports, 97, 151
Springer, Reuben, 74
Starr, Ellen Gates, 67
Stebbins, Emma, 89
Stebbins, Theodore, 86
"Steel Engraving Lady and the Gibson Girl, The" (Ticknor), 158–59
Steichen, Edward, 183, 186, 230
Stein, Gertrude: career of, 180–83; mentioned, 176, 189, 190, 197, 209, 210, 220, 238, 242
Stein, Leo, 180–82
Stein, Michael, 180
Stein, Sally, 180, 182, 185
Stella, Joseph, 199
Sterner, Marie, 198
Stettheimer, Florine, 208
Stevens, Thaddeus, 91
Stevenson, Sara Yorke, 129
Stewart, A. T., 53, 90
Stewart, David, 160, 174
Stickney, Mrs. E. S., 133
Stieglitz, Alfred: impact of, 210–11; and Meyer, 183–84; mentioned, 106, 187, 193, 198, 230, 231
Stimpson, Mrs. Henry, 43
Stokes, Mrs. Phelps, 20
Storrow, Mrs. James G., 71–72
Story, Ronald, 136
Story, William Wetmore, 89–91
Stowe, Harriet Beecher, 7
Strahan, Edward, 66
Straight, Dorothy, 228
Stravinsky, Igor, 228
Stuart, Gilbert, 12, 16, 17, 22
Stuart, Jane, 16, 17
Studios, artists', 9–10, 39, 95, 97
Sturges, Jonathan, 9, 13, 24–27, 33, 156
Suffrage movement, 129, 142
Sullivan, Cornelius, 196

Sullivan, Mary Quinn, 196–98, 202–4, 209, 212
Sully, Jane, 20, 88
Sully, Thomas, 22–23
Swisshelm, Jane Grey Cannon, 91–92
Szechenyi, Count Laszlo, 216

Taft, Lorado, 134, 259n.19
Taylor, Bayard, 28
Taylor, George, 53
Tenth Street Studio, 97, 98
Thomas, M. Carey, 124
Thomas, Theodore, 258n.29
Ticknor, Caroline, 158–59
Tiffany, Louis Comfort, 47, 56, 66–67, 77
Tile Club, 65–66, 100, 231
Titian, 165–69, 173
Tocqueville, Alexis de, 3
Toulouse-Lautrec, Henri de, 85, 191
Townsend, Gertrude, 125
Transactions, 26
Triggs, Oscar Lovell, 69
Tuckerman, Henry, 9, 13
Twain, Mark, 67
Tweed, William Marcy, 76, 117
291 (journal), 183

Union League Club, 116, 117
Universities: and sacralization, 113–14; women's role in, 143, 144, 152–53, 176. See also Colleges
University of Chicago, 174, 201, 204

Valentiner, William, 202, 204
Vanderbilt, Alice, 216, 221
Vanderbilt, Cornelius, 50, 67, 216
Vanderbilt, Cornelius ("Commodore"), 216
Vanderbilt, Gladys, 216
Vanderbilt, Mrs. W. K., Jr., 230
Vanderbilt, William H., 50
Vanderlyn, John, 13
Varian, Dorothy, 236
Vassar College, 78
Vedder, Elihu, 65, 89

Velázquez, Diego, 154, 166
Venetian Painters, The (Berenson), 166
Vermeer, Jan, 157, 165
Verplanck, Gulian, 9, 13
Victoria, Queen, 64, 104
Voluntary associations: antebellum, 3–4, 20; women's, xii, 61, 78–79. *See also* Philanthropy

Wadsworth Atheneum, 125, 157
Wagner, Maria Louisa, 17
Waldo, Samuel, 135
Wallace, Sir Richard, 157
Warburg, Edward M. M., 205
Ward, Samuel, 9, 12
Ware, Carolyn, 235
Warren, Edward, 138
Warren, Samuel, 139
Warren, Susan, 52, 138, 167
Waters Gallery, 158
Watson, Forbes, 228, 233, 237, 238, 242–43
Watson, Nan, 233, 236, 239
Webb, Electra Havemeyer, 71, 272n.37
Weber, Max, 199
Wellesley College, 205
West, Charles, 74
Wheeler, Candace Thurber: and arts and crafts movement, 67, 69–70; and Associated Artists, 67; career of, xiii–xiv, 37–56; and Columbian Exposition, 102; Dreier compared with, 194; Gardner compared with, 160, 163; Rockefeller compared with, 209, 210; Whitney compared with, 220; on women in art careers, 83, 95; mentioned, 59, 72, 79, 88, 97, 112, 119, 141, 216, 241, 272n.37
Wheeler, Dora, 55
Wheeler, Thomas, 39
Whistler, James McNeill, 98, 158, 163, 229
White, Stanford, 65, 88

Whitman, Sarah W., 87, 100, 165, 166
Whitman, Walt, 9–10
Whitney, Anne, 99, 102, 104
Whitney, Flora, 221, 227
Whitney, Gertrude Vanderbilt: and Armory Show, 185, 186; career of, xv, 215–44; illustrations, 214, 225; mentioned, 159, 195, 210, 212
Whitney, Harry Payne, 217–23, 226, 237, 239
Whitney, Helen Hay, 233
Whitney, Isabel, 236
Whitney Museum of American Art, 234, 237–43
Whitney Studio, 229–31, 240
Whitney Studio Club, 198, 232–33, 236, 241, 272n.37
Whitney Studio Galleries, 236
Whittredge, Worthington, 116
Widener, P. A. B., 167
Wiebe, Robert, 114–15
Wier, J. Alden, 65
Wilde, Oscar, 98
Williams College, 175
Wister, Mrs. Jones, 129
Wolfe, Catharine Lorillard, 117–18, 174
Wolfe, John, 118
Woman and Child (Beaux), 135
Woman's Exchange, 56
Women: class distinctions between, and work, 49; consumption and culture of, 53–54; Darwinian ideas on mentality of, 94; and domesticity cult, 4–8; and feminization myth, 149–52; "new woman," 158–60, 240–41; and suffrage movement, 142
—, as artists: antebellum era, 8, 14–22; and arts and crafts movement, 67–71; attacks on works by, 15–16, 91–95, 99–100; and decorative arts movement, 37–56, 59–60; design schools for, 63–65, 78; and Halpert, 199; mentoring relationship with men, 83–109, 275n.21;

Women (*continued*)
 and Stein, 182–83, 242; and
 Whitney, 235–36, 238–39, 241–
 42; and women's exchanges, 60–
 63, 78
—, as art patrons and philanthropists:
 antebellum era, 22–23, 27–34; of
 avant-garde, 179–212, 244; change
 in role of, ix–xiv, 243–44; Dreier,
 career of, 187–96; Gardner, career
 of, 158–76; Havemeyer, career of,
 107–8; male art patrons and phil-
 anthropists contrasted with, 73,
 173–75, 239; and museum devel-
 opment, 71–77, 111–45; Wheeler
 and decorative arts movement, 37–
 56; Whitney, career of, 215–16,
 226–44
Women's Art Museum Association
 (WAMA), 71–75, 132
Women's auxiliaries, 61
Women's Centennial Committee, 64,
 72
Women's Christian Temperance
 Union (WCTU), xiv, 50, 78
Women's clubs: aid to women artists

by, 61, 99, 104, 105, 109; and
 avant-garde, 186–87, 210; and de-
 corative arts movement, 44–45;
 and museum development, 125–
 26; pottery, 71; mentioned, 70, 78
Women's Educational Association
 (Boston), 60
Women's exchanges, 56, 60–63, 78
Women's National Art Association,
 101
Woolf, Virginia, 228
Worcester Museum of Art, 105, 192
World War I, 70, 125, 141, 182, 210
Wrightsman, Mrs. William, Jr., 128–
 29
Writers, and artists, 12–13

Yale University, 175, 195, 211

Zayas, Marius de, 183, 231
Zola, Emile, 153
Zorach, Marguerite, 185, 195, 199,
 208, 233
Zorach, William, 199, 233
Zorn, Anders, 148, 163–65
Zurbarán, Francisco de, 165, 166